HPBooks®

How to select & use
OLYMPUS
SLR CAMERAS

by Carl Shipman

THIS IS AN INDEPENDENT PUBLICATION

Cooperation of Olympus Camera Corporation is gratefully acknowledged. However, this publication is not sponsored in any way by Olympus Camera Corporation. Information, data and procedures in this book are correct to the best of the author's and publisher's knowledge. Because use of this information is beyond the author's and publisher's control, all liability is expressly disclaimed. Specifications, model numbers and operating procedures for the equipment described herein may be changed by the manufacturer at any time and may, therefore, not always agree with the content of this book.

Publisher: Rick Bailey; Executive Editor: Randy Summerlin; Senior Editor: Vernon Gorter; Art Director: Don Burton; Managing Editor: Cindy Coatsworth; Book Design: Paul Fitzgerald; Typography: Beverly Fine, Phyllis Hopkins, Michelle Carter; Director of Manufacturing: Anthony B. Narducci; Photos: Carl Shipman or as credited.

Cover Photo: Bill Keller

Published by HPBooks, a division of HPBooks, Inc.
P.O. Box 5367, Tucson, AZ 85703 602/888-2150
ISBN 0-89586-015-5 Library of Congress Catalog Card No. 79-84702
©1987, 1985, 1983, 1982, 1981, 1979 HPBooks, Inc. Printed in U.S.A.
10th Printing, Revised Edition

1
PREVIEW

Every photograph has technical ingredients, such as exposure, the lens used and which parts of the image are in good focus. Each picture also has artistic ingredients, such as choice of subject, vantage point, composition and lighting. Besides that, a photo is a time capsule that stores and brings back to your mind the memory of the moment you took that picture. For most of us, a good photo is one that satisfies us in all three aspects.

In 1972, Olympus introduced a trend-setting new camera called the OM-1. It was compact and lightweight compared to other cameras at that time. The OM-1 and all cameras discussed in this book are of a type called Single-Lens Reflex (SLR). The SLR design is discussed in Chapter 3.

In following years, Olympus introduced a series of new models: the OM-2, OM-3, OM-4, OM-PC and others. These cameras pioneered some advanced concepts of exposure control and electronic flash that are discussed later.

LENSES

All cameras in this book use interchangeable lenses, providing a variety of photographic effects. In parallel with the development of the OM series of cameras, a series of interchangeable lenses was produced, called Olympus Zuiko lenses. Zuiko lenses are focused manually by turning a focusing ring on the body of the lens.

In 1986, the OM77AF camera was announced. This model focuses the lens automatically, using a motor in the camera body. Announced with the camera was a companion series of interchangeable lenses that are designed to be focused automatically by the camera. These lenses are labeled Olympus AF lenses. AF means autofocus.

There are now two series of interchangeable lenses—Zuiko for manual focus and Olympus AF lenses for automatic focus.

AF lenses fit AF cameras—such as the OM77AF—but *do not* fit earlier camera models.

Zuiko lenses fit all earlier camera models. Most Zuiko lenses also fit AF cameras. When installed on an AF camera, a Zuiko lens must be focused manually and does not allow use of all capabilities of the camera.

An exception to the foregoing is the Olympus OM-F camera, which is no longer in

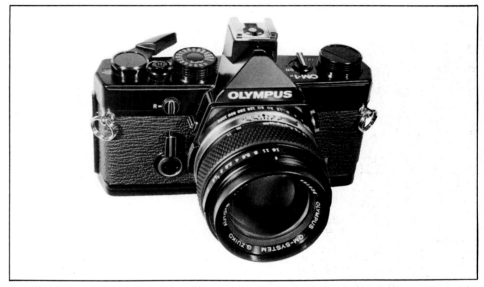

The OM-1N is a compact 35mm SLR. It's a non-automatic camera, which means that you set the exposure controls yourself.

production. This model provided automatic focus using a special *Zuiko AF* zoom lens which had a focusing motor built into the lens. Neither the OM-F camera nor the *Zuiko AF* lens is discussed in this book.

CAMERA MODELS

Olympus OM cameras that are currently available are discussed in this book. To introduce you to these models, they are shown in this chapter along with brief descriptions.

Most of the remaining chapters provide information that will help you operate your camera, no matter which model it is, and

make good pictures. For example, methods of exposure control and focusing are discussed. This information is general and may apply to more than one camera model.

The last chapter has specific descriptions and instructions for each camera model included in this book, along with specifications.

DEFINITIONS

The brief descriptions that accompany the camera photos in this chapter use some photographic terms that you may not know. Here are some simple definitions of those

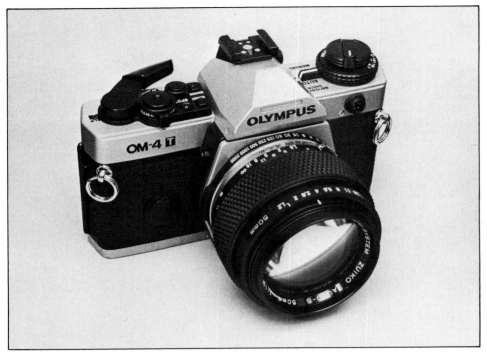

The OM-4T has automatic or manual exposure control with center-weighted, spot or multi-spot metering. It's the first OM camera to use the Olympus F280 Full-Synchro Flash unit, which offers a significant improvement in flash photography, as discussed in Chapter 11.

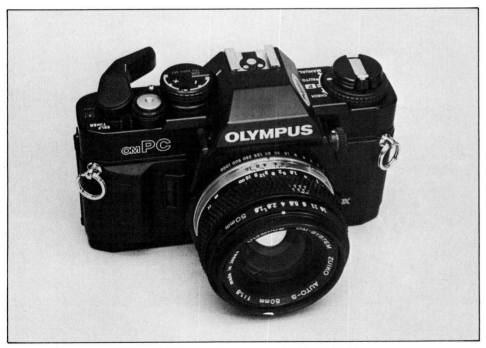

The OMPC has three exposure modes: manual, automatic and programmed. You can use either center-weighted or ESP metering.

terms. Later in this book, you will find more information on these topics.

Exposure Metering—Cameras have a built-in light meter that measures the brightness of the scene being photographed as an aid to setting exposure correctly.

Center-Weighted Metering—This metering method measures brightness at all parts of the scene but attaches more importance or "weight" to the brightness at the center of the scene. This method provides good exposure of average scenes.

Spot Metering—A spot meter measures the brightness of a small spot in the scene. Exposure is based on the brightness of that spot. Spot metering is used with non-average scenes, such as a person silhouetted against a bright background.

Multi-Spot Metering—The brightness of several spots in the scene is measured, one at a time. Exposure is based on the average of several spot measurements. Also used for non-average scenes.

ESP Metering—This offers another approach to non-average scenes such as a person against an unusually bright or dark background. ESP (Electro-Selective Pattern) measures brightness simultaneously in several areas of the scene and then automatically provides good exposure. ESP is simpler to use than spot or multi-spot metering.

Exposure Control—Exposure is affected by scene brightness and the type of film in the camera. Exposure is controlled by two camera settings, shutter speed and aperture size—discussed in the next chapter.

Manual Exposure Control—Manual means non-automatic. Manual exposure control requires you to set exposure manually by choosing a shutter speed and an aperture size.

Automatic Exposure Control—With this mode of operation, you set one of the exposure controls manually—shutter speed or aperture—and the camera then sets the other control automatically.

Programmed Automatic Exposure Control—This mode is "fully" automatic. The camera sets both shutter speed and aperture automatically.

Automatic Focus—The camera automatically focuses the lens on the subject at the center of the scene being photographed.

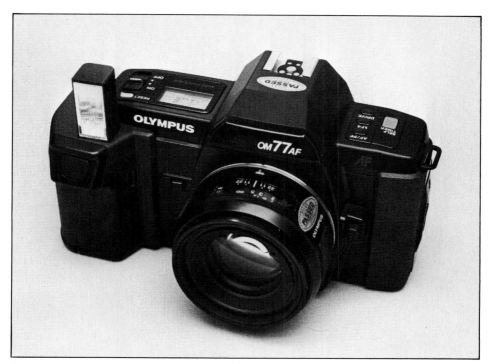

The OM77AF, when used with an Olympus AF lens, provides automatic focus and programmed automatic exposure. It has many other automatic features, including film loading, film advance and rewind. It has a built-in dark-red AF illuminator that casts a dark-red pulse of light on the scene to assist autofocus in the dark. Power Flash Grip 300, shown here, provides a small pop-up automatic flash unit that is very convenient. This camera also uses the F280 Full-Synchro Flash unit, which offers a significant improvement in flash photography, as discussed in Chapter 11.

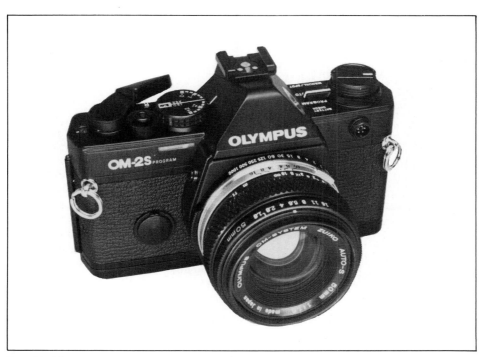

The OM-2SPROGRAM has manual exposure control, automatic exposure and programmed automatic exposure. It uses center-weighted or spot metering.

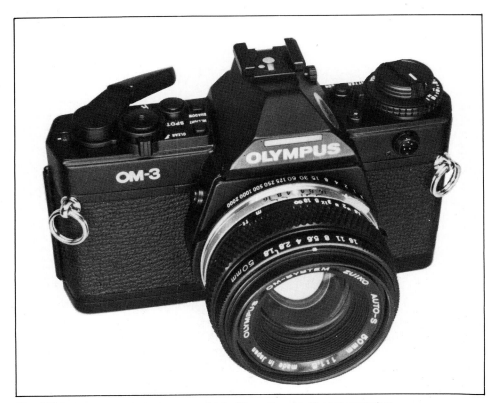

The OM-3 uses manual exposure control with spot or multi-spot metering.

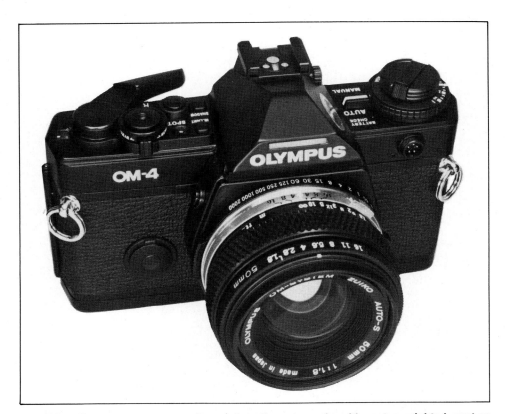

The OM-4 offers two exposure modes—automatic or manual—with center-weighted, spot or multi-spot metering.

2
EXPOSURE—THE BASIC TECHNICAL PROBLEM

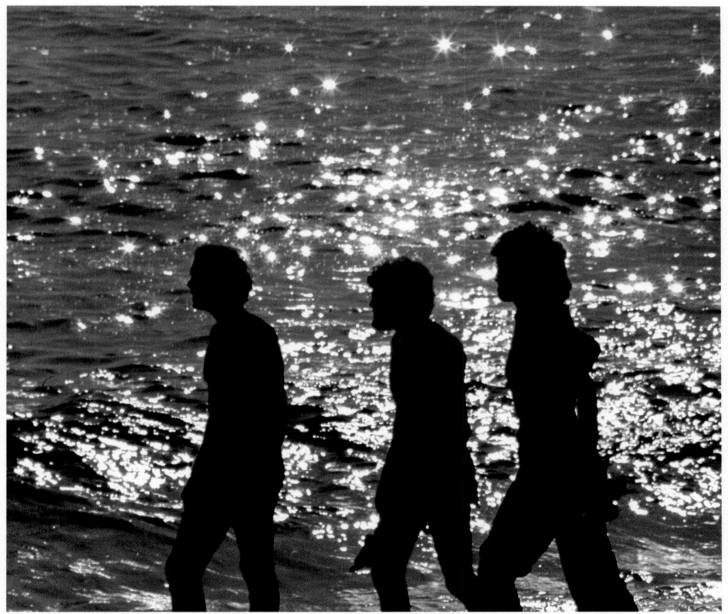

If you make exposures like this on purpose, you're in charge of the operation. To make silhouettes against a light background, base exposure on the background.

Film is exposed by light from the scene that passes through the lens and falls on the film in the back of the camera. To make a good photo, the light that reaches the film should normally form a sharply focused image of the scene and the film should be correctly exposed—neither overexposed nor underexposed.

APERTURE

Inside each lens is a *diaphragm* consisting of several metal leaves arranged in a ring. The inner edges of the leaves form an approximately circular opening called the *aperture*. The metal leaves can be pivoted to make the opening larger or smaller, as shown in the accompanying photos.

If the aperture becomes larger, more light passes through the lens, the image of the scene is brighter, and more exposure results.

Aperture size is stated by an *f*-number, such as *f*-4 or *f*-8. A peculiarity of *f*-numbers is that a larger *f*-number means a smaller

opening. The aperture size represented by *f*-8 is *smaller* than an aperture of *f*-4.

In this book, the phrase *large aperture* means a physically large opening and *small aperture* means a physically small opening.

In photographic literature, *f*-numbers are written in more than one way, such as *f/2* or *f:2*. Olympus uses F2 in instruction booklets. This book uses *f*-2. On cameras, the *f* symbol is omitted and only the number portion, such as 2, is used. The standard series of *f*-numbers is shown in Chapter 6.

SHUTTER SPEED

The film in the camera is normally protected from light by a shutter in the camera body, just in front of the film. To make an exposure, the shutter is opened for a period of time and then closed. If the shutter is held open for a longer time, more exposure results.

The length of time that the shutter is open is stated in seconds or fractions of a second,

such as 1/250. That number is called *shutter speed*. On cameras, the numerator of the fraction is omitted and 1/250 appears as 250.

The standard series of shutter speeds is shown in Chapter 6.

EFFECT OF LIGHT

When a pattern of light falls on film, such as the image of a scene, the film forms a record of that light pattern—called a *latent image*—which is invisible. The *development procedure* in a film laboratory causes the latent image to become visible.

RECIPROCITY LAW

The amount of exposure can be expressed by a simple formula that is a basic fact of photography:

Exposure = Illumination x Time

Illumination means the brightness of the light that falls on the film. *Time* is the length

The amount of light passing through a lens is regulated by the size of the *aperture,* formed by the movable leaves of a *diaphragm* inside the lens. At top, the diaphragm is set for a small aperture. At bottom, the aperture is almost fully open.

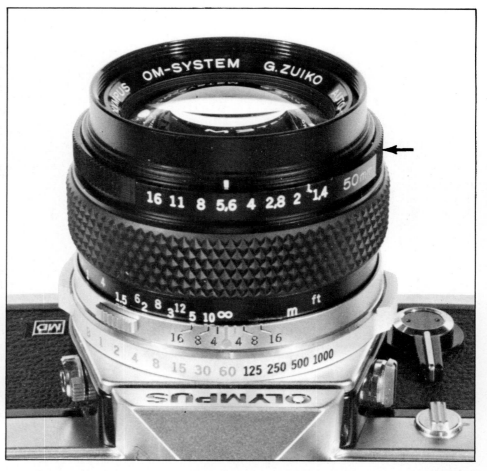

On Olympus Zuiko lenses, aperture size is manually controlled by rotating the Aperture Ring on the lens body (arrow). This lens has a range of aperture sizes from *f*-16 to *f*-1.4. The aperture setting is read using the white index mark on the lens body, just in front of the Aperture Ring. This lens is set for *f*-5.6.

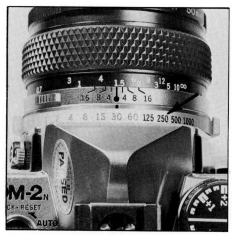

Some Olympus cameras have a Manual Shutter-Speed Ring (arrow) surrounding the lens mount on the camera body. This sets the length of time the shutter will be open so light can reach the film. Except for the 1 symbol, which means one second, the numbers on the scale are fractions of a second. For example, 125 means 1/125 second.

Film cannot record details in both bright sunlight and shadow. Notice the deep shadow across the walkway.

of time the shutter is open.

This formula is often written in abbreviated form as E = I x T.

To get a certain amount of exposure on the film, no particular amount of light is required and no particular length of time is required. The requirement is: The amount of light multiplied by the length of time must equal the desired exposure.

This means you can use less light and more time, or the reverse. When there is not much light, you expose for a longer time so the product of the two values is the desired exposure.

This leads to the basic rule for controlling exposure. When you double the intensity of light reaching the film, reduce exposure time to half. When you double the exposure time, cut the amount of light on the film in half. This is the essence of the reciprocity law.

HOW FILM REACTS TO EXPOSURE

This discussion applies to any kind of film, color or black and white (b&w). It is simpler to describe and understand when related to b&w film, but the same basic ideas apply also to color film.

If negative film is not exposed at all, but put through development anyway, it will be clear.

Increasing exposure causes b&w film to become darker after it is developed. There is a limit to how black it can get, just as there is a limit to how clear it can be.

It is convenient to think of changing exposure in a series of definite steps and then observe the amount of darkening that results at each step. The technical word for darkening of the film is *density*. More density means it is blacker or more opaque and transmits less light when you look through it.

All human senses, including vision, operate in a way that's surprising when you first learn of it. Suppose you are looking at a source of light such as a light bulb. It is making a certain amount of light and it gives you a certain *sensation* or mental awareness of brightness.

Assume that the amount of light from the source is doubled. It will look brighter to you. Not twice as bright, but you will notice a definite change.

To make another increase in brightness that you will interpret as *the same amount of change,* the amount of light must be doubled again. Successive increases in brightness that all appear to be *equal* changes must be obtained by doubling the amount of light to get the next higher step. This is a fact about the way we see. Therefore, it tells us what must be done on film to make equal steps of brightness to a viewer of the film.

Exposure Steps—Standard step increases in exposure are in multiples of two. When you change aperture from one *f*-number to the next, you either double the

amount of light or cut it in half.

Shutter speed is controlled by a series of standard steps including 1/2, 1/4 and 1/8 second. Notice that the standard steps of shutter speed are also multiples of two.

If you double the amount of light passing through the lens aperture, or double the length of time the shutter is open, you have made a *step increase* in exposure. Reducing either to one-half its former value is a *step decrease*.

Figure 2-1 is a test made by exposing each frame on a roll of film at a different exposure, doubling the exposure each time. The result shows how film behaves over a wide range of different exposures that were made in orderly steps for convenience. You can see that the negative reaches a point where it doesn't get any blacker even with more exposure. It also reaches a point where it doesn't get more clear with less exposure.

These two limits of the film—maximum black and maximum clear—are practical limitations in photography. Normally you try to fit the different brightness or tones of a real-world scene into the range of densities the film can produce.

This is done by adjusting the camera controls with a rather simple idea in mind. The film can produce a range of different densities between maximum and minimum. One of these densities on the film is the middle one. The scene you are photographing also has a range of brightness or tones to be transformed into densities on the film. One tone in the scene is the middle one.

If you arrange exposure so the middle tone of an average scene is transformed into the middle density on the film, exposure is just right. When the negative is made into a print, lighter tones of the scene use lighter densities on the print—above the middle value. Darker tones of the scene use the darker densities of the print.

The only technical problem that can result from exposing film this way is if the brightness range of the scene exceeds the density range of the film. In that case, the film doesn't have enough different densities to match the different brightnesses of the scene. That can happen when part of a scene is in bright light or sunlight and another part is in shadow.

CONTROL OF EXPOSURE

Getting a desired exposure on the film depends basically on three things:
• The amount of exposure the film needs—it varies from one type of film to another.
• The amount of light reflected toward the camera by the scene or subject.
• The settings of the camera exposure controls.

ISO/ASA Film Speed—Film manufacturers publish numbers called ISO/ASA Film Speed, a way of stating the amount of exposure required by each film type.

Film speed is a number such as 25 or 400. Higher speed numbers mean the film is more sensitive to light and requires less exposure. Doubling the film-speed number means the film requires only half as much exposure.

The standard series of ISO/ASA Film Speed numbers is 12, 25, 50, 100, 200, 400 and so on. It can be extended in either direction by doubling or halving the numbers, with some approximations.

Setting Film Speed—To get correct exposure, the speed of the film being used must be set into the camera. Some OM cameras have a control for this purpose. Typical controls are shown in the accompanying photos.

Recent OM cameras, such as the OMPC and OM77AF set film speed automatically when DX-coded film cartridges are used. These cartridges have a black-and-silver checkerboard pattern that encodes the film speed. Electrical contacts in the camera read the code pattern and the film speed is set automatically into the camera.

The accompanying table shows the relationships between ASA and ISO film-speed ratings. Film-speed controls and displays on recent OM cameras are labeled ISO/ASA or ISO. Even so, it is the ASA portion of the ISO value that is actually used. For example, if the film is ISO 125/22°, the number used in the camera is 125.

Intermediate Film Speeds—Not all films have speed ratings that fall on the standard film-speed scale. For example, a film speed of 64 is between the standard values of 50 and 100.

As shown in the accompanying illustration, the film-speed scale has intermediate values that are one-third steps. For example, between the standard values of 50 and 100 are two intermediate values: 64 and 80.

Amount of Light from the Scene—After film speed set into the camera, the next essential is to measure the amount of light reflected by the scene. Olympus 35mm cameras do this automatically, inside the camera. They measure light that has come through the lens, using an internal light meter built into the camera.

Exposure Controls—With film speed dialed into the camera, and the amount of light coming through the lens measured inside the camera, the camera itself can now figure the correct setting for the exposure controls. It indicates the correct setting on a display in the viewfinder, as you adjust the camera controls. Or, automatic cameras will make the setting for you.

The two exposure controls—aperture size and shutter speed—are used together to arrive at a pair of settings that produce the desired exposure indicated by the viewfinder display. Several pairs of settings can produce the same amount of exposure. You can change shutter speed and make a compensating change in aperture size so you end up with the same amount of exposure but you get it with a different pair of exposure control settings—a practical application of the reciprocity law.

There is an advantage to having several pairs of f-numbers and shutter speeds available to make the same exposure on the film. In addition to setting exposure, these controls have other effects on the picture. For example, at slow shutter speeds, meaning long exposure time, subjects in motion can be blurred on the film.

Taking the side-effects into consideration, the photographer makes settings and shoots the picture. The side-effects are discussed in detail later.

VIEWFINDER DISPLAYS

SLR cameras show you several things in the viewfinder: The scene you are photographing; a focusing aid in the center of the viewfinder screen; an exposure display to help you set exposure controls, and sometimes information about an electronic flash— such as when the flash is ready to fire.

When you have set the camera controls so the exposure display indicates correct exposure, or when an automatic camera has set exposure for you, the film will receive the amount of exposure requested by the speed

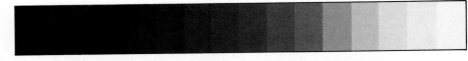

Figure 2-1/Different amounts of exposure result in different densities. Film testing is done by changing exposure in definite steps, making a *gray scale* as shown here.

number of the film.

A common error is to assume that this setting will be correct for anything you photograph. It will be correct for average scenes of the type most people shoot—most travel scenes for example. It will not be correct for non-average or unusual scenes, which often make the best pictures. This is so important that Chapter 8 is devoted to Exposure Metering.

APERTURE PRIORITY OR SHUTTER PRIORITY

For reasons discussed later, there are times when shutter speed is the most important consideration. There are other times when the aperture setting is most important.

Shutter Priority—If you are setting exposure manually, and shutter speed is the most important consideration, you will set shutter speed first. Then you'll find an aperture setting that gives correct exposure. This method of operation is called *shutter priority* because you set shutter speed first.

Aperture Priority—If aperture is more important than shutter speed, you will set aperture first. Then you'll use whatever shutter speed is needed for correct exposure. This is *aperture priority*.

Aperture-Priority Automatic—To use this capability, you set aperture first. Then the camera *automatically* sets shutter speed to give correct exposure of an average scene. This is aperture priority.

You still have control of shutter speed. The camera shows you the shutter speed it "plans" to use in a display in the viewfinder. If you prefer to use a different speed, change the aperture setting before making the shot. The camera will automatically select the corresponding correct shutter speed.

Programmed Automatic—If the camera has a programmed auto mode, it will set *both* aperture and shutter speed in that mode, according to a program built into the camera electronics. The settings depend on film speed and scene brightness.

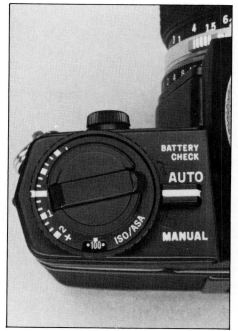

On the OM-3 and OM-4, the film-speed setting is shown in a window adjacent to the rewind knob. This camera is set for ISO/ASA 100. To change the setting, lift and turn the knurled outer rim of the control.

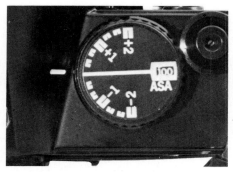

Other OM cameras show film speed in a window to the right of the viewfinder. Film speed is set by lifting and turning the outer rim of the control. This camera is set for ASA 100.

FILM-SPEED RATINGS

ASA	DIN	ISO
12	12	12/12°
16	13	16/13°
20	14	20/14°
25	15	25/15°
32	16	32/16°
40	17	40/17°
50	18	50/18°
64	19	64/19°
80	20	80/20°
100	21	100/21°
125	22	125/22°
160	23	160/23°
200	24	200/24°
250	25	250/25°
320	26	320/26°
400	27	400/27°
500	28	500/28°
640	29	640/29°
800	30	800/30°
1600	33	1600/33°
3200	36	3200/36°

There are three film-speed rating systems in common use. The United States standard is ASA numbers. The German standard is DIN. The international standard, ISO, combines the first two.

ASA and DIN agree at 12. Doubling the ASA number represents one full step in film speed—100 to 200 for example. Not all ASA numbers are exactly double; some are rounded off for convenience—12 to 25 for example. Adding three to the DIN number represents one full step in film speed—21 to 24 for example.

ASA and DIN scales are subdivided into 1/3 steps. ASA 125 and ASA 160 represent 1/3 steps between ASA 100 and ASA 200. On the DIN scale, adding one unit represents 1/3 step. For example, DIN 22 and DIN 23 are 1/3 steps between DIN 21 and DIN 24.

ASA	25	●	●	50	●	●	100	●	●	200	●	●	400	●	●	800	●	●	1600
		(32)	(40)		(64)	(80)		(125)	(160)		(250)	(320)		(500)	(640)		(1000)	(1250)	

If the film-speed dial doesn't show all film-speed numbers, use this table to find the film speeds represented by dots. Better still, memorize the film-speed numbers from ASA 25 to ASA 400.

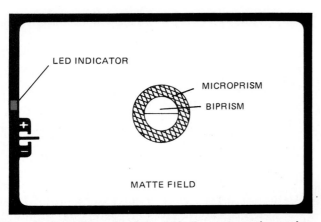

The OM-1ɴ viewfinder has a focusing aid in the center and a moving needle to indicate correct exposure. The red LED indicator on the left side works with Olympus flash units.

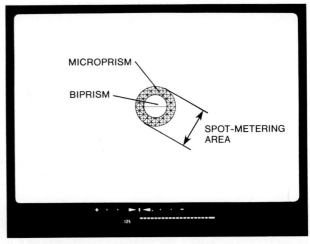

The OM-3 has several viewfinder displays, depending on the selected metering and exposure modes. In this display, the left end of the row of dots is aligned with an index mark which indicates correct exposure. Over- and underexposure are indicated by the + and − symbols. The set shutter speed is displayed as the numeral 125, which means 1/125 second.

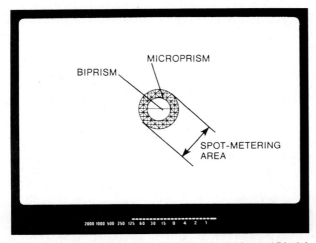

On automatic, the OM-4 and OM-4T use an LCD (Liquid Crystal Diode) viewfinder display to form a moving "bar chart" that indicates the camera-selected shutter speed. This display has indicators for flash, overexposure, spot metering and other features not shown here.

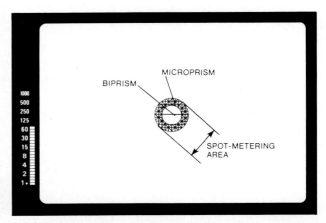

The OM-2Sᴘʀᴏɢʀᴀᴍ shows the set shutter speed by a bar at left of the viewfinder image. This camera is set for a shutter speed of 1/60 second. The overexposure warning symbol is not shown here.

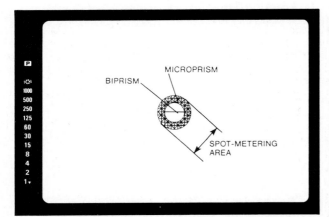

In the ᴏᴍPC viewfinder, one numeral glows to show the set shutter speed. The P symbol indicates that the camera is operating on Programmed automatic exposure. The lens aperture symbol glows to tell you that the lens aperture ring is not set correctly for this mode. The 1000 symbol blinks to warn of overexposure. Underexposure is not indicated.

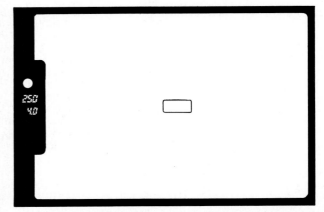

The ᴏᴍ 77ᴀꜰ is an autofocus camera. The small rectangle at the center of the viewfinder shows the area of the scene that is brought to focus automatically. At left, the circle is green if the image is in focus. The first number below the circle is shutter speed. The next is aperture size. Other symbols may appear below the aperture value. Overexposure is indicated when the fastest shutter speed—1/2000—appears and blinks. Underexposure is indicated when a Lo symbol appears instead of a shutter-speed number.

HOW A SINGLE-LENS REFLEX CAMERA WORKS

The main feature of a single-lens reflex (SLR) camera that distinguishes it from other types is this: You view and focus through the same lens used to cast the image onto the film. This has several important advantages and some relatively minor disadvantages.

The word *reflex* is a form of the word *reflection* and indicates that the image in the viewfinder is bounced off a mirror in the optical path between the lens and your eye.

Single-lens reflex cameras are designed as shown in the cutaway view (right). The lens receives light from the subject being photographed. A focusing control moves the lens closer to or farther away from the film.

To view, a mirror is moved to the "down" position to intercept light traveling from the lens toward the film. This intercepted light is bounced upward by the mirror to form an image on the *focusing screen*—sometimes called *viewing screen*. You view the image by looking into the camera, through the viewing *eyepiece* at the back. You see what is coming in through the lens, so you get the same view the film will get when you take the picture.

Between the eyepiece and the focusing screen is a special prism called a *pentaprism*. It causes the image you see to be correctly oriented—top to bottom and left to right. Like being wealthy, it's easy not to appreciate the benefit of correct viewing until you have to do without it.

The camera is built so the distance from lens to focusing screen by way of the mirror is the same as the distance from lens to the film in the back of the camera. Therefore, if the image is in focus as you see it on the focusing screen, it will later be in focus on the film when the mirror is moved out of the way to take a picture.

A convenient way to think about it is this: You look through the pentaprism and examine the focusing screen to see the image that will fall on the film later, when you trip the shutter. If you like what you see, squeeze the

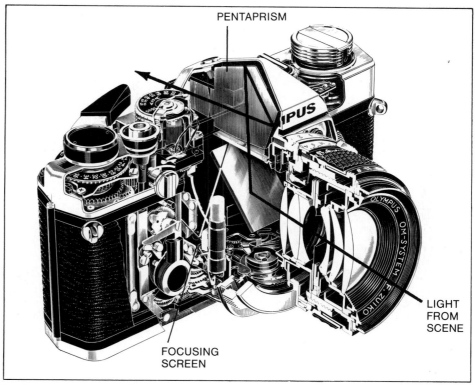

To view the scene through the lens of an SLR camera, look into the viewing window on the back of the camera body. What you see is light from the scene, which has come through the lens and is reflected upward by the angled mirror. An image of the scene is formed on the focusing screen, just above the mirror. Light rays from the focusing screen travel upward through the pentaprism, where multiple reflections cause a correctly oriented image to be seen through the viewing window.

When you are satisfied with focus and composition of the image and have the exposure controls set, depress the shutter button. The mirror moves up out of the way so light from the scene can travel to the back of the camera to expose the film.

shutter button and several things happen very quickly.

The mirror moves up out of the way. As it swings up to its parking place you lose your view of the image. When the mirror is out of the way, the focal-plane shutter in front of the film is opened so light from the lens falls on the film.

In addition to mirror movement in synchronization with operation of the focal-plane shutter, the busy camera mechanism also lets you view the scene through the widest possible lens aperture for maximum scene brightness in the viewfinder. When you press the shutter button, the camera automatically closes lens aperture to the *f-*

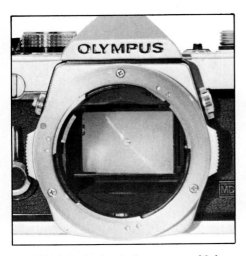

Looking into the front of a camera with lens removed, you can see that the mirror is down, reflecting the image upward through the pentaprism.

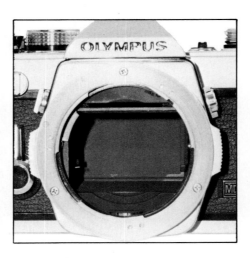

In the exposure sequence, the mirror moves up so it no longer intercepts light rays from the lens. You can see the bottom edge of the mirror near the top of the lens opening. The focal-plane shutter, at the back of the body, is closed in this photo so light from the scene does not strike the film.

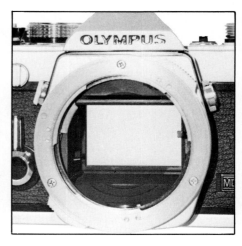

As the mirror swings up, the lens aperture closes to the correct size for proper exposure. *Then* the focal-plane shutter opens so light can reach the film. The frame size on film is determined by the rectangular window opened by the focal-plane shutter.

number selected manually, or automatically by the camera.

For example, if f-11 was selected, the lens will automatically close to f-11 after you depress the shutter button, before the shutter opens.

When the desired amount of time for film exposure has passed, the shutter closes.

The mirror automatically swings back down to the viewing position. Even though you lose sight of the scene while the film is being exposed, this time is usually brief and you quickly learn to ignore the blackout. It's as if the camera blinked.

Today, all modern SLR cameras return the mirror instantly to the "down" position as soon as the shutter is closed—a feature commonly called *instant-return mirror*.

FILM ADVANCE

After an exposure is completed, the film should be advanced in the camera so an unexposed portion is in position behind the shutter, ready for the next image.

Cameras with manual film advance have a Film-Advance Lever that you rotate with your thumb to advance the film.

Cameras with built-in motors for film advance, such as the OM77AF, don't have a Film-Advance Lever. The film automatically advances the film after each exposure.

FILM FRAME

The area on the film that receives an image is called the frame. The boundaries of the frame are determined by the size and shape of the rectangular opening in front of the focal-plane shutter that allows light to reach the film. For cameras using 35mm film, the frame is approximately 24mm tall and 36mm wide.

HOW A FOCAL-PLANE SHUTTER WORKS

The focal-plane shutter is mounted inside the camera body, very close to the surface of the film.

The basic idea is illustrated in the accompanying drawings. Two opaque curtains are mounted on rollers. Normally the first curtain is positioned so it covers up the surface of the film and does not allow light to reach it.

To make an exposure, the first curtain travels across the frame, opening the frame to receive light from the lens.

When the desired time of exposure is ended, the *second curtain* is released. The second curtain moves across the frame and covers up the film frame again. Exposure is completed.

Every point on the surface of the film receives the same total time of exposure by the moving curtains. The trailing edge of the first curtain travels across the frame, so exposure begins first at one edge of the frame.

When the film frame is fully opened to light by completed travel of the first curtain, the edge of the frame that first received light will have been exposed for a slightly longer period of time than other parts of the frame. In the drawing, the left side of the frame is opened to light first.

The small time difference is balanced out by the closing curtain. It follows the first curtain and stops exposure on one side sooner than it does on the other. In the drawing, the left side of the frame is closed first.

The total time of exposure is the same at all points in the frame.

The time duration of exposure is the time between *release* of the first curtain to begin its trip across the frame and *release* of the second curtain.

For a relatively long exposure such as one second, the exposure time begins with release of the first curtain. It moves quickly across the frame and stops with the entire frame open to light. One second later, the other curtain is released and closes off the film. For most of that one second of exposure, nothing is happening mechanically. The film just sits there looking out the window.

For a short exposure such as 1/1000 second, the same rule holds—the second curtain is released 1/1000 second after release of the first. The first curtain will not have traveled very far before the second curtain starts chasing it across the film frame.

The effect of the second curtain following so closely behind the first is this: The film is exposed through a narrow traveling slit—about 0.1 or 0.2 inch in width.

A frame of 35mm film is about 1 inch tall and about 1.5 inches wide. When it is exposed by a traveling slit only about 0.1 inch wide, all of the frame cannot be exposed at the same instant of time. It is exposed by a moving slit of light.

With short exposures, the strip of film near one edge of the frame will have started and completed its exposure before the strip of film nearest the opposite side even begins to receive exposure.

Except in unusual circumstances, it doesn't matter that the film frame is exposed by a narrow traveling slit of light, rather than all at once.

All you need to understand about the operation of a focal-plane shutter is the general idea of one curtain chasing the other across the film frame—with the time interval between them equal to the desired exposure time.

SLR cameras use focal-plane shutters called *horizontal* or *vertical*, according to which way the curtains move. A horizontal shutter is shown in the accompanying illustration.

HOW A FOCAL-PLANE SHUTTER WORKS

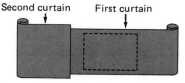

(1) Ready to make an exposure. Film frame is covered by first curtain.

Opening in camera body determines size of film frame.

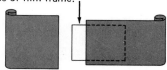

(2) First curtain begins to travel across frame, opening frame to image from lens.

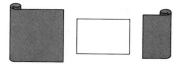

(3) First curtain travel completed. Film frame is fully open to light.

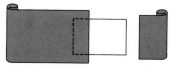

(4) Second curtain begins to travel across frame, closing frame to image from lens.

(5) Second curtain travel completed. Film frame covered by second curtain. Exposure completed. Advancing film to next frame resets shutter to (1) ready to make another exposure.

This drawing shows operation of a two-curtain focal-plane shutter that travels horizontally. When exposure time begins, the first curtain is released to start its travel. When exposure time ends, the second curtain is released to begin its travel and close off light to the film.

Exposure time is measured from *release* of the first curtain to *release* of the second curtain. This drawing shows an exposure time long enough that the second curtain does not start to move until after the first curtain has reached the end of its travel.

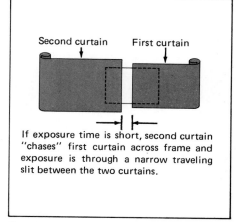

If exposure time is short, second curtain "chases" first curtain across frame and exposure is through a narrow traveling slit between the two curtains.

For short exposures, such as 1/500 second, the second curtain follows so closely behind the first curtain that the entire frame is never open to light all at the same time. The frame is exposed by a traveling slit of light formed by the narrow gap between the two curtains.

4
GETTING ACQUAINTED WITH LENSES

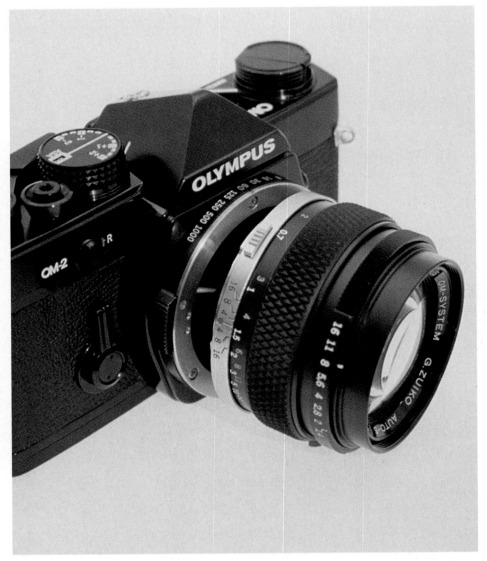

To mount a Zuiko lens on an Olympus OM camera, place the lens on the lens mount so the red dot on the lens aligns with the red dot on the mount. Hold lens against mount and turn the lens clockwise about a quarter-turn until the lens clicks into place.

An important feature of Olympus SLR cameras is interchangeable lenses, of which there are many types. Some are designed to capture a distant subject, some to photograph small objects that are very close to the lens, some for general use such as portraits and travel photography, and some for special purposes such as architectural photography.

There are two types of Olympus lenses. Those designed to be focused automatically by the camera are Olympus AF lenses. Those designed to be focused manually are Olympus Zuiko lenses.

Specifications and descriptions of Olympus lenses are in Chapter 10. This chapter covers basic ideas and general information applicable to both Zuiko and AF lenses.

LENS MOUNT

All Olympus OM cameras since the first model, the OM-1, have used the OM lens mount. This is a metal ring on the front of the camera body. The back of the lens fits into the lens mount.

To attach a lens, place it in the lens mount on the camera and turn the lens clockwise about 90° until it clicks into place. This arrangement is called a *bayonet mount*.

The OM77AF camera introduced a modified OM lens mount that I will refer to as the OM-AF mount. It has a mechanical coupling between the camera body and an AF lens that allows a focus motor in the camera to focus the lens automatically.

Mechanically, the OM-AF mount will accept *either* AF lenses or Zuiko lenses. Of course, it will not automatically focus Zuiko lenses.

The OM lens mount, used on non-autofocus cameras, will accept Zuiko lenses but *will not* accept AF lenses.

To remove a Zuiko lens, depress the Lens-Release Button (arrow) while turning the lens counterclockwise until it can be lifted from the mount. The Lens-Release Button is part of the lens. Exactly opposite the Lens-Release Button is another button—the Depth-of-Field Preview Button. Its use is explained later.

AUTOMATIC DIAPHRAGM

To provide the brightest possible image in the viewfinder when viewing the scene before making an exposure, the camera holds the lens aperture wide open until you press the shutter button. When you press the shutter button, the lens quickly closes down to a smaller aperture size if necessary for correct exposure.

This feature is called *automatic diaphragm*, sometimes *automatic aperture*. Nearly all Olympus lenses have this feature.

OPEN-APERTURE METERING

OM cameras measure light from the scene using a built-in light sensor and then calculate correct exposure for that scene. This is done while you are viewing the scene with the lens aperture wide open. Therefore, this method is called *open-aperture* metering, sometimes *full-aperture* metering.

Usually, the photo is not made with the lens wide open. The aperture size is reduced to whatever size is needed for correct exposure—which is called the *shooting aperture*.

During the open-aperture metering procedure, the camera takes into consideration the aperture size that will be used to make the exposure and makes the exposure calculation accordingly.

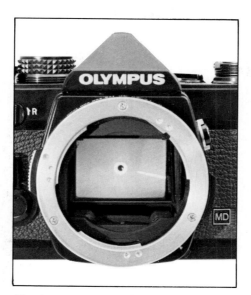

The bayonet lens mount on Olympus OM cameras is the metal ring on the front of the camera body and the three metal projections on the inner edge of the ring. There are three similar projections on the lens. When the lens is mounted and rotated, the projections interlock to hold the lens securely on the camera.

STOPPED-DOWN METERING

In the language of photography, reducing the size of a lens aperture is called *stopping down*. There are some special lenses and some accessory items that do not allow open-aperture metering. In these cases, metering is done stopped down. Olympus OM cameras adjust automatically to these situations, without any special control settings.

LIGHT RAYS

We assume that light travels in straight lines, called rays, and light rays do not deviate from straight-line paths unless they are acted on by something with optical properties such as a lens.

Light rays that originate from a source such as the sun, or reflect from an object such as a mountain, appear to be parallel rays after they have traveled a considerable distance. In explaining how lenses work, the simplest case is when the light rays reaching a lens have traveled far enough to appear parallel as in Figure 4-1.

CONVERGING LENSES

If you photograph a distant mountain, each point on the surface of the mountain reflects light rays as though it were a tiny source of light. The rays that enter the lens of your camera are effectively parallel. Rays from each point of the scene are scattered all over the surface of your lens but all that came from one point of the scene should be focused at one point on the film. Here's how a lens does that.

Figure 4-2 shows a simple single-element lens that is convex on both sides. This is called a *converging* lens because when light rays pass through, they converge and meet at a point behind the lens.

Focal length is defined as the distance behind the lens at which parallel light rays will be brought to focus by the lens. That implies a subject that is far enough away from the lens so the light rays appear to be parallel. We call that distance *infinity*—symbol ∞ on the distance scale of the lens—but it actually doesn't have to be very far away.

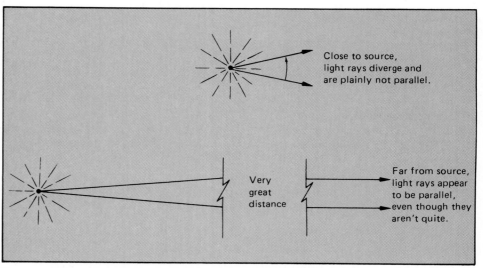

Figure 4-1/Light rays from a point source obviously diverge if you are close to the source. At a great distance, they still diverge, but *appear* to be parallel.

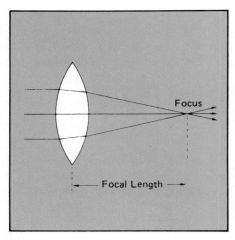

Figure 4-2/Lenses treat rays which appear parallel as though they are actually parallel. A converging lens brings parallel rays to focus at a distance behind the lens which is equal to the focal length of the lens.

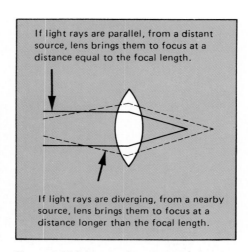

Figure 4-3/Light rays from a *nearby* source are not parallel, so more distance behind the lens is needed to bring the *diverging* rays into focus.

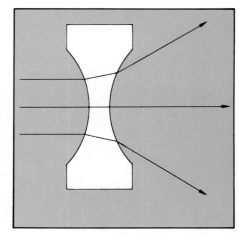

Figure 4-4/A diverging lens causes rays to diverge as they pass through.

Any subject beyond 100 feet or so appears to be so far away that the light rays from it are effectively parallel.

One of the descriptive terms we use for lenses is focal length, stated in millimeters (mm). In general, it is treated as the "name" of a lens and we learn what these names mean in terms of how the lens works and what kinds of pictures it makes. Common lens focal lengths are 50mm and 200mm, for example.

Because the focal length of a 50mm lens is 50mm, that's how far the lens must be positioned from the film to form a focused image of a distant subject—which we say is at infinity even though it may be close enough that we could hit it with a rock.

Figure 4-2 shows what happens to parallel rays when they are brought to focus by a converging lens.

This lens will also image subjects closer than infinity, but it takes a greater distance between lens and film to bring nearby subjects into focus.

Figure 4-3 shows why. Light rays from a nearby subject diverge as they enter the lens. The lens will still change their paths so they come to focus but, because they were diverging rather than parallel, it takes a greater distance behind the lens to bring them all together at a point.

Focusing a camera moves the lens toward or away from the film so there is the needed amount of distance between lens and film. This brings light rays from the subject into focus at the film, whether the subject is near or far.

Please notice that the shortest distance ever required between lens and film occurs when the subject is at infinity and this dis-

tance is equal to the focal length of the lens. All subjects nearer than infinity require a longer distance between lens and film. To change focus from a distant subject to something nearby, move the lens away from the film.

DIVERGING LENSES

Diverging lenses are shaped the opposite way and do the opposite thing. Parallel rays entering a diverging lens emerge on the other side as divergent rays—angled away from each other as shown in Figure 4-4.

FOCUSING A LENS

The focusing ring on the lens operates on an internal screw thread called a *helicoid*. To focus closer to the camera than infinity, the lens travels outward on the screw thread. When the end of the thread is reached, that's as close as you can focus with that lens. With different lenses, the closest focused distance varies, ranging from inches with short-focal-length lenses to feet with long lenses.

THE IMAGE CIRCLE

A circular lens makes a circular image of a

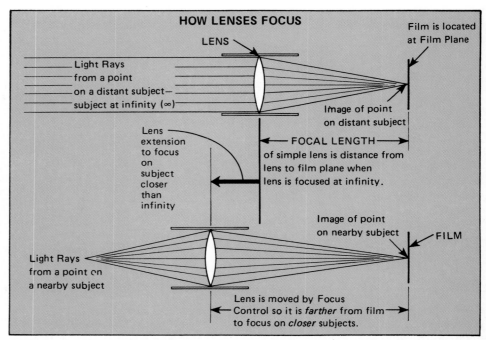

To make a focused image on film, the lens is moved so the distance between lens and film is correct—which depends on how far away the subject is.

circular portion of the scene. What the lens "sees" is called the field of view. In the camera, a rectangular opening in front of the film allows only part of the circular image to fall on the film.

Dimensions of the image frame on 35mm film are 24mm by 36mm. The circular image cast by the lens has a diameter slightly larger than the diagonal of the film frame, about 43mm.

Even though the camera viewing system shows you an image with correct orientation, the image on the film is upside down and reversed left-to-right.

EFFECT OF FOCAL LENGTH

Technically, focal length is the distance between a certain location in the lens and the film, when the lens is focused at infinity.

Lenses are grouped by focal length into three classes.

Short:	35mm and shorter
Medium:	45mm to 85mm
Long:	100mm and longer

The differences are *angle of view* and *magnification*.

Angle of view is the angle between the two edges of the field of view. Because a lens "sees" a circular part of the scene and makes a circular image, its true angle of view is the same vertically, horizontally, or at any angle in between.

Because the 35mm film format is a rectangle fitted closely into the image circle

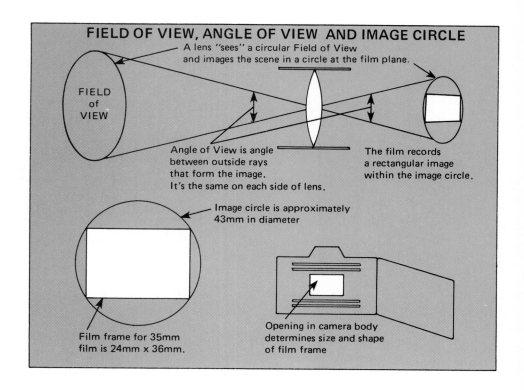

FIELD OF VIEW, ANGLE OF VIEW AND IMAGE CIRCLE

A lens "sees" a circular Field of View and images the scene in a circle at the film plane.

FIELD of VIEW

Angle of View is angle between outside rays that form the image. It's the same on each side of lens.

The film records a rectangular image within the image circle.

Image circle is approximately 43mm in diameter

Film frame for 35mm film is 24mm x 36mm.

Opening in camera body determines size and shape of film frame

made by the lens, everything seen by the lens is not recorded in the film frame. This results in a slightly different definition: the angle of view that is recorded on film.

In that sense, a lens mounted on a camera using 35mm film has three angles of view: horizontal, vertical, and diagonal. Diagonal is the largest angle because it is corner-to-corner of the film frame. Horizontal is small-er. Vertical is smallest because the film frame is not as tall as it is wide. In Olympus literature, when only one angle of view is given for a lens, it is the diagonal angle.

Magnification compares the size of the image on film in the camera to the subject in real life. If magnification is increased, the image becomes larger.

Short-focal-length lenses such as 20mm

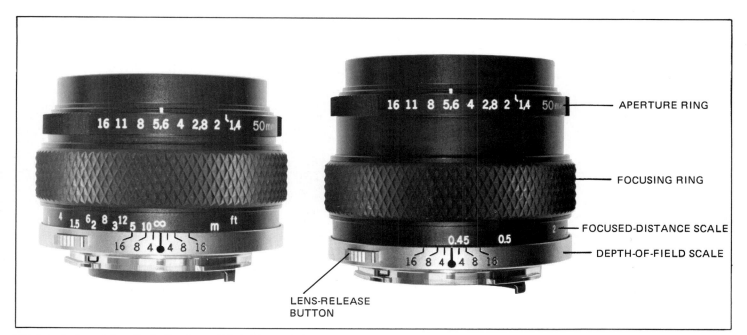

APERTURE RING

FOCUSING RING

FOCUSED-DISTANCE SCALE

DEPTH-OF-FIELD SCALE

LENS-RELEASE BUTTON

This lens is focused on the farthest possible subject at left; on the nearest possible subject at right. Notice that the lens elements travel farther from the film to focus on nearer subjects. Focused distance is read from the Focused-Distance Scale using the index mark on the adjacent Depth-of-Field Scale. Lens at left is focused at infinity (symbol ∞), which really means any distant subject. Lens at right is focused at about 0.45 meters.

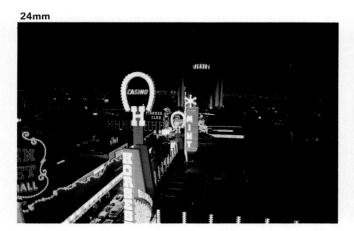

24mm

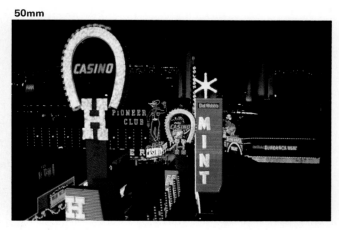

50mm

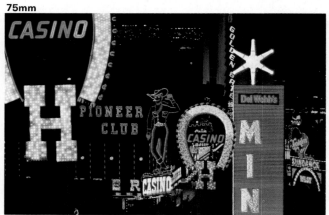

75mm

150mm

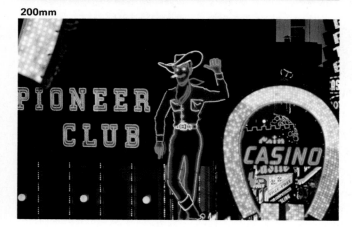

200mm

Focal length is an indication of the angle of view of a lens and the magnification or size of the image on film. Notice that short focal lengths, such as 24mm, have a wide angle of view but individual objects in the scene are very small in the picture because magnification is small. Long focal lengths, such as 200mm, perform in the opposite way. Angle of view is narrow but each object in the scene is larger in the picture because magnification is greater. The standard focal length for 35mm SLR cameras is about 50mm, which is a good compromise.

and 28mm have wide angles of view and low magnification.

Use wide-angle, short focal length lenses when you want to show a lot of the scene being photographed. They are handy in photographing interiors when you want to get a lot of the room but the walls prevent you from backing up very far.

You can get a feel for angle of view by testing your own vision. With both eyes open, hold your arms straight out to the sides and then move them forward until you can just see your hands while looking straight ahead. The angle will be a little less than 180 degrees.

Do it again with one eye closed. The angle will be a lot less. Clear vision for a single eye covers a total angle of around 50 degrees or so, depending on where you decide you can't see clearly enough to call it vision.

A 50mm lens has an angle of view of about 47 degrees. Olympus considers 40 or 50mm lenses to be standard for 35mm cameras because they are good general-purpose lenses and a compromise between wide and narrow angles of view. You can't do everything with a standard lens, but you can make a lot of fine pictures with one.

Long lenses such as 200mm and 300mm have narrow angles of view and greater magnification than a standard lens. A 200mm lens has a 12° angle of view, approximately.

A common type of lens with long focal length is called telephoto. Not all long lenses are of the telephoto design but most are, and the word has come to mean the same thing as a long lens in popular terms.

We think of a long lens as one that can "reach" out and fill the frame with a distant subject such as a mountain climber high up on a rock face. It excludes most of the mountain because of its narrow angle of view. That really means the lens has high magnification.

MAGNIFICATION

Magnification is illustrated with the outside rays of the lens as in Figure 4-5, where the subject is an arrow and the image is an upside-down arrow. In each case, the arrow extends all the way across the field of view.

Magnification is a ratio or fraction: *The size of the image divided by the size of the subject.*

The angle of view is the same on both sides of the lens. The sizes of image and subject are therefore proportional to their distances from the lens. If image and subject are the same distance from the lens, they will be the same size.

This leads to two ways to think about magnification. You can compare sizes and you can compare distances. Either way, you get the same answer. To figure magnification, M, use this formula:

$$M = I/S$$

where I is either image size or image distance from the lens, and S is either subject size or subject distance.

DEPTH OF FIELD

In most photographs, not every object in view is in sharp focus. Usually the subject is

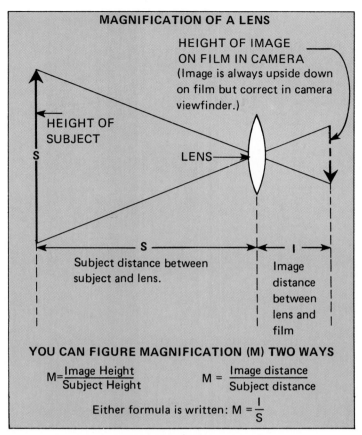

MAGNIFICATION OF A LENS

HEIGHT OF IMAGE ON FILM IN CAMERA (Image is always upside down on film but correct in camera viewfinder.)

HEIGHT OF SUBJECT

LENS

S — Subject distance between subject and lens.

I — Image distance between lens and film

YOU CAN FIGURE MAGNIFICATION (M) TWO WAYS

$$M = \frac{\text{Image Height}}{\text{Subject Height}} \qquad M = \frac{\text{Image distance}}{\text{Subject distance}}$$

Either formula is written: $M = \frac{I}{S}$

Figure 4-5/You can figure magnification by comparing subject and image heights, or subject and image distances from the lens.

sharp but objects closer to the camera may be out of focus and objects farther away than the subject may also be out of focus. When this happens, there is a *zone of good focus* that is not precisely defined. It is the distance between the nearest location where you think focus is acceptable and the farthest location where you think focus is OK.

In a particular scene, everything may be in sharp focus from 15 to 25 feet away from the camera. In that case, the zone of good focus is 10 feet deep. The measure of this zone is called *depth of field* so, in this case, we would say that the depth of field is 10 feet. I discuss this in more detail in Chapter 6 along with information on how you can control depth of field. One thing that controls it is aperture size.

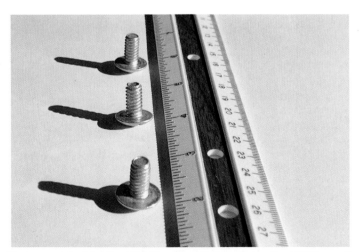
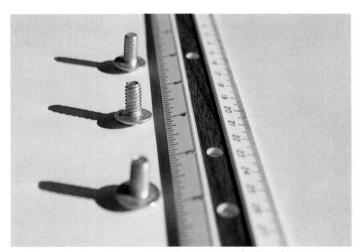

You can control depth of field by choosing aperture size. At left, small aperture gives pretty good focus on all three screws. At right, large aperture causes center screw to remain in focus but the other two are less sharp. You can see the zone of good focus along the ruler scales.

Stamps and other small objects are often photographed at higher-than-normal magnification, using special lenses described in Chapter 12. The lens property called *flatness of field* is important when photographing flat objects.

When a bright light source shines directly into the lens, flare and ghost images of the lens aperture usually appear.

FLATNESS OF FIELD

The film in a camera is flat and held so deliberately. If you photograph a flat surface such as a newspaper, all parts of the image should be in good focus on the flat film in the camera. If not, the lens correction for flatness of field is poor.

This is not of concern in most photography of nature, people and other non-flat objects. In close-up photography, many people copy things like postage stamps so special lenses for high magnification are designed with particular attention to flatness of field.

FLARE AND GHOST IMAGES

Light arriving at the air-glass surface of a lens is partly reflected at the surface and partly transmitted in the direction we want it to travel. This happens at both surfaces of a piece of glass, so there are internal reflections within a single glass lens element and multiple reflections in a compound lens with several pieces of glass.

In general, any light that is deflected or scattered from its intended path of travel will land somewhere it doesn't belong. This puts light on the film where there would otherwise be less light. The stray light has been "robbed" from areas where it should have been. Light areas on the film are not as light as they should be and dark areas are not as dark. The result is a general reduction in contrast between light and dark areas.

If the light that is scattered around by lens reflections forms no definite image on the film but is an overall fog or even a fog over a relatively large area of the picture, we call it *flare*.

Sometimes internal reflections from lens surfaces cause one or more images of the lens aperture on the film. These images are called *ghosts*. The cure is to reduce light reflection at each glass-air surface. This is done by lens coating.

LENS IDENTIFICATION

All lenses for Olympus cameras have important information engraved on them.

Zuiko Lenses—A typical Zuiko lens has data engraved on the circular ring surrounding the front glass element, as you can see in the lens photos at the beginning of this chapter.

This data includes OLYMPUS, the manufacturer; OM-SYSTEM, indicating that the lens is for OM cameras; ZUIKO, the brand name.

AUTO-S means that the lens has an automatic diaphragm and is one of the standard lenses with a focal length of 40mm or 50mm. AUTO-W means wide-angle lenses with focal lengths shorter than 40mm. AUTO-T means telephoto lenses with focal lengths longer than 50mm.

There is a symbol such as 1:1.4, which is a way of stating the maximum aperture size of the lens—f-1.4. Focal length is stated by a symbol such as 50mm. Some Zuiko lenses use f = 50mm instead. There is also a serial number for each lens.

AF Lenses—The series of AF lenses shows lens data on the body of the lens, as you can see in the lens photos in this chapter. Data includes OLYMPUS LENS; AF, meaning autofocus; and the focal length, such as 50mm.

Maximum aperture may be stated with a comma. For example, the symbol 1:1,8 means that the lens has a maximum aperture of f-1.8.

Most lenses have a threaded ring on the front that is used to attach filters and other accessories. AF lenses state the thread diameter, such as Ø 49mm, where the Ø symbol means diameter.

LENS COATING

The first lens-coating method was a single, very thin layer of a transparent material such as magnesium fluoride, applied in a vacuum chamber. This made a great improvement in picture quality by reducing reflections from coated lens surfaces; however, a single coating is not effective for all colors.

An improvement was obtained by using multiple coating layers of different thicknesses, so reflections are reduced throughout the visible spectrum. Olympus has steadily improved lens coating. Today, multiple-layer coating is used.

Besides greatly improving image quality of fixed-focus lenses, multiple coating made high-quality zoom lenses possible because zoom lenses have many more glass elements.

LENS ABERRATIONS

To photographers, lens aberrations are like the boogie-man: mysterious, threatening and always lurking around trying to do something bad. Aberrations of a lens cause defects in the image.

There is a long list, including *spherical aberration, chromatic aberration, coma* and *astigmatism*. All conventional lenses have these and other defects to some degree. Total elimination is probably impossible, but partial elimination, called *correction*, is part of the design of each lens. For more money you get more correction.

One problem is that the surfaces of conventional lenses are spherical, mainly for ease of manufacture. This causes spherical aberration. Another problem is the nature of lens glass. It does not behave the same with different colors of light. This produces chromatic aberration.

Correction of these and other lens aberrations is done three ways. Basic is the design of the lens itself, using multiple pieces of carefully shaped glass, called *elements,* to make a complete *compound lens* assembly in a mechanical housing. This has always involved laborious mathematics. The process has been both speeded and improved by use of modern computers to do the arithmetic.

To correct some aberrations, glass of differing chemical composition is used for the various elements in the lens. A limitation in the past has been the range of different types of glass.

In recent years, new types of optical glass that allow better correction of lens defects have been developed. Olympus lenses use a combination of advanced design techniques and state-of-the art materials to produce high optical quality with compact size and reduced weight.

Because of the long list of aberrations and

Shooting into the light produces flare, which reduces image contrast, even when ghost images of the aperture do not appear.

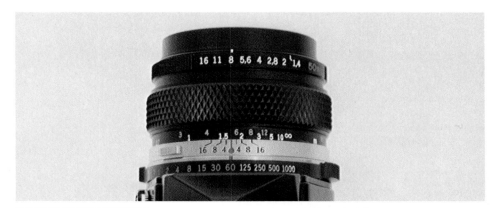

HOW TO READ FOCUSED DISTANCE AND SHUTTER SPEED
The normal index mark used to read focused distance and shutter speed is the red line and dot on a Zuiko lens. This index mark shows a shutter-speed setting of 1/60 second on this camera.

The focused-distance scale shows feet in yellow numbers and meters in white numbers. When the camera is focused between marked numbers on the scale, estimate the reading. This camera is focused at about 5.5 feet or 1.7 meters, depending on which scale you prefer to read.

The OM77AF does not have the shutter-speed dial shown here.

HOW TO SET FOCUS FOR INFRARED FILM
The small red IR index mark to the right of the normal index mark is used to correct focus when using b&w infrared film. First, focus on the subject in the usual way and read the focused distance using the normal index. Then change the focus setting so that distance appears opposite the IR focusing index.

The lens *was focused* at 6 feet with daylight. To expose infrared film, the Focusing Ring was rotated so the number 6 is opposite the IR index mark. Camera is *now focused* at 6 feet for IR. Place an IR filter over the lens for the exposure.

the fact that correcting them is a series of compromises, the best guide to the user is simply the reputation of the lens maker.

Most lens aberrations have less effect on the image if the lens is used at small aperture. Using ordinary films, it's hard or impossible to see any difference, but theoretically it's better to shoot at an aperture smaller than wide-open.

FOCUSING WITH INFRARED

As you will see in Chapter 13, the various colors of light result from different wavelengths. Blue light has short wavelengths. Red light has the longest wavelengths in the visible spectrum.

Infrared (IR) light has even longer wavelengths. We cannot see it with our eyes but some special films are sensitive to IR.

One of the aberrations that lens designers correct during design of the lens is chromatic aberration. The problem is that light of different wavelengths comes to focus at different distances from the lens. Short wavelengths focus closer to the lens and long wavelengths focus farther away.

Lens designers correct chromatic aberration for visible light. Otherwise an image on color film would have color fringes around the edges. However, most lenses are not corrected for infrared because most films are not sensitive to infrared.

There are special b&w films that are manufactured to be sensitive to both visible light and infrared. To use them as infrared films, put a filter over the lens to exclude visible light. These IR filters are opaque or appear very dark red if held against white light.

Focus the camera without the filter in place because the image is either very dark or totally indiscernible. After focusing, install the IR filter. Thus the film will be exposed by the infrared rays that pass through the filter. However, these rays require more distance between lens and film to produce a focused image on the film.

A special IR Index Mark is engraved on most Olympus Zuiko and AF lenses, just to the right of the normal index mark used to read focused distance. After focusing with visible light, read the focused distance using the normal index mark on the lens. Then change the focus setting so that same distance is opposite the special IR Focusing Index. If you watch the lens while doing this, you will notice that it moves farther away from the camera body. This gives the additional distance required to bring an IR image into focus.

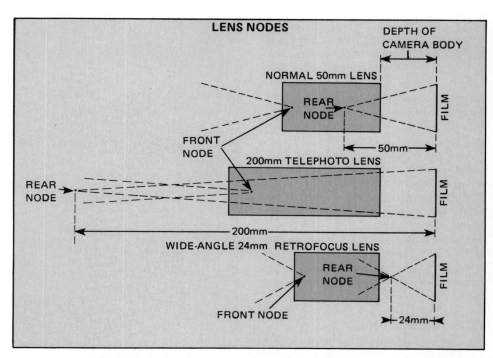

Lenses have optical points called the front and rear nodes. Lens-to-film distance is measured from the rear node. All lenses share the same *mechanical* distance between lens mount and film plane—it's the depth of the camera body. The *optical* path distance between the rear lens node and the film must always equal the focal length of the lens. This problem is solved by trickery in the design of the lens as you can see in this drawing. The rear node may actually be in the air in front of the lens, or behind the lens.

DIFFRACTION

Diffraction happens when a light ray makes grazing contact with an opaque edge such as the lens barrel or the edge of the aperture. Rays that contact the metal edge of the aperture on their way into the camera are changed in direction slightly, bending toward the edge. Also, a pattern of alternating light and dark bands of light is formed.

Light rays from any point of a scene should converge to a point-image on the film. Because of diffraction, some of the rays will be diverted and the image will be spread out. Only those rays that pass very close to the edge of the aperture are affected—those that go through the center of the lens are not diffracted.

Therefore, the amount of image degradation due to diffraction depends on what proportion of the rays graze by the edge of the aperture and what proportion pass through the center part of the hole.

As an aperture is made smaller, there is more edge and less center area, so the total percentage of rays that are diffracted by the edge is higher.

OPTIMUM SHOOTING APERTURE

If a lens is scientifically tested for image quality, starting at maximum aperture, the image will improve as the lens aperture is closed because the effect of aberrations is reduced. It varies among lenses, but typically at around f-5.6 or f-8 the image is as sharp as it's going to get. Further reductions in aperture size cause diffraction effects to degrade the image. This degradation is gradual and even at f-22 it is unusual to identify diffraction effects with the unaided eye.

Usually there are other compelling reasons that determine aperture size, but if you have none and you want the best image, set the lens at an aperture near the center of its range.

LENS NODES

As you remember, the distance from lens to film when the lens is focused at infinity is the focal length.

All lenses mount on the camera the same way and at the same place, so you may wonder how a long-focal-length lens finds room behind the lens to make the image. Image distances are not tiny. As a rule of thumb, 25mm equals one inch. A 50mm lens requires about two inches between lens and film. A 200mm lens requires about eight inches behind the lens to make a focused image.

Each lens of different focal length does have the correct distance between lens and film when mounted on the camera, but it's done optically rather than mechanically. There is a point in the optical path from which the distance to the film is measured. This point is called a *node*, and its location is controlled by the optical design of the lens rather than its mechanical construction.

You can tell if a lens is telephoto or retrofocus just by looking. Set the aperture to a medium size and stop down by depressing the Depth-of-Field Preview Button. If the apparent aperture size is larger looking in the front, the lens is telephoto. If the aperture looks larger from the rear, the lens is retrofocus. If the image is about the same size, front and back, the lens is a normal design—neither telephoto nor retrofocus. This is a Zuiko 200mm telephoto lens.

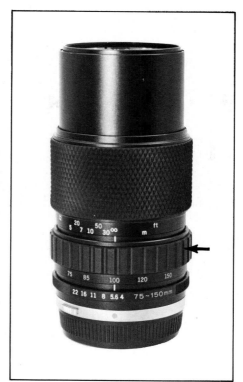

Zoom lenses have an additional control ring (arrow) that you rotate to change focal length. This is the Zuiko 75-150mm *f*-4 zoom lens, set to a focal length of 100mm. You can select any focal length between 75mm and 150mm even though all focal lengths are not engraved on the control. A zoom lens remains focused at the same distance while you change focal length. The result is that image size changes.

To get a longer *optical* distance between lens and film, the node is moved forward by scientific trickery. You can't see a node and you can't find it to measure from, but it's there. You can always assume that the optical distance between lens and film is equal to the focal length of the lens—when the lens is focused at infinity.

TELEPHOTO LENSES

The basic requirement to make a long-focal-length lens is to have a relatively long optical distance between lens and film. This can be done in a clever way by using a diverging lens element in the lens as shown in Figure 4-6.

The first lens converges the rays so they would come in focus as shown by the dotted lines. Before reaching the film, the converging rays are intercepted by the diverging lens element. This causes them to come together at a greater distance as shown by the solid lines.

Lenses built this way are called *telephoto*. A telephoto lens can be physically shorter than it would be without the diverging element. The node is located where it must be so the focused image lands on the film plane in the camera body.

You can identify a telephoto lens by looking into the front and back of the lens while holding it away from your eye and pointing it toward a window. At each end of the lens you will see a spot of light, called the *pupil*, which is actually the lens aperture seen through that end of the lens.

With a conventional lens, the two pupils will be the same size or nearly so. With a telephoto lens, the pupil seen looking in the front will be plainly larger than the pupil seen looking in the back.

If you change the lens aperture size while looking at a pupil, you will see the size of the pupil change, because the pupil is an image of the aperture.

RETROFOCUS LENSES

The telephoto design is used to move the lens node forward so there is enough distance between node and film plane to accommodate a long focal length.

The problem is reversed with very short-focal-length lenses. For example, a 24mm lens has a focal length of about one inch. But, the distance between the lens mounting surface and the film plane on SLR camera bodies is about two inches. Therefore, a conventionally designed 24mm lens would make a focused image about one inch in front of the film plane in the camera—with the lens set at infinity.

The design principle of the telephoto lens can be reversed to move the lens node toward the film plane rather than away from it. A reversed telephoto lens design is often called a *retrofocus* lens. The design is used primarily to fit a short focal-length lens onto a camera body whose dimension between lens mount and film exceeds the focal length of the lens. It moves the node closer to the film. With a retrofocus lens, the pupils are not the same size either—the rear pupil is larger than the front.

TELECONVERTERS

Accessory lenses called *teleconverters* fit between a camera lens and the camera body. Teleconverters are diverging lenses placed in the optical path between a lens and the camera to give the same effect as the diverging lens in a telephoto design. The focal length of the lens and teleconverter combination is longer than the focal length of the lens alone.

Teleconverters are normally labeled with the focal-length multiplier. A 2X teleconverter doubles lens focal length; 3X triples it. A 2X teleconverter used with a 50mm lens gives it an effective focal length of 100mm. A 3X teleconverter with a 200mm lens makes it act like a 600mm lens.

Teleconverters may degrade the image slightly but the effect is usually not noticeable, particularly if the teleconverter and lens are made by the same manufacturer. They are an economical way to get more focal lengths in your camera bag.

Another advantage is that a teleconverter does not change the minimum focusing distance of the lens. You can make larger images of small images with a lens and a teleconverter than with the lens alone.

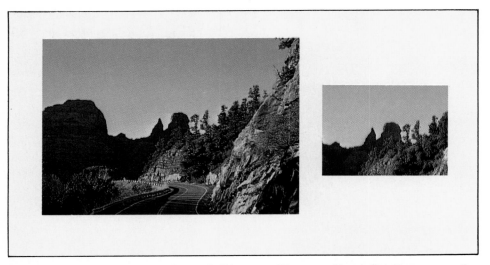

When the camera location is not changed, all lenses get the same perspective. Here you see the entire frame of two slides. The one at left was shot with a 100mm lens and is enlarged twice as much as the one at right, which was shot with a 200mm lens. The only difference between the 100mm view and the 200mm view is magnification. Perspective is identical for the part of the scene that appears in both photos.

A disadvantage is that teleconverters multiply both focal length and the *f*-number of a lens. This reduces the amount of light at the film. For example, an *f*-1.4 lens used with a 2X teleconverter acts like an *f*-2.8 lens. If set at *f*-5.6 it admits the same amount of light as if it were set at *f*-11.

Olympus offers two teleconverters for Zuiko lenses: Teleconverter 1.4X-A and 2X-A. Both preserve all automatic features of the lens. The 1.4X teleconverter is specifi-cally intended for use with 180mm, 250mm, 300mm, 350mm and 400mm lenses. The 2X is for the 100mm *f*-2.8, 135mm *f*-2.8, 135mm *f*-3.5, 200mm *f*-4 and the 100—200mm zoom lens.

The 1.4X teleconverter multiplies focal length by 1.4 and reduces aperture by one step. The 2X multiplies focal length by 2 and reduces aperture by two steps.

Lenses and accessories made by other manufacturers are not necessarily produced to the same specifications as genuine Olympus equipment and therefore may cause operating difficulties or actual damage to your camera. Your Olympus camera dealer can give you good advice on accessories for your system.

ZOOM LENSES

All I will attempt to do here is give you a general idea of what happens inside a zoom lens. As you probably know, these lenses can be focused on a subject and then by a separate control the lens focal length can be changed to alter the magnification and the size of the image on film.

Zoom lenses are complex, using many glass elements in a mechanical assembly. This requires high precision and extremely close manufacturing tolerances. They work by moving lens elements inside the lens tube to alter focal length. It would be ideal if nothing changed except focal length when zooming the lens. Focus on the film should remain sharp while image size changes. The *f*-number of the lens should remain constant. Aberrations should not increase.

In practice this is difficult to accomplish. A lens design can preserve good focus at one or more points along the zoom range, but it is difficult to keep sharpest focus at all focal lengths. Because of improvements in lens design and materials, this reservation about image quality with zoom lenses has become more theoretical than practical. With the un-aided eye, it is usually impossible to tell any difference between a photo made with a zoom lens and a photo made with a fixed-focus lens of the same focal length.

Today, the main disadvantage of zoom lenses is that the maximum aperture is usual-ly smaller than lenses with fixed focal lengths.

PERSPECTIVE

The word *perspective* literally means *to see through.* If you are looking at a photo or painting and the perspective is correct, what you see is indistinguishable from the original scene. You can't be too picky when applying this definition because it applies only to the big parts of the picture—its geometry.

The range of tone brightnesses may not be identical and small details may be lost, but that doesn't count. If perspective is correct, the geometry you photograph will be in-distinguishable from real life. Streets will become narrower as they recede into the dis-tance. The side wall of a building becomes less tall at great distance from the viewer. Distant people and automobiles are smaller than those nearby. As far as lines, angles and relative sizes of things are concerned, it's as though you are not looking at a picture, you are *seeing through* it to the actual scene.

For every photograph, there is only one

This is a shot of cars two blocks away, taken with a 400mm lens. The long-lens perspective effect makes them appear jammed together amid a jungle of signs and light poles. At the camera location, you get this same view but with a lot of cars and street *between* you and this distant scene. When you can see the entire situation, this illusion disappears.

viewing distance at which perspective is correct. Usually the photographer has no control over the distance from which people look at his pictures.

If you make a slide using your 50mm lens, correct viewing distance of the slide itself is the same as the focal length of the lens—about two inches. Don't bother to try it because your eye can't focus that close. When the image is made larger, correct viewing distance increases in the same proportion.

Let's say you have a print made from your slide so everything on the print is ten times as tall. Viewing distance becomes ten times as great—500mm or about 20 inches. This formula—focal length multiplied by enlargement of the image—gives the correct viewing distance for any photo taken with any lens. But most people don't pay any attention to it.

Because all of us have grown up looking at photos from the right distances and the wrong distances, we are very tolerant of incorrect perspective unless the effect is extreme. We often notice incorrect perspective in shots made with long-focal-length lenses and with short lenses. This is never the fault of camera or lens. It always results from viewing the finished photo at the wrong distance.

As photographers, we can *cause* these perspective effects to happen by choosing lenses that make it impossible or unlikely that the viewer will use the correct viewing distance for proper perspective.

Perspective with Long Focal Length Lenses—When two similar objects are in view, we judge the distance between them by their relative sizes. You may have to look outdoors to confirm this: A car at the end of the block looks tiny compared to a car in your driveway. Your mind doesn't say it's tiny, your mind says it's a block away.

Now we play a photographic trick on the viewer. Photograph the two cars from a quarter-mile away, using a long-focal-length lens such as 500mm. They are still a block apart, but they look about the same size on film. Enlarge the negative so the cars are ten times as tall on the print. The correct viewing distance for proper perspective is then 5000mm—about 200 inches or nearly 17 feet.

Nobody will view your print from that

Lenses with short focal lengths allow you to get too close to the subject resulting in apparent perspective distortion, big noses, and chuckles from everybody except your victim.

distance. It will be viewed from a few feet or maybe even held in the viewer's hand. This tricks the viewer's mind into thinking it is seeing two cars that are nearby. Because they are about the same size, the mind says they

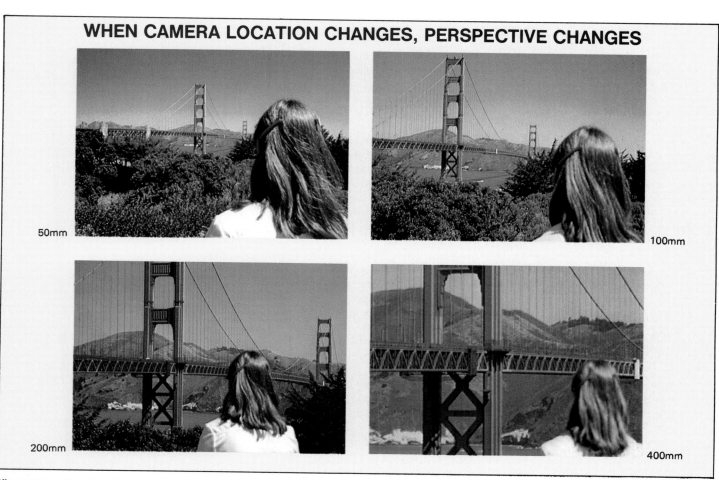

WHEN CAMERA LOCATION CHANGES, PERSPECTIVE CHANGES

50mm 100mm 200mm 400mm

When camera location changes, perspective changes. In these photos, the camera location was changed to keep the model about the same size in the viewfinder with lenses of different focal length. This changes perspective and the apparent distance between foreground and background. Longer focal lengths seem to "compress" distance.

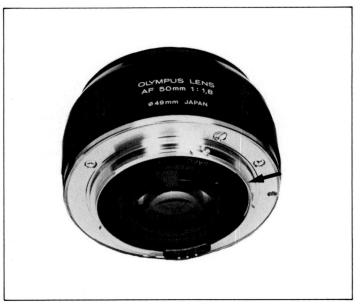

The Olympus AF 50mm *f*-1.8 lens has no controls on the lens body. The lens is controlled entirely by the camera. A focused-distance scale is visible through a window in the lens body, so you can see the distance at which the camera has focused the lens.

The back of an AF lens, such as this 50mm *f*-1.8, has three electrical contacts that transmit data from the lens to the camera. It also has a movable lever (arrow) that is used by the camera to control aperture size.

are very close to each other. They aren't, of course, but the picture sure looks that way.

This technique is often used in photographing race cars to make them look very close together, perhaps coming out of a turn. It is often used as a trick in newspapers and magazines to make houses or traffic signs appear jammed up against each other when in reality they are not. There are many ways you can use this trick and all are OK except one. Don't use it by accident. You should know when you are doing it.

Perspective with Short Focal Length Lenses—Put your eye eight inches from somebody's nose and notice exactly what you see. You see a very large nose with smaller facial features and ears receding into the distance. Find somebody with his feet on the desk and put your eye about 12 inches from the sole of his shoe. You see a very large shoe connected to a person with a tiny head.

Put your camera lens at either of these viewpoints and you'll get the same view on film. However, most lenses of 50mm focal length or longer won't focus that close. Lenses of shorter focal length allow close focusing; therefore, they allow the short-lens perspective trick.

Assume you used a 20mm lens and enlarged the negative so everything is ten times as tall on the print. Correct viewing distance of the print is 200mm—about eight inches.

Put your eye eight inches from the print and you get exactly the same view you would in real life. But most people don't know that's what they actually see in the real world. They think your picture has wrong perspective and is very funny.

Perspective in Portraiture—Because we don't often look at other people with our eyes eight inches from the nose, we quickly notice the short-lens perspective effect in a portrait. The long-lens effect can also occur. It tends to reduce the apparent distance between nose and ears, giving a face-flattening effect. But we are a little more tolerant of that because we see it often.

Some combinations of focal length, distance between camera and subject, subsequent enlargement and viewing distance result in portraits with short-lens effect even when taken with a standard 50mm or 55mm lens. It's never really obvious, but experienced photographers can see it readily or your subject may see it without being aware of it and reject the portrait as a "bad picture."

That's why most photographers using 35mm film prefer lenses of 85mm up to 135mm for portrait work. If you use a lens much longer than 135mm, you risk the long-lens effect.

Do Lenses Get Different Perspective?—From the same camera location, all lenses get the same perspective when perspective is defined as the see-through property dis-

cussed earlier. A long-focal-length lens gets a small section of the overall view and a short-focal-length lens gets a larger section. But both get the same perspective when viewed from the correct distance. You could cut out a section of the wide-angle view, enlarge it, and the result would be indistinguishable from the view obtained with a long lens as far as the perspective effect is concerned.

Change camera location and you change perspective, no matter what lens you are using. Every different location gets a different perspective view of the scene.

AUTOFOCUS LENSES

The OM77AF and the companion Olympus AF lenses were introduced in the fall of 1986. Available AF lenses at the time of this edition are listed in Chapter 10. It is likely that more lenses and accessories will be added.

Lens Controls—Zuiko lenses have a Focusing Ring for manual control of focus and an Aperture Ring for manual control of aperture size. If the Zuiko lens is a zoom, it also has a zoom control to change focal length.

AF lenses have no manual controls for focused distance or aperture size. If the AF lens is a zoom type, it has a zoom control. Except for the zoom control, AF lenses are controlled by automatic systems in the camera or manual controls on the camera.

AF lenses have a movable lever on the back, which the camera uses to control aperture size. There are also three electrical contacts on the back of the lens which mate with electrical contacts on the camera body. These contacts provide data about the lens to the electronic systems in the camera.

The data includes lens focal length, minimum and maximum aperture values, and the zoom setting, if appropriate. This data is used by the autofocus system and the automatic exposure system in the camera.

Some of the lens data is stored on a small computer chip in the lens body. The zoom focal-length setting is produced by contacts in the lens that trace the position of the zoom control and encode the setting.

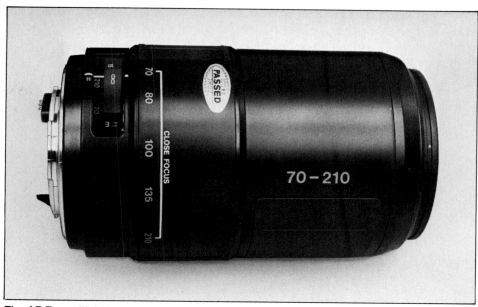

The AF Zoom 70-210mm f-3.5—4.5 lens has a zoom control that rotates to set focal length. Maximum aperture size changes from f-3.5 to f-4.5 as the lens is zoomed from 70mm focal length to 210mm. This lens is set at 70mm. The Close Focus feature is discussed in Chapter 10.

5
FILM HANDLING

A few simple rules and procedures for handling and using film may prevent problems and lost shots. This chapter gives you some basic ideas about film and film storage along with procedures for loading film into the camera and rewinding at the end of the roll.

The characteristics of photographic emulsion change slowly after manufacture.

Films carry a date on the carton, referred to as the *expiration date*, even though nothing drastic actually happens on that day. The date means the film should perform satisfactorily up to that time under normal conditions of storage.

Expiration dating of films intended for amateur use is based on storage at room temperatures comfortable for people— around 70°F (20C) and around 50% relative humidity.

High temperature and high humidity accelerate the aging process. Most film is sealed in a pouch or can to protect the film from external humidity changes. If the emulsion dries out excessively, that's not good either.

Storing film at reduced temperatures— such as in your refrigerator—slows down the aging process, and is recommended both before and after exposure if you keep the film a long time before shooting or a long time before development.

An exception is color films intended for professional use and some special b&w films. These should always be stored at reduced temperature. Follow the film manufacturer's instructions.

Film cartons show the type of film, number of exposures, film speed rating, expiration date and other information. This film has an expiration "Develop Before" date of 03/89. The film speed (E. I. for Exposure Index) is ISO/ASA 400. The cartridge is DX coded, so the film speed can be read automatically by a camera with that capability.

Film should be sealed before cold storage and allowed to return to room temperature before breaking open the seal. Otherwise, moisture may condense in the package and the film may be ruined. If you buy film in quantity, storing it in the refrigerator is a good idea provided you observe this precaution. After development, room temperature storage of photographic material is normally OK.

THE FILM PATH

Unexposed 35mm film is purchased in light-tight cartridges with a small amount of the film extending through a lip on the cartridge. This is called the film end or film leader.

To load the film cartridge into the camera, open the camera back. Place the film cartridge in a cavity at the left side of the camera body. Draw the film end across the back of the camera, behind the focal-plane shutter and feed it into the take-up spool. Then, close the camera back.

As frames are exposed, the film is advanced to bring a new frame into position for exposure. It is advanced by winding it onto the take-up spool. For film on the take-up spool, the only protection against light is the fact that the camera back cover is closed.

When all exposures have been made, it is necessary to *rewind* the exposed film back into the light-tight cartridge *before opening the camera back cover*. If you open the back cover before rewinding, light will strike the unprotected film on the take-up spool and spoil it.

FRAME COUNTER

As film is exposed and advanced, a frame counter keeps track of the number of frames that have been advanced. The frame number is read in a display on top of the camera.

When a new cartridge of film has been loaded, and the camera back cover has been closed, the frame counter shows the symbol S. At that time, the film between the cartridge and the take-up spool cannot be used

LIGHT-SENSITIVE EMULSION

FILM BASE

Basically, film is a light-sensitive layer of emulsion supported by a film base. Most films are more complex than this. Color film has three layers of emulsion, each sensitive to a different color.

to take pictures because it was light-struck during the film-loading procedure with the camera back cover open.

The film must be advanced until the frame counter shows the number 1. That draws all of the light-struck film onto the take-up spool and you are ready to shoot frame 1 on unexposed film.

Frames per Cartridge—Film packages show the number of frames in the cartridge, such as 12, 20, 24 or 36 exposures. You should know how many frames are in the cartridge that you have in the camera. A cartridge of film is commonly called a roll of film.

LOADING AND REWINDING FILM

The film-loading and rewinding procedures depend on the camera model. Most of the cameras in this book use manual procedures. These cameras are easy to identify—they have a Film-Advance Lever on top of the camera, at the right, and a Film-Rewind Knob at the left.

Motor-driven cameras such as the OM77AF have neither a Film-Advance Lever nor a Rewind Knob. Film advance and rewind is done by motors in the camera body.

Loading and unloading a camera should always be done in subdued light. If you have to do it in sunlight, shade the camera and film cartridge with your body.

Film cartridges are sold in light-tight containers, such as plastic cans. Leave the film in the container until you are ready to load it. When you remove the film from the camera, replace it in the light-tight container.

When loading film, be very careful not to touch the focal-plane shutter with your finger or with the end of the film being loaded.

Manual Film-Loading—The general procedure is shown in the accompanying photos. Here are some tips and suggestions.

To open the back cover, pull up on the Rewind Knob. The Rewind Crank is folded into the Rewind Knob. If you have difficulty grasping the knob, tip up the crank and then pull upward on the crank.

Before opening the back cover to load new film, be sure the camera is empty or the film in the camera has been fully rewound into the cartridge. The OMPC has a window in the back cover that allows you to see the film cartridge inside, if one is there. But that doesn't tell you if the film has been rewound.

With any manual camera, the test is to turn the Rewind Knob clockwise. If it turns freely, there is no film in the camera. If it turns with slight resistance, film has been rewound but the cartridge is still in the camera. If it turns a small amount or not at all, film is loaded and not rewound. Check the frame counter.

With manual cameras, the frame counter does not actually count frames of film as they are exposed. It just counts the number of times you have operated the Film-Advance Lever.

If the film end is caught in the take-up spool, film will be advanced each time you operate the Film-Advance Lever. The test is to observe the Rewind Knob. It should turn counterclockwise each time you operate the Film-Advance Lever. If it doesn't, film is not moving through the camera.

Setting Film Speed—If you don't set film speed correctly, you won't get good exposures. Before closing the camera back after loading film, look at the film cartridge to verify the type of film, the number of exposures in the cartridge and the film speed.

Close the back and *immediately* set film speed, using the procedure shown in Chapter 16 for each camera model.

The OMPC offers you a choice. You can set film speed manually if you wish. If you are using DX-coded film, you can let the camera set film speed automatically.

End of Roll—By observing the frame counter, you will know when the end of a roll is near. You may sometimes get one more frame, or one less, than shown on the cartridge.

When manually advancing film, using the Film-Advance Lever, you will feel resistance at the end of the roll. Typically, the Film-Advance Lever will rotate partway but not enough to advance a full frame.

Don't force the lever, hoping to get one more exposure. You may detach the film from the spool inside the cartridge. If that happens, you can't rewind. The camera must be opened in a darkroom and the film retrieved without rewinding.

Manual Rewind—When you have made the last exposure on a roll, *rewind immediately*. The general procedure is shown in the accompanying photos.

Rewind slowly, particularly if the humidity is low. If you rewind rapidly, static electricity may build up on the film and discharge during rewinding, causing "lightning" tracks on the film.

By rewinding slowly and noticing the "feel" of the Rewind Crank, you can tell when the film end pulls free of the take-up spool. If you stop rewinding at that point and remove the cartridge, the film end will extend from the cartridge about as much as it did when you loaded the film.

It is advisable to continue rewinding until the film end is pulled all the way into the cartridge. That avoids the possibility of mistaking an exposed roll for an unexposed roll.

Auto Film Loading—With a motor-driven camera, such as the OM77AF, film loading and rewinding is done automatically by a built-in motor. The general film-loading procedure is shown in accompanying photos.

This procedure is very reliable and foolproof—*if you watch the LCD display on top of the camera.* For example, if film is loaded incorrectly, the OM77AF will seem to operate normally if you press the shutter button. The frame counter on top of the camera will show 0 and the film-cartridge symbol in the display blinks to tell you that something is wrong.

The OM77AF has a film window in the back cover that allows you to see if a film cartridge is in the camera. If the film is ready to be rewound, or not fully rewound, an R symbol appears in the LCD display.

DX-coded film cartridges are imprinted with film data at the location that can be seen through the film window. You can read a film-type symbol, the number of exposures and the film speed.

With the OM77AF, you should normally use DX-coded film. If you load a film cartridge without DX-coding, the camera uses a film-speed setting of 100, no matter what film speed is loaded.

Setting Film Speed—With DX-coded film, the OM77AF sets film speed automatically. To see what speed has been set, press the green RESET button. The adjacent LCD panel will show the set film speed.

MANUAL FILM LOADING AND REWINDING WITH OM-1N, OM-2SPROGRAM, OM-3, OM-4, OM-4T, OMPC

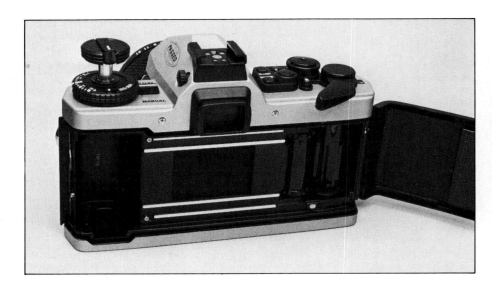

TO LOAD FILM:

1. Turn the Rewind Knob clockwise to be sure there is no film in the camera or it has been fully rewound into the cartridge.

2. Pull up Rewind Knob until camera back cover springs open.

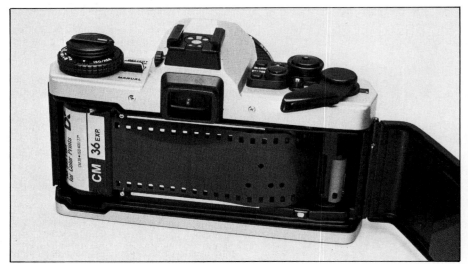

3. Drop film cartridge into cavity at left.

4. Press Rewind Knob downward, turning it slightly if necessary.

5. Pull film end across back of camera and insert end into slot in take-up spool.

6. With lens cap removed, press the Shutter Button and use the Film-Advance Lever to wind film onto the take-up spool. Continue until sprocket teeth engage sprocket holes on both sides of film.

7. If necessary, turn Rewind Knob clockwise gently to draw film flat against back of camera. Lip of film cartridge should be flat against camera.

8. Close camera back.

9. Set film speed, following instructions in Chapter 11. This camera is set to 400, as you can see on the ISO/ASA dial at left.

10. With lens cap off, use Shutter Button and Film-Advance Lever to shoot "blank shots" until Frame Counter reaches frame 1, as you can see in the frame-counter window at right. While advancing film, watch the Rewind Knob. It should turn. If not, open the camera back and start over.

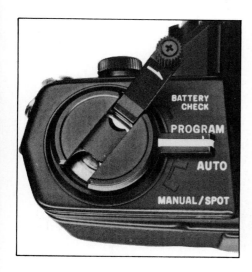

TO REWIND:

1. Press Rewind-Release Button near Film-Advance Lever. It will remain depressed. Location of Rewind-Release is different on OM-1N. See Chapter 16.

2. Tip up Rewind Crank and turn clockwise until film pulls free of take-up spool. Continue turning, if you wish to draw film end entirely into film cartridge. Open back of camera and remove cartridge.

End of Roll—When the last frame has been exposed, tension in the film path causes the OM77AF to display a blinking R symbol. Press the Rewind Button on the bottom of the camera. Film is automatically rewound, all the way into the cartridge.

MEMO HOLDER

Some camera models have a Memo Holder on the back to hold the end flap of a film carton. The flap shows film data. Cameras with a film window to read data directly on the cartridge do not also have a Memo Holder.

SCRATCHES ON THE FILM

No matter what you do, you will occasionally get lengthwise scratches on film. This can happen in the camera, in film developing machines, in printing, or in machines at commercial labs that cut and mount slide film into slide holders.

If it is happening inside your camera, the location of the scratches can give you a clue where to look. Check for a piece of dirt or even a bit of broken film lodged in the mechanism.

If you don't find anything in your camera, suspect the lab. Complain loudly and emphatically. They may give you a new roll of film but that doesn't help much if you drove two days and climbed a mountain to shoot the roll that was scratched.

AUTOMATIC FILM LOADING AND REWINDING

TO LOAD FILM:

1. Open back cover by pressing Back-Release Locking Button on left side of camera body while sliding Back-Release downward.

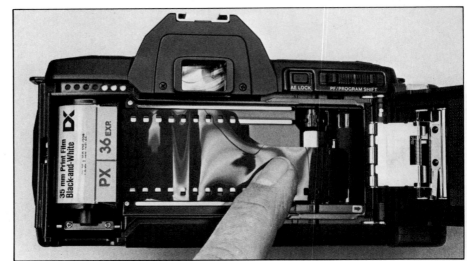

2. Drop film cartridge into cavity at left.
3. Draw film end across back to align with arrow symbol at far right, near the bottom hinge of the back cover.
4. Use your finger to place a sprocket hole in the film over a tooth on the sprocket roller.
5. Close the camera back.

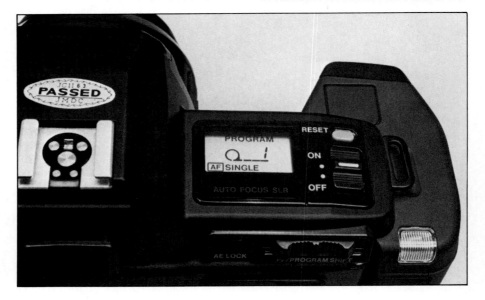

6. Watch the LCD panel on top of the camera. It should show the film being advanced to frame 1.
7. If the film did not load correctly, the frame counter will show 0 and the film-cartridge symbol will blink. Open the back and start over.

TO REWIND:

1. At end of roll, an R symbol appears in LCD display.

2. While sliding the Rewind Lock in direction of arrow, press the round Rewind Button, labeled R, on bottom of camera. Film is rewound automatically, all the way into the cartridge. When motor stops running, open the back and remove the cartridge of exposed film.

6
EXPOSURE CONTROLS AND THEIR EFFECTS

The basic requirement is to get a good exposure. Starting with the darkest photo, exposure was increased a half-step at a time for each of the others. Shooting several frames with different exposures is called *bracketing*.

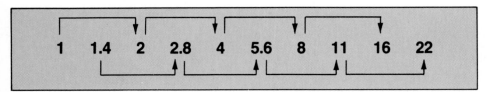

1 1.4 2 2.8 4 5.6 8 11 16 22

Figure 6-1/It's easy to write or remember the *f*-number series. Start with the numbers 1 and 1.4; then double them alternately as shown here.

In Chapter 2, I mentioned that the two exposure controls working together determine exposure, but they each have other effects on the picture. Often these other effects have a major influence on the control settings you choose to use.

THE *f*-NUMBER SERIES

Aperture size is indicated by a standard series of *f*-numbers. It is useful and practically necessary to memorize the series, and it is easy to do. See Figure 6-1.

The *f*-number series continues both above and below the numbers shown, but those are the common *f*-numbers.

Notice there is an approximation between 5.6 and 11. The *f*-number 11 is not exactly double 5.6, but it is close enough and easier to remember.

Larger *f*-numbers mean smaller lens openings, something you also have to remember.

The series of *f*-numbers is chosen so the *area* of the aperture is doubled with each full step toward larger aperture and reduced to half with each full step toward smaller aperture. Because the amount of light that gets through a hole is determined by the area of the hole, each *f*-number step allows twice as much light, or half as much, as its immediate neighbors in the series.

If you have a lens set at *f*-8 and change it to *f*-11, the amount of light passing through the aperture will be reduced to half. If you change a lens aperture setting from *f*-2 to *f*-1.4, the amount of light on the film will be doubled.

In the early days of photography, variable apertures had not been invented. Cameras used removable metal plates in the light path to the film. The metal plates were made with holes of different size and the thinking was that the plate would *stop* all of the light

except that which got through the hole. Changing these plates to allow more or less light on the film became known as changing stops.

The word remains with us; *f*-numbers are often called *f*-stops and changing the *f*-number setting of a lens to allow less light on the film is often called stopping down.

Changing from *f*-22 to *f*-16, the nearest larger opening, is called changing by one *stop*. Earlier I defined doubling the amount of light as an exposure change of one *step*.

You can conclude that the words *step* and *stop* mean the same thing in photography. I prefer to use *step* to mean doubling or halving exposure and international standards for the photographic industry use *step* rather than *stop*. Popular literature and most books cling to *stop*.

THE SHUTTER-SPEED SERIES

Shutter speeds also change in steps so each longer time is double the preceding step. The standard series of shutter-open times in seconds includes 1, 1/2, 1/4, 1/8, 1/15, 1/30, 1/60, 1/125, 1/250, 1/500 and 1/1000.

Just below the slowest timed shutter speed on the dial is the symbol B, which we say stands for *bulb*. When set at B, the shutter will remain open as long as you depress the shutter-release button.

With all Olympus SLR cameras except the OM77AF, you can use a locking cable release for long time exposures. The cable release screws into the top of the shutter button and

When the shutter-speed control is set at B and the camera is set for manual operation, the shutter will remain open as long as you hold the shutter button depressed. You can do it with your finger or with a locking cable release as shown here. To lock this type of cable release, depress the plunger then tighten the lock screw (arrow).

allows you to operate the shutter remotely by a plunger at the far end of the cable. Locking cable releases have a set screw or locking arrangement to keep the plunger depressed when you want a long exposure.

For simplicity and ease of reading, the shutter-speed dial does not show the numerator of the shutter opening-time fraction. Instead, 125 is used to mean 1/125 second, 500 means 1/500 second, and so forth.

APERTURE VALUES IN FULL AND HALF STEPS

Full Steps	Half Steps
f-1	
	f-1.2
f-1.4	
	f-1.8
f-2	
	f-2.5
f-2.8	
	f-3.5
f-4	
	f-4.5
f-5.6	
	f-6.7
f-8	
	f-9.5
f-11	
	f-13
f-16	
	f-19
f-22	
	f-27
f-32	

Some cameras display aperture settings in full and half steps.

The shutter speed series is intended to double as it goes from shorter to longer times. There are some approximations such as between 1/125 and 1/60, but they are not important. You should also learn this series of numbers.

When setting shutter speed manually, the camera can use only those speeds marked on the dial. Always set exactly on a marked speed.

On a practice day at the Indianapolis Motor Speedway I photographed the cars in several ways. Here, I used a 200mm lens and a shutter speed of 1/1000. To keep a speeding racer in view, it was necessary to *pan*—which means *swing* the camera to follow the moving subject. At a shutter speed of 1/1000, all motion was frozen. This photo does not convey the illusion of speed.

Panning the same way, but with a shutter speed of 1/125, caused the car to remain fairly sharp but everything else is blurred because of camera motion. This is a good way to capture the illusion of speed but retain identification of the moving object.

Here I did not pan. The cars were moving so fast I couldn't catch them in the field of view of a 200mm lens, so I switched to a 50mm lens and used a piece of paper in the foreground as a marker. When the nose of the car reached the paper, I pressed the shutter button. Background is sharp; car is blurred. There is an illusion of speed, but the car is not recognizable.

SHUTTER-SPEED VALUES IN FULL AND HALF STEPS

Full Steps	Half Steps
2000	
	1500
1000	
	750
500	
	350
250	
	180
125	
	90
60	
	45
30	
	20
15	
	10
8	
	6
4	
	3
2	
	0.7"
1"	
	1.5"
2"	

Some cameras display shutter speed in full and half steps. In this table, numbers with the symbol " are seconds. The other numbers represent fractions of a second, such as 1/2000.

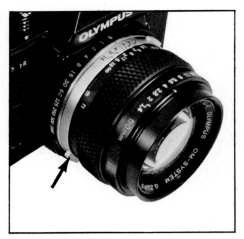

Zuiko lenses have a Depth-of-Field Preview Button (arrow) that stops down the aperture to the value set on the lens Aperture Ring.

EFFECT ON EXPOSURE

In their effect on exposure, one step in aperture size is exactly equal to one step in shutter speed. When metering a scene, you may have the controls set for correct exposure and then notice that shutter speed is slower than you want to use. If so, for each step toward a faster shutter speed you can compensate by making one step toward a larger aperture size. If you change shutter speed three steps and change aperture three steps in the "opposite direction," exposure will be unchanged.

DEPTH OF FIELD

Depth of field is the distance between the nearest object that is in focus on the film and the farthest object that is also in focus. It is the *zone of good focus*.

Depth of field is often an important consideration when taking a photograph. For example, a portrait of a person against a distracting background can be "saved" by causing the background to be out of focus and blurred. Similarly, it is sometimes helpful to blur the foreground, or sometimes to blur both foreground and background. Sometimes, on the other hand, you want the depth of field to be as extensive as possible, to record everything in a scene sharply.

Depth of field is affected by aperture size, which is the primary control, plus lens focal length and the distance from camera to subject. If you have selected a lens focal length and a place to stand when making the picture, aperture size is the remaining variable. *Smaller* apertures produce *greater* depth of field.

VIEWING DEPTH OF FIELD

When you view the scene through the viewfinder eyepiece, the lens is normally held at maximum aperture and therefore you see *minimum depth of field*. To see the actual depth of field that will be recorded on film, you must close the aperture to the size that will be used to make the exposure.

With Zuiko Lenses—These lenses have a manual Aperture Ring to set aperture size and a manual Focusing Ring. They have a Depth-of-Field Preview Button opposite the lens-release button. Depressing the Depth-of-Field Preview Button closes aperture to the value that has been set on the lens Aperture Ring.

In some situations, that will allow you to see depth of field at shooting aperture—it depends on the exposure mode being used. All OM cameras have one or more of the following modes.

On manual exposure control, you set both aperture and shutter speed manually. The camera uses the aperture value set on the lens Aperture Ring to make the exposure. Depress the Preview Button *after setting aperture* and you will see depth of field at that aperture.

On aperture-priority automatic, you set aperture and the camera sets shutter speed. To see depth of field, depress the Preview Button *after setting aperture*.

In the programmed exposure mode, the camera sets both shutter speed and aperture size automatically. This mode requires setting the Zuiko lens Aperture Ring to *minimum aperture*. If you press the Preview Button, you view the scene through minimum aperture and therefore see *maximum depth* of field. Usually, the camera will make the exposure through some other aperture size, so the depth of field that you saw is not what you will get.

Zuiko lenses will fit the OM77AF autofocus camera. When so used, the camera operates only in the aperture-priority automatic-exposure mode. It uses the aperture set on the lens Aperture Ring. Therefore, pressing the Preview Button will show a valid depth of field.

In summary, you can view depth of field with Zuiko lenses but only when using manual exposure control or aperture-priority automatic.

With Autofocus Lenses—The AF lenses fit only autofocus cameras. These lenses don't have a depth-of-field preview button. The OM77AF camera has no provision to view depth of field.

RULES ABOUT DEPTH OF FIELD

Smaller apertures give more depth of field; larger apertures give less.

A large image has less depth of field than the same image made smaller. That's because depth of field is based on what you see. If you see a fuzzy edge in a photo, it appears to be out of focus. If the size of the image is reduced, the fuzzy edge becomes smaller. It seems to be sharper and in better focus. Therefore a smaller image *appears* to have greater depth of field than the same image made larger, when the two are viewed from the same distance.

Lenses with longer focal lengths, such as telephotos, fill the frame with a smaller area of the scene. Therefore, each object in a photo is larger than it would be if shot with a 50mm lens. Because the image is larger, out-of-focus edges are easier to see and depth of field is apparently reduced.

Wide-angle lenses, such as 24mm or 28mm, fill the frame with a larger area of the scene and each object in the picture is smaller compared to a photo made with a 50mm lens. Because the objects are smaller, they appear sharper to your vision and depth of field appears to be greater.

With any lens, if you move closer to the scene, objects in the photo appear larger. Out-of-focus edges are easier to see. Depth of field is reduced. If you move back from the scene, objects in the photo are smaller

Depth of field and focused distance, used together, give you great control. With large aperture, to reduce the depth of field, you can focus on the background and have the foreground out of focus. Or, you can focus on the foreground and have the background out of focus, which makes no sense here but is often helpful. By changing to small aperture so depth of field is greater, you can sometimes have both foreground and background in good focus. Notice what happens to the light in the doorway when the background is out of focus.

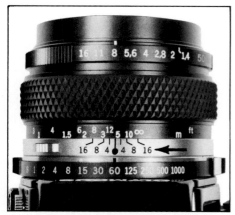

The Depth-of-Field Scale (arrow) is centered on the index mark that you use to read focused distance. The numbers on the Depth-of-Field Scale are *f*-numbers. There is a 4 on each side of the index, an 8 on each side, and so forth. The pair that you use to find depth of field are the same as the *f*-number setting on the lens.

This lens is set to *f*-8 and focused at a subject distance a little less than 5 meters. To find the near limit of depth of field, locate the symbol 8 on the left side of the Depth-of-Field Scale and read the distance directly opposite—about 3 meters. The far limit is opposite 8 on the right side—about 9 meters. With these settings, depth of field is about 6 meters, starting 3 meters away from the camera.

If lens aperture is changed to *f*-16, and the focused distance remains the same, depth of field will increase. As you can see on the scale, it will be about 2.5 meters at the near limit and extend to infinity.

If lens aperture is set at *f*-11, you have to estimate depth of field. Not all *f*-numbers are engraved on the Depth-of-Field Scale.

and appear sharper. Depth of field is increased.

Making prints from a negative or slide affects depth of field. Larger prints have less depth of field than smaller prints.

When looking at a photograph, if you move closer, objects seem larger. Depth of field is reduced. If you move farther back, objects appear smaller and depth of field appears to increase.

DEPTH OF FIELD SCALE

A method of estimating depth of field is to use the depth-of-field scale that is on most fixed-focal-length lenses and some zoom lenses.

Fixed-Focal-Length Lenses—The caption for the accompanying photo of a fixed-focal-length Zuiko lens explains how to read the depth-of-field scale. The photo of a fixed-focal-length AF lens shows a similar scale that is read the same way.

Zoom Lenses—There are two types of zoom controls. Some Zuiko zoom lenses have a focusing ring and a separate rotating

zoom ring. To change the focal length, turn the zoom ring.

Some Zuiko zoom lenses, called *one-touch*, combine focus and zoom controls in a single ring. Turn the ring to change focus, slide it along the lens body to zoom. Zooming is done by a "push-pull" movement of the zoom control.

Zoom lenses with a push-pull zoom control have enough room on the lens body for a depth-of-field scale, as shown in the accompanying photo. The scale is the set of curved lines, which are read where they intersect the edge of the zoom control. The lines curve and become farther apart at shorter focal lengths because depth of field increases at shorter focal lengths.

Most Zuiko zoom lenses with a push-pull zoom control have a depth-of-field scale.

Because depth of field changes with focal length, there is no practical way to put a depth-of-field scale on a zoom lens that uses a rotating zoom ring.

The AF zoom lenses that were introduced with the OM77AF camera have rotating zoom

With the camera on a tripod, I photographed this little waterfall at four different shutter speeds: 1/1000, 1/250, 1/60 and 1/15.

controls and do not have depth-of-field scales. Other AF zoom lenses will be announced in the future, but their design is not yet generally known.

HYPERFOCAL DISTANCE

The hyperfocal distance is a special focused distance that provides maximum depth of field. The accompanying photos show how to set hyperfocal distance on a Zuiko lens.

This setting is often used with non-autofocus cameras as a standby focused distance so a quick "grab shot" can be made without taking the time to focus.

With an autofocus camera and lens, you may prefer to let the camera focus on the subject, which it does quickly. However, there are some situations that prevent the autofocus system from operating. In these cases, you can turn off the autofocus system and manually focus the AF lens at the hyperfocal or any other distance. AF lenses can be focused manually by a control on the camera body.

EFFECTS OF SHUTTER SPEED

Shutter speed has three effects:
• It affects how much a moving subject is blurred on the film.
• With a hand-held camera, it affects the amount of image blurring of a stationary subject due to your inability to hold the camera absolutely steady.

• It affects the aperture size you can use because aperture and shutter speed in combination must give the desired exposure.

To choose a shutter speed that stops action of a moving subject, the basic idea is to select an exposure time so short that the subject's motion is imperceptible on the film. In general, the faster shutter speeds, such as 1/1000 and 1/500, will stop action of most moving subjects, including racing cars. Medium speeds, such as 1/125, will stop action of subjects moving at medium speeds, such as a person riding a bicycle. Slow shutter speeds, such as 1/15 second or slower will allow most moving subjects to blur—even a person walking.

Both shutter speed and lens focal length determine blurring of a stationary subject due to camera shake when you are hand-holding the camera—also how steady you are and the way you support the camera.

A guide to usable shutter speeds when hand-holding the camera with nonmoving subjects is to take the reciprocal of the lens focal length. The reciprocal of 50 is 1/50 and so forth. Use the reciprocal of focal length as the *longest* time that can safely be hand-held unless you have proved to yourself that you can hold the camera steady at slower shutter speeds. With a 200mm lens, use 1/250 because 1/200 isn't an available shutter speed.

With a 50mm lens, you should not have any trouble shooting at 1/60 and most people who are careful about it can shoot at 1/30. By

HOW TO SET HYPERFOCAL DISTANCE

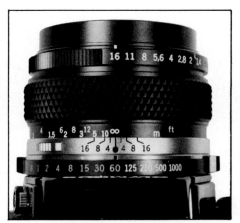

1/You can find hyperfocal distance in two steps. First, focus the lens at infinity and notice the near limit of depth of field. This lens is set for *f*-16, so the near limit is about 5 meters. Notice that the far limit is beyond infinity and therefore not useful.

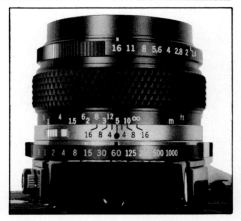

2/Then refocus to the near limit as determined in step 1. In this example, focus at 5 meters. Now, the far limit is at infinity and the near limit is about 2.5 meters. Depth of field is from 2.5 meters to infinity. Focusing at the hyperfocal distance gives more total depth of field than at any other focused distance. Naturally, it will change if you change aperture size.

Now you can do it in one step: Notice that you end up with the infinity symbol (∞) opposite the far limit on the Depth-of-Field Scale. You can make this setting directly, eliminating step 1.

This AF 50mm *f*-1.8 lens has a focused-distance scale and an adjacent depth-of-field scale.

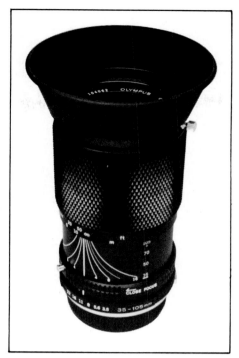

Zoom lenses with a "push-pull" zoom control have room for a depth-of-field scale. The lines curve because depth of field changes with focal length.

bracing yourself you can do better, and by pressing the camera against the side of a building or a post, you can do still better. Don't pass by a good shot on account of this rule of thumb. Give it your best effort and get the picture. If it blurs you can always say you did it on purpose.

Sometimes there is conflict between the aperture you would like to use for depth-of-field effect and the shutter speed you need to stop motion or to hand-hold the camera. The two together must satisfy a third requirement—correct exposure. However, exposure is not the same for all film types because films have different speed ratings. It always helps to select a film speed for the kind of shooting you intend to do—it gives you the best chance of being able to use appropriate apertures and shutter speeds.

EFFECT OF FILM SPEED

The film-speed rating is assigned by the film manufacturer as a way of stating how much exposure a particular type of film requires.

Among commonly available film-speed ratings, ISO/ASA 25 is considered slow, 125 is intermediate, and 400 is fast. More exposure is required when you have ISO/ASA 25 film in your camera than when using ISO/ASA 400.

Here's another rule of thumb that's worth remembering:

To photograph a subject illuminated di-

rectly by sunshine, use *f*-16 and a shutter speed that is the reciprocal of the ISO/ASA film speed. If you are using ISO/ASA 25 film, shoot at 1/25 second—1/30 will be close enough. If you are using ISO/ASA 64 film, shoot at 1/60 second, and so forth. This is not a hard and fast rule, but it beats an outright guess. With the camera's built-in metering you seldom have need for rules about exposure, but this one is easy to remember and worth storing in your mental computer.

Naturally you don't have to shoot at *f*-16 and 1/30 with ISO/ASA 25 film, even if you use the rule. You can change the aperture and make compensating changes in shutter speed to end up with a long menu of possible settings in sunlight as follows:

f-16	1/30
f-11	1/60
f-8	1/125
f-5.6	1/250
f-4	1/500
f-2.8	1/1000

Without putting film in your camera or even going out in the hot sun, you can use the menu just figured to see how it's going to be when you go out there.

Assume you intend to shoot action with a 200mm lens. You decide to shoot at 1/1000 so you can stop motion. Depth of field will be poor because you also have to shoot at large aperture—*f*-2.8. If you close down to *f*-11 or *f*-16 to get better depth of field, the action will blur at the slow shutter speeds and you will not be able to hand-hold that long lens.

The only way out of this problem is not to use ISO/ASA 25 film for this shooting assignment because the film is too slow.

With some films, you can deliberately underexpose to operate at faster shutter speeds than normal exposure requires. For these films, most labs can make a compensation in development called push-processing. If you turn up at your friendly local lab and ask the man to push-process your ISO/ASA 25 film because you had to underexpose it in sunlight, he will think you didn't ever read this book.

Let's try the whole deal again with ISO/ASA 400 film, which is faster by 4 exposure steps. You have to double four times to get from ISO/ASA 25 to ISO/ASA 400.

The choices in sunlight then become:

f-16	1/400—use 1/500
f-11	1/1000
f-8	1/2000 with some cameras
f-5.6	No shutter speed available
f-4	No shutter speed available
f-2.8	No shutter speed available
f-2	No shutter speed available

As you can see, ISO/ASA 400 film in sunlight forces you to use small apertures and fast shutter speeds. That very neatly solves the problem I just mentioned.

But if you are photographing people or flowers in the garden, you may not want depth of field from here to the back fence. A much more artistic photo usually results when the competing background is thrown out of focus by using less depth of field. With the settings required for 400 film speed, you can't reduce depth of field by using large aperture because you don't have fantastic shutter speeds. You can reduce the amount of light entering the camera by using a neutral-density filter on the lens as described in Chapter 13.

7
CAMERA CONTROLS

This chapter contains a general discussion of controls on Zuiko lenses and Olympus non-autofocus cameras—which have a "family resemblance" among the various models. The camera used as a typical model is the OM-4. Only controls that are common to several models are discussed here.

In Chapter 16 is a specific description of each camera model in this book, including photographs with the controls labeled.

The OM77AF autofocus camera and companion AF lenses are significantly different from earlier non-autofocus models. If you are mainly interested in an autofocus camera, I suggest that you skip this chapter and refer to the camera description in Chapter 16.

LENS CONTROLS

Zuiko lenses work the same way no matter which camera you install them on. The lens controls are few and easy to use.

Focusing Ring—Turn this ring to focus the lens at different distances from the camera. All conventional lenses focus out to infinity, symbol ∞, but the near limit is different among various lenses. When considering a lens, check its near-focus limit.

Focused distance is shown in feet and meters on the distance scale of the Focusing Ring, opposite the red index mark on the lens body.

Aperture Ring—Use to select any desired aperture. With manual exposure control, adjust the Aperture Ring and the Manual Shutter-Speed Ring to satisfy the exposure display in the viewfinder.

Depth-of-Field Scale—This works with the focused-distance scale on the Focusing Ring to show depth of field at various aperture settings.

Depth-of-Field Preview Button—This control is on the lens body where you can conveniently depress it with the first or second finger of your left hand as you hold the camera to your eye. When depressed, this button closes lens aperture to the value you have selected on the Aperture Ring. This allows you to see depth of field at that aperture on the focusing screen, provided the screen has a groundglass *matte* surface. This is explained in Chapter 9.

Lens-Release Button—Depress this button and turn the lens counter-clockwise to remove the lens.

CAMERA BODY CONTROLS

Camera controls are similar and in the same locations on the various models, with only a few exceptions.

Film-Advance Lever—To advance film for the next shot, use your right thumb to rotate this lever either all in one stroke or in a series of short strokes.

The lever has a storage position pushed flush against the body and a stand-off or

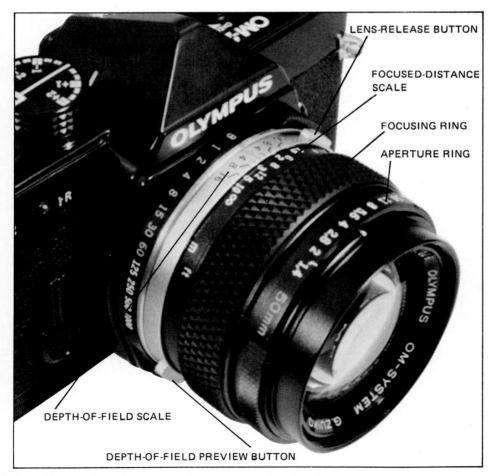

LENS-RELEASE BUTTON

FOCUSED-DISTANCE SCALE

FOCUSING RING

APERTURE RING

DEPTH-OF-FIELD SCALE

DEPTH-OF-FIELD PREVIEW BUTTON

Most Olympus Zuiko lenses have the controls and scales shown here.

pre-advance position extending outward from the body so it is convenient to hook it with your thumb. Film advance begins from the stand-off position.

Shutter-Release Button—To make an exposure, use your right index finger to smoothly squeeze the shutter button so you operate the camera without jiggling it. In the center of the button is a threaded socket for attachment of a cable release.

Exposure Counter—Just to the right of the Film-Advance Lever is a window through which you read frame numbers. The number visible after you have advanced the film is the frame you will expose next. This counter is automatically reset when you open the back cover to load film.

Film-Speed Dial—Use this control to set the camera for the film speed you are using. The procedure varies among models, as explained in Chapter 16.

Exposure-Compensation Dial—Automatic cameras have this control combined with the film-speed control. It commands the camera to give more or less exposure than the camera normally would on automatic operation. Control range is from −2 to +2 exposure steps in increments of 1/3 step.

Mode Selector—This control is on the left side of the pentaprism housing. It serves as the camera on-off switch, selects automatic or manual exposure and checks the batteries on some models.

Rewind-Release Button—To prepare the camera for rewinding film, press this button. It resets automatically to the normal position while you are loading the next roll of film.

Rewind Knob—Watch this knob while advancing film. If it rotates, you know film is actually being advanced through the camera. To rewind film, lift up the Rewind Crank that is built into the knob and turn it clockwise. To open the camera back cover, lift up the Rewind Knob.

Flash Socket—An electrical socket is provided so you can plug in a synchronization cord to trigger flash units.

Manual Shutter-Speed Ring—Surrounding the lens mount, this ring is used to select shutter speeds. Two knurled projections on the ring make it convenient to operate the control with the thumb and forefinger of your left hand.

Selecting B—On the lower right corner of the lens mount, looking from the front, is a small pushbutton labeled B LOCK. To select B with the Manual Shutter-Speed Ring, push in this button. To rotate the shutter-speed ring away from B, it is not necessary to depress the button.

Self-Timer—This control provides a time delay between pressing the shutter button

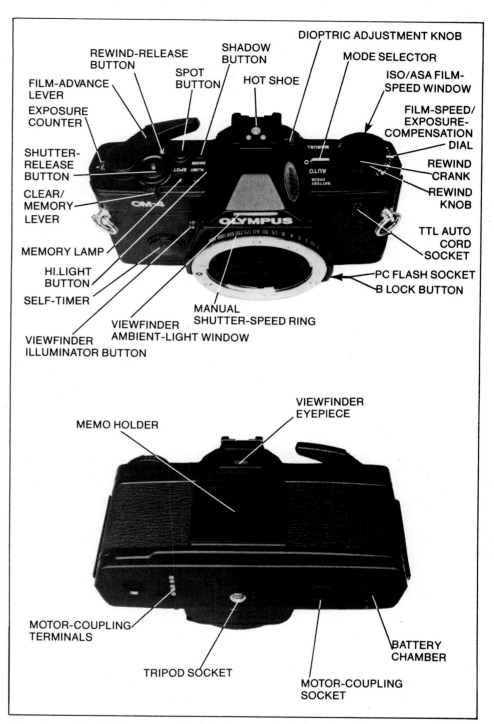

Controls on the OM-4 are generally similar to controls on other Olympus non-autofocus cameras. The OM77AF autofocus camera is significantly different.

and making the exposure. This allows you to dash around in front of the camera to take your own picture if you wish. It's also a good way to release the shutter without causing vibrations that could blur the picture. Setting the self-timer on each model is described in Chapter 16.

Battery Check—Rotate the Selector Lever to the BATTERY CHECK position for a three-stage indication of battery condition.

If the red indicator light on the camera glows steadily, the batteries are OK. If it flickers, the batteries are depleted and should be changed. If the light does not glow, the batteries are dead and must be replaced.

OTHER CAMERA FEATURES

Although not controls, there are some camera features you should know about.

Tripod Socket—On the bottom of the camera is a threaded socket you can use to mount the camera on a tripod.

Battery Chamber—Also on the bottom is a removable screw cap that gives access to the battery chamber so you can install or replace batteries. Observe battery polarity as indicated in the battery chamber and on the inner surface of the screw cap.

Motor Drive and Winder Connections—Also on the bottom plate are mechanical and electrical connections for a motor drive unit that advances frames continuously or a film winder that advances frames one at a time, as discussed in Chapter 14.

Memo Holder—On the back cover of some models is a holder into which you can insert the end flap of a film box or any other memorandum you want to display. Olympus memo holders load from the bottom.

Hot Shoe—A hot shoe on the top of the camera pentaprism housing provides the mechanical mount and electrical connection for a flash unit. It's called a *shoe* because the mounting foot of the flash unit fits into it. It's called *hot* because there is a center electrical contact in the shoe that fires the flash.

Combinations of flash, camera and hot shoe are discussed in Chapter 11.

OPERATING THE CONTROLS

It's good practice to operate lens controls with your left hand while also cupping the lens and supporting it with that hand. You should also operate the shutter-speed ring with the fingers of your left hand even though it's part of the lens mount on the camera body.

Operate all camera-body controls with your right hand while supporting the camera with your left hand. All Olympus cameras are designed so you can see the setting of every control by removing the camera from your eye and looking downward at camera and lens. This makes it quick and simple to make or verify control settings.

EXPOSURE METERING

Olympus SLR cameras have built-in light meters to measure the amount of light coming from the scene. This measurement helps the camera set exposure automatically or assists you in setting exposure manually. On automatic, there will be times when you must intercede to prevent an incorrect exposure even though the camera "thinks" it is doing it right.

The built-in light meters measure the amount of light after it has come through the lens and any accessories that you may have attached to the lens, such as filters. Because some filters and lens accessories reduce the amount of light, this is a great advantage and adds to the convenience of using the camera.

This type of metering is sometimes called *behind-the-lens* metering because that's where the light-sensing device is located. It is also called *through-the-lens* metering, which implies that the light sensor measures the light after it has come through the lens. Through-the-lens is usually abbreviated TTL.

Depending on camera model and mode of operation, Olympus uses a variety of light sensors, metering patterns and metering methods. I'll discuss these individually, then I'll describe how they are used in the cameras.

TYPES OF SENSORS

Olympus uses two different types of sensors to measure the amount of light. The characteristics of these sensors affect both the design of the cameras and the way you use the cameras.

Cadmium Sulfide (CdS)—These sensors are relatively simple, with a high electrical output in bright light. In use, current from the camera battery flows through CdS sensor. The sensor conducts more current when the light is bright and less current when the light is dim—a property called *photoconductive*. With a dead battery, the sensor is inoperative.

CdS sensors have some disadvantages that

What you have to do is work with the light, measure the light, control the light and control the *effect* of the light.

do not affect ordinary photography but may appear when you are shooting in dim light.

They have a memory. If used to measure bright light and then suddenly used to measure dim light, the dim-light reading may be too high. After bright-light measurements, a recovery time of about one minute eliminates the error in dim-light readings.

They have a slow response time in dim light. When the focusing screen looks dark to your eye, a CdS sensor requires more time to stabilize and give an accurate reading. If you observe the meter reading, it will slowly drift toward the correct value. When it stops drifting, the reading is accurate. In dim light this may take as much as 30 seconds.

The light meter in a camera with full-frame averaging measures the light with equal sensitivity everywhere in the frame.

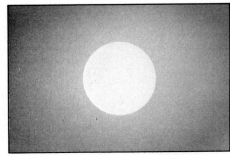

This drawing shows center-weighted metering. In the center of the frame, the meter has full sensitivity. Outside of the center area, meter sensitivity gradually decreases toward the edges of the frame. Light at the edges of the frame does not affect the meter as much as light in the center.

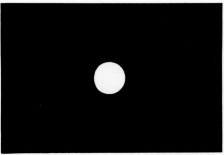

Spot metering is sensitive to light in a small "spot" and insensitive to light outside of that area.

Silicon Blue Cell—These sensors are made of silicon and have a blue coating. They produce a small amount of electricity due to light falling on the cell—a property called *photovoltaic*. The electrical output is so small that an amplifier is required inside the camera to build up the electrical signal so it can be used. The amplifier draws power from the camera battery, so a Silicon Blue Cell (SBC) also is inoperative without a battery.

Silicon cells do not have the disadvantages of CdS. They have no memory and respond virtually instantaneously. They can be made to operate well in very dim light.

BRACKETING

With any camera there will be occasions when the exact exposure setting you should use is not certain. The uncertainty can be due to reciprocity failure of the film, which is discussed later, metering an unusual scene, or indecision about the photographic effect you want.

Bracketing means to make several shots at different exposures. For example, make one shot at the exposure you think may be best and then make several more exposures using more and less exposure than the first shot.

Sometimes you know that correct exposure lies in one direction from a certain exposure. In such cases, bracket only in the direction you know is correct.

I enjoy the challenge of thinking about a scene and trying to get a good shot with only one exposure. However, if the shot is important and there is any doubt about correct exposure, I bracket. Professional photographers bracket because it is very important to get at least one good exposure of everything they shoot.

Recent Olympus models use a single light sensor in the bottom of the camera facing backward toward the film. Depending on the model, this sensor has a variety of functions. It may measure the light before exposure and during exposure. It may use either a center-weighted or spot metering pattern. It may also control TTL flash exposure automatically.

METERING PATTERNS

As you will see later in this chapter, it is essential to monitor the exposure measuring process in your camera and intercede at times to prevent the camera from making a mistake. Exposure measurement requires some thinking about the scene being measured and your purpose or preference in making the photo. The camera cannot think for you.

Several meter sensitivity patterns have been developed to reduce the amount of thinking required of the photographer, but none are entirely successful.

Full-Frame Averaging—The simplest metering pattern is to make the light sensor respond equally to every part of the frame. A bright light in the corner will affect the meter just as much as a bright light in the center.

The meter takes all of the brightnesses of the scene, averages them impartially, and reports an overall average brightness for the scene. This is called *full-frame averaging*.

When using a meter with full-frame averaging, some photographers get bad exposures when the background and foreground are unusually bright or dark. For ex-

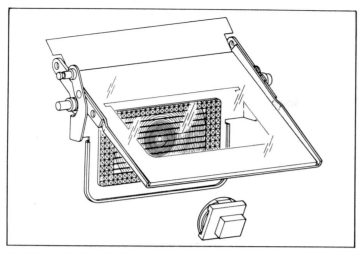

To allow metering before exposure, using the light sensor in the bottom of the camera, Olympus developed this two-part mirror assembly. The main mirror reflects light upward into the viewfinder, in the conventional way, to allow viewing and composing the scene to be photographed. A small amount of light passes through the main mirror to an auxiliary submirror. The sub-mirror reflects this light downward and into the light sensor at the bottom of the camera.

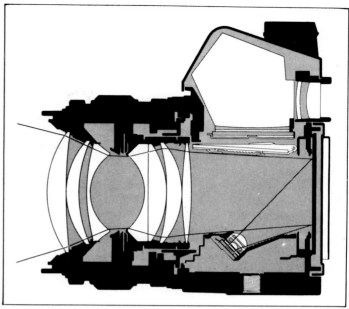

Figure 8-1/The OTF (Off The Film) metering method uses a light sensor in the bottom of the camera to measure light reflected from the surface of the film during exposure. When sufficient exposure has been measured, the camera closes the shutter.

ample, when shooting a portrait at the beach, sky and white sand may completely surround your subject with an unusually bright area. The full-frame averaging meter concludes that the overall scene is bright, so it recommends using less exposure. In the resulting photo, sky and sand look pretty good but your subject's face is too dark.

Similarly, some photographers will get overexposure of a baby on a dark blanket because the blanket persuades the meter that the overall scene is rather dark. So the meter recommends too much exposure for the subject of interest.

Center-Weighted—Because the usual exposure problem with full-frame averaging results from the meter reading the edges of the frame, a meter sensitivity pattern was developed that makes the meter more sensitive to the center part of the picture and less sensitive to the edges. This is called *center-weighting* because it attaches more importance or weight to the brightness in the center of the frame. Meter sensitivity *gradually* diminishes toward the edges of the frame.

This works well and has become a very popular metering pattern. But you still have to think when you use it.

Spot Metering—This metering pattern measures the light in a small circular spot within the scene and *disregards* the area outside of the spot. In OM cameras using spot metering, the metering spot is indicated by the outer circle that is faintly visible in the center of the viewfinder image. This circle contains the focusing aids, discussed in Chapter 9.

METERING METHODS

There are two general methods of measuring light using a light sensor in the camera.

Metering During Exposure— This method was introduced by Olympus in the OM-2 camera and has been used for *automatic* exposure control in the OM-2 and later models. A light sensor is mounted in the bottom of the camera facing backward toward the film surface as shown in Figure 8-1.

Because the light sensor "looks at" the film surface, it measures the amount of light actually used to make the exposure. When the film has received sufficient exposure, the camera closes the shutter.

Because the light being measured has traveled *Through The Lens* and is measured *Off The Film*, Olympus refers to this as TTL OTF metering. It is used to control exposure

both in ordinary photography using continuous light on the scene and in flash photography.

This method measures light reflected by the film surface. It works very well with films normally used for pictorial photography because the emulsion surfaces of such films all reflect about the same amount of light. If you are using a special film with an unusually light or dark front surface, you may have to make some tests and adjust exposure accordingly.

When shooting without flash, the exposure interval begins when the first shutter curtain *begins* to open and ends when the second curtain *begins* to close. The light sensor is active during this period. Therefore, when the sensor begins to measure light, the first shutter curtain is closed but just starting to open. Therefore, the first shutter curtain is manufactured with a pattern of reflective dots or a light-gray solid tone so it reflects about the same amount of light as conventional films. A patterned shutter curtain is shown in the accompanying photo.

Some camera models use the OTF light sensor in the camera body to control flash exposure automatically when using Olympus T-series flash units. The flash is fired

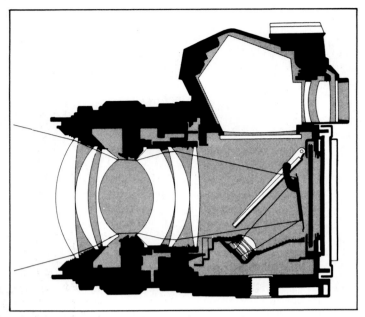

Figure 8-2/This design allows the sensor in the bottom of the camera to measure light before the exposure. The main mirror transmits a small amount of light from the scene to the auxiliary mirror. When the sensor views the entire surface of the auxiliary mirror, metering is center weighted.

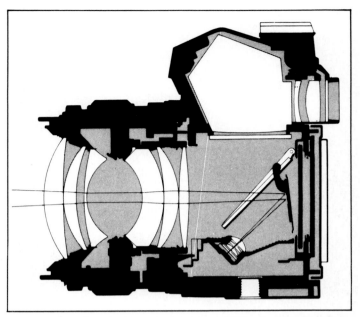

Figure 8-3/Spot metering is done by electronically changing the angle of view of the light sensor so it views only the center of the auxiliary mirror.

The pattern of reflective dots on the first shutter curtain is essentially uniform in reflectivity.

when the first shutter curtain is fully open. When sufficient exposure has been measured, the flash is turned off and the second shutter curtain is closed. Both flash and continuous light are measured.

Metering Before Exposure— Before the introduction of the OTF method, metering was done before the actual exposure. With continuous light, automatic exposure settings were "memorized" by the camera and used later to make the shot. Automatic flash exposure was done by a light sensor on the front of the flash unit and did not depend on metering by the camera.

Historically, metering before exposure was done by light sensors mounted in the viewfinder housing above the focusing screen. The sensor views the image on the focusing screen from above and measures its brightness. OM-1 and OM-2 cameras use that method.

The OM-2S, OM-3 and OM-4 cameras introduced a new way to meter before exposure, using a silicon sensor in the bottom of the camera—the same sensor used to measure light off the film.

These cameras have a main mirror and an auxiliary submirror as shown in Figure 8-2. The main mirror reflects the image upward so it can be viewed in the usual way. However, the mirror allows a small amount of the light to pass through it, to the surface of the auxiliary mirror. From the auxiliary mirror, it is reflected downward to the sensor in the bottom of the camera. The shutter is closed and exposure has not yet started.

The surface of the auxiliary mirror is shaped so it reflects a center-weighted metering pattern to the sensor. In Figure 8-2, the sensor views the entire surface of the auxiliary mirror, so the camera is operating with center-weighted metering.

When exposure begins, the main mirror moves up against the bottom of the pentaprism and the auxiliary mirror folds up against the bottom of the main mirror. The light sensor can then view the surface of the film to control exposure automatically using the OTF method if desired.

The light measurement before the shutter opens can be used in two ways. If the camera is being operated manually, the measured exposure will be displayed in the viewfinder. You set the exposure controls as desired, and those settings are used to make the actual exposure. The light sensor is not used during exposure.

If the camera is on automatic or programmed automatic, measurement before exposure allows the camera to display the approximate shutter speed that will be used to make the exposure. When the shutter opens, exposure is controlled by OTF method. If the light changes during exposure, the actual shutter speed may be slightly different than displayed.

Spot Metering—The silicon light sensor can be switched electronically so it views only the center part of the auxiliary mirror and thereby does spot metering, as shown in Figure 8-3. With spot metering, exposure measurement is done before the shutter opens. OTF exposure control is not used.

If the camera is on manual, the spot measurement is displayed and used as a guide to set the exposure controls manually.

On automatic, the camera calculates and

displays the shutter speed to be used, based on the spot measurement in advance of exposure. The light sensor in the camera body does not function during exposure.

On programmed automatic, the camera calculates and sets both shutter speed and aperture, based on the spot measurement in advance of exposure. The shutter speed to be used is displayed. The calculated settings are used to make the exposure. The light sensor does not function during exposure.

HOW THE CAMERA SETS EXPOSURE

Olympus SLR cameras have a built-in

light meter that measures light from the scene after it has passed through the lens. The output of the light meter is fed into a built-in calculator that figures the exposure.

To do this, the calculator must know two more things: lens aperture and film speed. It knows lens aperture because of the mechanical coupling between lens and camera. It knows film speed because you set the value on the camera film-speed dial or it is done automatically. With that information, the built-in calculator figures exposure and shows you the result in the viewfinder display.

With non-automatic operation, the viewfinder display tells you if the exposure setting you make manually is too little, correct,

or too much for an average scene. With non-automatic operation, you should consider the viewfinder display as a *recommendation* made by the exposure meter in the camera. You can follow it or not, as you choose, because you make all exposure settings yourself, manually.

With automatic operation, the viewfinder display shows you what the camera intends to do. It shows the shutter speed the camera will use. The camera "thinks" this shutter speed will work fine with the aperture you selected and will give correct exposure of an average scene.

If you don't agree with what the camera plans to do, you must intercede. I'll tell you how to do that later in this chapter.

Cameras with automatic exposure control usually make good photos when the scene or subject has approximately equal areas of light and dark so they average out to a medium tone—

but no metering system can cope with a back-lit subject without some help from the camera operator.

49

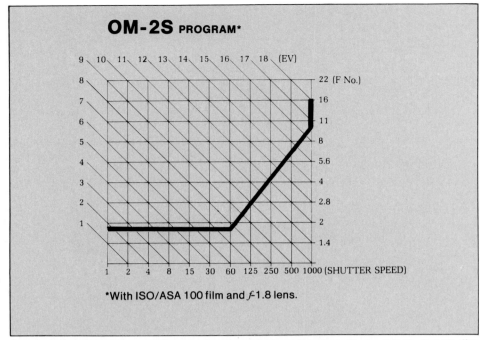

OM-2S PROGRAM*

*With ISO/ASA 100 film and *f*-1.8 lens.

This graph is for ISO/ASA 100 film speed and an *f*-1.8 lens. Starting at lower left, the light is dim enough to require slowest shutter speed and largest aperture. As the light becomes brighter, the lens is held wide open and shutter speed becomes faster. When shutter speed is 1/60, increasing scene brightness causes aperture to close gradually and shutter speed to increase gradually, at approximately equal rates. When the fastest shutter speed is reached, aperture continues to close until minimum aperture is reached.

weighted metering begins with the mirror down. Aperture is set manually and the approximate shutter speed is displayed. When the shutter opens, metering is switched to OTF. The OTF system closes the shutter when sufficient exposure has been measured.

On manual, spot metering is performed with the mirror down using the method of Figure 8-3. The camera-recommended shutter shutter speed is displayed. Aperture and shutter speeds are set manually. Exposure is made at the set values. There is no metering during exposure.

Olympus T-series flash in the TTL auto mode is controlled automatically by the OTF system.

OM-3 METERING

The OM-3 is manual only using either center-weighted or spot metering as shown in Figures 8-2 and 8-3. In either mode, metering is performed before exposure. Shutter speed is displayed in the viewfinder by an electronic bar graph below the image. Displays are shown in Chapter 16.

Several spot readings can be made in the scene and averaged as discussed later in this chapter. This capability is called *Multi-Spot*

metering. Exposure controls are set manually and exposure is made at the set values.

The sensor in the camera body is not used for automatic OTF control of T-series flash.

OM-4 AND OM-4T METERING

These models have aperture-priority automatic and manual exposure modes. Center-weighted, multi-spot or spot metering before exposure can be used in either mode, as shown in Figures 8-2 and 8-3. Shutter speed is displayed in the viewfinder by an electronic bar graph below the image. Displays are shown in Chapter 16.

On aperture-priority auto with center-weighted metering, the camera switches to OTF metering when the shutter opens, as shown in Figure 8-1.

On aperture-priority auto with spot metering, exposure settings are memorized by the camera before exposure and used to make the exposure. OTF metering is not used.

On manual, with either type of metering, exposure controls are set manually before the exposure.

The sensor in the camera body is also used for automatic OTF control of T-series flash in the TTL auto mode and the F280 flash unit.

omPC METERING

The omPC uses the arrangement shown in Figure 8-2 to provide three exposure modes: progammed auto, aperture-priority auto and manual. In all three modes, metering begins before exposure, with the main mirror down. The selected shutter speed is displayed in the viewfinder.

For programmed and aperture-priority auto, metering switches to the OTF method when the mirror moves up. In the manual mode, the exposure is made by setting aperture and shutter-speed manually before exposure.

Two metering patterns are available in any of the three exposure modes. The light sensor in the bottom of the camera reads two zones separately: the center of the frame and the edges of the frame. For an average scene, with uniform illumination, these two readings are combined to provide conventional center-weighted metering.

The second metering pattern is called ESP (Electro-Sensitive Pattern). Its purpose is to adjust exposure for non-average scenes, such as a person silhouetted against a bright background. The light readings in the two zones are analyzed in the camera to determine if the scene illumination is average or non-average. If non-average, the camera adjusts exposure as needed. The exposure adjustment is discussed later in this chapter.

The OTF light sensor is also used to control flash in the TTL auto mode.

om77AF METERING

The OM77AF is an autofocus camera using programmed automatic exposure with AF lenses. With a Zuiko lens installed, it becomes a non-autofocus camera with aperture-preferred automatic exposure.

The autofocus system uses a semi-transparent main mirror with a small auxiliary submirror behind it. When the main mirror is down, light from the scene is reflected downward by the submirror to the electronic focus detector, which is in the bottom of the camera.

Exposure metering is provided by two light sensors. A sensor in the viewfinder housing measures light before exposure, with the mirror down, and provides a preliminary indication of the shutter speed and aperture settings.

When the mirror moves up to make the exposure, another sensor—in the camera body—takes over and controls exposure using the OTF method. Because the autofocus sensor is in the bottom of the camera, the OTF sensor is placed in the side of the mirror box, looking backward toward the film surface.

The OTF sensor is also used to control flash exposure in the TTL auto mode.

RECIPROCITY FAILURE

So far, this book has encouraged you to believe that you can shoot at any shutter speed you choose, adjusting aperture for correct exposure. That is true when photographing in daylight and in well-lit interiors. With a normal amount of light on the scene, the Reciprocity Law applies.

People once thought the law applied to all values of light and time, but there are exceptions when the light is either unusually bright or unusually dim. These exceptions are called *reciprocity-law failure,* or *reciprocity failure.*

The problem lies in the nature of film, not in the camera. It is always due to light that is brighter or dimmer than the design range of the film emulsion. Even though reciprocity failure is caused by the amount of light, the best clue is shutter speed. Unusually long exposure times mean the light is dim. Unusually fast shutter speeds mean there is a lot of light. You are unlikely to encounter bright-light reciprocity failure.

As a general rule for most amateur films, if the shutter speed is faster than 1/1000, or slower than 1/10 second, consider the possibility of reciprocity failure. Consult the film data sheet. Some films have a more limited "normal" range of exposure times.

The basic effect of reciprocity failure is always *less actual exposure* on the film than you expect. Therefore, the basic correction is to give more exposure by using larger aperture, more time, or both.

For example, if an exposure meter or an exposure calculation suggests using *f*-4 at 4 seconds, the film manufacturer may say to give one step more exposure to compensate for reciprocity failure. Use *f*-2.8 if it is available on the lens, or shoot at 8 seconds.

For dim-light reciprocity failure, the best correction is larger aperture rather than longer time. If you increase exposure time, reciprocity failure affects the added time interval also and it won't produce quite as much added exposure as you expect. Use larger aperture if available. If not, use longer time.

With b&w film, the film data sheet may call for more exposure and also a change in the development procedure. With color film, reciprocity failure can cause both underexposure and a color change on the film. The compensations may be more exposure, use of a color filter on the lens, and a change in development.

Olympus cameras will meter in dim light and make exposures that are well into reciprocity failure for most films. Making pictures in dim light is challenging and enjoyable, provided you remember to compensate for reciprocity failure.

There are four ways: Best is to use the film

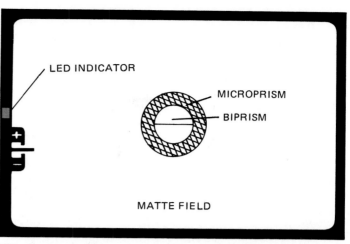

This is the viewfinder of an OM-1N—a manual, non-automatic camera. After composing and focusing, set the exposure controls to center the moving needle at the left. As you change aperture or shutter speed, the needle will move toward + for overexposure, − for underexposure. The red LED indicator above the exposure display is used with Olympus T-series flash units.

manufacturer's data. If you don't have data, make tests to find the best correction. If you don't have time to make tests, you can shoot several exposures bracketing in the direction of increased exposure, hoping one will be right. The poorest way is to guess, but even that is better than making no correction at all.

THE OM-1N METERING SYSTEM

Metering is done by two CdS sensors located near the viewfinder eyepiece, acting as one sensor. The sensor measures brightness of the focusing screen using a center-weighted pattern.

The Om-1N is non-automatic. The viewfinder display is a moving-needle type. It indicates correct exposure when you have set the camera controls the way the meter "thinks" you should, as shown in the accompanying illustration. By not centering the needle in the display, you can give more or less exposure than the camera meter recommends.

OM-2S PROGRAM METERING

The OM-2S has three exposure modes: programmed auto, aperture-priority auto and manual.

On programmed automatic, center-

The position of the meter needle in an OM-1N tells you if you are overexposing or underexposing—which you sometimes do on purpose.

weighted metering begins with the mirror down as shown in Figure 8-2. This measurement allows the camera to select both aperture and shutter speed according to a built-in program—discussed later in this chapter.

The selected shutter speed is displayed by an electronic "bar graph" at the left of the viewfinder image area. Displays for this camera are shown in Chapter 16.

When the shutter opens, metering is switched to OTF as shown in Figure 8-1. The OTF system closes the shutter when sufficient exposure has been measured.

On aperture-priority automatic, center-

Most scenes don't have large areas that are extremely bright or extremely dark. They don't have a lot of sky in view or an unusually bright foreground. These are average scenes. You can shoot them at the exposure settings recommended by the meter in your camera.

This is not an average scene. More than half of the frame is sky. This chapter tells you how to expose for non-average scenes.

AN AVERAGE SCENE

By measurement of many typical scenes, it has been found that most outdoor scenes and many shots in a man-made environment have the same average amount of light coming from the entire scene. Some parts are brighter and some are darker but they average out, or *integrate,* to the amount of light that would come from a certain shade of gray. This shade is called 18% gray because it reflects 18% of the light that falls on it.

Printed cards that are 18% gray on one side and 90% white on the other are sold at camera shops. The inside covers of my book *SLR Photographer's Handbook* are printed approximately 18% gray so you can use them as a metering aid.

The idea is that you can meter on an average scene, or meter on an 18% gray card in the same light, and the exposure meter in your camera will give the same settings.

HOW TO INTERPRET EXPOSURE READINGS

If you decide to go around photographing 18% gray cards, I guarantee every exposure will be a whopping success. It's built into the system. The exposure called for by the film-speed rating will put an 18% gray card right in the middle of the density scale of the film.

It takes good photographic judgment to look at a real-world scene and decide if it will average out to 18% gray. If so, you can shoot it just as you would a gray card—follow the advice of the camera exposure meter or let the camera set exposure automatically.

Most outdoor scenes have sky, people, dirt, rocks, foliage and maybe a distant building. This is average. If your scene is

When metering on a gray card, be sure the card fills the metering area in the viewfinder.

Light skin reflects about one step more light than 18% gray. Take the reading, then set the camera to give one step more exposure.

mainly sky, that is not an average scene but the exposure meter in your camera doesn't know the difference.

In the following discussion, remember that a camera on manual operation will suggest an exposure. You can follow the camera's recommendation or use any other exposure setting because you have manual control of the camera. A camera on automatic will control the exposure, using the settings it "thinks" are correct.

If you don't want to use the settings the automatic camera "intends" to make, you must override the camera and control exposure yourself.

Exposure meters are manufactured to "think" that every scene they measure is an average scene that reflects 18% of the light. The exposure meter, unless you override it

with your own good judgment, will place the average brightness or tone of every scene at the middle density of the film. If the scene is mainly sky, sky will become a middle tone on the print or slide and faces of people against the sky will be too dark.

You can believe your exposure meter or trust your automatic camera only when it is looking at an average scene. If you shoot a bird on a snow bank, the camera will think the snow bank is an average scene in very bright light. It will recommend less exposure so the white snow appears gray on the negative. If faithfully printed, it will also appear gray on the print.

If you shoot a coin on black velvet, the camera will think the scene is in very poor light and open up the lens until the black velvet registers middle gray on the film.

Many things around you have reflectances that are surprisingly close to 18%. With your camera exposure meter and a gray card for reference, you'll discover that you can use grass, old paving, brown dirt, foliage and a lot of other things as a substitute metering surface.

The clue is the amount and brightness of the background. If the subject is small and the background large, worry. If the background is significantly brighter than middle gray, you know the camera exposure meter will want to reduce exposure on account of the bright background and underexpose your subject. You have to give more exposure than the exposure meter will suggest.

If the background is significantly darker than average and your main interest is the subject against that background, you have to give less exposure than the meter suggests to avoid overexposing the subject.

Another situation where an exposure meter may give an unsatisfactory reading is when everything in the scene is unusually light or dark. If you photograph a marshmallow on a white tablecloth, the exposure meter will suggest camera settings that make everything middle gray on the negative. If printed that way, the result is a gray marshmallow on a gray tablecloth—probably not your intention.

To make both marshmallow and cloth appear white on the negative, you need about two more steps of exposure than the meter suggests. Similarly, a dark subject against a dark background will both be changed to a medium gray by the unthinking exposure meter if you allow it to happen. For realism, you probably want both subject and background to appear dark on the print. You probably need one or two steps less than the meter will suggest.

WHEN TO WORRY ABOUT BACKGROUND

The only time you need to worry about

I spent a pleasant hour, one sunny afternoon in Wisconsin, photographing this tree from several angles with several different lenses. I set exposure by metering on grass in full sunlight.

background affecting exposure-meter readings is when there is a lot of it *in the metering area* and the background is brighter or darker than middle gray.

Center-Weighted System—As a rule of thumb for center-weighted metering, if your subject is centered and fills one-third or more of the focusing screen, disregard background.

If the subject of interest is small compared to the metering area, increase exposure over the meter recommendation if the background is bright. Decrease if the background is dark—because the meter reading is being affected by background. The usual limits are:
• 2 steps more exposure if the background is white.
• 2 steps less exposure if the background is black.

For intermediate background tones, use intermediate settings.

ESP Metering—The disadvantage of center-weighted metering is that you have to mentally analyze each scene to decide if it is average or not. If not, you must decide how much to increase or decrease exposure and then apply that correction.

The ESP metering system, used in the OMPC, measures the background brightness separately from the brightness at the center of the frame. It calculates the necessary exposure adjustment and applies it automatically.

SPOT METERING

Spot metering measures light in a small spot and ignores the rest of the scene. In cameras with this capability—the OM-3, OM-4 and OM-4T—the spot-metering area is the center of the focusing screen, the same area occupied by the circular focusing aids.

The advantage of spot metering is that you can exclude unusually light or dark backgrounds. Place the metering spot over the subject to be measured and press a button on the camera labeled SPOT.

The camera measures the brightness of the designated spot in the scene, calculates exposure for that brightness, and holds the exposure setting for two minutes or until you make the exposure. You can recompose the scene as you wish and press the shutter button to make the exposure.

AVERAGING EXPOSURE MEASUREMENTS

Some exposure problems are conveniently solved by taking more than one measurement and averaging the results. Suppose you are photographing a scene with a light area and a dark area. You want to set exposure to preserve details in both areas.

Meter both areas. Suppose the light area measures 1/500 at *f*-4 and the dark area measures 1/30 at *f*-4. Shoot at a shutter speed of 1/125, which is halfway between the two on the shutter-speed scale—two steps slower than 1/500 and two steps faster than 1/30.

MULTI-SPOT METERING

The OM-3, OM-4 and OM-4T provide an easy way to average spot exposure readings. The camera has a SPOT button. When pressed, it switches the camera to spot metering, makes a spot measurement in the circular area at the center of the viewfinder, and memorizes that exposure setting. The shutter speed for that reading is marked on the display by a dot adjacent to the shutter-speed scale. The shutter speed to be used is shown by the bar graph.

If you then point the camera at different parts of the scene, another dot moves along the shutter-speed scale in the viewfinder to show the spot measurement of whatever is in the circle at the center of the viewfinder.

To take a second spot reading, press the SPOT button again while holding the measuring spot over the part of the scene that you wish to measure. A second, fixed dot appears adjacent to the shutter-speed scale representing the second spot reading. The shutter speed to be used is shown by the bar graph. It will be between the two spot readings, at the average value.

By the same method, you can take and average up to eight spot readings. Each will be shown by a dot adjacent to the shutter-speed scale. The bar graph will show the average shutter speed of those spot measurements, which is the shutter speed to be used.

If you make a ninth spot measurement, its value replaces the first one made, and so forth. The camera averages the *last* eight spot measurements, if you make that many.

The average is held in memory for 120 seconds or until you press the shutter button to make the exposure. If you decide to start over without making the shot, there is a CLEAR control that erases the spot-exposure memory.

PROGRAMMED AUTOMATIC

The OM-2SPROGRAM camera sets both aperture and shutter speed automatically in the program mode, using center-weighted metering. Based on metering before exposure, the camera sets aperture and displays a shutter speed according to a built-in program shown in an accompanying graph.

When the shutter opens, exposure is controlled by the OTF method using the sensor in the bottom of the camera. If the light changes during exposure, the actual shutter speed may be slightly different than that displayed.

SUBSTITUTE METERING

Here is a way to solve some difficult exposure problems. Suppose you are shooting a scene with no middle tone. You can sidestep the problem by placing an 18% gray card in the scene, so it receives the same amount of light as the rest of the scene. Meter on the card, and set exposure manually. Remove the card and make the exposure.

If it is not convenient to place the 18% gray card at the scene—perhaps because the scene is on the other side of a chasm or river—you can meter on the card anywhere as long as it is in the same light as the scene.

Angle the card so it faces a point between camera and main light source and so the camera does not see glare reflected from the surface of the card.

Metering on a substitute surface instead of the scene itself is called *substitute metering*.

Many photographers carry an 18% gray card for this purpose.

In dim light, a gray card may not reflect enough light to allow metering. Some gray cards are 90% white on the reverse side and white paper is about the same. If you meter on 90% white instead of 18% gray, the white card will reflect five times as much light into the exposure meter as the gray card would, because 90%/18% = 5.

Because the exposure meter assumes everything out there is 18% gray, it attributes the high value of light to brighter illumination rather than more reflectance of the surface. Therefore it will recommend an exposure only 1/5 as much as it would if you were actually metering on 18% gray. Because you know that, you compensate by increasing exposure by 5 times over the exposure metering reading.

To make the correction, multiply the indicated exposure time by 5 and select the nearest standard number. If the exposure meter says shoot at 1/60 second, you will want to shoot at 5/60 second, which reduces to 1/12 second. The nearest standard speed is 1/15 second.

You can also correct by changing aperture. Opening up by 2 steps is an increase of 4 times, which is often close enough. Opening up aperture by 2-1/2 steps increases exposure 5.6 times, which is closer. The click stops or detents between the numbered settings of the aperture ring are half-stops. There is no exact setting of the aperture ring that gives a 5-times exposure increase. You can guess at it by setting between 2 steps and 2-1/2 steps increase but you normally don't need such precision.

A handy substitute metering surface is the palm of your hand. You should check your own palm but light skin typically reflects about one step more than an 18% gray card. If so, you can hold your palm in front of the camera—in the same light as your subject or scene—meter on your palm and then open up one more step. If your palm reflects only a half-step more, obviously that's how much to open before shooting.

You will find that dirt, grass, weeds, foliage and other common things have a surprisingly uniform reflectance and often it is the same as an 18% gray card. Spend some time measuring common surfaces around you and you can learn to use them in a hurry as substitute metering surfaces to set your camera for a quick shot of some unusual scene such as a flying saucer passing by. Another advantage of using your exposure meter to measure the reflectance of common objects is that it helps you learn to distinguish non-average scenes from average scenes.

You can use substitute metering with any camera with manual control of exposure set-

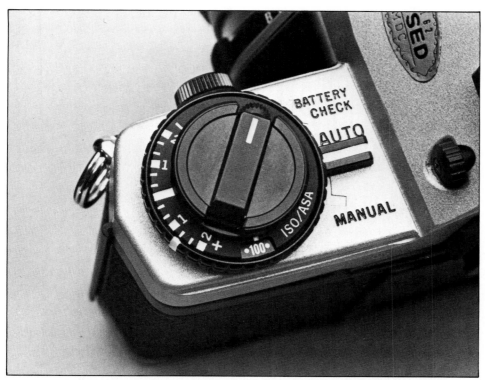

The Film-Speed/Exposure-Compensation Dial on this OM-4T surrounds the Rewind Knob. To set film speed, lift and turn the outer ring to place the desired film-speed number in the window. This control is set to 100.

The exposure-compensation scale is at the left. It reads from −2 at the top to +2 at the bottom, with zero in the middle. The small marks are 1/3 steps. To use exposure compensation, turn the outer ring without lifting it. Place the index mark on the outer ring opposite the desired amount of exposure compensation. The control shown here is set to increase exposure by one and one-third steps.

tings. To use substitute metering with an Olympus camera on automatic requires taking charge of the camera as described in the following section.

HOW TO TAKE CHARGE OF AN AUTOMATIC CAMERA

When an Olympus camera operates automatically, it chooses shutter speed to get what it "thinks" is correct exposure based on the meter reading. It can be fooled by non-average scenes just like any other meter and camera can be fooled. Here are some ways you can take charge and prevent the camera from making a mistake.

Take It Off Automatic—Before making an exposure, notice the exposure settings that the camera would use on automatic—shutter speed in the viewfinder and the lens aperture setting on the lens. If you don't want to use those settings, take the camera off automatic and use it on manual. Make whatever settings are appropriate for the scene and your purpose.

Change the Film-Speed Setting—Film speed is a message from the film manufacturer to the exposure calculator in your camera, requesting a certain amount of exposure.

As you remember, doubling ISO/ASA film speed means the film needs half as much exposure—and the reverse.

With some cameras, you don't have to use the ISO/ASA number as an input to the camera—you can use whatever you choose. If you dial in a higher or lower speed number, then you are not using the ISO/ASA number but you are using your own *exposure index* to control the camera.

If you have selected 32 at the camera when the film is ISO/ASA 64, the camera is set to give one step more exposure than it would if you dialed in 64.

If you change the film-speed setting to adjust exposure for one scene, be sure to change it back again after shooting. Otherwise, the remainder of the roll may be incorrectly exposed.

Use Exposure Compensation—Most Olympus automatic cameras have a special control to give more or less exposure *without* taking the camera off automatic and *without* changing the setting of the film-speed control. It is the Exposure-Compensation Dial. As you can see in the accompanying photo, it lets you give more or less exposure than the camera normally would on automatic. The adjustment range is from +2 to −2 exposure steps in increments of one-third step.

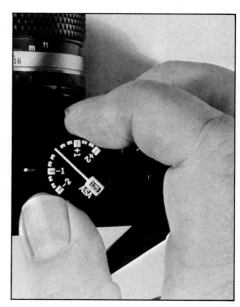

This camera is set for ASA 125 and an exposure compensation of −1 step. It will give the scene one step less exposure than it would if the Exposure-Compensation Dial were set to zero.

EV NUMBERS & EQUIVALENT EXPOSURE SETTINGS

EV	4 min.	2 min.	1 min.	30 sec.	15	8	4	2	1	1/2	1/4	1/8	1/15	1/30	1/60	1/125	1/250	1/500	1/1000	1/2000
															SHUTTER SPEED					
-8	ƒ-1																			
-7	1.4	ƒ-1																		
-6	2	1.4	ƒ-1																	
-5	2.8	2	1.4	ƒ-1																
-4	4	2.8	2	1.4	ƒ-1															
-3	5.6	4	2.8	2	1.4	ƒ-1														
-2	8	5.6	4	2.8	2	1.4	ƒ-1													
-1	11	8	5.6	4	2.8	2	1.4	ƒ-1												
0	16	11	8	5.6	4	2.8	2	1.4	ƒ-1											
1	22	16	11	8	5.6	4	2.8	2	1.4	ƒ-1										
2	32	22	16	11	8	5.6	4	2.8	2	1.4	ƒ-1									
3	45	32	22	16	11	8	5.6	4	2.8	2	1.4	ƒ-1								
4	64	45	32	22	16	11	8	5.6	4	2.8	2	1.4	ƒ-1							
5		64	45	32	22	16	11	8	5.6	4	2.8	2	1.4	ƒ-1						
6			64	45	32	22	16	11	8	5.6	4	2.8	2	1.4	ƒ-1					
7				64	45	32	22	16	11	8	5.6	4	2.8	2	1.4	ƒ-1				
8					64	45	32	22	16	11	8	5.6	4	2.8	2	1.4	ƒ-1			
9						64	45	32	22	16	11	8	5.6	4	2.8	2	1.4	ƒ-1		
10							64	45	32	22	16	11	8	5.6	4	2.8	2	1.4	ƒ-1	
11								64	45	32	22	16	11	8	5.6	4	2.8	2	1.4	ƒ-1
12									64	45	32	22	16	11	8	5.6	4	2.8	2	1.4
13										64	45	32	22	16	11	8	5.6	4	2.8	2
14											64	45	32	22	16	11	8	5.6	4	2.8
15												64	45	32	22	16	11	8	5.6	4
16													64	45	32	22	16	11	8	5.6
17														64	45	32	22	16	11	8
18															64	45	32	22	16	11
19																64	45	32	22	16
20																	64	45	32	22
21																		64	45	32

What this actually does inside the camera is change the film-speed setting internally.

On some models, this control is adjacent to the shutter button. On others, it surrounds the Rewind Knob. In either case, operation is the same.

Suppose you meter on a gray card or other average substitute surface and the reading is ƒ-11 at 1/125. Then you meter on the scene and the reading is ƒ-11 at 1/60. This tells you that the scene is not average because average scenes meter the same as a gray card. The camera meter would give one step too much exposure. If you allow the camera to do that, the subject will be overexposed.

The exposure settings you want to use are those measured on the substitute surface—ƒ-11 at 1/125. You can force the camera to use those settings by turning the Exposure-Compensation Dial until the viewfinder display indicates a shutter speed of 1/125. In this example, you would turn the dial to −1.

Because this control actually changes film speed, it changes the meter reading on both automatic and manual. Be sure to return the Exposure-Compensation Dial to zero when you don't want the exposure altered.

AE Lock—The OM77AF camera has an AE (Automatic Exposure) Lock button. With an AF lens, this camera has only programmed automatic exposure. As you point the camera toward different brightnesses in the scene, the exposure-control settings change accordingly.

With non-average scenes, the AE Lock makes it easy to perform substitute metering. While metering on the substitute surface, press in the AE Lock button. Then recompose the scene as you wish and shoot. Exposure will not change as long as you hold down the AE Lock button, even if you make a series of exposures.

EV NUMBERS

To simplify identification of an *amount* of exposure, a number has been assigned to each value. These numbers are called *exposure-value* (EV) numbers. For some purposes they are convenient. In the accompanying EV Table, each amount of exposure is represented by a single EV number—shown at the left—rather than the whole assortment of combinations of aperture and shutter speed that will yield the same amount of exposure. The body of the table shows the equivalent control settings. For example, EV 7 can be ƒ-64 at 30 seconds, or ƒ-45 at 15 seconds, or ƒ-32 at 8 seconds, and so forth.

EV numbers do not completely specify amount of exposure, because an EV number is determined only by shutter speed and aperture size. Exposure is also influenced by scene brightness and film speed.

USING EV NUMBERS

The simplest application was discussed in the preceding section—using an EV number to represent all pairs of shutter-speed and aperture settings that provide the same exposure.

EV numbers are also used to specify the light-measuring range of camera exposure meters, the range of scene brightnesses over which an autofocus system can operate, and similar purposes.

In these applications, an EV number represents a certain scene brightness or amount of light. For that purpose, an EV number alone is not sufficient. The EV specification must also include a film speed and a lens aperture. Typically, these are ISO/ASA 100 and *f*-1.4.

For example, the autofocus system of the OM77AF operates from EV 4 to EV 18 at ISO/ASA 100 and *f*-1.4. EV 4 is dim light and EV 18 is bright.

Here's how to interpret that specification. Look up EV 4 in the EV table. With an aperture of *f*-1.4, shutter speed must be 1/8 second. Assume a camera loaded with ISO/ASA 100 film with the aperture set at *f*-1.4 and a shutter speed of 1/8 second. The scene brightness that produces correct exposure in that camera is represented by EV 4.

To see how dark that actually is, use your camera and duplicate the situation just described. EV 4 is about as dark as twilight outdoors.

The autofocus system needs help at light levels below EV 4, which the OM77AF camera provides automatically. An AF Illuminator built into the camera casts a dark-red beam of light onto the subject while the autofocus system is focusing.

The exposure meter in the OM77AF has an operating range of EV 1 to EV 20 with ISO/ASA 100 and *f*-1.8—which is specified because an AF 50mm *f*-1.8 lens is normally supplied with that camera. If the light is darker than EV 1 or brighter than EV 20, the exposure meter is beyond its operating range and exposures may be incorrect.

A scene illuminated directly by sunlight has a brightness of about EV 15. Neither the exposure meter nor the autofocus system has a problem in bright light.

PROGRAM SHIFT

Figure 8-4 is a graph showing three program lines. The line labeled 2 is the standard program line used by the OM77AF with 50mm lenses.

That line shows every possible pair of exposure-control settings that can be used by the camera, when operating on the standard program—assuming ISO/ASA 100 and an *f*-1.8 lens.

The diagonal lines marked with EV num-

Figure 8-4/The point labeled 2 is on the standard program graph used by the OM77AF with a 50mm lens. At point 2, the camera is using *f*-4 and 1/250 second, which is EV 12, as indicated by the diagonal line passing through that point.

If you prefer smaller aperture or slower shutter speed, you can *shift* the program, using the PROGRAM SHIFT control on the camera. Suppose you shift to line 1. The program then uses two steps smaller aperture and two steps slower shutter speed—*f*-8 and 1/60 second—which is still EV 12.

The camera provides the same amount of exposure, but with different values of shutter speed and aperture. Shifting from line 2 to line 3 provides the same exposure with still larger aperture and faster shutter speed.

bers represent scene brightnesses. For example, the point labeled 2 is at the intersection of the standard program line and the EV 12 line. The exposure controls will be set at *f*-4 and 1/250 second. If the scene becomes less bright, such as EV 10, the intersection of the EV 10 line with the program line shows the new control settings: *f*-2.8 and 1/125 second.

When using programmed automatic exposure, you may want to use a different shutter speed or aperture than the values selected by the program. Changing to smaller aperture, for example, should increase depth of field. You want to change aperture size, but not exposure.

The OM77AF has a feature, called *program shift*, that allows you to change the control settings made by the program without changing the amount of exposure.

Using the PROGRAM SHIFT control on the camera, you can shift the program line upward and to the left, or downward and to the right, so different values of shutter speed and aperture are used to provide the same amount of exposure. Shifted program lines are shown in Figure 8-4.

WHEN TO WORRY ABOUT SCENE BRIGHTNESS RANGE

First, let me tell you when not to worry.

Operate the PROGRAM SHIFT control on the OM 77AF with your right thumb. In the programmed auto mode, move the control to the right to select faster shutter speed with a correspondingly larger aperture. Move the control to the left for slower shutter speed and smaller aperture.

All film manufactured for general use will record any scene under uniform illumination—unless the scene itself includes bright light sources. If the light on the scene is the same everywhere, or nearly so, any film will record the scene satisfactorily.

When a scene is uniformly illuminated, light reflected toward the camera is governed

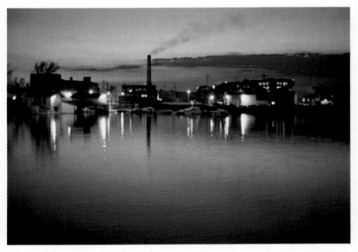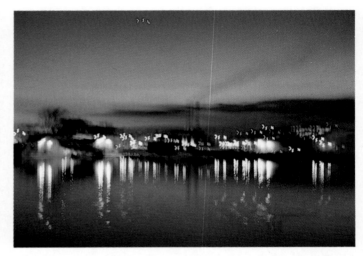

Using ASA 200 color-slide film, I made a "straight" shot of this water scene. Then I made a multiple exposure of four shots on the same frame, hand-held, as you can see by the four squiggly moons. Because of image overlap in the multiple exposure, I multiplied the ASA film-speed number by 4 and set the camera film-speed dial to 800. A handy way to remember how to adjust the film-speed setting is: When you are making *multiple* exposures, *multiply* the film-speed number.

only by the reflectance of the different surfaces in the scene. A very light object may reflect about 90% of the light. A very dark object may reflect 3% or 4% of the light. But this is a brightness range of only about 5 exposure steps. Most films can handle that. Just put the middle tone of the scene on the middle density of the film and you should get a satisfactory picture.

The brightness-range problem occurs when part of the scene is in light and part in shade. If you go exploring outdoors with the light meter in your camera, you'll find lots of shaded areas where the amount of light is 3 or 4 steps less than direct sunlight.

If the light across a scene changes by 4 steps because part of it is in shade, you can normally figure that the scene brightness range is increased.

This will happen when the lowest-reflectance part of the scene is in shadow, because then it will reflect 4 steps less light than it would if the scene were uniformly illuminated.

A scene with a reflectance range that uses 5 exposure steps, illuminated by light and shadow with a 4-step difference, requires 9 exposure steps on film.

No commonly available film can do that. You can decide either to sacrifice picture detail in highlights or shadows because you can't get both.

To preserve detail in the highlights, meter on a medium tone in the brightly lit part of the scene. If necessary, put a substitute-metering surface in the light. This gives a full range of tones in the brightly lit part of the scene and the lighter tones in shadow.

To preserve detail in the shadows, meter on a medium tone in the shade.

To make a compromise between losing detail in highlight and shadows, average the highlight and shadow readings as described earlier.

With experience, you learn to judge scenes for brightness range. Sometimes you can get fooled. If you use your camera meter to measure the brightest part and the darkest part where you want to record surface texture or details, you won't be fooled. Count the number of steps difference between these two exposure readings and that's the brightness range you must cope with.

As a rule of thumb, here are the maximum brightness ranges you should shoot with various film types:

B&W film: 7 exposure steps.
Color-slide film: 5 steps.
Color-negative film: 6 steps.

When using this rule, it's important to remember to measure only surfaces where detail is important to the picture. If a white shirt or a white painted wall is in the picture, surface details may not be necessary in these.

DOUBLE AND MULTIPLE EXPOSURES

If a subject against a dark background is photographed with normal exposure, the film frame can be considered as two distinct areas. The subject area is normally exposed. The dark background caused little or no exposure on the film.

A second subject against the dark background can be photographed on the same frame. You can use normal exposure if the areas on the film occupied by the two subjects do not overlap.

Now the film frame can be considered as three areas. One for each subject and some still unexposed or underexposed background. Obviously a third subject could be placed in the unused dark background area and normal exposure could be given to the third subject.

The rule for multiple exposures against a dark background where the subjects *do not overlap* is to give normal exposure to each shot.

When subjects do overlap, the situation is different. Normal exposure of two subjects occupying the same area on film amounts to twice as much exposure as that area needs—one step too much. Three overlapping exposures give three times as much total exposure as the film needs, and so forth.

With overlapping subjects, the rule is to give the correct *total* amount of exposure to

the film, allowing each individual shot to contribute only a part of the total. If there are two overlapping images, each should receive one-half the normal exposure. Three overlapping images should each receive one-third the normal exposure, and so forth.

This is done by dividing the normal exposure for each shot by the total number of exposures to be made. This does not require each exposure to be the same.

Measure exposure for each subject, divide by the number of exposures to be made, and give the resulting amount—whether or not it is the same as some other subject requires.

This procedure tends to give normal exposure to the combined image on the film, but each individual image is less bright according to how many shots there are. If you make more than three exposures, each individual image becomes pretty dim, but the effect is sometimes pleasing anyway. Also, even though the background is dark, it will get lighter and lighter with successive exposures.

RULES FOR MULTIPLE EXPOSURES

Dark uncluttered backgrounds are preferable.

The background gets lighter with each exposure.

If there is no image overlap, give normal exposure to each shot.

If there is image overlap, divide the normal exposure for each shot by the total number of shots to be made.

A handy way to adjust exposure is: Multiply film speed by the planned number of shots and set the nearest available speed on the camera film-speed dial. You can use the Exposure-Compensation Dial if it has enough range of adjustment. Then use the camera normally for each shot. Don't forget to reset film speed afterwards.

You can also adjust exposure by changing shutter speed or aperture.

OPERATING THE CAMERA FOR MULTIPLE EXPOSURES

All OM cameras except the OM77AF use the same procedure. The OM77AF doesn't allow multiple exposures.

Make the first exposure in the normal way, except that you adjust exposure according to the number of shots you intend to make on the same frame. Then turn the Rewind Knob clockwise gently until you feel slight resistance. This is to take out any slack in the film. Hold the knob in that position throughout the remainder of the procedure.

While holding the Rewind Knob, operate the Rewind-Release control. Hold in that position for the remainder of this procedure. Then operate the Film-Advance Lever smoothly through one complete stroke and allow the lever to return to its normal position. This "winds up" the camera for the next exposure but does not advance the film because you operated the Rewind-Release.

Make the next exposure on the same frame.

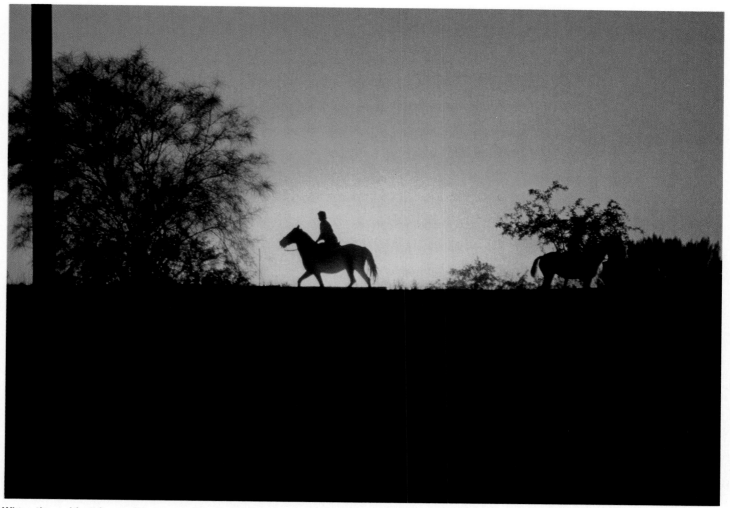

When the subject is small compared to the background, the camera exposure-measuring system will give an exposure that records the background as a medium tone. If the background is bright, this causes the subject to appear in silhouette.

For each additional exposure on the same frame, operate the Film-Advance Lever through a full stroke while holding both Rewind Knob and Rewind-Release so neither can move.

When the desired number of exposures has been made, release the Rewind Knob and Rewind-Release. Then advance the next frame of film using the Film-Advance Lever normally.

Put a lens cap over the lens and depress the shutter button. This makes a "blank" exposure on the frame following the multiple exposures. The film may move slightly to the left or right during the multiple-exposure procedure. The blank frame is to guard against overlap of the multiple-exposed frame and the following frame.

There is also some chance of overlap with the preceding frame. Therefore, a blank frame both before and after a multiple exposure is good insurance. Remove the lens cap, advance the film again and use the camera normally for the next frame.

If the camera is on automatic, it will hold the shutter open for a relatively long time when you make the blank shot with a lens cap in place. To avoid this, set to a fast manual shutter speed.

What the Frame Counter Does—The frame counter in a non-autofocus OM camera counts strokes of the Film-Advance Lever rather than actual frames of film as they go by. Therefore, the counter advances one number for each multiple exposure, even though the film isn't moving through the camera at all. If you make several multiple exposures in a roll, the counter will indicate that you are out of film when you have some exposures left. It will count past frame 36 to a dot that represents frame 37 and then to the symbol E, which means empty.

After that, you can continue advancing film and shooting frames until you reach the end of the roll, but the frame counter remains on E. You will know when you have reached the end of the roll because you will feel resistance when you attempt to advance the film. Don't force it, hoping to get another frame. Remember to rewind immediately.

SUMMARY OF METERING TECHNIQUES

Center-weighted metering is less sensitive around the edges where the background usually lives. It helps you compensate for unusually bright or dark backgrounds.

The camera metering system tends to make the average tone it sees into middle gray on the print. With color film, it will make the average brightness it sees into the middle brightness of print or slide, no matter what color it is.

If you meter on caucasian skin, you should probably use one step more exposure. Maybe half a step.

When using substitute metering, the tone you show to the meter will record as a middle tone on the film. An 18% gray card is just right, or anything else with 18% reflectance. There are many common things you can use. If you meter on a surface with reflectance different than 18%, correct the reading. You can always meter at a different aperture, film speed, or shutter speed, and then count steps to find your way back.

Film speed is an exposure control only if the camera ends up set for the exposure requested by that speed.

A good exposure usually results if you meter the brightest and darkest areas of interest in the frame and then set to the average of the two exposures that result. Average by counting steps.

With b&w or color-negative film, the exposure range the film can accept is often wider than the brightness range of the scene. If so, you can miss exposure a step or two without losing picture detail either into white or black. Overall scene brightness will be wrong on the negative but can be corrected on the print, and usually is. When the exposure range of the film is greater than the brightness range of the scene, we say there is some *latitude*. Latitude is not a property of film alone. It results from a combination of film and scene.

Everybody says color-slide film must be properly exposed within a half step.

The main reason for this is to get correct scene brightness when you project the slide. A moderately underexposed slide will appear too dark when projected. If you could increase the brightness of the projector lamp, the slide would look just fine.

But you can't do that, so you must control exposure closely with color slides. Metering on a gray card in the same light does the job or any other thoughtful metering technique.

VIEWING AND FOCUSING

Use your left hand to cradle the lens, operate lens controls and turn the Shutter-Speed Ring. Operate camera-body controls with your right hand. Take a braced stance, pull in your elbows and don't breathe at the moment of exposure.

When the long dimension of the frame is vertical, we call it a vertical-format picture. Ted DiSante demonstrates a good way to hold the camera. Brace the camera against your cheek and forehead, use your index finger to operate the shutter button.

Some photographers prefer this method of holding the camera for a vertical frame, operating the shutter button with the right thumb. Press the camera against nose, cheek and forehead.

In an SLR camera, one purpose of viewing the image from the lens is to determine if it is in good focus. This is done by placing a focusing screen above the mirror with the mirror angled so it intercepts light rays from the lens. Most focusing screens have an irregular surface called a *matte* surface.

Each small point on the matte surface receives light from the lens and becomes luminous. Each small point retransmits light rays toward the eye of the camera operator. What you see is the image on the screen whether it is in focus or not.

The camera is designed so the distance from the lens mount to the film plane is the same as the distance to the focusing screen by way of the mirror. Therefore, if the image is in focus on the screen, it will also be in focus on the film when the mirror is moved out of the way. When you make focus adjustments, you are using the focusing screen as a *substitute* for the surface of the film.

FOCUSING SCREEN BRIGHTNESS

A matte screen works fine as a surface on which to judge image focus. It will be brighter at the center than at the edges unless the brightness variation is corrected.

As shown in Figure 9-1, each point of the matte screen sends light rays in all possible directions. Away from the center of the screen, the brightest rays are not directed toward the observer's eye, so the screen appears dark around the edges.

More uniform focusing-screen brightness is obtained by use of a *field lens* that bends the rays from the edges of the screen toward center, as shown in Figure 9-2.

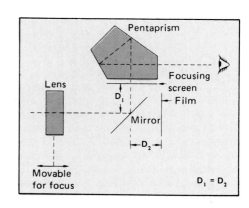

The distance from lens to focusing screen by way of the mirror is the same as the distance from lens to film when the mirror is raised. Judging focus by looking at the screen is equivalent to viewing the image at the film plane.

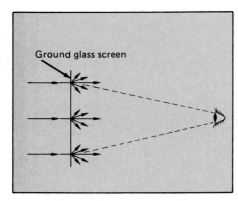

Figure 9-1/Most focusing screens have an irregular *matte* surface on one side, similar to ground glass. Without correction, much of the light around the edges of the screen goes out of the observer's line of vision. The screen appears dark around the edges even though the image is actually uniformly bright.

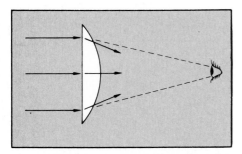

Figure 9-2/Correction of uneven focusing screen illumination is done by a *field lens* that bends the outside light rays toward the viewer's eye. This makes the image appear to have equal brightness from edge to edge.

Figure 9-3/To save weight and space, a converging lens can be "flattened" by dividing it into concentric rings and then making each ring thinner. Viewed from the side, it looks like this. From the front, you can sometimes see faint circles at the steps in the contour of the lens. This is a Fresnel lens.

Figure 9-4/A biprism is two wedges of glass, tapering in opposite directions. The outer edge is normally made into a circle so it fits a circular area in the center of the focusing screen.

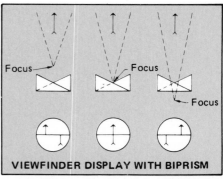

VIEWFINDER DISPLAY WITH BIPRISM

Figure 9-5/A biprism visually separates lines into two displaced segments when the image is not in focus at the focusing screen.

Figure 9-6/A microprism is an array of small pyramids whose intersections work like little biprisms. Microprisms work well to show good focus on any subject with surface details.

A conventional field lens is relatively thick and heavy. Changing the direction of light rays is done by the front and back surfaces of a lens. The glass inside does nothing. It is possible, for special applications, to remove glass from the inside of the lens without changing the contour or shape of the surfaces. Visualize the result, a Fresnel lens, by looking at Figure 9-3. The lens is divided into a series of concentric rings.

Each concentric ring is made thinner by removing material from the inside without changing the shape of either top or bottom surface. Vertical faces between the circular segments of the lens result from "collapsing" the segments.

SLR cameras use a Fresnel field lens to give uniform brightness across the focusing screen. The focusing screen in Olympus OM cameras is acrylic with a precision-molded Fresnel field lens on the bottom surface.

The rings are so tiny that it is usually impossible to see them except with a magnifier. They are usually imperceptible in the viewfinder image. Because their purpose is to correct the direction of light rays at the edge of the focusing screen, the rings are not needed in the center of the screen. This allows a "clear" space in the center for a focusing aid.

The image you see in the viewfinder is noticeably brighter with current Olympus OM cameras than older models. This is due to special multi-layer optical coating on the mirror and silvered reflecting surfaces on the pentaprism to minimize light loss. Also, the focusing screens themselves have very low light loss.

FOCUSING AIDS

Judging focus by looking at the image on a matte screen depends a lot on how good your eyesight is. Even with good vision it is inferior to other methods of indicating good focus. Two other methods, called *focusing aids*, are used.

Split Image—A split-image focusing aid is two small prisms with their faces angled in opposite directions to form a *biprism*—see Figure 9-4.

Each of the two prisms *refracts* or bends light rays that pass through it. If the image from the lens is brought to focus in front of or behind the focusing screen, rather than at the focusing screen, the two halves of the image appear misaligned as shown in Figure 9-5.

At best focus, the two halves of the image are not displaced in respect to each other.

The human eye is better at judging alignment of lines or edges in an image than judging focus by general appearance, so a split-image focusing aid is a good way to find focus.

For most effectiveness with vertical lines in the scene, the focusing aid should move the top half of a vertical line to the right or left and the bottom half in the other direction.

If the prisms are positioned in the camera to split vertical lines and the image consists mainly of horizontal lines, it will be difficult to see any indication of focus. If the split-image focusing aid is not oriented correctly

The focusing screen in some camera models is held in a metal frame that is hinged at the back. To change the focusing screen, pull forward on the tab (arrow) at the front edge of the focusing screen. The frame will pivot downward. Interchange screens as shown on the following page.

An assortment of interchangeable focusing screens is available for different purposes. Each comes in a plastic case with special tweezers and a cleaning brush. In the side of each case is a slot you can use to hold the screen that was removed from the camera while you are installing the new screen from the case. This is shown in the open case at the front of this photo.

to split the lines of whatever you are shooting, rotate the camera until it does. Focus, return the camera to the best orientation for the scene, and make the picture.

A biprism that splits lines doesn't work well when there aren't any lines in the picture. Examples are a plain surface or a mottled surface such as a mass of foliage.

Focusing-Aid Blackout—Imagine that your eye is looking out at the scene through the biprism and the lens. Your line of sight will be displaced in one direction by one prism and in the other direction by the other prism.

Even though the prism angles are small enough to allow you to look through the lens at large aperture, a smaller aperture may block your line of sight so you end up looking at the back side of the aperture diaphragm rather than out to the world beyond. This is common for focusing aids of this type. The biprism will black out on one side or the other.

The side that goes black depends on where your eye is. Move your head one way or the other and the opposite side of the biprism will go black. By changing the position of your eye, you alter your line of vision to favor one prism or the other.

The aperture size at which a biprism blacks out is determined by the prism angle.

Large angles give a very good focusing indication, but black out quickly as aperture size is reduced. Smaller prism angles don't give such a strong focusing indication but function without blackout at smaller apertures.

Microprism—Another type of focusing aid that is more useful on scenes without strong geometric lines is a *microprism,* shown in Figure 9-6.

It is an array of many small pyramids whose intersections work in a way similar to the biprism. Visually, the microprism displaces small segments of the image causing it to "break up" and have an overall fuzzy appearance. When focus is reached, the image seems to "snap" into focus.

A microprism is even more helpful when hand-holding the camera. If you jiggle the camera— on purpose or because you can't help it—the image will seem to scintillate when it is out of focus. Because operation of the microprism is similar to the biprism, it has the same problem with blackout at small apertures.

Combination Screen—Some screens offer a combination—a central biprism surrounded by a microprism ring. You can use the focusing aid best suited for the scene.

Choosing a Focusing Aid—A biprism works better where there are definite lines in the scene that can be split by the biprism. These include corners of buildings, furniture, window openings, tree trunks, the edge of a rock, the side of a face, and similar things. If the scene doesn't have strong lines, then a microprism works best.

The combination screen offers the best of both methods.

INTERCHANGEABLE FOCUSING SCREENS

The standard focusing screen for all current models is type 1-13, shown in the accompanying table. It has a central biprism surrounded by a microprism ring. The area outside of the microprism ring is matte— called a *matte field.*

All cameras discussed in this book, except the OMPC and OM77AF use interchangeable screens. Interchanging screens is easy. The method is shown in the accompanying photo.

For cameras with spot-metering capability, such as the OM-2S, OM-3 and OM-4, the outer diameter of the microprism ring of screen type 1-13 also designates the boundary of the spot-metering area.

As you can see in the focusing-screen table, most of the other screens have a circular focusing aid of about the same diameter, which can be used for the same purpose. If

HOW TO INTERCHANGE FOCUSING SCREENS

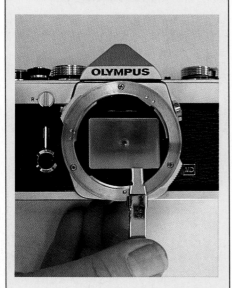

1. Remove the lens. Open the case containing the replacement screen.
2. Reaching into the camera body, carefully pull forward on the small metal catch just in front of the focusing screen. Don't touch the focusing screen or you may damage it. The focusing screen is held in a frame that will pivot downward when you release the catch.
3. Observe the tab extending forward from the focusing screen as it rests in its frame. Using the special tweezers provided with replacement focusing screens, grasp the tab and carefully lift the focusing screen out of its frame and out of the camera body.
4. Place the screen on its side in the slot provided in the case holding the replacement focusing screen. Then grasp the tab of the replacement screen and carefully install it in the focusing-screen frame of the camera.
5. Using the special tool provided, or any suitable instrument, carefully pivot the focusing-screen frame upward until it snaps into place. Jiggle the camera to be sure it is securely in place. Don't touch the screen.
6. Put the screen you removed in the normal nesting place in the focusing-screen case. Close the lid.

NOTE: It is possible to use your fingers for this operation but Olympus doesn't recommend it. If you get finger marks on a screen, don't try to clean it yourself. Have it cleaned at an Olympus Authorized Service Center. If you see dust on a screen, use an air blower or the special brush furnished in the case to remove it. Never touch or rub the surface of a focusing screen with anything other than the special brush.

you use a screen with a larger circle, the spot-metering area does not change. It is simply not clearly defined on the focusing screen.

The general-purpose screens have focusing aids that black out at apertures smaller than f-5.6. Some have prism angles small enough for lenses that have maximum apertures of f-8 or f-11.

In addition to prism angle, the focal length of the lens in use has an effect on focusing-aid blackout because focal length affects ray angles. Also, with certain focal lengths, the Fresnel field lens receives ray angles it cannot cope with entirely and the edges of the viewfinder image may darken. If so, this affects the viewfinder image only. The image on film will not show edge darkening.

Special Screens—Some screens are transparent and do not intercept the image in the plane of the screen. The image you see is called an aerial image because it exists "in the air." This image may be in focus at the screen, in front of it, or behind it.

We see the image in good focus because our eyes adapt, whether or not it is in focus on the focusing screen. Therefore, these screens have a focusing aid to indicate when the image is actually in focus at the screen and will be in focus on the film. When viewing an aerial image, we do not see depth-of-field effects because our eyes find the point of best focus for each part of the scene.

An exception is screen 1-9, which is transparent but has no focusing aid at all. This is intended only for a special medical application with Olympus fiberoptic endoscopes, which require no focusing.

Screens 1-4 and 1-8 are all matte, with no focusing aid. Focus and depth of field are observed on the matte screen. These are intended for the photographer who prefers not to use a focusing aid and for use with lenses that would cause focusing-aid blackout anyway.

Screen 1-10 has a rectangular grid—called a *reticle* or *reticule*—overlaying the entire matte surface. The grid is useful for horizontal and vertical alignment of objects in a photo, for architecture and other special applications. It has no focusing aid except the matte surface.

Two of the screens use cross-hairs as a special focusing aid. When both image and cross-hairs are in sharp focus, the image is in focus in the same plane as the cross-hairs. You can verify focus by moving your eye from side to side as you view the screen. If the cross-hairs seem to move in relation to the image, they are not in focus at the same plane. Change focus so there is no relative motion between cross-hairs and image.

Here's how to use the special tweezers to handle focusing screens.

EXPOSURE READINGS WITH INTERCHANGEABLE SCREENS

All focusing screens do not transmit the same amount of light upward into the viewfinder. Meter readings taken with a light sensor in the viewfinder, above the focusing screen, may be different with different screens.

For cameras that don't meter by measuring focusing screen brightness, this is not a consideration. The OM-2S, OM-3 and OM-4 are examples. All metering is done by the sensor in the mirror box and the metered light does not pass through the focusing screen.

For the other cameras in this book, the following discussion applies.

All focusing screens with a matte surface give a correct exposure reading. Among the others, three types will give an incorrect reading. These are 1-5, 1-6 and 1-7, which are all clear. Too much light passes through the clear screen, so the camera exposure meter recommends too little exposure.

If you are controlling exposure manually, the correction is approximately 1/2 step more exposure. You can find a more exact correction by testing if you need to.

If the camera is on automatic, the viewfinder indication is just to show approximate shutter speed. Exposure is controlled by the SBC sensor in the camera body. Exposure is not affected by the focusing screen. When using a clear focusing screen, shutter speed will be about 1/2 step slower than the viewfinder display indicates.

TYPE	APPLICATIONS	FOCUSING	NOTES
1—1 **Microprism/Matte** For most lenses.	General photography.	Fast and accurate focusing is done with the central microprism and also on the surrounding matte area.	Microprism darkens when a lens with maximum aperture of f-5.6 or smaller is used. When microprism darkens, focus on matte area.
1—2 **Microprism/Matte** For standard & telephoto lenses.	General photography with a standard or tele-photo lens.	Focus on microprism and surrounding matte area.	The focusing aid uses smaller microprism angles so it does not darken until lens aperture is f-8 or smaller. When microprism darkens, focus on matte area.
1—3 **Split-image/Matte** For most lenses.	General photography.	Biprism (split-image) focusing aid works well when scene has definite lines and edges.	Biprism darkens when a lens with maximum aperture of f-5.6 or smaller is used. When biprism darkens, focus on matte area.
1—4 **All Matte** For most lenses.	General photography; also with super-tele-photo lenses and macro photography.	Surface is all matte without a focusing aid. Judge focus by image on matte surface. Matte surface is ground rough to aid in easy focusing.	
1—5 **Microprism/Clear Field** For wide angle & standard lenses.	Transparent screen provides an exceptionally bright image in the viewfinder. Microprism angles suitable for wide-angle and standard lenses.	Focus by microprism only. Clear screen area does not show good or bad focus.	Depth-of-field effects cannot be seen in view-finder because of clear screen. Meter needle does not give correct readings but exposure will be correct with OM-2 or OM-2N on AUTO.
1—6 **Microprism/Clear Field** For standard & telephoto lenses.	Transparent screen provides an exceptionally bright image in the viewfinder. Microprism angle suitable for standard and telephoto lenses.	Focus by microprism only. Clear screen does not show good or bad focus.	Depth-of-field effects cannot be seen in view-finder because of clear screen. Meter needle does not give correct readings but exposure will be correct with OM-2 or OM-2N on AUTO.
1—7 **Microprism/Clear Field** For super telephoto lenses.	A transparent screen primarily for super-tele-photo lenses. Gives exceptionally bright view-finder image and focusing aid does not darken at lens maximum apertures of f-11 or larger.	Focus by microprism only. Clear screen does not show good or bad focus.	Depth-of-field effects cannot be seen in view-finder because of clear screen. Meter needle does not give correct readings but exposure will be correct with OM-2 or OM-2N on AUTO.
1—8 **All Matte** For super telephoto lenses & astro-nomical telescopes.	Suggested for use with super-telephoto lenses with focal lengths of 300mm or longer and for astrophotography.	Fine-ground matte surface gives unusually good definition of image.	More accurate focusing may result from use of Varimagni Finder on viewfinder eyepiece.
1—9 **Clear Field** for endoscopic photography.	Not used with OM cameras.		
1—10 **Checker-Matte** For shift lens.	Same as screen 1-4 except for added grid primarily for use with shift lens to aid in image alignment. Grid can serve other uses in general photography and macro photography.	Focus on matte area.	
1—11 **Cross Hairs/Matte** For close-up & macrophotography.	Cross hairs useful in finding best focus in close-up and macro photoghapy. Cross hairs are surrounded by fine-ground matte surface in inner ring to aid focusing and observation of fine detail in image.	At magnifications up to 1, focus using matte area. At magnifications greater than 1, use cross-hair focusing method described in text.	
1—12 **Cross Hairs/Clear Field** For photomicrography & greater than life-size macrophotography.	Clear screen with cross hairs primarily for use with special Zuiko Macro 20mm and 38mm lenses on a bellows.	Use cross-hair focusing method described in text.	This is the only transparent screen that gives correct meter readings in the viewfinder.
1—13 **Microprism/Split-image/Matte** For most lenses.	The split-image biprism focusing aid is sur-rounded by a microprism ring to give the ad-vantages of both types of focusing. Suitable for general photography with lenses having maxi-mum apertures larger than f-5.6.	Use microprism, biprism or matte area.	Both focusing aids darken at apertures of f-5.6 or smaller. If so, focus on matte area.
1—14 **Microprism/ Angled Split-Image Matte** For most lenses.	Similar to 1-13 except the biprism is angled at 45° to aid focusing on lines and edges in image whether horizontal or vertical.	Use microprism, biprism or matte area.	Both focusing aids darken at apertures of f-5.6 or smaller. If so, focus on matte area.

RECOMMENDED COMBINATIONS OF LENSES AND FOCUSING SCREENS

Legend for the vertical column headings:
- 1-8: For Telephotography & Astrophotography
- 1-9: For Endoscopic Photography
- 1-11: For Close-Up & Macro Photography
- 1-12: For Macro Photography & Photomicrography
- 1-13: For Macro Photography

Lens Type	Lens		1-1	1-2	1-3	1-4	1-5	1-6	1-7	1-8	1-9	1-10	1-11	1-12	1-13	1-14
Fisheye	Zuiko Fisheye	8mm f2.8														
	Zuiko Fisheye	16mm f3.5		*												
Super Wide	Zuiko MC	18mm f3.5		*												
	Zuiko MCX	21mm f2		*												
	Zuiko	21mm f3.5		*												
	Zuiko MC	24mm f2		*												
	Zuiko	24mm f2.8		*												
Wide	Zuiko MC	28mm f2		*												
	Zuiko	28mm f3.5		*												
	Zuiko MC	35mm f2														
	Zuiko	35mm f2.8														
	Zuiko Shift	35mm f2.8	*	*	*										*	*
Standard	Zuiko	55mm f1.2														
	Zuiko	50mm f1.4														
	Zuiko	50mm f1.8														
	Zuiko MC Macro	50mm f3.5														
Zoom	Zuiko MC Zoom	35-70mm f3.6														
	Zuiko Zoom	75-150mm f4														
	Zuiko MC Zoom	85-250mm f5														
Telephoto	Zuiko	85mm f2														
	Zuiko	100mm f2.8														
	Zuiko MC	135mm f2.8														
	Zuiko	135mm f3.5														
	Zuiko MC	180mm f2.8														
	Zuiko MC	200mm f4														
	Zuiko	200mm f5														
Super Telephoto	Zuiko	300mm f4.5													*	*
	Zuiko MC	400mm f6.3	*		*										*	*
	Zuiko MC	600mm f6.5	*		*										*	*
	Zuiko MC	1000mm f11	*	*	*										*	*
Special Use	Zuiko Macro	20mm f3.5	*	*	*	*							*		*	*
	Zuiko Macro	38mm f3.5	*	*	*										*	*
	Zuiko 1:1 Macro	80mm f4	*	*	*										*	*
	Zuiko MC Macro	135mm f4.5	*	*	*	*							*	*	*	*

Compatible. The meter needle gives correct readings in the viewfinder. If marked with *, microprism, split-image biprism and edges of finder will darken.

Compatible. These focusing screens provide a brighter viewfinder image and easy focusing. The built-in exposure meter of the OM-1N and the OM-2N on MANUAL will give an incorrect reading. The OM-2N on AUTO gives correct exposure on film but the meter needle in the viewfinder gives incorrect readings.

Not used with OM cameras.

Exception—The 8mm f-2.8 Zuiko fisheye lens casts a circular image, 23mm in diameter, that fits inside the film frame. The rest of the frame is black. Therefore, the metering system in the viewfinder does not read correctly.

Take a reading using a different lens or with an accessory exposure meter. On automatic, OTF metering will give overexposure of the image circle unless corrected. Exposure correction is about −0.5 or −1 step, which can be done with the Exposure-Compensation Dial. This applies no matter what focusing screen is installed.

IMAGE CUTOFF WITH LONG FOCAL LENGTHS

With short-focal-length lenses, which have wide angles of view, the cone of light rays leaving the back of the lens expands at a wide angle as the rays travel back to the film plane. When the cone of rays reaches the mirror location, it has not yet expanded very much and the image doesn't fill the surface area of the mirror.

With long-focal-length, narrow-angle lenses, the image is nearly full size at the mirror location. Therefore, a relatively large mirror area is required to intercept the rays and reflect them up to the focusing screen.

In some camera designs, the bottom edge of the mirror is shortened so the edge doesn't collide with the camera body or the back of the lens when it swings up. When this is done, part of the image cast by long-focal-length lenses is not intercepted by the bottom of the mirror and therefore is not reflected up to the focusing screen.

The bottom of the image on the mirror becomes the top of the image in the viewfinder. With most models, what you see, with long lenses, is a dark band across the top of the focusing screen with part of the

image lost in the dark band. This is sometimes called image cutoff.

Even if it happens in the viewfinder, the image on film is not affected and not cut off because the image on film is not reflected by the mirror.

All camera designers face this technical problem. Olympus solved it by shortening the bottom of the mirror only a small amount so image cutoff happens only with very long focal lengths such as 1000mm. In the specs, this is referred to as an *oversize mirror*.

VIEWFINDER IMAGE SIZE

Not only is the Olympus viewfinder image brighter than some other designs, it also appears larger. This is done by putting more magnification in the viewfinder eyepiece so you can see more details in the image.

VIEWFINDER IMAGE COVERAGE

When you project a slide, you don't see a narrow strip along each edge of the frame because that part is masked by the slide mount.

The viewfinder in OM cameras is designed to show you approximately what you will see when projecting a slide; therefore, the viewfinder image omits a narrow strip along each edge of the actual image that is recorded on the film. With most models, what you see is approximately 97% of the image area on the film. Specifications for each model are in Chapter 16.

This can be considered as a safety factor for slide shooters—so you don't compose all the way to the edge of your slide and then have part of the composition cut off by the slide mount. If you shoot negative film, the additional picture around the edges of the frame is usually so small that it doesn't matter and is not noticed. If it does matter, it can easily be cropped when printing.

VIEWING AIDS

Accessories called *viewing aids* are available to attach to the viewing eyepiece on the back of the camera.

Eyecup 1—This rubber eyecup is a useful accessory with or without eyeglasses. It excludes stray light from the gap between your eye and the viewfinder eyepiece. This makes viewing easier. When using an OM camera on manual, stray light entering the viewfinder eyepiece can cause an incorrect meter reading by illuminating the focusing screen from the top. Eyecup 1 should improve metering accuracy, particularly when the light is likely to enter the eyepiece from the side, through the gap between your eye and the finder.

On automatic, there may be an erroneous viewfinder indication due to stray light entering the eyepiece. But when the exposure is

Once you use a Rubber Eyecup, you'll always use one.

made, it will not be affected by light through the eyepiece because the mirror is up. This closes off the light path between the viewfinder section of the camera and the camera body.

If you wear eyeglasses, a rubber eyecup prevents banging or scratching them on the back of the camera. Without glasses, an eyecup makes viewing more comfortable. It is easy to install. The metal mounting frame on the back of the eyecup just slips over the viewfinder eyepiece, held in place by grooves on each side of the eyepiece. I recommend using an eyecup as a permanent attachment to your camera.

Optical Corrections—Those who wear prescription eyeglasses may find that the viewing optics on some camera models do not provide a clear image of the focusing screen. There are two ways to adapt the viewfinder optics to your vision, depending on camera model.

The OM-3, OM-4 and OM-4T have a Dioptric Adjustment Knob on the viewfinder housing. Point the camera at a blank surface and adjust the lens so the surface is out of focus. Pull out the Dioptric Adjustment Knob and turn it to bring the circles surrounding the focusing aids into sharp focus. Then press the knob back in.

The other models in this book do not have adjustable viewfinder optics but use special attachments instead, discussed in the following section.

Dioptric Correction Lenses—Cameras without adjustable viewfinder optics are designed for people with normal vision. If you wear prescription eyeglasses, you may find it inconvenient to wear them while looking into the viewfinder eyepiece.

Also, they keep your eye far enough away from the eyepiece that you can't see all of the frame without moving your eye left and right, up and down.

If you remove your glasses, you no longer have normal vision and you may find it difficult to get sharp focus of the image.

These problems can be solved by adding an accessory Dioptric Correction Lens to the viewfinder, so you don't have to wear your glasses. Correction lenses mount in Eyecup 1. Inside the rubber cone is a threaded ring. Remove the ring, drop in the correction lens, replace the ring. Then install the eyecup on your camera.

You may end up taking your glasses off to look into the viewfinder and putting them back on again to read dial settings and the frame counter.

Eyeglass prescriptions are written in numbers called *diopters*. Dioptric correction lenses are also rated in diopters and may be selected to match your eyeglass prescription. They are available in eight strengths as follows: $+2$, $+1$, 0, -1, -2, -3, -4, -5. These numbers state the diopter rating of the camera viewing system *after* you have installed the correction lens. Without a correction lens, the diopter rating of the viewfinder is -0.5.

The focusing screen in SLR cameras appears to be at about arm's length. Therefore, the diopter number you need is the one that corrects your vision for objects at arm's length.

If you wear bifocals, neither of the two numbers on your prescription is likely to be suitable. One corrects your vision for long distance and the other corrects it for reading at a distance of about 18 inches. If you wear trifocals, the middle correction is probably the right one. If you wear single-vision glasses or contact lenses, consult your eye doctor.

The best way to choose a dioptric correction lens is to find an Olympus dealer with all of the listed types in stock and try them until you find the one that fits your vision. Take someone along who has good vision without glasses and ask that person to focus the camera on a prominent object. Then find a correction lens that shows you good focus at the same setting of the focus control.

Eyecoupler—The Eyecoupler is a simple

The Varimagni Finder attaches to the Eyecoupler, which is mounted on the viewfinder eyepiece. The knurled ring next to the Varimagni Finder eyecup is a dioptric adjustment to adapt the unit to your eyesight. There are two magnification settings, selectable by the lever near the camera: 1.2X and 2.5X. In addition to magnifying the viewfinder image so you can focus precisely, the Varimagni Finder rotates so you can look into the camera from any angle.

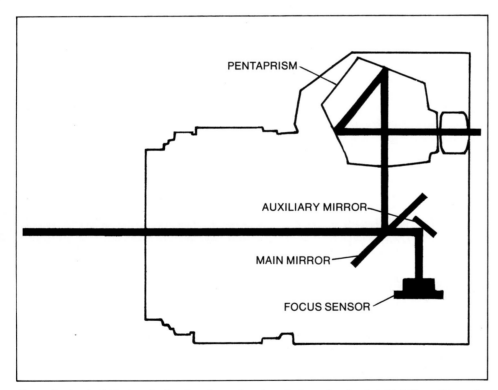

PENTAPRISM

AUXILIARY MIRROR

MAIN MIRROR

FOCUS SENSOR

Focus is checked electronically when the main mirror is down for viewing. Light from the center of the scene passes through a semi-transparent area in the mirror and is reflected downward by a small auxiliary mirror. The Focus Sensor in the bottom of the camera produces electrical signals to indicate good focus or which way to focus the lens if the image is not in focus.

U-shaped mechanical spacer that fits between eyepiece accessories and the eyepiece itself. It is needed only with two accessories: Varimagni Finder and 250 Film Back 1.

Varimagni Finder—This accessory is a right-angle viewer that you attach to the camera eyepiece frame using the Eyecoupler in between. It solves two problems: One is viewing when the camera is located in an unusual or awkward way. The other is to magnify the image for more precise focusing.

If you are taking a picture with the camera on the ground, you will not be able to look through the viewfinder conveniently. If you have the camera on a tripod or copy stand, pointing downward, it may be difficult to look into the viewing eyepiece in the normal way. Whenever you have difficulty getting your eye in the right position to look directly into the viewfinder eyepiece, the Varimagni Finder will usually solve the problem. It can be rotated on the camera so you can view from above, from the side, from below, or at any angle.

An old trick used to find best focus with enlargers and view cameras is to use a magnifier to examine the image while focusing. This can be done in an OM camera by using the Varimagni Finder.

Two values of image magnification are available, selected by a lever. When set to 1.2X, you still see the entire frame, provided you have placed the Eyecoupler between the finder and the camera. When set to 2.5X, you see only the central part of the frame.

This unit has an inclined mirror inside that reflects light rays at 90 degrees so they "turn the corner." Every mirror reflection in an optical system reverses one axis of the image, either top-to-bottom or left-to-right. One axis is reversed when using this finder. The axis that appears reversed depends on rotation of the finder on the camera and your orientation while looking into it.

The finder has its own eyecup. Just below the eyecup is a Correction Ring that you turn to adjust the optics to your eyesight. Range of diopter corrections is from +3 to −7. To set the diopter correction for your vision, focus the camera lens sharply on some prominent object. Then find best focus using the diopter correction ring on the finder. Repeat the procedure until one adjustment no longer affects the other.

After making that adjustment, you need not change the diopter correction ring on the finder when you refocus the camera lens.

AUTOMATIC FOCUSING

The Olympus "Zero-In" electronic automatic focusing system operates with the main mirror down, before the shutter opens. Some of the light from the scene passes

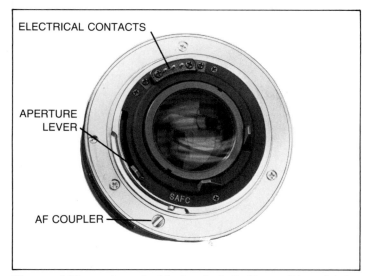

Olympus AF lenses have electrical contacts that transmit lens data to the camera. The data is used for automatic exposure control and automatic focus. An aperture lever on the lens is used by the camera to control aperture size mechanically. The grooved AF coupler is used by the camera to focus the lens.

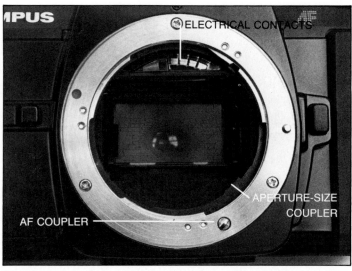

Electrical contacts inside the OM 77AF lens mount receive lens data from electrical contacts on the lens. The aperture-size coupler controls the position of the aperture lever on the lens. The AF coupler on the camera is shaped like a screwdriver blade, to fit into the grooved AF coupler on the lens.

through the main mirror and is reflected downward by an auxiliary mirror to a focus sensor in the bottom of the camera. See the accompanying drawing.

The focus sensor uses the phase-detection principle. In effect, it views the image from two off-center locations, left and right. By comparing the two views, the autofocus system can determine if the image is in focus or not. If not, it knows which way it is out of focus, and by how much.

The autofocus system controls a focus motor in the camera body, which is linked to the AF lens by a mechanical coupling at the lens mount. The focus motor brings the lens quickly to focus. A lamp in the viewfinder display, shown in Chapter 2, glows green when the image is in focus.

If the lamp glows red, the system is unable to focus automatically, as discussed later in this section. You can turn off the autofocus system and manually focus the lens using a control on the camera body.

Autofocus Control—Pressing the shutter button partway turns on the autofocus system. Depressing it fully makes an exposure. Even with the shutter button fully depressed, the camera will not make an exposure unless the image is in focus and the green light glows in the viewfinder.

Autofocus Problems—Autofocus works very well on most subjects and scenes. However, there are some situations in which the autofocus system cannot operate and which require manual focusing.

The focus sensor must "see" a vertical line or edge on which to focus. This can be the edge of a person's face, the pupil of an eye, the shadow cast by a nose, the edge of a building, and many similar things. It can be part of a complex image such as foliage or clothing—the autofocus system will focus on a vertical line within the image.

One side of the line or edge must be brighter than the other so there is sufficient contrast to distinguish the line or edge.

If the autofocus system has difficulty focusing, you can sometimes help it. Try focusing on a different part of the subject or scene. If the scene has only horizontal lines, rotate the camera 90°. Lock focus by holding the shutter button partially depressed, rotate the camera as you wish and make the exposure.

The autofocus system may be "confused" by scenes with vertical lines that are not part of the subject—for example, photographing through a window with vertical bars. It may focus on the bars instead of the scene. It may have difficulty focusing on objects with repeating patterns. It cannot focus on rapidly moving subjects.

AF Illuminator—In dim light, Olympus autofocus cameras and companion flash units use built-in AF Illuminators to automatically project a brief pulse of dark-red light toward the subject. This provides sufficient illumination for autofocus, even in total darkness. Depending on the subject and ambient illumination, the autofocus range with an AF Illuminator is around 30 to 40 feet.

10 OLYMPUS LENSES

In my opinion, the greatest advantage of an SLR camera system is interchangeable lenses. Each additional focal length expands your capability and your vision as a photographer.

Interchangeable lenses with various focal lengths and angles of view are a major advantage of SLR cameras. They allow you to match the characteristics of the lens to the scene you intend to shoot and the purpose you have in mind. To enjoy and benefit from the versatility of an SLR camera, you need more than one lens. This chapter will help you decide which lenses you should have.

There are two series of Olympus lenses. Zuiko non-autofocus are intended primarily for non-autofocus cameras but will fit autofocus cameras. Olympus AF lenses are intended for autofocus cameras and will not fit non-autofocus cameras.

Optically, Zuiko and AF lenses are similar. That is, a telephoto or wide-angle lens makes the same picture, no matter how it is focused or mounted. Therefore, the general information in this chapter about Zuiko lenses applies also to AF lenses.

The Zuiko series is larger and more comprehensive. This chapter discusses Zuiko lenses first. The AF series is smaller, because it is new. AF lenses are listed at the end of this chapter.

LENS HOODS

An important accessory for lenses of either type is a lens hood, which improves image quality by keeping stray light out of the lens. I recommend that you buy and use a lens hood for each of your lenses—if a hood is available. A hood also helps keep stray fingers off the front surface and protects the lens against bumps. Many lenses that have been dropped have been saved from damage by landing on the hood.

METERING WITH ZUIKO LENSES

Most Zuiko lenses are designed for metering at full aperture even though the lens aper-

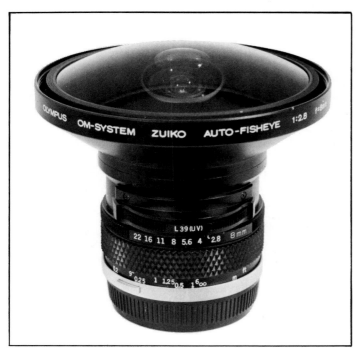

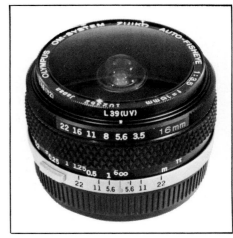

The Zuiko Auto-Fisheye 16mm *f*-3.5 lens makes a rectangular image. The film frame fits snugly inside the image circle cast by the lens. Therefore, this lens has a 180° viewing angle only across the diagonals of the film frame. This lens also has a special filter-selector control that is set for the L39 (UV) filter. Filters are discussed in Chapter 13.

The Zuiko Auto-Fisheye 8mm *f*-2.8 lens has a true 180° angle of view. It images a full hemisphere in a circular image area that fits inside the film frame. This lens has a special control to select a built-in filter. The control is just in front of the Aperture Ring and is set for the L39 (UV) filter.

ture ring is set to a smaller aperture size. The lens stops down to shooting aperture just before the shutter opens because of the automatic diaphragm feature. Such lenses are called *meter coupled*.

Most Zuiko lenses have a Depth-of-Field Button on the lens body that causes the lens to stop down to whatever aperture size is set on the Aperture Ring. If the aperture is set to any value smaller than wide open, pressing the Depth-of-Field Button reduces the amount of light entering the camera.

With meter-coupled lenses—designed to meter at full aperture—you should always meter at full aperture. If you meter with the Depth-of-Field Button depressed, exposure will not be correct.

There are a few Zuiko lenses and equipment setups that are not meter coupled. With these lenses, turning the aperture ring to select the shooting aperture size causes the aperture to stop down immediately. Metering is done with the lens stopped down. No special camera settings are needed—the camera performs stopped-down metering automatically, when necessary.

LENS CATEGORIES

Available Zuiko lenses are listed in the accompanying table. Most photographers think of lenses in groups or categories such as standard or wide-angle.

REFLEX LENSES

This is a special lens design used to make long-focal-length lenses more compact. Reflex lenses have a mirror at each end and are sometimes called *mirror* lenses. The mirrors reflect light back and forth, thereby "folding" the light path and making the lens physically shorter.

Light enters the lens through a ring around the front mirror and leaves the back of the lens through a central opening. Because all diameters are of fixed size, reflex lenses do not have adjustable aperture. Exposure is controlled by selecting film speed, shutter speed, and using neutral-density filters if needed.

Both mirrors are curved, which helps focus the image. In addition, glass lens elements are used. Lenses with both mirrors and glass elements are called *catadioptric*.

Compared to conventional lens designs of the same focal length, reflex lenses are very small and lightweight. The Zuiko Reflex 500mm *f*-8 is an example. A characteristic of mirror lenses is that small unfocused points of light in a scene often appear as small "doughnuts" in the image. This is caused by the ring shape of the front lens element.

FISHEYE

If you go underwater and look upward, you see the outside world through a circular area at the water's surface and you get a surprisingly wide-angle view.

For sure, this is a people-eye view from underwater. We surmise that it is also a fisheye view, although I don't think anybody has actual testimony from a fish to support that conclusion.

Nevertheless, special lenses that produce an extremely wide-angle view are called *fisheye* lenses. There are two types.

Circular Fisheye—Lenses that record the complete circular view on film are called *circular fisheyes*. The circular fisheye image fits inside the rectangular film frame as shown in the accompanying photo. The rest of the frame is black in a slide or print.

The Zuiko Fisheye 8mm *f*-2.8 lens has a 180° angle of view and makes a circular image within the frame. It has automatic diaphragm but it is not meter-coupled.

If you are setting exposure manually, you can meter the scene with a different lens, note aperture size and shutter speed, and then make those same settings.

With an OM camera on automatic operation, exposure is controlled by the OTF metering system. The dark areas outside the image circle may cause overexposure. With an average subject, bracketing one-half step and one step toward less exposure should get you a good shot. If the shot is important, test first.

ZUIKO INTERCHANGEABLE LENSES

Lens Type	Lens		Angle of View Degrees	f-stop Range	Minimum Focus Ψ Meters	(ft.)	Weight Grams	(oz.)	Length mm	Filter Size mm
Fisheye	Zuiko Fisheye	8mm f-2.8	180 (circle)	2.8–22	0.20	(0.7)	640	(22.6)	82	Built-in
	Zuiko Fisheye	16mm f-3.5	180	3.5–22	0.20	(0.7)	180	(6.3)	31	Built-in
Super-Wide	Zuiko	18mm f-3.5	100	3.5–16	0.25	(0.8)*	250	(8.8)	42	72
	Zuiko	21mm f-2.0	92	2–16	0.20	(0.7)*	250	(8.8)	43.5	55
	Zuiko	21mm f-3.5	92	3.5–16	0.20	(0.7)	180	(6.3)	31	49
	Zuiko	24mm f-2.0	84	2–16	0.25	(0.8)*	280	(9.8)	48	55
	Zuiko	24mm f-2.8	84	2.8–16	0.25	(0.8)	180	(6.3)	31	49
	Zuiko Shift	24mm f-3.5	84 (Max. 100)	3.5–22	0.35	(1.2)	510	(18)	75	Built-in
Wide	Zuiko	28mm f-2.0	75	2–16	0.30	(1.0)*	250	(8.8)	43	49
	Zuiko	28mm f-2.8	75	2.8–22	0.30	(1.0)	170	(6.0)	32	49
	Zuiko	35mm f-2.0	63	2–16	0.30	(1.0)	240	(8.5)	42	55
	Zuiko	35mm f-2.8	63	2.8–16	0.30	(1.0)	180	(6.3)	33	49
	Zuiko Shift	35mm f-2.8	63 (Max. 83)	2.8–22	0.30	(1.0)	310	(10.9)	58	49
Standard	Zuiko	40mm f-2.0	56	2–16	0.30	(1.0)	140	(4.9)	25	49
	Zuiko	50mm f-1.2	47	1.2–16	0.45	(1.5)	290	(10.2)	43	49
	Zuiko	50mm f-1.4	47	1.4–16	0.45	(1.5)	230	(8.1)	39	49
	Zuiko	50mm f-1.8	47	1.8–16	0.45	(1.5)	165	(5.8)	32	49
	Zuiko Macro	50mm f-2.0	47	2–16	0.24	(0.8)*	320	(11.3)	55	55
	Zuiko Macro	50mm f-3.5	47	3.5–22	0.23	(0.8)*	200	(7.1)	40	49
Zoom	S Zuiko Zoom	28–48mm f-4.0	75–49	4–22	0.65	(2)	300	(10.6)	54	49
	Zuiko AF Zoom	35–70mm f-4.0	63–34	4–22	0.75	(2.5)	560	(19.7)	77	55
	S Zuiko Zoom	35–70mm f-3.5-4.5	63–34	3.5–22	0.75	(2.5)	190	(6.7)	51	49
	S Zuiko Zoom	35–70mm f-4.0	63–34	4–22	0.75	(2.5)	380	(13.4)	71	55
	Zuiko Zoom	35–70mm f-3.6	63–34	3.6–22	0.80	(2.7)	400	(14.1)	74	55
	Zuiko Zoom	35–105mm f-3.5-4.5	63–23	3.5–22	1.50	(4.9)•	470	(16.6)	85	55
	Zuiko Zoom	65–200mm f-4.0	37–12	4–32	1.2	(4.0)	730	(25.9)	147	55
	Zuiko Zoom	75–150mm f-4.0	32–16	4–22	1.60	(5.2)	440	(15.5)	115	49
	Zuiko Zoom	85–250mm f-5.0	29–10	5–32	2.0	(6.6)	890	(31.4)	196	55
	S Zuiko Zoom	100–200mm f-5.0	24–12	5–32	2.4	(2.9)	570	(20.1)	196	55
Telephoto	Zuiko	85mm f-2.0	29	2–16	0.85	(2.8)*	260	(9.2)	48	49
	Zuiko	100mm f-2.0	24	2–22	0.7	(2.3)*	520	(18.5)	72	55
	Zuiko	100mm f-2.8	24	2.8–22	1.0	(3.3)	230	(8.1)	48	49
	Zuiko	135mm f-2.8	18	2.8–22	1.5	(4.9)	360	(12.7)	80	55
	Zuiko	135mm f-3.5	18	3.5–22	1.5	(4.9)	290	(10.2)	73	49
	Zuiko	180mm f-2.0	14	2–22	1.6	(5.3)	1900	(67.1)	174	100
	Zuiko	180mm f-2.8	14	2.8–32	2.0	(6.6)	700	(24.7)	124	72
	Zuiko	200mm f-4.0	12	4–32	2.5	(8.2)	510	(17.9)	127	55
Super-Telephoto	Zuiko	250mm f-2.0	10	2–22	2.2	(7.3)	3700	(130.5)	246	Slip-in
	Zuiko	300mm f-4.5	8	4.5–32	3.5	(11.5)	1100	(38.8)	181	72
	Zuiko	350mm f-2.8	7	2.8–32	3.0	(10)	3900	(138)	280	Slip-in
	Zuiko	400mm f-6.3	6	6.3–32	5.0	(16.4)	1300	(46.0)	255	72
	Zuiko Reflex	500mm f-8.0	5	–	4.0	(13.3)	590	(20.8)	97	72
	Zuiko	600mm f-6.5	4	6.5–32	11.0	(36.1)	2800	(98.8)	377	100
	Zuiko	1000mm f-11	2.5	11–45	30.0	(98.4)	4000	(141.0)	662	100
Special Lenses	Zuiko Macro	20mm f-2.0	9 at highest mag.	2–16			170	(6.0)	46	21 Slide-on
	Zuiko Macro	38mm f-2.8	9 at highest mag.	2.8–22	Bellows or 65–116 Tube		176	(6.0)	46	32 Slide-on
	Zuiko 1:1 Macro	80mm f-4.0	9 at highest mag.	4–32			170	(6.0)	33	49
	Zuiko Macro	135mm f-4.5	18	4.5–45			320	(11.3)	47	55

* Automatic close-distance correction mechanism.
Ψ Minimum Focus Distance given is film-to-subject.
• Minimum focus distance of Zoom 35–105mm is 0.31 meter at close-focus setting.

Rectangular Fisheye—Another type of fisheye lens makes an image circle that is slightly larger than the diagonal of the film frame. The film frame fits snugly inside the image circle and records a recangular image that is a portion of the circular fisheye view.

The Zuiko Fisheye l6mm *f*-3.5 has an angle of view of 180°. The film frame is completely filled so you see a *rectangular fisheye* image.

This lens has automatic diaphragm operation by the camera and is fully meter-coupled. Use it in the normal way.

Filters for Fisheyes—Because these lenses have a 180° field of view, front-mounted lens accessories cannot be used because they will intrude into the field of view and vignette the image.

The 8mm fisheye has four built-in filters, selectable by a control on the lens body. The filters are L39, Y48, O56 and R60.

The l6mm fisheye has three built-in filters, selectable by a control on the lens. They are L39, Y48 and O56.

Filters are discussed in Chapter 13.

Lens Hoods—For the reason indicated above, hoods cannot be used on fisheye lenses.

Fisheye Distortion—The extremely wide angle of view of fisheye lenses is produced by a special optical design. A byproduct of this design is an unavoidable distortion of the image called *fisheye distortion*. This causes straight lines in the picture to appear curved or bowed outward unless the lines pass through the center of the image.

Fisheye distortion causes the sides of windows to curve outward. The corners of rooms or buildings bulge out. Trees and telephone poles may seem to soar upward, curv-

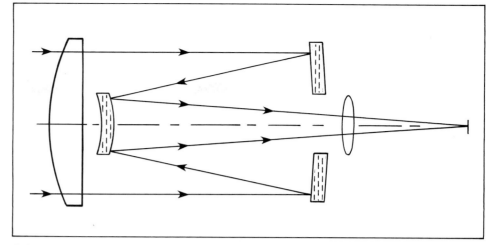

Reflex lenses use mirrors to "fold" the light path, which makes the lens physically shorter. Light enters through the front lens and reflects off the back mirror. It reflects again off the rear surface of the front mirror. The light leaves the lens through the central opening in the rear mirror. Glass lens elements are used in conjuction with mirrors. The aperture of the lens is not adjustable in size.

ing strangely as they go. The effect is much more noticeable if there are straight lines in the image. When shooting nature, such as flowers or a scenic view without straight lines, the effect may not be noticed by the casual viewer.

Uses of Fisheyes—A circular fisheye lens is useful for dramatic special effects and scientific applications—such as mapping the sky from horizon to horizon.

It is difficult to use in general photography because it produces a circular image and thereby calls attention to itself. Viewers expect trickery in a circular image and view the

photo as a curiosity rather than an image to be examined for its content.

Both types of fisheyes have great depth of field. Sometimes this is very useful.

Rectangular fisheyes can be used for special effects and also in general photography where the viewer may not be aware that the photo was made with a fisheye. This is mainly because the image is rectangular and therefore does not alert the viewer to look for something special.

When used in general photography, choose the scene carefully so the fisheye distortion is not blatantly obvious, unless

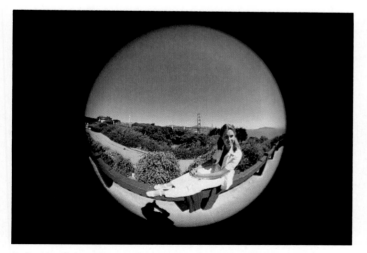

A circular fisheye lens calls attention to itself by making a circular image. With a rectangular fisheye, the lens type is less obvious because of the full-frame image. Fisheye distortion will be apparent with either lens if there are straight lines in the scene—unless the lines pass through the center of the image. You can sometimes photograph landscapes and water views without calling attention to the fact that you used a fisheye. Put the horizon line through the center of the image.

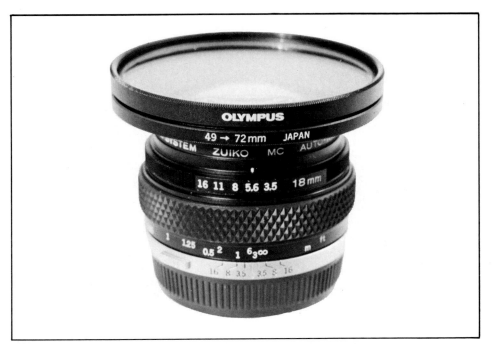

The Super-Wide-Angle 18mm Zuiko lens uses a special dual-purpose lens hood that also serves as a 49→72mm adapter to mount filters. Filter diameter is 72mm but the filter-thread diameter of the lens is only 49mm.

All unmounted lenses in this chapter are shown with a rear lens cap in place to protect the lens mechanism. These are the Zuiko 21mm and 35mm lenses.

you want the distortion to be visible.

When shooting scenic views, be careful to place the horizon line through the center of the image. Otherwise it will curve up or down in an unnatural way.

In composing the image, be sure to check the edges because the wide angle of view can surprise you by including your foot in the picture, or the tripod leg, or something else you didn't really intend to photograph.

The fisheye design requires the front glass element to extend forward of the metal lens barrel—so it can look sideways to get the 180° angle of view. This makes the front element more vulnerable to scratches and damage than other lenses with recessed front elements. You should keep the lens cap in place except when you are actually using the lens.

WIDE-ANGLE LENSES

These fall into two groups: wide-angle and super-wide-angle. The distinction is mainly historical. For a long time, lens designers have been making wide-angle lenses. Then improvements in lens glass and design methods allowed the production of lenses with angles of view much wider than the world had become accustomed to. Therefore, the designers called them *super-wide-angles*.

As you can see in the lens table, the super category ranges from 18mm to 24mm in focal length with angles of view from 100° to 84°.

The wide-angle category includes 28mm with a viewing angle of 75° and 35mm focal length with a 63° angle of view. All lenses in these categories are meter-coupled. Use them in the normal way.

Lenses that do not cause straight lines to curve are called *rectilinear*. All Zuiko lenses except fisheyes are rectilinear.

The minimum focusing distance of wide-angle lenses is small, which allows you to compose so a foreground object dominates the picture but the wide angle of view still includes a lot of background. Pictorially this can be effective in many situations, such as a wildflower up close with a background of towering mountains.

Because of the close-focusing capability, you can use wide-angle lenses to make portraits that turn out to be caricatures. Stick the lens very close to your friend's nose and you get a photo showing a big nose with a receding forehead, chin and ears. You can also use these lenses to give people big feet, big hands, or big whatevers.

Technically, these photos have correct perspective because they show what you would actually see if you placed your eye where the camera lens was when the photo was made. From a normal viewing distance, they have unusual perspective, which is why they are eye-catching and sometimes offensive to the subject.

These lenses solve a lot of problems. In any situation where you can't back up far enough to include what you want in the field of view, consider changing to a shorter focal length. Such situations include buildings and monuments in cities where other buildings restrict your movement.

Special Precautions—Because of the very wide angle of view of the Zuiko 18mm *f*-3.5 lens, a conventional screw-in filter with a diameter of 49mm should not be attached directly to the front of the lens because it will darken the corners of the picture by intruding into the field of view. This is called *vignetting*.

Filters with a diameter of 72mm can be used with this lens by screwing them into the front of a special lens hood called Adapter Ring 49→72. This adapter serves as a lens hood to give protection against stray light but it flares out rapidly so it doesn't intrude into the field of view, as you can tell from the dimensions.

The viewing angle of the 21mm *f*-3.5 lens is so wide that accessory filters with a thick frame should not be used even though they fit the 49mm filter threads on the front of the lens. The thick frame will darken the corners of the picture. Olympus filters are designed to prevent this and can be used with this lens.

STANDARD LENSES

The standard lens for an OM camera is a 40mm or 50mm focal length with an angle of view of 56° or 47° respectively. There are several explanations for this.

One is that the angle of view of a 50mm lens is about the same as the human eye; therefore, the pictures look natural.

Another explanation is that the standard lens should have a focal length approximately the same as the diagonal of the film frame. For ordinary 35mm cameras, the frame diagonal is about 43mm. Therefore, the standard lens by this definition should have a focal length of 43mm.

I prefer to say that a lens of about 50mm focal length is standard because it's a good compromise between narrow and wide angles of view and is a very serviceable lens.

With a standard lens, you can move right up to your subject—as close as 18 inches—when that suits your purpose. Of course, shorter focal lengths and some accessories allow even closer focusing, but these are usually for special applications. In the wide world of general photography, the close-up capability of a standard lens is often exactly what you need.

Similarly, the angle of view of a 40mm or 50mm lens is about right for many things that we photograph: groups of people, scenic views, your dog, farmhouses and barns, and so forth.

With wider angles of view, you will often be disappointed when you see what you photographed because everything is too small. When you include more of the scene, everything has to be smaller in the picture.

With narrower angles than the standard lens, everything in the picture is larger but you may find that you can't include some important parts of the scene. For example, if you are photographing a teenager admiring his first car, you should include both the teenager and the car.

I'll suggest a rule that you may find useful: Always use a 40mm or 50mm lens unless you have a specific reason not to. We see too many pictures in which the "message" is simply the unusually long or short focal length of the lens used to make the picture. The lens should support the purpose of the photo—not be the purpose.

A benefit of this rule is that it will cause you to think about focal length when you plan a picture and visualize the effect you

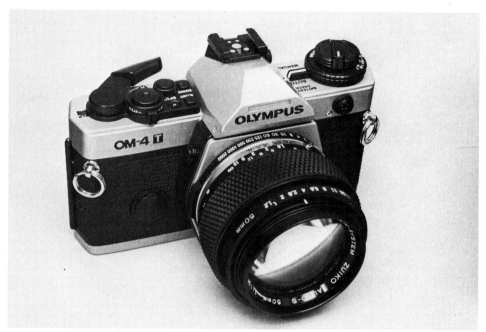

Lenses with 50mm focal length are useful for a great variety of shooting situations. You may choose among the 50mm *f*-1.2, *f*-1.4, *f*-1.8, Macro *f*-2 and Macro *f*-3.5 lenses.

The 85mm telephoto uses a screw-in lens hood. This hood is made of rubber. It folds back over the lens for storage.

will get with different lenses. You'll end up finding some good reasons *not* to use the standard lens and you'll probably be pleased with the creativity of the results.

There has been some ambiguity about using the words *standard* and *normal* when discussing lenses. I prefer to use *standard* to mean the 40mm or 50mm lenses usually sold with the camera. This book will use *normal* to mean a lens that is not telephoto or retrofocus—in other words, a conventional lens design.

Zuiko general-purpose lenses with focal lengths of 135mm or longer have built-in telescoping hoods around the front part of the lens. This is the 135mm *f*-2.8. The hood is collapsed.

TELEPHOTO

Olympus divides this group of lenses into two categories: telephoto and super-telephoto.

Telephoto focal lengths start at 85mm and include 200mm. The range in angle of view is 29° to 12°. Usually you can hand-hold these lenses because focal length is not too long and because all lenses in this category weigh less than a pound.

Super-telephoto lenses range from 300mm to 1000mm with viewing angles from 8° down to a tiny 2.5°. In general, you cannot hand-hold these lenses satisfactorily—focal length is too long and they weigh from about 2.5 pounds up to almost 9 pounds for the 1000mm lens.

Practical exceptions are hand-holding the 300mm and 400mm lenses, which you can do if you use a shutter speed of 1/500 or 1/1000 and are very careful not to jiggle the camera during exposure. In photographing sports, you'll find many occasions when you need a 300mm or 400mm lens to fill the frame with the action. You may also want the mobility and quick-response capability that hand-holding gives you. Sometimes you can compose the picture and steady the lens on a

Super-Telephoto lenses with focal lengths of 600mm and 1000mm are for specialists. They have tripod mounts on the lens barrel and are too large to hand-hold except in unusual situations.

railing or post. When possible, use these lenses with a tripod.

All of the super-telephoto lenses have tripod-mounting rings on the lens barrel. The camera and lens combination will balance better using the tripod mount on the lens. Don't use the tripod mount on the camera bottom because you may overstress it.

The tripod mounts allow the lens to be rotated inside the mount so you can turn the camera to make vertical-format or horizontal-format shots. The tripod mounts on the 300mm and 400mm lenses are removable for occasions when you hand-hold the lens. Tripod mounts on the longer lenses are not removable.

At sports events, I sometimes put camera and long-focal-length lens on a tripod but leave the clamps loose on the tripod head so I can instantly move the camera in any direction.

We tend to think of a tripod as a firm support because, after all, that's what it is designed for. Actually, a camera with a physically long lens mounted at a single point on the tripod vibrates very readily. Putting your hands on the camera and lens tends to stabilize the mechnical arrangement and reduce vibrations—provided you don't shake the camera yourself.

With long lenses on a tripod, Olympus recommends holding the camera in both hands while operating the shutter button with your finger. I prefer to hold the camera with my right hand while using the left to steady the lens. Pushing downward on the lens at the tripod mount seems to stabilize both lens and tripod.

Using Telephoto Lenses—The lower end of this range, 85mm to 135mm, includes useful portrait lenses. They allow you to fill the frame with your subject's head without standing so close that you create tension or distortion. When there is more working distance between lens and subject, the subject tends to relax more and you get a more natural looking portrait.

When making portraits with a 50mm lens, you have to get close to make a head shot. This can produce a subtle version of the "big nose" effect you get with wide-angle lenses close to the subject. Your subject may not like the picture without knowing why. Using an 85mm or 100mm lens requires you to stand back far enough so you automatically avoid this perspective problem.

You'll find telephotos useful when you want to be unobtrusive. For example, you can photograph children at play without interrupting them. Sometimes they don't notice the camera at all. You can get delightful unposed and spontaneous facial expressions this way.

In general, reach for a longer lens when

The Zuiko 85-250mm *f*-5 zoom lens is relatively large. In some situations and at some focal-length settings, you can hand-hold it. In other cases, you will want to mount it on a tripod, so a tripod mount is provided on the lens body. You can loosen the mount to rotate camera and lens for a vertical-format shot. The 75-150mm *f*-4 (center) and the 35-70mm *f*-3.6 zoom at left can be hand-held in virtually any shooting situation.

you can't get close enough to make the photo you want.

That is an oversimplification because long focal lengths produce a characteristic perspective just as wide angles do. When you photograph a distant scene with a long lens, it seems to compress distance between near and far objects in the distance. You can use the effect to make racing cars seem very close together, or to make traffic look terrible, or to make houses seem all jammed together on a hillside.

There are some shots that you can't get without a long lens. A mountain climber high up and far away on a rock face makes a dramatic photo that most people can take only with a telephoto lens. Bird and wild animal photos usually require long lenses.

Long lenses also give selectivity. When shooting a group of houses on the hillside, you can use a telephoto lens to isolate just

one—a photogaphically different approach than with a normal or wide-angle lens. Or you can use a telephoto lens to isolate one face in a crowd.

The combination of long focal length and relatively large maximum aperture makes it easy to use depth of field creatively. At maximum aperture, the depth of field is a relatively narrow band that you can move closer or farther away as you rotate the focus control. Try this with the Zuiko 135mm *f*-2.8, for example, and explore the variety of ways you can interpret a scene.

I like to use a 200mm lens to search out small views in a big landscape. The intimacy of "being there" while standing some distance away makes me feel like I have found a secret place. When these photos work, I find that they please me very much. I also use a 200mm for sports and find it handy for travel pictures.

The super-telephotos—at least those longer than 400mm—are lenses for a specialist. If you want a giant sun on the horizon—use a long lens. The longer the focal length, the larger the sun or moon in your photo.

When using these lenses, you are likely to be shooting through a lot of atmosphere between camera and subject. Image quality often suffers because of air turbulence, atmospheric scattering of light and sometimes dust or air pollution.

RELATIVE MAGNIFICATION

The word *magnification* means the height of the image in the camera divided by the height of the subject in real world. If magnification is 2.0, the image is twice as tall as the subject—also twice as wide. Chapter 12 tells you how to do that.

Relative magnification compares the image size made by two different lenses when camera-to-subject distance remains the same. It is simply the ratio of focal lengths. From the same distance, a 100mm lens makes an image twice as large as a 50mm lens. A 200mm lens makes an image that is four times as large.

TELEPHOTO RATIO

As you remember from Chapter 4, the telephoto design is used to put the correct distance in the optical path between lens and film. This design allows the lens to be physically shorter than a lens of the same focal length using the conventional or normal lens design.

As a way of demonstrating this, lens makers calculate a number called *telephoto ratio*. This ratio is the distance from the front surface of the lens to the film—with the lens focused at infinity—divided by the lens focal length. Obviously, if the telephoto ratio is 1.0, the distance from the lens front surface to the film is the same as the focal length.

If the telephoto ratio is less than 1.0, that means the lens front-surface-to-film distance is less than the focal length.

ZOOM LENSES

Zoom lenses have a control that changes focal length over a specified range. One zoom lens can provide the angles of view of several conventional, fixed-focal-length lenses. While zooming, the subject becomes larger or smaller in the frame, but the focused distance does not change.

Olympus zoom lenses have excellent image quality. The only disadvantage is that zooms have smaller maximum aperture than fixed-focal-length lenses in the same focal-length range. However, most photos are not made at maximum aperture, so this may not be a disadvantage.

The 35-105mm zoom lens changes maximum aperture from *f*-3.5 to *f*-4.5 when focal length changes from 35mm to 105mm. It has a CLOSE FOCUS control that provides magnifications up to 0.2.

The Zuiko Shift 35mm *f*-2.8 can be shifted sideways or up and down on the front of the camera. This lens is shifted both to the right and downward as you can see from the scales on top and side of the lens, near the camera body. Shifting the lens is simple. Just grab it and push it in the direction you want it to move. It does remarkable things to improve shots of buildings and interiors.

Zoom Control—Some zoom lenses use a single control ring for focusing and zooming. Turn the control to focus and slide it forward or backward to zoom. This design is sometimes called *one-touch*. Other zoom lenses have two controls: one to focus and another to set focal length. Olympus manufactures both types.

Aperture Variation—A zoom lens can be made simpler, lighter and less expensive if the *f*-number is allowed to vary a small amount as focal length is changed. An example is the 35-105mm *f*-3.5-4.5 lens. If the aperture ring is set to *f*-3.5 and focal length is changed from 35mm to 105mm, the aperture will change from *f*-3.5 to *f*-4.5. At any other setting, the aperture will change similarly as the lens is zoomed.

With the camera on automatic exposure, this doesn't matter. Exposure will be correct for the actual aperture, whatever it is. You can zoom during exposure if you wish.

With the camera on manual, set exposure after setting lens focal length. The camera exposure meter reads the amount of light that comes through the lens at that aperture.

To make an exact aperture setting for use with flash, there are two index marks on the aperture scale. One is used at 35mm, the other at 105mm. For intermediate focal lengths, make an intermediate setting.

Close Focusing—Some zooms have a control that allows closer focusing than normal, with a slight reduction of image quality.

The 35-105mm *f*-3.5-4.5 is an example. Used normally, the closest focused distance is 1.5 meters. At the Close-Focus setting, the minimum distance is 0.31 meter at 35mm and about 0.9 meters at 105mm. Magnification is about 0.2 at 35mm and 0.15 at 105mm. Focus is affected mainly by the setting of the Close-Focus ring and the zoom control. Turning the focus control has little effect.

THE SHIFT LENS

A common problem in photographing architecture is that corners of a room or building look closer together near the top of the photo. This makes it appear that the structure is leaning backward. This sometimes surprises the unwary—but it shouldn't

If you point the camera up to get all of the building and not much parking lot, the building seems to lean over backward. You can see it in the viewfinder: The sides of the building are not parallel with the sides of the frame.

What to do: Hold the camera so the film plane is parallel to the face of the building and the sides of the building are parallel with the sides of the viewfinder. This gives you too much parking lot and not enough building.

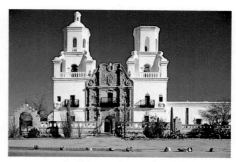

Then shift the lens upward and watch the building move *downward* in the viewfinder until the top of the building is in the frame. Hold the camera that way and shoot. For the OM-1N and OM-2N, Focusing Screen 1-10 is designed to help you use the shift lens.

because you can see it before you take the picture. You can avoid this effect by holding the camera so vertical lines of a structure, such as corners, are parallel to the sides of the viewfinder.

This means holding the camera so the film plane in the camera is parallel to the face of the building you are photographing. Often, you can't get the picture you want that way. When shooting a tall building, you get a lot of parking lot but not enough building to show the top. Angle the camera upward to include all of the building and it seems to fall over backward in the resulting photo.

A Zuiko shift lens solves the problem. Instead of making a 44mm diameter image circle that is only slightly larger than the film frame, as conventional lenses do, this lens makes an image circle about 60mm in diameter.

Assume you are holding the camera with the film plane parallel to the front surface of a building. Within that 60mm image circle is the entire building plus a lot of parking lot in the foreground.

You can't get all of the image inside the film frame anyway, so the trick is to select the part you want and put it inside the frame. In this example, you want to include the building but leave out most of the parking lot.

If you could move the film frame around inside the image circle, you could select any part of it that you want to put on film. Of course you can't do that. But, with a shift lens, you can move the image circle in respect to the film frame. This is because you can shift the lens itself—vertically and horizontally.

The lens body is attached to the lens mount through two sliding joints. One allows up-down motion. The other allows left-right motion. You can use both slides together to shift the lens diagonally. Just grab the lens barrel and move it in the direction you want it to go—a simple and uncomplicated design.

The image in the viewfinder will shift in the same direction you move the lens. And, what you see in the viewfinder is what will be recorded in the film frame. If the view does not include the top of a building, but you

want it to, shift the lens upward. This is shown in the accompanying drawing and photos.

You can do other tricks with a shift lens. Sometimes you have to stand where your shadow or reflection is in the picture. If you move to the side, you don't get the composition you want. Put on your handy shift lens, move to the side so your shadow is out of the picture, then shift the lens sideways to regain the composition you want.

There are two Zuiko Shift lenses, the

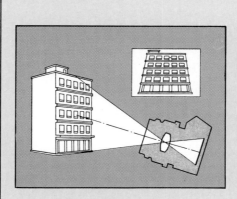

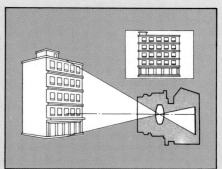

A shift lens makes a larger image circle than the diagonal of the film frame. If you tip the camera up to include the top of the building, the building seems to lean over backward as shown in the inset drawing at left.

If you hold the camera so the film plane is parallel to the face of the building and shift the lens *upward* to include the top of the building, perspective is OK as you can see in the inset drawing at right.

The image in the film frame is off-center in respect to the image circle cast by the lens—it uses more of the bottom part than the top. Remembering that the image on film is upside down, you can see that the top of the building is included in the film frame.

Using a 24mm wide-angle lens, I brought back this souvenir of a cold and overcast day in the Rocky Mountains.

For some views, a telephoto lens is either helpful or essential.

24mm *f*-3.5 and the 35mm *f*-2.8. The 35mm Shift lens specs show two angles of view— 63° (Max. 83°). The angle of view of a conventional 35mm lens is 63°, which is what actually appears within the film frame. The actual angle of view is 83°, which gives the larger image circle.

Similarly, the 24mm Shift lens has a nominal angle of view of 84° but an actual angle of view of 100°.

There is a special metering precaution. Olympus recommends that you compose the scene as you intend to shoot it, but without shifting the lens. In other words, if you intend to include the top of a building in the frame, tip the camera up so you see the top in the viewfinder. Take the meter reading this way and set the controls. Then tip the camera downward so the film plane is vertical, shift the lens upward to get the view you want and take the picture without changing exposure controls.

The reason for this is mildly complicated. With nearly all lenses, image brightness is less at the edge of the image circle than in the center, but usually we don't notice it. With wider-angle lenses, the problem becomes worse and if you look for it, you will see less brightness in the corners of the frame than in the center. In optics, this fall off in brightness is called the *cosine⁴law*.

Because the actual angle of view is 83° or 100°, the edge of the image circle is visibly darker than the center and the fall off is quite rapid near the edge. If you shift the lens and then take an exposure reading, the darker perimeter of the image circle will cause the camera meter to recommend more exposure than the center part of the photo really needs. If you shoot that way, the center part may be overexposed.

Following the recommended metering procedure gives priority to the center of the image and lets other parts of the image become darker when you shift. In the example of shifting upward to get the top of a building in view, the top and the upper corners of the frame may be darker but the main part of the building should be properly exposed.

The shift lens does not have automatic diaphragm. It requires stopped-down metering using a special procedure. When you rotate the aperture ring on the lens, the aperture will not close unless the depth-of-field preview button is depressed. To make stopped-down exposure measurement easier, the depth-of-field preview button locks in when depressed.

Leave the button locked in while you take the exposure measurement and while you take the picture. In other words, you meter and shoot with the depth-of-field preview button locked in. After shooting, you can unlock the button by pushing it a second

time. This lets you view once again with maximum brightness so you can compose and focus for the next shot.

Here's the operating sequence: Switch the camera to manual if on auto. Without shifting, point the lens at the scene you intend to shoot. Focus. Push in the depth-of-field preview button. Adjust the exposure controls to center the needle. Tilt the camera so the film plane is parallel to the surface you are shooting. Shift the lens to get the view you want. Shoot without changing the exposure controls even though the needle is no longer centered. Push the preview button a second time to unlock it.

If you find that your pictures are slightly overexposed in the center area, make some tests using the Exposure-Compensation Dial on the camera to find a setting that corrects the problem.

It's very easy to discover that you must have a shift lens in your camera bag. All you have to do is use one a couple of times and you will probably decide that it is essential. I think a shift lens is very useful for travel photography. The angle of view is wide enough for many shooting situations in close quarters. Using the shift feature on architecture makes your pictures look professional.

Focusing Screen 1-10 is recommended for use with the shift lens. The vertical and horizontal lines on this screen help you use lens and camera so buildings are vertical and not leaning in your photos.

MACRO LENSES

There are several macro lenses listed in the lens table. I'll disuss the 50mm macro lens here. Chapter 12 covers close-up and macro photography in detail and you'll find information on the other lenses there.

The word *macro* means that magnification is larger than 1. The image on film is larger than the object in real life. The word is also used to mean the use of special equipment to make larger-than-usual images in the camera, whether they are larger than life size or not.

The 50mm macro lens is an example of the latter meaning. When mounted directly on the camera without any accessories, you can get a magnification of 0.5 with this lens— image size is half as large as the subject.

The closer you can position a lens to an object being photographed, and still focus the lens, the larger the resulting image on film. The minimum focusing distance of ordinary 50mm lenses is about 18 inches. Magnification when focused that close is only about 0.15. The 50mm macro focuses to about 9 inches and at that setting has a magnification of 0.5.

As you know, focusing a lens on a nearby subject requires the lens to move away from

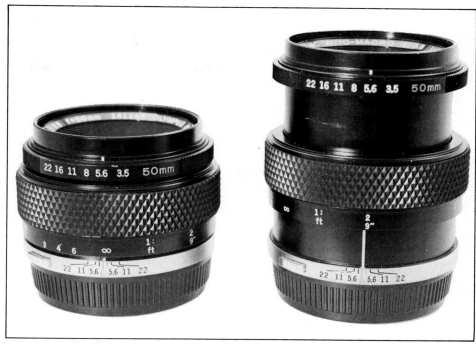

The 50mm Macro lens can be mounted directly on the camera. The focusing movement of this lens is 25mm which is much more than other 50mm lenses. This provides a magnification of 0.5 using this lens with no accessories.

ZUIKO LENSES WITH CLOSE-DISTANCE CORRECTION MECHANISM

Lens Type	Lens
Super-Wide-Angle	Zuiko 18mm *f*-3.5
	Zuiko 21mm *f*-2
	Zuiko 24mm *f*-2
Wide-Angle	Zuiko 28mm *f*-2
Standard	Zuiko Macro 50mm *f*-3.5
	Zuiko Macro 50mm *f*-2
Telephoto	Zuiko 85mm *f*-2
	Zuiko 100mm *f*-2

the film plane. This is done in most lenses by an internal screw thread in the body, called a *helicoid*. When you rotate the lens focus control, the glass elements of the lens travel in and out on the helicoid.

The 50mm macro lens has a longer helicoid than usual so it can move farther from the film plane and thereby focus on closer subjects and give more magnification.

To photograph objects in nature, small items such as jewelry or stamps, rock collections and anything from the size of your fingernail to the size of your fist, the 50mm macro serves very well. With no accessories

and no special techniques you can fill the frame by cranking out the lens on its long-travel helicoid.

The front glass element of the lens is deeply recessed so it doesn't need a lens hood. It won't gather as much light as ordinary 50mm lenses because maximum aperture is *f*-3.5. Except for that, the 50mm macro does everything that ordinary 50mm lenses do, and more.

By using extension tubes or a bellows between this lens and the camera body, magnifications greater than 0.5 are possible, as discussed in Chapter 12.

OLYMPUS AUTOFOCUS LENSES

Lens Type	Lens	Angle of View (Degrees)	Minimum Aperture	Min. Focus (Close Focus) Meters	Length (mm)	Weight Grams	Filter Diam. mm
Wide Angle	AF 24mm *f*-2.8	84	*f*-22	0.25	32	170	49
	AF 28mm *f*-2.8	75	*f*-22	0.30	32	170	49
Standard	AF 50mm *f*-1.8	47	*f*-22	0.45	32	170	49
Macro	AF Macro 50mm *f*-2.8	47	*f*-32	0.20	57	340	49
Zoom	AF 28–85mm *f*-3.5–4.5	75–29	*f*-22–27	0.80 (0.6)	84	460	55
	AF 35–70mm *f*-3.5–4.5	63–34	*f*-22–32	0.75 (0.45)	53	250	49
	AF 35–105mm *f*-3.5–4.5	64–23	*f*-22–27	1.50 (0.85)	84	460	55
	AF 70–210mm *f*-3.5–4.5	34–11	*f*-22–32	1.50 (1.35)	125	790	55

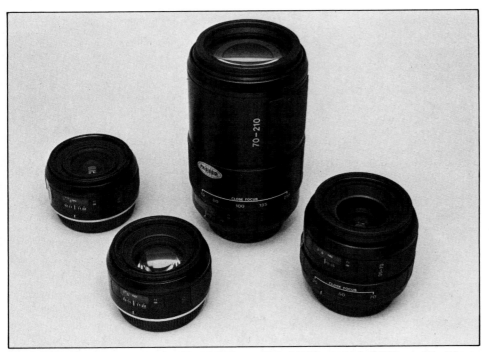

Olympus AF lenses from left to right: AF 28mm *f*-2.8, AF 50mm *f*-1.8, AF Zoom 35—70mm *f*-3.5—4.5, AF Zoom 70—210mm *f*-3.5—4.5. AF Zoom lenses have Close-Focus capability without any special control settings.

AUTOMATIC CLOSE-DISTANCE CORRECTION MECHANISM

Ordinary lenses are designed to give the best images when focused on subjects at medium distance or farther. This is because most lenses are used that way. It is not possible with an ordinary lens to make lens corrections that work equally well at all distances. Therefore, ordinary lenses give slightly reduced image quality when focused at short distances.

A relatively new design technique has been used to solve this problem. The lens is more complicated because not only do all of the glass elements move for focusing, but also some of the elements move in respect to the others. The elements that change position independently are called *floating elements*. Lenses designed this way have an automatic *close-distance correction mechanism*.

OLYMPUS AF LENSES

Along with the OM77AF camera, Olympus announced eight AF lenses—shown in the accompanying table. All operate with full-aperture metering and have automatic diaphragm. Four are zooms with close-focus capability at all focal lengths.

HOW TO USE FLASH

Different combinations of Olympus cameras and flash provide different operating features, depending on the models. A table later in this chapter shows these differences. This discussion begins with general information about flash and operating features that are common to more than one model. At the end of this chapter, specific models are described with their characteristics and specifications.

ARTIFICIAL LIGHT SOURCES

Photographers commonly use artificial light sources of three types: flashbulbs, electronic flash, and continuous sources such as incandescent lamps.

Flashbulbs superseded the old-fashioned pile of flash powder that the photographer held aloft and burned to make a bright light. In the same way, electronic flash has replaced flashbulbs in SLR photography.

FLASH MOUNTING METHODS

Whatever kind of flash you use, if it is portable there is usually some way to attach it to your camera. This combines flash and camera into one unit that is easy to carry and handle. Flash on camera is not always the best way to use flash. Nevertheless, it is common because of its convenience.

Hot Shoes—The first flash-holding gadgets used on cameras were simple metal brackets called *accessory shoes*. To install a flash unit, slide the mounting foot of the flash into the accessory shoe.

Later, accessory shoes were equipped with an electrical contact that mated with a contact in the mounting foot of the flash. This allows the camera to fire the flash without any other electrical connection between flash and camera. This type of flash mount is commonly called a *hot shoe*. Olympus calls it an Accessory Shoe.

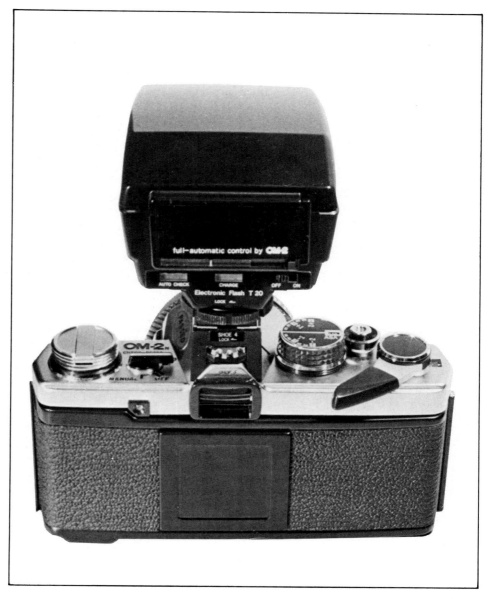

Olympus T-series flash units can be controlled by an Olympus camera on automatic, which has several advantages including great simplicity of operation.

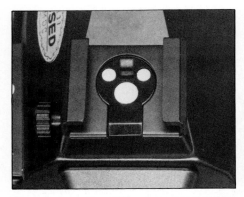

The hot shoe of an OM camera has a center contact to fire the flash. One or more smaller auxiliary contacts provide special operating features with Olympus flash units.

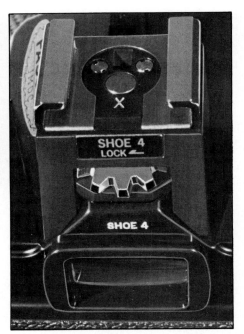

OM-1N accessory shoes are removable. They fit on top of the pentaprism housing and are attached by turning the screw just below the word LOCK in the direction of the arrow.

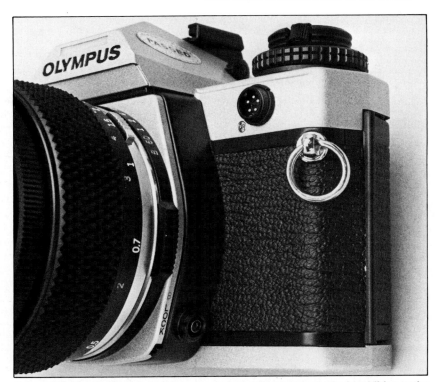

Some OM cameras have two sync connectors on the camera body, in addition to the hot shoe. This OM-4T has a PC socket near the bottom of the lens mount to accept single-conductor PC cords. It also has a multi-pin connector—on the front near the Rewind Knob—to accept multi-pin TTL Auto Cords.

Flash Brackets—Another way to combine flash and camera into one unit is an accessory bracket that holds both. One arm of the L-shaped bracket extends under the camera body and uses the camera's tripod socket to mount the camera. The vertical arm serves as a grip and mounts a flash unit.

The grip allows the flash to be tipped upward, so the light bounces off the ceiling, and also rotated horizontally if desired. This technique is called *bounce flash.* Olympus calls this a *bounce grip.*

Sync Cords—When flash is not mounted in a hot shoe on the camera, an electrical cord is used between flash and camera so they can operate together. Common names for these cords are *PC cord, sync cord* and *synch cord.*

One type of electrical connector on camera bodies is called a *PC socket,* whence the name PC cord.

Standard PC sync cords have only a single conductor. They are used to fire a flash but do not provide any special "dedicated" features.

TTL AUTO CORDS

Olympus T-series flash units offer a variety of special features, such as viewfinder displays to show when the flash is ready and automatic control of the flash by the metering system in the camera.

To provide these features with the flash mounted on the camera, Olympus hot shoes have several electrical contacts.

To provide these features with the flash detached from the camera, special TTL Auto Cords are used to connect flash to camera. These cords use multi-pin connectors on each end. They connect directly to multi-pin sockets on most current camera and flash models.

ELECTRONIC FLASH

Electronic flash requires a high voltage, usually obtained from batteries through a voltage-multiplying circuit.

Electronic flash units fire virtually instantaneously and reach full brightness immediately. They produce light that has approximately the same photographic effect as daylight. Filters on the camera lens or over the flash can be used to alter the color if necessary.

ELECTRONIC FLASH WITH A FOCAL-PLANE SHUTTER

As you know, exposure time with a focal-plane shutter begins at the instant the first curtain is released to travel across the frame. At the end of the desired exposure time, the second curtain is released to close off the frame.

When the first curtain reaches the end of its travel, the film frame is uncovered as far as the first curtain is concerned. At that instant, the camera shutter mechanism closes electrical contacts in the camera to fire the electronic flash.

If the second curtain is following too closely behind the first, at 1/500 second for example, part of the frame will already have been covered by the second curtain at the instant of the flash. The only part of the frame that could be exposed is the narrow slit between the two curtains.

To use electronic flash with a focal-plane shutter, a shutter speed must be selected so the first curtain reaches the end of its travel

and then a brief moment passes before the second curtain *begins* its journey across the frame. During that moment, all of the frame is open to light and the flash occurs.

This means the exposure time must be longer than the time required for the first curtain to travel across the frame. The fastest shutter speed that allows use of electronic flash is called the *X-synchronization* speed, or *X-sync*. With electronic flash, you can operate the camera at the X-sync shutter speed, or *any slower* speed.

X-SYNC FOR OM CAMERAS

The theoretical X-sync speed for most OM cameras is 1/60 second but sometimes there is a practical reason to use 1/30 instead. This is discussed later in this chapter.

GHOST IMAGES

When using electronic flash, the shutter is held open for 1/60 second or longer. But the actual time of exposure due to the bright light of the flash itself is very much shorter: 1/500 second to as little as 1/50,000 second.

If sources other than the flash provide enough illumination on the scene to cause some exposure during the full time the shutter is open, then there are two exposures: one short-time exposure due to the flash and another longer-time exposure due to other sources—such as ambient light on the scene. If the subject moves while the shutter is open, or if the camera moves, the image due to ambient light will not be in register with the image due to flash. This can cause a blur or a faint "echo" of the subject on film.

With a motionless subject, the cure is to hold the camera still during the entire period of exposure. With a moving subject, there isn't much you can do about it except try to shoot so the flash is dominant and the other light is too dim to make a visible image. Or else pan with the subject. *Pan* means follow motion by moving the camera.

SHORT- AND LONG-DURATION FLASH

The preceding discussion of X-sync shutter speed was based on using electronic flash with a very short time duration, such as 1/20,000 second. With *conventional short-duration flash*, it is necessary to use a shutter speed slow enough that the first shutter curtain is fully open when the flash fires, but the second curtain has not yet started to close. That is the X-sync shutter speed.

With conventional flash, X-sync or a slower shutter speed can be used. Sometimes, using the relatively slow X-sync shutter speed, or a slower speed, is a disadvantage.

When shooting in *continuous light*, such as daylight, any shutter speed can be used

because the light exists throughout the exposure.

FP Flashbulbs—There is a special long-duration flashbulb type, called FP (focal-plane shutter). It simulates continuous light because it is fired before the shutter opens and does not extinguish until after the shutter closes. To the camera, there is no difference between continuous light and the light of an FP flashbulb. Shutter speeds faster than X-sync can be used—up to the fastest available speed on the camera.

The shutter-speed problem with FP flashbulbs is to avoid using a speed so slow that the bulb extinguishes while the shutter is still open—because the amount of exposure would be unpredictable.

FP flashbulbs burn for about 1/40 second. You must get the shutter open and closed again during that interval. This allows shutter speeds of 1/60 *or faster*, but not 1/30 or slower.

Among the cameras discussed in this book, only the OM-1N is designed to use FP flashbulbs.

F280 FULL-SYNCHRO FLASH

Olympus developed a novel electronic flash, the F280, which is the electronic equivalent of an FP flashbulb. The F280 has two modes. It can fire in a single short-duration burst, the same as conventional electronic flash. This mode is used with X-sync shutter speed or slower.

Or, the F280 can "spread out" the light to occupy a longer time, such as 1/40 second—which is called the Super FP mode. In this mode, the flash tube does not emit light continuously. It is pulsed on and off, 20,000 times per second. To the film, it appears to be continuous light.

The total amount of light produced in the

two modes is about the same. As an analogy, the single-burst mode can be thought of as a dollar bill while the Super FP mode is like 100 pennies.

With the F280 in the Super FP mode, there is no upper limit to shutter speed except what is available on the camera. You can use 1/2000 second, for example. At shutter speeds of X-sync or slower, the Super FP mode has no advantage over the conventional single-burst mode. Either may be used, depending on the camera model.

For example, the OM77AF automatically selects the Super FP mode at shutter speeds faster than 1/100—which is X-sync speed for this camera. The camera chooses the single-burst mode at 1/100 or slower speeds. With the OM-4T, you can select either mode at slow shutter speeds.

SELECTING FLASH SYNC

OM-1N cameras have a Flash Sync Selector switch to select X or FP sync at the camera-body sync socket when a hot shoe is not installed. With a hot shoe installed, X-sync appears at both hot shoe and camera-body sync socket, no matter how you have the switch set.

The other cameras in this book offer X-sync only from the hot shoe, the PC connector on the camera body or the multi-pin connector on the camera body. An exception is the sync pulse used to fire the F280 flash in the Super FP mode—discussed later in this chapter.

Firing Flashes Simultaneously— You can fire one flash in the camera hot shoe and another that is cord-connected to the camera-body sync socket.

Accessory optical "slave" units are available to fire multiple flash units without multiple electrical connections to the camera.

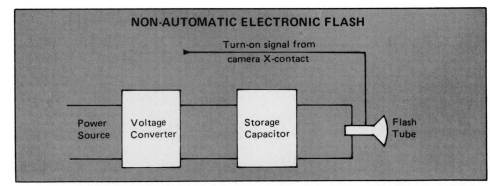

NON-AUTOMATIC ELECTRONIC FLASH

Turn-on signal from camera X-contact

Power Source — Voltage Converter — Storage Capacitor — Flash Tube

Figure 11-1/A non-automatic electronic flash is turned on by an X-sync signal from the camera. It makes light until the storage capacitor discharges. Then the flash tube extinguishes.

These units sense the light output of the first flash, which is fired by the camera. The slave triggers another flash that is connected only to the slave.

Multiple slaves and flash units can be used if needed. A disadvantage is that they can be triggered by another photographer's flash. Another is that exposure control with multiple flash is very difficult.

With special connectors and TTL Auto Cords, described later, you can fire and control exposure from up to nine flash units simultaneously. This method eliminates both of the disadvantages of optical slaves.

NON-AUTOMATIC ELECTRONIC FLASH

You don't have to be an electronic whiz to understand the basic operation of an electronic flash. Figure 11-1 shows a power source feeding a voltage converter. The power source is usually batteries, but for some equipment it is AC power from a wall socket.

Either way, the electrical voltage needed to operate the flash tube is higher than the source provides. A special circuit in the flash converts the source voltage to a higher voltage. This high voltage is accumulated in a capacitor.

An electrical capacitor behaves very much like a rechargeable battery. The capacitor charges up to the high voltage from the voltage converter. When the flash is triggered, it suddenly dumps its charge into the flash tube to make the bright light.

A trigger signal is required to tell the capacitor to dump its charge and cause the flash. This is the X-sync signal from the camera. The signal wire in the drawing is shown leading to the flash tube. It turns on the flash. The flash extinguishes when the storage capacitor has discharged.

Non-automatic electronic flash and flashbulbs are similiar in one important way: The amount of light is constant and repeatable. Each time you fire a non-automatic electronic flash, you expect it to make the same amount of light. It will do that if the batteries are in good condition and if you wait long enough for the capacitor to be fully charged.

Automatic electronic flash units, discussed later, do not make the same amount of light each time they flash.

RECYCLE TIME

Once a flash has been fired, it cannot be operated again for the time needed to charge the capacitor again, or *recycle* it. This can vary from one second or less up to a period as long as 30 seconds. When batteries are the source of electricity, recycle time depends on battery condition. As the battery becomes discharged, recycling takes longer.

BRIGHTNESS-RATIO LIMITS	
With Black-and-White Film	5:1
With Color Slide Film	4:1
With Color Negative Film	3:1

As a rule of thumb, film will show detail in both shadows and highlights if you limit brightness ratio to the values shown in this table.

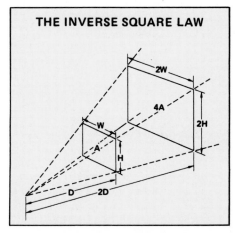

THE INVERSE SQUARE LAW

If an expanding beam of light, such as that produced by a flash, travels *twice* as far, it illuminates a surface that is *four* times as large. The amount of light on the illuminated surface decreases to 1/4 as much. If distance increases *three* times, light falls off by a factor of *nine*, which is three squared, and so forth. That's the *inverse-square law* about light.

BATTERY TYPES

If you use non-rechargeable flashlight batteries, consider alkaline cells. They give more flashes than other types, before recycle time becomes excessive.

With rechargeable batteries, longer recycle time tells you the batteries need charging. Using rechargeable batteries may damage flash units not designed for them. Check the specs for your flash.

STORAGE

The type of capacitor used in electronic flash units may deteriorate if left a long time without an electrical charge. Just before you put the flash away, it's a good idea to let it recycle so it is ready to shoot, but don't fire the flash. In long storage it is beneficial to turn on the flash unit and recharge the capacitor about once a month, returning it to storage in a charged condition.

If the flash is to be stored longer than a few weeks, remove the batteries and store them separately.

GUIDE NUMBERS

Guide numbers help you set camera exposure controls properly when using flashbulbs or non-automatic electronic flash. Higher guide numbers indicate more light from the flash.

Suppose a non-automatic electronic flash has a guide number of 60 feet for ASA 25. Here's how to use guide number (GN) to find the aperture you should use:

$$f\text{-number} = GN/\text{Distance}$$

If the guide number is 60 feet, and you are shooting at a distance of 15 feet from the subject, the *f*-number you should use is

$$60 \text{ feet}/15 \text{ feet} = f\text{-4}$$

If you move closer, say 7.5 feet to keep the arithmetic simple, the new aperture is

$$60 \text{ feet}/7.5 \text{ feet} = f\text{-8}$$

Sometimes a guide number is specified for only one film speed. If you decide to shoot with film of a different speed, you should know how to convert the guide number. Let's use the terms New GN and New ASA to mean the guide number and film speed you intend to use. Old GN and Old ASA mean the published guide number.

$$\text{New GN} = \text{Old GN} \times \sqrt{\frac{\text{New ASA}}{\text{Old ASA}}}$$

Sometimes the film speeds make the calculation easy. Suppose the guide number as stated in the specifications is 60 feet with ASA 100 film. You intend to shoot with ASA 400 film.

$$
\begin{aligned}
\text{New GN} &= 60 \text{ feet} \times \sqrt{\frac{400}{100}} \\
&= 60 \text{ feet} \times \sqrt{4} \\
&= 60 \text{ feet} \times 2 \\
&= 120 \text{ feet}
\end{aligned}
$$

If you switch to ASA 400 film instead of ASA 100 film, the guide number doubles. You can place the flash at double the distance or close the aperture two steps.

Guide numbers for electronic flash units are quoted at ASA 25 or ASA 100 or some other film speed. The flash "looks better" when a higher film speed is used as the base—because the guide number is higher.

When shopping for an electronic flash, compare guide numbers based on the same film speed.

Guide numbers are just that—a guide. They are based on photographing people indoors because more flash is used for that purpose than any other.

Some light from the flash bounces off ceiling and walls and then illuminates the subject while the shutter is still open. If you use flash outdoors, you will lose the light that would otherwise bounce off ceiling and walls and the picture may be underexposed. Try figuring aperture using the guide number; then open up one-half step or more for outdoor locations.

LIGHTING RATIO

A thing to worry about with artificial lighting, and sometimes outdoors, is the difference in the amount of light on the best-lit areas of the subject and the amount in the worst-lit areas.

Direct sunlight from above or the side can spoil a portrait by casting deep and well-defined shadows of facial features. This effect can be reduced by using reflectors to cast some light into the shadows, or using flash to fill some of the shadowed areas with more light— called *fill lighting*.

If you are using more than one source of light, you can usually control some or all of them to adjust both the amount and the direction of illumination on the subject. In portraiture and other kinds of photography, arrangement of lighting is important for artistic effect.

For a portrait, suppose there are two light sources such as flood lamps or flash. With the subject looking straight ahead, one light source is to the left at an angle of 45 degrees. Let's say this source puts 4 units of light on the subject.

Another source, at a 45-degree angle on the opposite side, puts only 1 unit of light on the subject. This gives a *lighting ratio* of 4 to 1, which is simply the ratio of the two amounts of light.

There are three values of light on the subject. Where illumination is only from the brighter source, the amount of light is 4 units. Where it is only from the less-bright source, which will be in the shadows cast by the brighter source, the illumination is 1 unit. Where both lights overlap and both illuminate the subject, the total light is 5 units.

This *brightness ratio* of 5 to 1 is only a little more than two steps, usually no problem for b&w film. It is often recommended as the upper limit for brightness variation in color photography because of the nature of color film.

Color film has two jobs to do. It must record differences in scene brightness, just

If your subject is in directional light that makes shadows, you can use a flash to fill the shadows. Photo at left was made in late afternoon sunlight. At right, there was nearly as much light from the flash as from the sun. Notice the difference in color between flash and the afternoon sun.

as b&w film records the different brightnesses along the gray scale. In addition, it has to record color information.

A simple way to think about that is to remember that brightness gets on the film first. After that, color is introduced by chemical processing. When there is conflict between brightness and color, color loses.

There are no firm rules, but by restricting the brightness ratio with color films as shown in the accompanying table, you can be pretty sure of recording details in both shadows and highlights. These ratios allow "room" on the film for both brightness and color variations. The colors themselves produce visual differences between objects, so we don't have to rely as much on brightness differences.

HOW TO CONTROL LIGHTING RATIO

If the lights are floods or flash, you can control the difference in brightness between sources by choosing sources with different light outputs. You can control the amount of light from any source by adjusting the distance from source to scene.

With floodlights, you can confirm lighting ratio by measuring at the scene with a hand-held meter, or by moving your camera up close so it only "sees" parts of the scene. Measure the brightest part and the darkest part of interest.

With lights of the same intensity, control lighting ratio by moving one farther back. If they are located so they put the same amount of light on the scene, and then one is moved back to double the distance, the light from that one drops to one-fourth its former value due to the inverse-square law.

Using Flash for Fill Lighting—When using ordinary flash, you have to predict the

amount of light on the scene when the flash happens. The simplest way is to use the guide number to figure aperture and then consider the aperture as an indication of the amount of light.

Suppose you are using two flash units to make a portrait. One is located so it requires *f*-4; the other requires *f*-8 to produce full exposure. You will get a 4-to-1 lighting ratio by setting the camera at *f*-8.

Set camera exposure controls for *the brightest light*. The flash unit that requires *f*-8 for proper exposure is obviously brighter. Use *f*-8 to avoid overexposure by the brighter source.

FLASH FILL IN SUNLIGHT

Pictures of people outdoors in bright sunlight are a problem. If the sunlight falls at an angle across facial features, it makes dark shadows that are sometimes objectionable. If the subject faces squarely into the sun, there are no shadows but the person squints. Many people avoid this problem by shooting outdoor portraits only in the shade or on hazy or cloudy days—but we can't always have the conditions we want.

A simple but effective technique is to use a white reflector to cast some reflected sunlight into the shadows. A white purse or a newspaper works fine and sometimes the subject can hold the reflector out of camera view. If not, use an assistant to hold it.

Another way is to use fill flash, considering the sun as the main source of illumination. The maximum amount of fill flash you should consider is a 1-to-1 lighting ratio. If you do this, the amount of fill light is the same as the sunlight, so there are no facial shadows at all. This looks unnatural in an outdoor environment where everything else

casts a shadow, so I don't recommend 1-to-1 lighting for outdoor fill.

If you set up so the fill light is brighter than the sunlight, the effect is unbelievable because you create facial shadows that fall in a different direction than the natural shadows in the background.

In practice, if you set up for 1-to-1 lighting using flash outdoors, you will actually get about 2-to-1 because flash is not as effective outdoors as the guide number suggests. Therefore, it is permissible to make a guide number calculation that would yield 1-to-1 indoors, knowing that you will get less illumination from the flash.

This makes a pleasing outdoor portrait in sunlight and is the procedure Olympus recommends. In the discussion that follows, I will call this a *guide-number lighting ratio* so you will know it is based on guide numbers rather than the actual amount of light on the subject produced by flash outdoors.

Here's a procedure for electronic flash fill with sunlight:

1. Set camera and flash for manual operation. Set the shutter speed as required for flash.

2. This step assumes that the flash is on or near the camera. Focus, meter the subject and set aperture for normal exposure using sunlight. If the film speed is too fast to allow using the slow shutter speed required for flash sync, you'll have to use a neutral-density filter or a slower film. Note the distance from the flash location to the subject, either by reading the distance scale on the lens or actual measurement.

3. Using the guide number of the flash, calculate aperture size for the distance between flash and subject.

4A. If you want a guide-number lighting ratio of 1-to-1, follow this paragraph. For 2-to-1, use 4B. The calculated aperture for flash should be the same as you have already set on the camera for sunlight. If it is not, use the flash guide number to figure the distance between flash and subject that will give the desired aperture setting.

$$\text{Distance} = \frac{GN}{f}$$

Example: GN is 60 feet, the aperture you want to use is *f*-11.

$$\text{Distance} = 60 \text{ feet}/11$$
$$= 5.5 \text{ feet.}$$

4B. For a guide-number lighting ratio of 2-to-1, the calculated aperture for flash should be one step larger than the camera setting. If not, use the guide number to figure distance between flash and subject using the desired aperture, as shown in step 4A.

5. Locate the flash at the calculated distance from 4A or 4B. If the flash is mounted on the camera, you also have to put the camera at this distance. If that doesn't give the composition you want, a different lens may solve the problem. Or you can use a long sync cord so you can put the flash at one location and the camera at another. The distance given by a guide number calculation is always flash-to-subject distance, no matter where the camera is.

6. Make practical adjustments. After you have tried guide-number lighting ratios of 1-to-1 and 2-to-1, you may not like either one. You may end up preferring more or less distance than the calculation suggests.

7. Shoot at the camera setting you made for sunlight.

If you cannot remove the flash from the camera because it is a direct-connected hot-shoe type, then you can't use a different distance for flash and camera. It is always possible to find some distance that will give the lighting ratio you want, but that may not give good composition of the picture.

When your calculation indicates that the flash should be moved back to reduce its light, but you can't move it back independent of the camera, you can reduce the amount of light coming from the flash. Cover half of the flash window with your fingers and about half of the light will come out. Don't do this with bulb flash—you'll burn your fingers! Another rule of thumb is that one thickness of pocket handkerchief or facial tissue reduces the light output by half.

Neutral-density filters are available for some Olympus flash units. They fit over the flash lens to reduce the light output.

You can control the lighting ratio when using non-automatic flash with sunlight by changing shutter speed. Normally you should use the X-sync speed to minimize the ghost image problem. However, if the subject will not move and you have the camera on a steady support, you can sync with electronic flash at any slower shutter speed.

If you are set up with 1/30 and *f*-4, for example, you can change to 1/15 and *f*-5.6. This will keep the same exposure due to sunlight. Reducing aperture size by one step will reduce the flash exposure by one step because the aperture is smaller. Shutter speed doesn't matter with conventional single-burst electronic flash, provided it is slower than X-sync.

PROBLEMS WITH FLASH

Flash on camera, very close to the axis of the lens, can cause "red eye" when using color film. Light rays from the flash enter the subject's eyes and reflect back to the lens from the retina of the eye. The light will be colored red from the blood vessels in the eye.

To avoid this, some pocket cameras come with an extension that raises the flashbulb a few inches above the lens. Most SLR cameras mount a flash high enough to avoid this problem, but it can happen.

To avoid red-eye problems: Brighten the room to reduce the size of the pupils in your subject's eyes. Ask the subject not to look directly into the lens. Don't mount the flash on the camera— locate it away from the camera and use a flash sync cord.

Flash on camera produces "flat" lighting because it is usually aimed straight at the face, eliminating all shadows. The exception is when the flash is used for fill lighting.

When people stand close to a wall while being photographed with flash on camera, there are often sharp shadows of the people visible on the wall behind them.

If the flash connects to the camera with a sync cord, and the cord is long enough, it is preferable to hold the flash high and to one side. This casts shadows similar to those caused by normal overhead lighting and the effect is more realistic.

Also, a flash held high tends to move shadows downward on the wall so they are not be visible in close "head shots" of people.

The light from a flash decreases drastically with increasing distance. If you photograph a group of people at different distances from the flash, and make a guide-number calculation for the middle of the group, people nearest the camera will be overexposed. Those in the center will be OK and those in the back will be underexposed.

Using guide numbers to find aperture is a bother, particularly when you are shooting in a hurry. The bother can be eliminated by using an automatic electronic flash.

BOUNCE FLASH

A technique used to avoid flat lighting and harsh shadows from a single flash is to aim it at the ceiling or a wall. With a flash detached from the camera or on a bracket, point it at an angle toward the reflecting surface so the bounced light will illuminate your subject. Some flash units intended for hot-shoe mounting have a movable head so the light can be bounced.

If the reflecting surface is colored, it will color the reflected light and change colors in a color photo.

To bounce with non-automatic flash, the distance to use in the guide-number calculation is the distance from flash to reflecting surface and then from that surface to the subject. With a little practice and a tape measure if necessary, you can learn to estimate this distance fairly well. You must also allow for light absorption by the surface, which can require opening up the lens aper-

Direct flash creates flat lighting and well-defined shadows behind the subject. Bounce flash off the ceiling produces a softer light from above, which looks more natural, and soft shadows that give some modeling of facial features. You can also bounce flash off a wall. The color of the bounce surface affects the color of the flash. Notice the color change in Bob Cazin's shirt.

ture one or two steps larger than the guide-number calculation suggests.

A flash must be more powerful—meaning make more light—to be used this way, but it is a much-improved method of taking flash pictures indoors.

For people who do a lot of flash photography, particularly portraits, it's worthwhile getting equipment so you don't have to depend on a ceiling or wall to diffuse and bounce your flash. One way is portable reflecting umbrellas. These fit on a light stand, with the open side of the umbrella pointed toward the subject. A flash unit, usually mounted on the same stand, is pointed away from the subject and into the umbrella. Light reaching the subject is bounced off the inside of the umbrella and is well diffused. The umbrella acts as a larger source of light and casts softer shadows.

Another way is to use a translucent diffuser in front of the flash. Some accessory flash units have plastic light-diffusing attachments that clip over the flash window.

ENERGY-SAVING AUTO FLASH

The first automatic electronic flash units switched off the flash tube to control expo-sure time but did it in such a way that the entire electrical charge in the capacitor was used up no matter how short the time duration of the flash. This had the advantage of controlling flash duration but wasted electrical energy.

Recent developments in auto flash use a switching circuit that does two things: It shuts off the flash at the desired instant; and if all of the electrical engergy in the capacitor was not used to make the flash, the unused energy is saved for the next flash.

An energy-saving flash unit is preferred because the battery charge lasts longer and makes more flashes. Also, when all of the charge is not taken out of the capacitor by one flash, recycle time is shorter because only the energy used must be replaced.

The word *thyristor* and the phrases *energy saving* or *series type* are used to identify this type of flash.

OPEN FLASH

A technique that is sometimes useful could be called "open the shutter and then pop the flash," but that long name is short-ened to *open flash*.

Most electronic flash units have a button on the case that will fire the flash whether or not the flash is connected to a camera. One technique is to put the camera on B; open the shutter and hold it open; fire the flash and then close the shutter. If there isn't much light on the scene, exposure depends primarily on light from the flash. If it is dark enough, you can leave the shutter open quite a while and use the flash more than once—to illuminate different parts of the scene or just to get more light.

DEDICATED ELECTRONIC FLASH

Camera manufacturers offer electronic flash units that perform special functions with cameras of the same brand. The special features do not operate with cameras of other brands. For example, the camera may have a viewfinder display that shows when the flash is ready to fire. The general name for this is *dedicated flash*.

In addition to being dedicated or non-dedicated, flash units can be categorized according to the mode of operation. Olympus flash units can operate in one or more of the following three modes: non-automatic, which is usually called *manual* and uses guide numbers, *normal automatic* and *TTL automatic*.

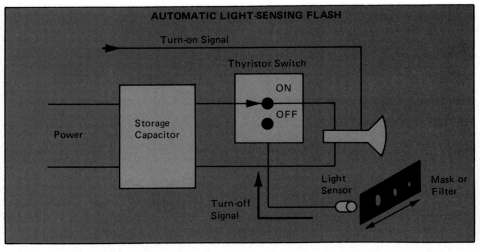

AUTOMATIC LIGHT-SENSING FLASH

Figure 11-2/A light-sensing automatic flash is turned on by the camera, then turns itself off when it has measured what it "thinks" is the right amount of light reflected from the scene.

The built-in light sensor on some Olympus flash units is inside the letter O in the word OLYMPUS on the front of the flash.

NORMAL AUTOMATIC FLASH

This type of auto flash was developed first. It uses a light sensor built into the flash.

Figure 11-2 shows the general principle. An X-sync turn-on signal comes to the flash tube from the camera. The flash is turned on and starts making light. The light sensor in the flash unit measures light reflected from the scene. When the flash sensor has measured sufficient light for correct exposure, *the flash turns itself off*.

Because this method was conventional or normal for several years, Olympus refers to it as *normal automatic* flash. Normal automatic flash always uses a light sensor outside of the camera to measure light and turn off the flash.

The light-measuring sensor of most normal automatic flash units is mounted in the flash housing, so it faces the scene when the flash unit is mounted in the camera hot shoe. Some units are designed to mount in the hot shoe but have a flash head that pivots upward for bounce flash. The sensor remains pointed straight ahead so it measures light from the same scene that the camera photographs.

Normal auto flash units eliminate guide-number calculations and are handy for bounce flash.

Specifications for different distance ranges, lens settings and film speeds seem complicated because there are many different combinations of those three variables. The data is usually presented to the user by a calculator on the flash.

You set film speed into your camera and also into the calculator on the automatic

flash. Then the calculator shows an aperture setting for the camera along with a *maximum* shooting distance. There is also a *minimum* distance. See the shooting-distance tables for the T-series flash units, later in this chapter.

Set the lens to the aperture called for by the flash calculator. You can shoot at any distance between the maximum and minimum distances without changing the aperture setting. The flash sensor measures light reflected from the scene and turns off the flash when it has measured sufficient light for correct exposure of an average scene.

If the subject is farther away than the maximum distance, the subject will be underexposed. The flash will make light as long as it can—until the capacitor is discharged—but that won't be enough because the subject is too far away.

If the subject is closer than the minimum distance, overexposure is likely. The flash turns on and then turns itself off as quickly as possible, but that may still be too much light for a subject that is too close.

Some automatic flash units allow you to choose from two or more apertures at the camera with correct exposure. Choice of aperture gives you some control over depth of field.

TTL AUTOMATIC FLASH

TTL automatic flash is controlled by the silicon sensor in the body, when the camera is on automatic.

The flash is fired by the camera. The OTF light sensor in the bottom of the camera measures light at the film plane. When suf-

ficient light has been measured for correct exposure of an average scene, *the camera turns off the flash* and closes the focal-plane shutter.

With the introduction of programmed automatic exposure, two types of TTL auto flash became possible. Both are controlled by the OTF light sensor in the camera.

If the camera is operating on aperture-priority automatic, you set aperture and the camera sets shutter speed. This is OTF automatic.

If the camera is on programmed auto, it sets both shutter speed and aperture using a built-in program for electronic flash. This is OTF *programmed automatic*.

In this book, *TTL auto* means either type. The flash is controlled by the camera. If the camera is on programmed auto, the flash is on OTF programmed auto. If the camera is on aperture-priority auto, the flash is on OTF auto.

In addition to simplicity and flexibility in general photography, this method of automatic exposure control has great advantage in some specialized applications. One is close-up and macro photography, discussed in Chapter 12. Another is the control of multiple flash units, discussed later in this chapter.

WHAT THE SENSOR SEES

All automatic flashes use a light sensor. It is either part of the camera or part of the flash. Basically, the sensor is an exposure meter that works during exposure because it must measure light produced by the flash.

The T20 doesn't have a five-pin socket. To attach a TTL Auto Cord, attach TTL Auto Connector T20 to the bottom of the flash. Another way is to mount the T20 on Power Bounce Grip 2, described later.

TTL Auto Multi Connectors are used to fire multiple flash units from one camera.

The sensor can be fooled by small subjects against unusually light or dark backgrounds, just as any exposure meter can be fooled by non-average scenes.

The sensor can also be fooled by non-average subjects that fill the entire frame.

Sensor Angle of View—As with all exposure meters, the background problem exists only when a large amount of background is in view, compared to the size of the subject. This depends on two things— what you are photographing and the angle of view of the sensor.

Electronic flash sensors usually have a fixed angle of view in the range of about 20° to 30°, depending on brand and model. This angle is sometimes called *sensor acceptance angle* or *measuring angle*.

With TTL automatic flash, the sensor angle of acceptance is always the same as that of the lens on your camera, so part of this problem is automatically solved.

Exposure Compensation with Flash— Correcting for these problems is the same as discussed earlier in Chapter 8.

With the flash on manual, you can make the correction with aperture or with shutter speed.

With the flash on normal automatic, make the correction by changing lens aperture.

With the flash on TTL automatic, make the correction with the Exposure-Compensation Dial on the camera. Even though this control changes film speed, the end result when you make the exposure is to change shutter speed. After using the Exposure-Compensation Dial, look in the viewfinder

to check the resulting shutter speed. If it is too fast for X-sync, and the flash doesn't have a Super FP mode, select a smaller aperture.

TTL AUTOCORDS AND CONNECTORS

To use a flash out of the hot shoe and retain dedicated flash features, use special sync cords called TTL Auto Cords. These cords have five-pin connectors at each end.

TTL Auto Cords are available in four lengths: 0.3m (1 ft.), 0.6m (2 ft.), 2m (6.5 ft.) and 5m (16 ft.). The 0.6m length is coiled and is convenient to use when hand-holding the flash away from the camera. The 0.3m length is intended for use with flash and camera mounted together on a bracket. The longer lengths are for setups with flash units mounted on tripods or light stands.

Using TTL Auto Cords—These cords are easy to plug in and remove if you know how. The plug body has three ridges that fit into three grooves in the mating sockets. Don't bother trying to locate these visually. Just turn the plug until it fits and push it in.

The metal outer body of each plug is slightly expanded at the tip to hold the plug firmly in place. Surrounding the outer body is a knurled metal ring that is used to install and remove the plug.

To install the plug, push in using the metal ring. This compresses the metal body so it will go into the socket and lock in place. To remove the plug, pull out on the metal ring. It takes a pretty strong pull. Don't pull on the cable.

MULTIPLE FLASH

A good way to have complete control of lighting is to use multiple light sources, each placed for the desired effect.

Olympus offers accessory cords and connectors that allow firing up to nine flash units from one OM camera. The camera measures light at the film plane and turns off the flash units when exposure is correct.

The flash must be T-series units, but models can be intermixed. The camera must be set for automatic exposure using the OTF sensor in the camera body. All cameras in this book can be used this way except the OM-1N and the OM-3.

In addition to camera and flash units, you need an assortment of TTL Auto Cords and one or more TTL Auto Multi Connectors. The multi connectors allow you to make branching connections using auto cords.

Each TTL Auto Multi Connector has four five-pin sockets—one on the back and three on the front.

With four TTL Auto Multi Connectors and suitable auto cords, you can control nine flash units. One is on the camera and the other eight wherever you place them. If some of the remote flash units are T20 type, each must be mounted on a bounce grip or TTL Auto Connector T20, shown in the accompanying photo. The auto connector provides a tripod socket. It can be used on a T32 to provide a tripod socket if desired.

To set up, put the camera on a tripod and place a maximum of eight other flashes where you want them. The only technical

limitation is that the total length of TTL Auto Cords used can not exceed 98 feet (30m).

You will find helpful information about using multiple light sources in *How to Control & Use Photographic Lighting* by David Brooks, also published by HPBooks.

BEAM ANGLE

Most portable electronic flash units are designed for a certain format. If designed for a 35mm camera, the flash will produce a rectangular beam of light whose proportions are similar to the 35mm film frame—the width is about 1.5 times the height. The flash therefore illuminates a rectangular portion of the scene. This conserves light by putting most of it in the area that will expose the film.

Because these flash units produce a rectangular pattern, it is important to rotate the flash when you rotate the camera to make a vertical shot. Then the long dimension of the illuminated area will continue to align with the long dimension of the picture. This happens automatically if the flash is mounted on the camera. If the flash is hand-held, you must rotate it yourself.

Flash units are designed to illuminate the field of view of a range of lenses, but not all lenses. The Olympus T32 flash, for example, has beam angles of 53° vertical and 74° horizontal. This approximates the field of view of a 24mm lens and covers the field of view of any lens with longer focal length. If you use the T32 with a shorter lens than 24mm, the picture will be dark around the edges. The T20 covers the field of view of a 35mm lens and anything longer.

PARALLAX

When mounted in a hot shoe, the center of the window in the flash is about four inches higher than the center of the camera lens. Therefore, the center of the illumination pattern cast by the flash will be about four inches higher than the center of the field of view of the lens.

In most cases this doesn't matter because the area illuminated by the flash is significantly larger than the field of view of the lens.

If the area covered by the flash is only slightly larger than the area covered by the lens, there can be uneven illumination due to the offset between flash and lens centerlines—called *parallax*.

What happens depends on how far away the subject is. Imagine that you are holding the camera and flash as close as possible to a wall. The area of light made by the flash will not overlap the field of view of the lens at all. They will be two separate "spots" on the wall.

If you back away, the area illuminated by the flash will become larger, the area seen by the lens will also become larger, and the two areas will start to overlap.

As distance to the subject increases, these areas become larger and the four-inch offset between their centers becomes less significant. At distances smaller than five feet, the lower corners of the picture may be darker because of the parallax error if the flash just covers the field of view of the lens.

When flash and camera are mounted on the bounce grip, a similar problem exists if the flash is pointed straight ahead. But you can correct for parallax by pointing the flash and camera so they both "look at" the same area.

CHARGE INDICATOR

Olympus flash units have a ready-light on the back panel of the flash that glows when the capacitor has enough charge to operate the flash. This light is labeled CHARGE.

The charge indication is also visible in the viewfinder of an OM camera by the steady glow of a red signal light.

If you fire the flash as soon as the charge indicator turns on, light from the flash will be less than if you wait a while longer and allow the capacitor to accumulate more charge. If you wait an additional length of time equal to the recycle interval, the capacitor will be fully charged. In other words, if it takes two seconds for the charge light to come on, wait another two seconds and get full charge.

When the capacitor has more charge, the flash will make more light, provided all of the charge is used. On manual, each firing of the flash uses all of the available charge, so there will be more light if you allow the unit to charge longer. The maximum increase is about one exposure step. If the batteries are nearly discharged, the additional light after waiting may be only a small amount more.

To eliminate this variability on manual, form the habit of firing when the charge indicator first glows or else waiting for full charge.

On either normal automatic or TTL automatic, the flash is turned off when there is sufficient light for correct exposure. Full charge of the capacitor is usually not used. Therefore, you can fire anytime the charge indicator glows.

AUTO CHECK

Another useful feature of Olympus automatic flash units is an indication that there was enough light for correct exposure of an average scene. To make this decision, the auto-check circuit monitors the condition of the capacitor in the flash and applies some rules. The rules are based on the fact that an automatic-exposure system *turns off* the flash when sufficient light has been measured. This is true whether the light sensor is in the camera or in the flash. The rules are:

• If all of the charge was used, the automatic-exposure system did not turn off the flash before the flash ran out of light. Underexposure is indicated.

• If no charge was used from the capacitor, the flash didn't fire. The camera made a correct exposure without light from the flash.

• If some charge was removed from the capacitor, but not all, the automatic-exposure system turned off the flash. Therefore, there must have been sufficient light. The auto-check system tells you so.

This works on either normal auto or TTL auto operation. There are two indicators. One is a light on the back panel of the flash, labeled AUTO CHECK. After each flash in an automatic mode, if there was sufficient light, this light will blink on and off while the capacitor recharges.

A signal light in the camera viewfinder also blinks so you can watch it instead of the flash if you wish.

Be aware that this warns you of underexposure but not overexposure.

It tells you if there was enough light, but it does not tell you if there was too much. You can avoid overexposure in an automatic mode by observing the minimum distance limit between flash and subject.

X-SYNC SPEED WITH
TTL AUTO FLASH

I said earlier that the theoretical X-sync speed for OM cameras is 1/60 second but there are practical considerations that sometimes suggest using 1/30.

This applies with a flash on TTL automatic. Suppose you have set up to use flash but the ambient light, without flash, is bright enough to cause a shutter speed of 1/250. The automatic-exposure system in the camera will release the second curtain to start closing before the first curtain is fully open. It must do this to provide a shutter speed of 1/250. This decision is made automatically, *before* the flash is fired.

If the flash were fired, the second curtain would already be partway across the frame. So, the camera does not fire the flash.

To fire the flash, the amount of light at the film plane must cause the automatic-exposure system to choose a shutter speed of 1/60 or slower *while the first curtain is opening and before the flash occurs*. You must adjust lens aperture so this happens using whatever amount of light there is on the scene.

If the viewfinder indicates a shutter speed of 1/60 second, but the light changes just as you push the shutter button, the actual shutter speed could be faster than 1/60. The flash

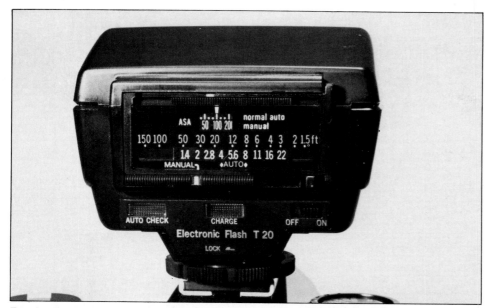

T-series flash units have a CHARGE **indicator to tell you when the flash is ready to fire. Also, an** AUTO CHECK **light to tell you if the flash made sufficient light for correct exposure of an average scene.**

won't flash.

For these reasons, when you are using flash, it is risky to set lens aperture for a shutter speed of 1/60 second in the viewfinder display even though theoretically it should be OK.

That's why Olympus suggests choosing a lens aperture that gives an indication of 1/60 second or slower when you are setting up to make a flash exposure.

In the TTL auto mode, adjusting aperture for a shutter speed indication of 1/30 actually *does not cause a longer exposure time than* setting 1/60 second. During exposure, the sensors in the camera body will turn off the flash and close the second shutter curtain when they have measured enough exposure—no matter what shutter speed was indicated.

THE EFFECT OF AMBIENT LIGHT

All automatic OM cameras provide a way for users to let the camera decide whether or not to use the flash. On TTL auto or normal auto, set the flash to operate and push the shutter button. If the ambient light requires a shutter speed faster than X-sync, the flash won't fire.

If ambient light calls for a shutter speed slower than X-sync, the flash will fire.

Suppose the flash didn't fire but you really wanted it to. Before making the next shot, set aperture so the shutter-speed indication in the viewfinder is X-sync or slower. Then you know it will fire.

VIEWFINDER SIGNAL LIGHT

OM cameras have a signal light in the camera viewfinder. This light combines the functions of the CHARGE and AUTO CHECK indicators on the flash.

It glows steadily when the flash is charged and ready to fire. After you make the exposure, if the signal light continues to glow steadily, the flash didn't fire. Shutter speed was faster than 1/60. Exposure will be OK because the camera set shutter speed for the ambient light.

If the light goes out, the flash used all of its charge. On automatic, the flash isn't supposed to use all of the charge. Therefore, this indicates that there was insufficient light from the flash and underexposure of that frame. Choose a larger aperture or move closer to the subject.

If the light blinks, there was sufficient light for exposure.

When the flash has recharged, the signal light in the viewfinder glows steadily again and you can make the next exposure.

SHOOTING WITH THE FLASH TURNED OFF

If you want to use flash for some shots and not for others, you can leave the flash mounted in the hot shoe or connected by a TTL Auto Cord. When you want it to flash, turn it on. When turned off, it will not flash and the camera will operate as though the flash had been disconnected.

T-SERIES FLASH UNITS

The number in the flash model designation is the guide number in meters. For example, the T45 guide number is 45 meters or 147 feet with ASA 100 film.

T-series flash units are similar in many details of operation. This section begins with the similarities. Then it discusses the individual models with emphasis on special features and accessories.

The T-45 is a powerful "handle mount" flash with a handle permanently attached. It does not mount in the camera hot shoe. A bracket extends from the handle to mount the camera, if desired. Flash and camera are connected by a sync cord.

The T-32 fits in the camera hot shoe. It swivels upward for bounce flash if desired. It can be detached from the camera and mounted on a handle—Power Bounce Grip 2—and cord-connected to the camera.

The T-20 fits in the camera hot shoe. It does not swivel for bounce flash. It can be detached and mounted on Power Bounce Grip 2, cord-connected to the camera.

The T-10 Ring Flash 1 is a special circular flash head for close-up and macro photography. The flash head mounts on the front of the lens. It is cord-connected to a T Power Control 1 unit, which mounts in the camera hot shoe. The T Power Control unit can also be detached and mounted in Power Bounce Grip 2 if desired.

The T Power Control unit can be used to control other flash heads that are mounted on the lens. They include T8 Ring Flash 2, which is a rear-facing ring flash that mounts on the front of the lens with a circular reflector that bounces light forward to the subject. Also, T28 Macro Flash, which is a mounting ring that attaches to the front of the lens and supports either one or two rectangular flash heads.

Capabilities—The capabilities of T-series flash units depend mainly on the camera model they are used with. The accompanying table shows which capabilities can be used with each camera model.

Except for the Ring Flash, all T-series flash units offer TTL auto flash controlled by a light sensor in the camera, normal auto controlled by a light sensor on the flash unit, and manual.

The T Power Control 1 unit does not have

CAPABILITIES OF T-SERIES FLASH UNITS

T45 FLASH Guide Number* 146 (45)

Camera	TTL Auto	Normal Auto	Manual	Bounce In Hot Shoe	Use Out of Hot Shoe	Multiple Auto Flash Units
OM-2s	yes	yes	yes	—	yes	yes
OM-1n	no	yes	yes	—	yes	no
OM-3	no	yes	yes	—	yes	no
OM-4 and 4T	yes	yes	yes	—	yes	yes

T32 FLASH Guide Number* 104 (32)

Camera	TTL Auto	Normal Auto	Manual	Bounce In Hot Shoe	Use Out of Hot Shoe	Multiple Auto Flash Units
OM-2s	yes	yes	yes	yes	yes	yes
OM-1n	no	yes	yes	yes	yes	no
OMPC	yes	yes	yes	yes	yes	yes
OM77AF	yes	no	yes	yes	no	yes
OM-3	no	yes	yes	yes	yes	no
OM-4 and 4T	yes	yes	yes	yes	yes	yes

T20 FLASH Guide Number* 66 (20)

Camera	TTL Auto	Normal Auto	Manual	Bounce In Hot Shoe	Use Out of Hot Shoe	Multiple Auto Flash Units
OM-2s	yes	yes	yes	no	yes	yes
OM-1n	no	yes	yes	no	yes	no
OMPC	yes	yes	yes	no	yes	yes
OM77AF	yes	no	yes	no	no	yes
OM-3	no	yes	yes	no	yes	no
OM-4 and 4T	yes	yes	yes	no	yes	yes

RING and MACRO FLASH

Camera	TTL Auto	Normal Auto	Manual	Bounce In Hot Shoe	Use Out of Hot Shoe	Multiple Auto Flash Units
OM-2s	yes	no	yes	—	yes	yes
OM-1n	no	no	yes	—	yes	no
OMPC	yes	no	yes	—	yes	yes
OM77AF	yes	no	yes	—	yes	yes
OM-3	no	no	yes	—	yes	no
OM-4 and 4T	yes	no	yes	—	yes	yes

* Guide number is feet and (meters) with ASA 100.

a built in light sensor for normal auto, but it is capable of TTL auto and manual flash.

TTL auto flash is available only with cameras that have OTF metering, *which is also used for flash.* The OM-3 uses a sensor in the bottom of the camera to control exposure in photography using continuous light but not with flash.

Normal auto requires only an X-sync signal from the camera to start the flash. The light sensor on the flash turns off the light when sufficient exposure has been measured. This mode is available with any camera and any T-series flash except those using the T Power Control 1 unit.

Manual flash requires only an X-sync signal from the camera. The flash produces full light output each time it is fired. This mode is available with any camera and any T-series flash unit.

Control Panels—All T-series flash units use reversible control panels. Because the T Power Control 1 unit is intended for close-up or macro photography, those panels are special and discussed later.

The other T-series control panels are similar. One side has no scales or controls. It is blank except for a label that says *full-automatic control by* followed by a list of cameras such as OM-2, OM-4. The list is updated as new cameras are introduced. When the panel is installed with the "blank" side out, the flash is set for TTL auto operation.

The other side of the panel has scales. It is used for normal auto and manual operation. In the normal auto mode, two or three aperture choices are available, depending on the flash model. In the manual mode, variable power may be available, depending on the flash model.

ELECTRONIC FLASH T45

This is a high-powered professional handle-mount flash. Guide number is 147 feet (45 meters) with ASA 100 film. Power is supplied by a rechargeable NiCad battery pack that slides into the bottom of the handle or by an accessory AC adapter.

The flash head rotates 340° and tilts from horizontal to vertical. A pushbutton on the handle must be pressed to rotate or tilt the head.

Mounting—A camera-mounting bracket clips onto the side of the flash handle and holds the camera, using a screw threaded into the tripod socket. An accessory hand strap attaches to the handle on the opposite side from the bracket.

The flash may be held so the camera bracket is either on the left or right side of the handle. The flash head is then rotated on the handle so it points forward. In the normal auto mode, the light sensor must also point

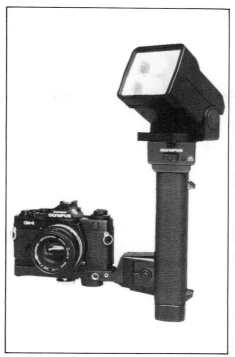

The T45 provides a mounting bracket for the camera.

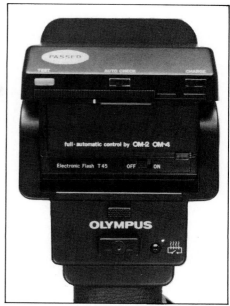

This T45 control panel is set for TTL automatic operation.

forward. There are two sockets for the plug-in light sensor—one on the front of the handle and one on the back. Plug it into the socket that faces forward. Cover the empty socket with the rubber plug provided.

Connection—The flash is cord-connected to the camera body using an accessory TTL Auto Cord T2. There are two five-pin connectors on the bracket. Either may be used, depending on which way the camera is facing. With a TTL Auto Cord, all flash modes may be used.

TTL Auto Cord T2 is available in three lengths. With OM-2S, OM-3 and OM-4 but no motor drive, use TTL Auto Cord T2 0.1m. If a motor drive is used, the longer T2 0.15 meter cord is required. To reach the five-pin adapter in the hot shoe of an OM-1N, use TTL Auto Cord T2 0.3m.

For use with cameras without a five-pin flash connector on the body, a standard PC cord is held in a groove on the bottom of the bracket. This allows only normal auto or manual flash modes.

Flash Controls and Indicators—On the back of the flash head is the ON-OFF switch, an AUTO CHECK lamp and a CHARGE indicator lamp. There is also a TEST button that fires the flash independent of the camera. The TEST button may be used to

check for sufficient light in the normal auto mode without exposing film.

Control Panel—When the reversible panel is set for normal auto and manual, move the sliding film-speed scale to place the film speed being used in the center of the film-speed window. This window is labeled ISO but you actually set in ASA film speed. If you are using ISO 120/22° film, set 125 in the film-speed window. This makes the calculator scales on the panel accurate for the film speed being used.

Six power levels are available on manual, each with a different guide number. With ASA 100, the guide numbers in feet (meters) are: 147 (45), 104 (32), 72 (22), 52 (16), 36 (11), and 26 (8).

Three apertures are available on normal auto, providing maximum operating ranges in feet (meters) of approximately 37 (11), 26 (8), and 18 (5.5). The distances do not change with film speed but the *f*-numbers do.

For example, with ASA 100 an aperture of *f*-4 provides maximum range. With ASA 400, the same range is provided by *f*-8.

Viewfinder Indicators—The T45 controls flash-related viewfinder indicators. The position and appearance of the indicators varies slightly among camera models but their functions are similar.

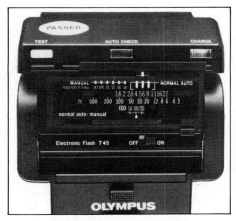

To set the T45 for normal auto operation, install the control panel as shown here. Set film speed on the panel. Move the Mode Selector to choose one of the three auto ranges.

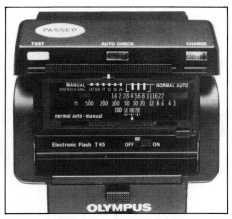

To set the T45 for manual operation, install the control panel as shown here. Set film speed on the panel. Move the Mode Selector to choose one of the five manual power levels.

T45 MAXIMUM AND MINIMUM SHOOTING DISTANCES ON AUTOMATIC WITH ASA 100 FILM*

Aperture	Shooting Range in Feet (Meters)
f-1.2	15.7 to 119 (4.8 to 36.4)
f-1.4	12.8 to 102 (3.9 to 31)
f-2	9 2 to 72.1 (2.8 to 22(
f-2.8	6.6 to 52.5 (2 to 16)
f-4	4.6 to 36.6 (1.4 to 11.3)
f-5.6	3.3 to 26.2 (1 to 8)
f-8	2.3 to 18.4 (0.7 to 5.6)
f-16	1.1 to 9.8 (0.36 to 3)

*To convert distances for another film speed (FS), multiply indicated shooting distance by $\sqrt{FS/100}$.

When the flash is charged and ready to fire, the flash-ready indicator in the viewfinder glows steadily.

On TTL auto and normal auto, after an exposure is made, the flash indicator blinks if there was sufficient exposure. If it glows steadily, the flash did not fire because shutter speed was faster than 1/60. If it goes out, the flash used full power and insufficient exposure is likely.

On manual, the indicator blinks and then turns off after each flash. It remains off until the flash charges again.

TTL Auto Operation—Set the camera to automatic. Install the flash control panel with the blank side out. Turn on the flash. Select any aperture on the lens that produces a shutter speed of 1/60 or slower with the ambient light. Wait for the flash-charge indication. Press the shutter button.

Check the exposure indicator. Shoot again or turn off the flash.

Normal Auto Operation—Set the camera to manual. Install the flash control panel with the scales out. Set film speed on the flash. Set one of the three usable apertures on the flash control panel and manually set that value on the lens. Set shutter speed to 1/30 or slower. Wait for the flash-charge indication. Press the shutter button. Check the exposure indicator. Shoot again or turn off the flash.

Manual Operation—Set the camera to manual. Install the flash control panel with the scales out. Set film speed on the flash. Set one of the manual power levels on the flash control panel. If maximum power is used, consult the calculator scales to select a suitable aperture for the subject distance. Set that value on the lens. Set shutter speed to 1/30 or slower. Wait for the flash-charge indication. Press the shutter button. Shoot again or turn off the flash.

T45 FLASH SPECIFICATIONS

Type: Energy-saving with three modes—TTL automatic, Normal Automatic and Manual.
Guide Number with ASA 100: 45m (147 feet) max. Six manual power settings available.
Beam Angle: 53° vertical, 74° horizontal. Covers 28mm lens.
Flash Duration: 1/40,000 to 1/1000 second.
Recycling Time: 0.2 to 2 seconds on auto.
Flashes per Battery Charge: 100 approx.
Color Temperature: 5800K
Working Ranges:
 TTL auto: 4.8m (15.7 ft) to 36.4m (119 ft) with f-1.2 and ASA 100.
 Normal auto: 1.4m (4.5 ft) to 11m (36 ft) with f-4 and ASA 100.
 Manual: According to guide number.
Aperture Settings at Camera:
 TTL auto: Not limited by flash.
 Normal auto: f-4, f-5.6 and f-8 with ASA 100.
 Manual: According to guide number.
Internal Power Source: 4 AA bateries. NiCad OK.

Manual With Reduced Power— To reset the calculator scales, for each step toward reduced power divide the film speed by two and reset the film speed dial *on flash only*. Starting at the maximum power setting at the left, the film-speed divisors are 1, 2, 4, 8, 16 and 32. For example, if you are using minimum power, divide film speed by 32 and reset the scale. Don't forget to change it back when you return to full power.

With Motor Drive—Use TTL Auto Cord T2 1.5m between the five-pin connector on the bracket and the five-pin connector on the camera body. Accessory M. Grip Cord 2 may be connected between the connector on top of the motor-drive grip and the matching connector on the camera bracket. This allows using the pushbutton on the flash handle to control the motor drive.

The number of repeated flashes depends on subject distance and reflectivity on automatic or power level on manual.

Overheat Indicator—If the flash overheats, perhaps because of sequential operation with a motor drive, a safety circuit turns the flash off and turns on a red lamp on the flash handle. When the flash has cooled sufficiently, it will resume operation.

Power Sources—Portable power is provided by T45 Ni-Cd Pack 1, which slides into the bottom of the handle. When recharge takes more than 15 seconds, or if the charge lamp fails to turn on, recharge the power pack using T45 Ni-Cd Charger 1. Recharging takes about 8 hours.

If AC power is available, Electronic Flash AC Adapter 2 or 3 may be used instead of the NiCad battery. Connect the AC Adapter to the three-pin External Power Socket on the flash head.

ELECTRONIC FLASH T32

This flash has three modes of operation: TTL automatic, normal auto, and manual. It is usually mounted in the hot shoe but it can be mounted on Power Bounce Grip 2 if desired. The grip is then connected to the camera using a TTL auto cord.

The flash head tilts from 15° below horizontal to vertical. Guide number is 104 feet (32 meters) with ASA 100 film.

Flash Controls and Indicators— On the back of the flash head is the ON-OFF switch, an AUTO CHECK lamp and a CHARGE indicator lamp. There is also a TEST button that fires the flash independent of the camera. The TEST button may be used to check for sufficient light in the normal auto mode without exposing film.

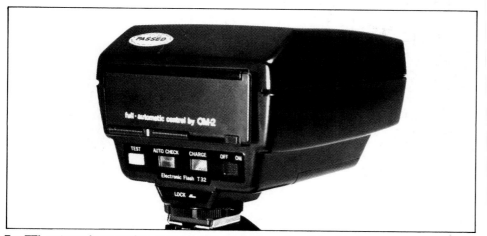

For TTL automatic operation, turn the T32 control panel so this side faces out.

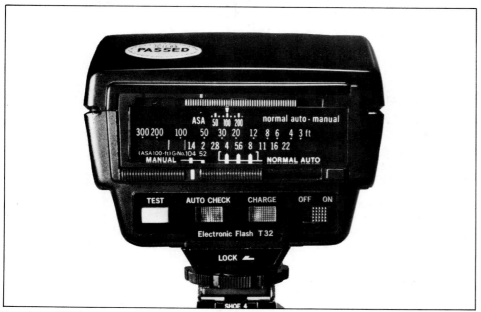

To set up a T32 for normal auto or manual operation, insert the back panel so this side faces out. The Mode Selector is just above the AUTO CHECK light. Slide the Mode Selector to select from two manual settings or three normal auto settings.

Control Panel—When the reversible panel is set for normal auto and manual, move the sliding film-speed scale to place the ASA film speed being used in the center of the film-speed window. If you are using ISO/ASA 125 film, set 125 in the film-speed window. This makes the calculator scales on the panel accurate for the film speed being used.

Two power levels are available on manual, each with a different guide number. With ASA 100, the guide numbers in feet (meters) are: 104 (32), and 52 (16).

Three apertures are available on normal auto, providing maximum operating ranges in feet (meters) of approximately 26 (8), 18 (5.6), and 4 (13). The distances do not change with film speed but the *f*-numbers do. For example, with ASA 100 an aperture of *f*-4 provides maximum range. With ASA 400, the same range is provided by *f*-8.

The control panel is used as described earlier in this chapter.

Viewfinder Indicators—The T32 controls flash-related viewfinder indicators. The position and appearance of the indicators varies slightly among camera models but their functions are similar.

When the flash is charged and ready to fire, the flash-ready indicator in the viewfinder glows steadily.

On TTL auto and normal auto, after an exposure is made, the flash indicator blinks if there was sufficient exposure. If it glows steadily, the flash did not fire because shutter speed was faster than 1/60. If it goes out, the flash used full power and insufficient exposure is likely. The viewfinder indication in the OM-4 is slightly different—see Chapter 16.

On manual, the indicator blinks and then turns off after each flash. It remains off until the flash charges again.

TTL Auto Operation—Set the camera to automatic. Install the flash control panel with the blank side out. Turn on the flash. Select any aperture on the lens that produces a shutter speed of 1/60 or slower with the ambient light. If the camera is on programmed auto, the camera sets both shutter speed and aperture. Wait for the flash-charge indication. Press the shutter button.

Check the exposure indicator. Shoot again or turn off the flash.

Normal Auto Operation—Set the camera to manual. Install the flash control panel with the scales out. Set film speed on the flash. Set one of the three usable apertures on the flash control panel and manually set that value on the lens. Set shutter speed to 1/30 or slower. Wait for the flash-charge indication. Press the shutter button.

Check the exposure indicator. Shoot again or turn off the flash.

Manual Operation—Set the camera to manual. Install the flash control panel with the scales out. Set film speed on the flash.

Set one of the manual power levels on the flash control panel. If maximum power is used, consult the calculator scales to select a suitable aperture for the subject distance. Set that value on the lens. Set shutter speed to 1/30 or slower. Wait for the flash-charge indication. Press the shutter button. Shoot again or turn off the flash.

Manual With Reduced Power— To reset the calculator scales for the low-power setting, divide the film speed by four and reset the film speed dial *on flash only*. Don't forget to change it back when you return to full power.

Power Sources—The T32 uses 4 AA-size batteries housed in the flash unit. NiCad cells are OK. Additional power can be drawn from batteries in Power Bounce Grip 2, as discussed later in this chapter. If AC power is available, Electronic Flash AC Adapter 2 may be used to power the bounce grip.

ZOOM ADAPTER T32

This is a Fresnel lens in a telescoping holder that fits over the flash window of the T32. The normal beam angle of the T32 covers the field of view of a 28mm lens. This adapter narrows the beam so it just covers the field of view of these focal lengths: 50mm, 75mm, 100mm or 135mm. Because the beam is narrower, the guide number of the flash is greater and the operating range is extended.

You can use the Zoom Adapter with the flash on TTL auto or manual. It cannot be used on normal auto because the adapter blocks the view of the light sensor on the flash.

To mount the adapter, tip the flash head fully upward. With your fingers, grasp the inner section of the Zoom Adapter at the rear and pull it backward as far as it will go. Slide the back of the adapter into the grooves in the flash window. Then tip the adapter and flash window back down.

Set the adapter by sliding the outer telescoping section until the lens focal length is visible in a window on the adapter. Do not use intermediate settings.

The effects on guide number and TTL auto ranges are shown in the accompanying tables.

WIDE ADAPTER/ND
FILTER SET T32

This is a set of three plastic panels that fit over the flash window of the T32. They can be used in all modes.

Wide Adapter Panel—This is a Fresnel lens that widens the beam angle so it covers the angle of view of a 21mm lens. This

T32 FLASH SPECIFICATIONS

Type: Energy-saving with three modes of operation: TTL Automatic, Normal Automatic and Manual.
Guide Number: HI: 32m (104 ft) with ASA 100.
LOW: 16m (52 ft) with ASA 100.
Beam Angle: 53° vertical, 74° horizontal. Covers 28mm lens.
Flash Duration: 1/1000 to 1/40,000 second.
Recycling Time: 0.2 to 10 seconds on auto with alkaline batteries.
Flashes per set of AA Alkaline Batteries: 100 to 500 on auto.
Color Temperature: 5800K.
Working Ranges:
TTL Auto: 3.4m (10 ft) to 26m (86 ft) with f1.2 and ASA 100.
Normal Automatic: 1m (3.3 ft) to 8m (26 ft) with f4 and ASA 100.
Manual: According to Guide Number.
Aperture Settings at Camera:
TTL Automatic: Not limited by flash.
Normal Automatic: f4, f5.6 and f8 at ASA 100.
Manual: According to Guide Number.
Internal Power Source: 4 AA batteries. NiCad OK.

T32 SHOOTING RANGES WITH WIDE ADAPTER OR ND PANELS IN FEET (METERS) USING ASA 100 FILM*

Lens Aperture	ATTACHMENT		
	Wide Adapter	ND4	ND8
f-2	4.6 to 36.1 (1.4 to 11)	3.3 to 25.6 (1 to 7.8)	2.3 to 18 (0.7 to 5.5)
f-2.8	3.3 to 25.6 (1 to 7.8)	2.3 to 18 (0.7 to 5.5)	1.6 to 12.8 (0.5 to 3.9)
f-4	2.3 to 18 (0.7 to 5.5)	1.6 to 12.8 (0.5 to 3.9)	1.1 to 8.9 (0.35 to 2.7)
f-5.6	1.6 to 12.8 (0.5 to 3.9)	1.1 to 8.9 (0.35 to 2.7)	0.8 to 6.6 (0.25 to 2)
f-8	1.1 to 8.9 (0.35 to 2.7)	0.8 to 6.6 (0.25 to 2)	0.6 to 4.3 (0.17 to 1.3)
f-11	0.8 to 6.6 (0.25 to 2)	0.6 to 4.3 (0.17 to 1.3)	0.4 to 3.3 (0.13 to 1)
f-16	0.6 to 4.3 (0.17 to 1.3)	0.4 to 3.3 (0.13 to 1)	0.3 to 2.3 (0.09 to 0.7)
f-22	0.4 to 3.3 (0.13 to 1)	0.3 to 2.3 (0.09 to 0.7)	0.2 to 1.6 0.024 to 0.192)

T32 SHOOTING RANGES WITH ZOOM ADAPTER T32 IN FEET (METERS) USING ASA 100 FILM*

Lens Aperture	SETTING OF ZOOM ADAPTER T32			
	50	75	100	135
f-2	7.5 to 59.1 (2.3 to 18)	7.9 to 62.3 (2.4 to 19)	8.2 to 65.6 (2.5 to 20)	8.5 to 68.9 (2.6 to 21)
f-2.8	5.2 to 39.4 (1.6 to 12)	5.6 to 42.7 (1.7 to 13)	5.9 to 45.9 (1.8 to 14)	6.2 to 49.2 (1.9 to 15)
f-4	3.6 to 30 (1.1 to 9)	3.9 to 31.1 (1.2 to 9.5)	4.1 to 32.8 (1.25 to 10)	4.3 to 34.4 (1.3 to 10.5)
f-5.6	2.6 to 21 (0.8 to 6.4)	2.8 to 22 (0.85 to 6.7)	3 to 23 (0.9 to 7)	3.3 to 24.6 (1 to 7.5)
f-8	1.9 to 14.8 (0.57 to 4.5)	2 to 15.4 (0.6 to 4.7)	2.1 to 16.4 (0.63 to 5)	2.2 to 17 (0.66 to 5.2)
f-11	1.3 to 10.8 (0.41 to 3.3)	1.4 to 11.2 (0.43 to 3.4)	1.5 to 11.8 (0.45 to 3.6)	1.6 to 12.4 (0.48 to 3.8)
f-16	0.91 to 7.2 (0.28 to 2.2)	0.98 to 7.5 (0.3 to 2.3)	1 to 8.2 (0.31 to 2.5)	1.1 to 8.5 (0.33 to 2.6)
f-22	0.65 to 5.2 (0.2 to 1.6)	0.72 to 5.6 (0.22 to 1.7)	0.75 to 5.9 (0.23 to 1.8)	0.8 to 6.2 (0.24 to 1.9)

*To convert distances for another film speed (FS), multiply indicated shooting distance by $\sqrt{FS/100}$.

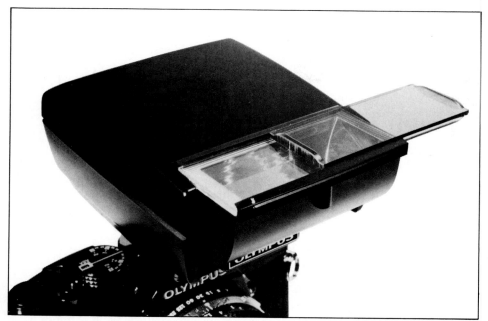

The flash head of the T32 rotates upward for bounce flash. To install accessories over the window, rotate the head fully upward and slide the accessory onto the grooves. This is a Wide Adapter.

COLOR FILTER SET T32

This is a set of five colored panels that fit over the T32 flash window. The colors are red, orange, yellow, green and blue. The orange panel is approximately the correct color to correct light from the flash for use with tungsten film as discussed in Chapter 13. Any of the panels can be used for special effect.

The simplest way to use these panels is on an automatic exposure mode, which corrects for the reduced amount of light. Use less maximum distance than the T32 allows without a panel. Observe the AUTO CHECK indication to be sure of sufficient exposure. To avoid overexposure, use the minimum distances allowed for the T32 without an accessory panel.

ELECTRONIC FLASH T20

This flash has three modes of operation: TTL automatic, normal auto, and manual. It is usually mounted in the hot shoe but it can be mounted on Power Bounce Grip 2 or TTL Auto Connector T20 if desired. The grip is then connected to the camera using a TTL auto cord.

The flash head does not tilt when mounted in a hot shoe. For bounce flash, use Power Bounce Grip 2. Guide number is 66 feet (20 meters) with ASA 100 film.

TTL Automatic—Set the reversible panel on the flash to the "blank" side. Set the camera to automatic. Turn on the flash. Select any aperture that produces a shutter speed of 1/60 or slower with the ambient light. If the camera is on programmed auto, the camera sets both shutter speed and aperture. Wait for the flash-charge indication. Press the shutter button. Check the exposure indicator. Shoot again or turn off the flash.

Flash Controls and Indicators—On the back of the flash head is the ON-OFF switch, an AUTO CHECK lamp and a CHARGE indicator lamp.

Control Panel—When the reversible panel is set for normal auto and manual, move the sliding film-speed scale to place the ASA film speed being used in the center of the film-speed window. If you are using ISO/ASA 125 film, set 125 in the film-speed window. This makes the calculator scales on the panel accurate for the film speed being used.

One power level is available on manual. Two apertures are available on normal auto, providing maximum operating ranges in feet (meters) of approximately 17 (5), and 8 (2.5). The distances do not change with film speed but the f-numbers do. For example, with ASA 100 an aperture of f-4 provides maximum range. With ASA 400, the same range is provided by f-8. The control panel is used as described earlier in this chapter.

T32 MAXIMUM AND MINIMUM SHOOTING DISTANCES ON NORMAL AUTOMATIC OR TTL OTF AUTOMATIC WITH ASA 100 FILM*

Aperture	Shooting Range in Feet (Meters)
f-1.2	10 to 86 (3.4 to 26)
f-1.4	9 to 73 (2.8 to 22)
f-2	6.5 to 52 (2 to 16)
f-2.8	4.5 to 36 (1.4 to 11)
f-4	3.2 to 26 (1 to 8)
f-5.6	2.2 to 18 (0.7 to 5.6)
f-8	1.6 to 13 (0.5 to 4)
f-11	1.1 to 9 (0.36 to 3)
f-16	0.8 to 6.5 (0.25 to 2)
f-22	0.5 to 4.5 (0.18 to 1.5)

*To convert distances for another film speed (FS), multiply indicated shooting distance by $\sqrt{FS/100}$. Example: To use ASA 400, multiply minimum and maximum shooting distances by $\sqrt{400/100}$ = $\sqrt{4}$ = 2. If shooting distance is 4.5 to 36 feet at f-2.8 with ASA 100, it will be 9 to 72 feet with f-2.8 and ASA 400.

T32 GUIDE NUMBER WITH ZOOM ADAPTER T32 USING ASA 100 FILM*

Focal-Length Setting of Adapter	Guide Numbers In Feet (Meters)
50	118 (36)
75	125 (38)
100	131 (40)
135	138 (42)

T32 GUIDE NUMBER WITH WIDE ADAPTER OR ND PANELS IN FEET (METERS) USING ASA 100 FILM*

Attachment	Guide Number
None	104 (32)
Wide Adapter	72 (22)
ND4	52 (16)
ND8	36 (11)

*To convert the guide number for another film speed (FS), use New GN and New ASA to mean the guide number and film speed you intend to use. Old GN is the guide number from the table above.

New GN = Old GN x $\sqrt{\text{New ASA}/100}$

reduces guide number and range.

ND4 and ND8 Panels—These are neutral-density filters to reduce the amount of light from the flash as discussed in Chapter 13. ND4 reduces the light by two exposure steps. ND8 reduces light by three steps. The effects on guide number and auto ranges are shown in the accompanying tables.

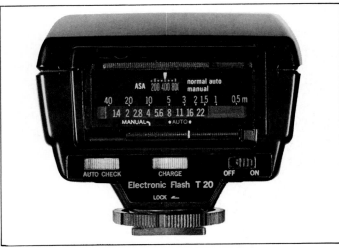

To prepare the T20 for normal auto or manual flash, move the serrated slider at the top until the desired film speed is opposite the triangular index. This flash is set for ASA 400. Then slide the Mode Selector at the bottom until the white index mark aligns with the operating mode you want. This flash is set for one of two AUTO settings. At this setting, the scales show that you should use *f*-16 for a maximum operating range of about 2.5 meters.

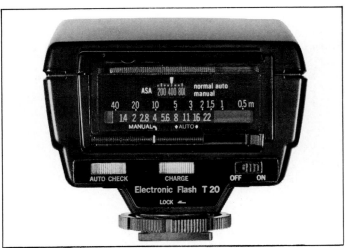

Move the slide to the MANUAL setting and the flash is non-automatic with a guide number. The two scales become a guide-number calculator. For example: use *f*-4 for 10 meters range, *f*-16 for 2.5 meters range.

T20 FLASH SPECIFICATIONS

Type: Energy-saving with three modes of operation: TTL Automatic, Normal Automatic and Manual.
Guide Number: 20m (66 ft) with ASA 100.
Beam Angle: 40° vertical, 58° horizontal. Covers 35mm lens.
Flash Duration: 1/1000 to 1/40,000 second.
Recycling Time: 0.2 to 10 seconds on auto with alkaline batteries.
Flashes per set of AA Alkaline Batteries: 120 to 500 on auto.
Color Temperature: 5800K.
Working Ranges:
 TTL Auto: 3.3m (10 ft) to 16.7m (54.8 ft) with *f*1.2 and ASA 100.
 Normal Automatic: 1m (3.3 ft) to 5m (17 ft) with *f*4 and ASA 100.
 Manual: According to Guide Number.
Aperture Settings at Camera:
 TTL Automatic: Not limited by flash.
 Normal Automatic: *f*4 and *f*8 at ASA 100.
 Manual: According to Guide Number.
Internal Power Source: 4 AA batteries. NiCad OK.

T20 MAXIMUM AND MINIMUM SHOOTING DISTANCES ON NORMAL AUTOMATIC OR TTL AUTOMATIC WITH ASA 100 FILM*

Aperture	Shooting Range in Feet (Meters)
*f*1.2	10.8 to 54.8 (3.3 to 16.7)
*f*1.4	9.2 to 46.3 (2.8 to 14.1)
*f*2	6.6 to 32.8 (2 to 10)
*f*2.8	4.6 to 23.3 (1.4 to 7.1)
*f*4	3.3 to 16.4 (1 to 5)
*f*5.6	2.3 to 11.5 (0.7 to 3.5)
*f*8	1.6 to 8.2 (0.5 to 2.5)
*f*11	11.1 to 5.9 (0.35 to 1.8)
*f*16	60.8 to 4.3 (0.25 to 1.3)
*f*22	20.6 to 2.9 (0.18 to 0.88)

*To convert distances for another film speed (FS), multiply indicated shooting distance by $\sqrt{FS/100}$.

Viewfinder Indicators—The T20 controls flash-related viewfinder indicators. The position and appearance of the indicators varies slightly among camera models but their functions are similar.

When the flash is charged and ready to fire, the flash-ready indicator in the viewfinder glows steadily.

On TTL auto and normal auto, after an exposure is made, the flash indicator blinks if there was sufficient exposure. If it glows steadily, the flash did not fire because shutter speed was faster than 1/60. If it goes out, the flash used full power and insufficient exposure is likely. The viewfinder indication in the OM-4 is slightly different—see Chapter 16.

On manual, the indicator blinks and then turns off after each flash. It remains off until the flash charges again.

T10 RING FLASH 1

This is a special flash normally used for close-up and macro photography. The flash is in two parts, a control unit and a flash head. The control unit, T Power Control 1, mounts in the camera hot shoe or on Power Bounce Grip 2—connected to the camera with a TTL Auto Cord.

The flash head is ring shaped and mounts on the front of a lens with 49mm or 55mm filter threads. Control unit and flash head are connected by a coiled cable that is permanently attached to the flash head. Built into the flash head is a set of incandescent lights to provide illumination for focusing— called the *illuminator*.

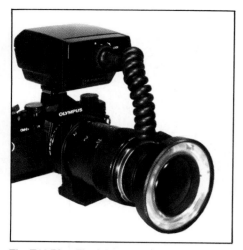

The T10 Ring Flash has two parts. The control and power source is T Power Control 1, which is usually mounted in the camera hot shoe. The Ring Flash head screws into the filter threads on the front of the lens. The two are connected by an electrical cable that is part of the flash head.

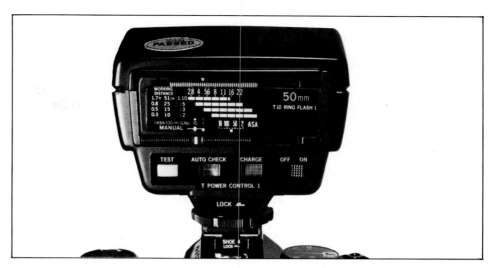

T Power Control 1 has a TTL Automatic mode and a Manual mode. To select Manual, turn the back panel so you see these scales. Each scale has a small dot and a small circle, not visible in this photo, which indicates correct aperture size by reference to the aperture scale at the top.

Two operating modes are possible, TTL auto flash and manual. Guide number is 33 feet (10 meters) with a subject distance of 1 meter, ASA 100 film and full flash power.

Flash Controls and Indicators— On the back of the flash head is the ON-OFF switch, an AUTO CHECK lamp and a CHARGE indicator lamp and a TEST button, which fires the flash independent of the camera. It does not test for sufficient exposure.

Control Panel—Special control panels are used. One side is blank for the TTL auto mode. The other side shows aperture size and working distance for several values of magnification for specific lenses. The panel supplied with the T10 is for a 50mm lens. Accessory panels are available for the 135mm macro and the 80mm macro lenses.

Manual Operation—Set the camera to manual. Set shutter speed to 1/60 or slower. Install the flash control panel with the scales out. Set film speed on the flash.

Focus and establish subject distance for the desired image size and magnification. Estimate or measure flash-to-subject distance. This is the *working distance*.

There are two manual power settings on the flash, with ASA 100 guide numbers of 10 and 4 meters. Each control panel shows scales for four working distances and the resulting magnifications. For each working distance and magnification, a solid dot on a scale indicates the correct aperture size for the higher guide number. A circle shows the aperture for the lower guide number.

Find the scale for the working distance and magnification you are using. Change working distance if necessary so one of the scales is suitable. On that scale, find the dot and circle and notice the aperture sizes shown directly above. Choose an aperture. Set that value on the lens.

If you use the aperture indicated by the dot, set the flash to the higher manual power level. If you use the aperture indicated by the circle, use the lower manual power level.

Wait for the flash-charge indication. Press the shutter button. After exposure, the flash indicator in the viewfinder will extinguish if you used the higher guide number setting. At the lower setting, the light will flicker to indicate reduced power. Disregard the AUTO CHECK lamp on the flash. Shoot again or turn off the flash.

TTL Auto Operation—Set the camera to automatic. Install the flash control panel with the scales visible. Establish working distance the same way as on manual.

Find a scale on the flash control panel that corresponds to the working distance and magnification you are using. Notice the range of aperture sizes defined by the white portion of the scale. This is the range of apertures that can be used on TTL auto.

Then reverse the control panel so the blank side faces out. Manually set a lens aperture within the allowable range so the shutter-speed indication is 1/30 or slower.

Wait for the flash-charge indication. Press the shutter button. Check the exposure in-

dicator. Shoot again or turn off the flash.

Power Sources—The T10 uses 4 AA-size batteries housed in the flash unit. NiCad cells are OK. Additional power can be drawn from batteries in Power Bounce Grip 2, as discussed later in this chapter. If AC power is available, Electronic Flash AC Adapter 2 may be used to power the bounce grip.

Illuminator Power—The incandescent lamps built into the flash ring for focusing require a separate power source. Use either 6V Power Pack 2, which uses four 1.5-volt D-size batteries, or AC Adapter 3, which plugs into household AC power.

The power cord from either of these sources plugs into a socket on the back of the ring flash. The on-off switch for the illuminator surrounds the power-cord socket.

Ring Cross Filter Polarizer— This accessory filter reduces reflections of the ring-shaped light source. It is discussed along with general-purpose polarizing filters in Chapter 13.

With Autofocus Lenses—The T10 Ring Flash will not fit on AF zoom lenses or fixed-focal-length AF lenses with built-in hoods. It does fit the AF 50mm *f*-2.8 Macro lens.

POWER BOUNCE GRIP 2

This is an accessory handle for T-series flash units except the T45, which has an attached handle. The bounce grip has a detachable bracket to mount the camera if desired. Batteries in the bounce grip supply additional power to the flash, if used. There

is a standard hot shoe on top of the bounce grip so any flash with a standard mounting foot can be used. The flash mount on the bounce grip tilts from –20° to 90° for bounce flash.

A five-pin connector for a TTL Auto Cord is near the bottom of the grip. In addition, a standard PC sync cord is permanently attached to the bracket held in a groove on the bottom. Either can be used, depending on the camera model.

Batteries in the Grip—The grip can be used as a handle without batteries. To provide additional battery power for the flash, four 1.5-volt C batteries may be installed in the grip. With T-series flash units, ordinary dry cells, alkaline or NiCad batteries can be used.

The flash draws power from the batteries in the flash and in the grip, if installed. Either way, power is controlled by the ON-OFF switch on the flash.

With batteries in the grip, recycle time is shorter and the number of flashes per battery set is greater. An accessory hand strap may be attached to the handle on the side opposite the camera bracket.

A pushbutton on the grip can be used to control a motor drive. An accessory M. Grip Cord must be used to connect the socket labeled M.GRIP CORD on the bounce grip to the Remote Control socket on the motor drive or winder.

T8 RING FLASH 2

The T8 is suitable for copying, medical photography and similar applications. It is similar to the T10 Ring Flash except that the flash head of the T8 points toward the camera. Light is reflected toward the subject by one of two interchangeable ring-shaped reflectors. This gives a soft, shadowless illumination of any subject smaller than the reflector. Specs are similar to the T10 except guide numbers. With 1 meter flash-to-subject distance and ISO/ASA 100, the guide number on Manual HI is 8 meters or 26 feet. On Manual LO, the guide number is 3.2 meters or 10 feet.

With Autofocus Lenses—The T8 Ring Flash will not fit on AF zoom lenses or fixed-focal-length AF lenses with built-in hoods. It does fit the AF 50mm f-2.8 Macro lens.

T28 MACRO FLASH

These are small rectangular flash units that are controlled by T Power Control 1, similar to the ring flashes. They are available as T28 Macro Single Flash 1 (one flash head) or T28 Macro Twin Flash 1 (two flash heads).

T28 Macro Twin Flash 1 plugs into T Power Control 1. Each flash head has a separate coiled cord. The flash heads can be supported as you wish, such as on tripods or

T10 RING FLASH SPECIFICATIONS

Type: Energy-saving with special flash head that attaches to front of lens. Two modes of operation: TTL Automatic and Manual.
Guide Number with ASA 100 and 1m subject distance:
10m (33 ft) at full power.
4m (13 ft) at low power.
Beam Angle: 80° circular.
Flash Duration: 1/1000 to 1/40,000 second.
Recycling Time: 0.2 to 10 seconds on auto with alkaline batteries.
Flashes per set of AA Alkaline Batteries: 100 to 500 on auto.
Color Temperature: 5800K.
Working Ranges: Depends on lens and magnification. Refer to flash calculator panel for lens in use.
Aperture Settings at Camera:
TTL Automatic: Not limited by flash.
Manual: According to Guide Number.
Internal Power Source: 4 AA batteries. NiCad OK.

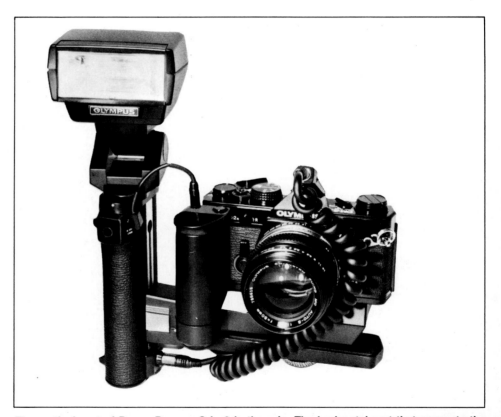

The vertical part of Power Bounce Grip 2 is the grip. The horizontal part that supports the camera is the bracket. They can be separated so you can use the grip alone, as a handle for a flash. Or, they can be connected together to mount flash, camera—and a winder or motor drive if desired—as one unit.

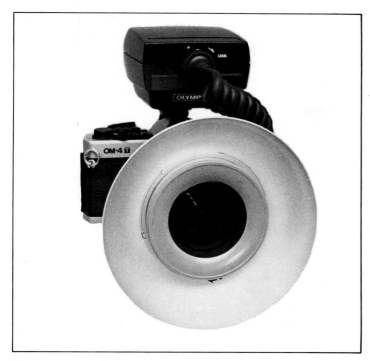

The flash head of T8 Ring Flash 2 points toward the camera. Light is reflected toward the subject by one of two interchangeable ring-shaped reflectors.

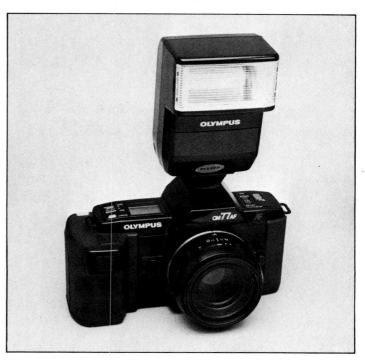

The F280 flash has both conventional single-burst flash output and Super FP long-duration flash. It is primarily intended for use with the OM-4T and OM 77AF.

handheld. The accessory Macro Flash Shoe Ring screws into the front of the lens and mounts one or both flash heads.

The flash heads can be fired individually or both together. The single-head guide number is 28 (HI) or 14 (LO) meters at ISO/ASA 100. If both heads are fired together, the guide number is 22 or 9 meters.

T28 Macro Single Flash 1 is supplied with a mounting bracket that fits on the front of the control unit, or it may be cord-connected to the power unit and supported another way, such as a tripod or the Macro Flash Shoe Ring. Guide number is 28 (HI) or 14 (LO) meters at ISO/ASA 100.

With Autofocus Lenses—The Macro Flash Shoe Ring will not fit on AF zoom lenses or fixed-focal-length AF lenses with built-in hoods. It does fit the AF 50mm *f*-2.8 Macro lens.

F280 FULL-SYNCHRO FLASH

With an OM-4T or OM77AF, this flash offers either conventional single-pulse flash or Super FP long-duration flash as described earlier. With earlier camera models, the F280 operates only as a conventional flash requiring a shutter speed of X-sync or slower.

Super FP Advantages—In the Super FP mode, shutter speeds faster than X-sync can be used, up to the maximum available speed on the camera. This has several advantages.

With an ordinary flash, if the ambient light is bright, there may be two images of a moving subject. One is a sharp image produced by the short-duration flash. The other, a ghost image, is caused by ambient light during the entire exposure interval, such as 1/60 second. The ghost image may be blurred.

Using a faster shutter speed with Super FP flash will prevent the ghost image. There is only a single exposure made by ambient light augmented by the long-duration light from the flash. By choosing shutter speed, you can control the image blur of the moving subject.

Another advantage is automatic flash fill in daylight. In a TTL automatic mode, the sensor in the camera body measures both light from the flash and ambient light. It ends the exposure when sufficient light has been measured. At distances normally used for people pictures, the F280 flash does not overwhelm the daylight exposure. The result is that the F280 fills the shadows automatically, without any figuring or calculations. It will also improve exposure of a subject against a bright background.

Flash Sync—In the single-pulse mode, the F280 is fired by the camera when the first shutter curtain *is fully open*—the same as any other conventional electronic flash. The flash emission is completed before the second curtain *begins to close.*

In the Super FP mode, the flash is fired by the camera at the instant the first curtain *begins to open.* It remains on until the second curtain is *fully closed.* That requires addi-

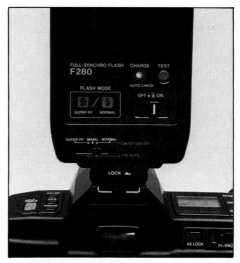

On the F280 control panel, the single flash symbol labeled NORMAL indicates that conventional single-pulse flash is being used. The double flash symbol labeled SUPER FP glows when the special long-duration flash is used.

tional electrical contacts on flash and camera.

The F280 mounting foot has five electrical contacts instead of the usual three. The hot shoes on the OM-4T and OM77AF also have five electrical contacts. The two additional contacts are for the Super FP flash mode. On the flash body is a 7-pin—instead of 5 pin—OTF Auto Cord F Socket.

The F280 can be used out of the hot shoe with TTL Auto Cord F 0.6m. One end of the cord plugs into the hot shoe and the other into the 7-pin socket on the flash.

Flash Controls and Indicators—The F280 control panel has a CHARGE indicator that glows when the flash is charged and ready to fire. The same lamp serves as an AUTO CHECK indicator, blinking to indicate sufficient exposure. The TEST button fires the flash independently of the camera.

The Flash Mode Indicator panel has two symbols. A double "lightning" symbol glows to show that the flash is operating in the SUPER FP mode. A single symbol glows to indicate that the flash is operating in the single-pulse NORMAL mode. There is an ON-OFF switch. At the bottom of the panel is the Mode Select Switch.

What Does "Normal" Mean?—With T-series flashes, Normal Auto means automatic flash using a light sensor on the flash unit—as opposed to TTL auto using the OTF light sensor in the camera.

On the F280 control panel the word NORMAL appears beside the single "lightning" symbol. If that symbol glows, it means that the flash emitted a "normal" conventional single-pulse short-duration flash.

On the F280 Mode Select Switch, at the bottom of the control panel, NORMAL is a setting of that switch. With the OM77AF, it's the normal and only setting that can be used.

With the OM-4T, setting the F280 Mode Select Switch at NORMAL provides conventional single-pulse flash requiring X-sync shutter speed or slower, using OTF automatic exposure control.

Operating Procedure—The general operating procedure is to turn on the flash and wait for the ready indication on the back of the flash or in the viewfinder. Press the shutter button to make the exposure. Check the exposure indication on the flash or in the viewfinder.

Control settings for use with the cameras in this book are shown in the accompanying table.

With OM77AF—This programmed auto camera switches the flash automatically to Super FP if the ambient light calls for a shutter speed faster than 1/100. At speeds of 1/100 or slower, the flash is switched to conventional single-pulse short-duration flash.

With OM-4T—By moving the F280 Mode Selector Switch to SUPER FP, you can use long-duration flash at any shutter speed. You can also use the F280 as a conventional flash as shown in the accompanying table.

With OM-1N, OM-2SPROGRAM, OM-3, OM-4, OMPC—The Super FP mode is not available. The F280 can be used as a conventional flash.

F280 FULL-SYNCHRO FLASH CONTROL SETTINGS

Flash Method	OM77AF	OM-4T	Other Models
SUPER FP above 1/100 sec.; Conventional at 1/100 sec. or slower.	Flash mode: NORMAL Camera mode: No special settings.		
SUPER FP at any shutter speed.		Flash mode: SUPER FP Camera mode: AUTO above 1/60 MANUAL at 1/60 or slower.	
NORMAL OTF (Conventional flash with OTF exposure control)		Flash mode: NORMAL Camera mode: AUTO at 1/60 or slower.	**OM-2S, OM-4, OMPC** Flash mode: NORMAL Camera mode: AUTO at 1/60 or slower.
MANUAL (Conventional flash with manual control)		Flash mode: MANU. Camera mode: MANUAL, 1/60 or slower.	**OM-1N, OM-3** Flash mode: MANU. Camera mode: MANUAL, 1/60 or slower.

F280 FULL-SYNCHRO FLASH SPECIFICATIONS

Type: Super FP long-duration flash with OTF control, Normal (conventional) flash with OTF control, Manual.
Guide Number at ISO/ASA 100: 28 meters, 91 feet.
Beam Angle: 53° vertical, 74° horizontal. Covers 28mm lens.
Color Temperature: 5800K.
Camera Mount: Hot shoe.
Batteries: Four 1.5V AA-size.

Super FP Working Distance* with OM77AF, f-1.8, ASA/ISO 100:

Shutter Speed	Meters	Feet
100	3.9	13
125	2.8	9.3
250	1.9	6.3
500	1.6	5.3
1000	1.1	3.7
2000	0.8	2.7

*Flash only. Ambient light extends distance.

Battery Check—If recycling between flashes takes longer than 20 seconds, change the batteries.

AF Illuminator—The F280 has a built-in AF Illuminator lamp that casts a dark red light beam on the subject to help the OM77AF autofocus system function in dim light. The illuminator is triggered automatically by the camera when needed.

12
CLOSE-UP AND MACRO PHOTOGRAPHY

You can use close-up and high-magnification photography to show the world in a different way.

Close-up photography means placing the lens unusually close to the subject, so the image on film in the camera is unusually large. *Macro* photography means making an image on film that is larger than the subject. The dividing line between close-up and macro is a magnification of 1, at which the image is exactly the same size as the subject—sometimes called *life-size*.

This isn't a firm rule except in theoretical discussions. There are lenses called *macro* that won't make a larger-than-life macro image without some help from accessories. Some of the equipment that we call *close-up* can also be used to make images in the macro range.

Making images larger than life-size is properly called *photomacrography* but many people call it macro photography. Still another branch of high-magnification photography is called *photomicrography,* which means taking pictures through a microscope. The dividing line is when you stop using camera lenses and start using the microscope instead.

The general information in this chapter about close-up and macro photography applies to all cameras. Some of the equipment discussed can be used with both autofocus and non-autofocus cameras, some only with non-autofocus models. I will tell you which equipment can be used with which cameras.

WAYS TO SPECIFY MAGNIFICATION

In this book, image size and subject size are compared to each other in only one way: *Image size divided by Subject size equals Magnification.* Magnification can also be calculated by comparing distances: *Image distance divided by Subject distance equals Magnification.* Both are written by the same formula. To find magnification (M),

$$M = \frac{I}{S}$$

Close-up lenses are a very simple way to increase image size. They screw into the lens filter threads.

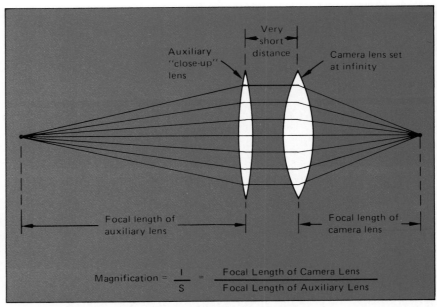

$$\text{Magnification} = \frac{I}{S} = \frac{\text{Focal Length of Camera Lens}}{\text{Focal Length of Auxiliary Lens}}$$

Figure 12-1/With close-up lenses, minimum magnification is very easy to calculate.

where I is either image size or image distance and S is either subject size or subject distance. Divide size by size, or distance by distance. You can't mix them together.

This book always does it the same way and always calls the end result *magnification*. If magnification is greater than 1.0, that means the image on film is larger than the subject. If magnification is less than 1.0, image size is smaller than subject size.

Some literature uses other terms to mean the same thing. *Reproduction ratio* means magnification as just defined.

Some literature uses the symbol X to indicate magnification. 2X means a magnification of 2. 1/5X means the image is 1 unit tall and the subject is 5 units tall. In this book, I will complete the indicated division. 1/5 = 0.2. A magnification of 1/5 is the same as a magnification of 0.2.

Sometimes it is helpful to convert magnification expressed as a decimal number into a percentage. A magnification of 0.2 is 20%, which means the image in the camera is only 20% as large as the subject. A magnification of 1 is 100%, and so forth.

MAGNIFICATION OF A STANDARD LENS

A lens used by itself on the camera has greatest magnification when focused on the closest possible subject. The closest focusing distance of a 50mm lens is a little less than 0.45 meters—the smallest marked distance on the focusing ring. This distance is measured from the film plane inside the

camera body.

When focused at the closest subject distance, magnification of a 50mm lens is approximately 0.15—the image on the negative is about 15% as tall as the subject.

CLOSE-UP PHOTOGRAPHY

If the lens you are using won't make an image as large as you need, one simple solution to the problem is use of clear-glass accessory lenses to increase magnification. These accessory lenses are usually called *close-up lenses*.

Accessory close-up lenses can be used with Olympus Zuiko and Olympus AF lenses. With AF lenses, autofocus works very well, or manual focus can be used if desired.

A close-up lens screws into the filter-mounting threads on the front of the camera lens. This results in a very short distance between close-up and camera lens. See Figure 12-1.

The subject is placed at the focal point of the close-up lens. If the close-up lens has a focal length of 500mm, the subject is placed 500mm in front of the lens. Light rays from the subject enter the close-up lens and emerge as parallel rays. The parallel rays immediately enter the front of the camera lens.

When the camera lens is focused at infinity, it is "expecting" parallel rays from a distant subject but it actually receives parallel rays from a nearby subject due to the action of the close-up lens. The camera lens

doesn't care. When it receives parallel rays, it brings them to focus behind the lens at a distance equal to its focal length. If the camera lens has a focal length of 50mm, it will bring parallel rays to focus at a distance of 50mm behind the lens—actually behind the optical point called the rear lens *node*.

In this situation, when the camera lens is focused at infinity, magnification is very easy to figure.

$$M = \frac{\text{Image Distance}}{\text{Subject Distance}}$$

Image distance is the focal length of the camera lens; subject distance is the focal length of the close-up lens. I'll show an example of this calculation in a minute.

Because close-up lenses attach by screwing into the filter threads, they are virtually universal in application. All you have to do is buy close-up lenses with the correct thread diameter to fit your lens. Several accessory manufacturers offer sets of close-up lenses in various thread diameters. These are available in commonly used sizes at most camera shops.

Focal Length and Diopters—Accessory close-up lenses are usually packaged in sets of three or four lenses. Each is identified by a number, such as 1, 2, 3, 4, or 10.

These numbers are properly called *diopters*, a measure of lens power. Eyeglass prescriptions are written in diopters. The diopter rating of a lens is the reciprocal of its focal

ACCESSORY CLOSE-UP LENSES WITH A 50mm CAMERA LENS

Close-Up Lens	MINIMUM MAGNIFICATION			MAXIMUM MAGNIFICATION		
	M	Subject Distance mm	Subject Distance inches	M	Subject Distance mm	Subject Distance inches
1	0.05	1000	40	0.21	277	10.9
2	0.10	500	20	0.26	217	8.5
3	0.15	333	13	0.32	178	7.0
4	0.2	250	10	0.38	151	6.0
1+3	0.2	250	10	0.38	151	6.0
2+3	0.25	200	8	0.44	131	5.2
1+2+3	0.33	167	6	0.5	116	4.6
1+2+4	0.35	143	5	0.55	104	4.1
10	0.5	100	4	0.73	79	3.1

Figure 12-2/This table shows approximate minimum and maximum magnifications with combinations of diopter-rated close-up lenses and a 50mm camera lens. To use other camera lenses: Doubling focal length will double *minimum* magnification. It will not double maximum magnification although it will increase.

length—1 divided by focal length—with focal length expressed in meters. To find the diopter rating of a 500mm lens, remember that 500mm is 0.5 meter.

$$\frac{1}{0.5 \text{ meter}} = 2 \text{ diopters}$$

That's a 2 close-up lens.

An easier way to do it is divide 1000 by the lens focal length *in millimeters*.

$$\frac{1000}{500\text{mm}} = 2 \text{ diopters}$$

To figure magnification with an accessory close-up lens rated in diopters, you must work that problem backwards. You know the diopter rating—it's engraved on the close-up lens—but you need to know focal length. Here's the formula:

$$\text{Focal Length (mm)} = \frac{1000}{\text{Diopters}}$$

If you have a 2-diopter close-up lens,

$$\text{Focal Length (mm)} = \frac{1000}{2} = 500\text{mm}$$

If you are using the 2 close-up lens with a 50mm camera lens set at infinity, now you can figure magnification.

$$M = \frac{\text{Image Distance}}{\text{Subject Distance}}$$
$$= \frac{\text{Focal Length of Camera Lens}}{\text{Focal Length of Close-up Lens}}$$
$$= \frac{50\text{mm}}{500\text{mm}}$$
$$= 0.1$$

In this example, the image in the camera will be 0.1 (one-tenth) as tall as the subject. That is true only when the camera lens is focused at infinity. Focus closer and two things happen: Image distance gets longer because the focusing mechanism moves the lens farther from the film. Subject distance gets shorter.

Therefore, when you focus the camera lens closer than infinity with a close-up lens attached, magnification increases. Greatest magnification occurs with the camera lens focused at its shortest distance, but it isn't simple to calculate.

Figure 12-2 does the arithmetic for you if you are using accessory close-up lenses rated in diopters. It gives minimum and maximum distances at which the subject can be focused, and the range of magnification obtainable over the focusing range of the lens. The numbers are approximate but close enough to get set up. Then look through the viewfinder to make final adjustments.

Here's how to use the table: First, figure the amount of magnification you need, using the formula M = I/S. You can compare the height of a 35mm frame with the height of your subject, or compare widths. Frame height is 24mm, a little less than one inch. For most purposes, assume it is an inch.

If the subject is 3 inches tall and you want it to fill the narrow dimension of the film frame, you want a magnification of approximately 1/3, or 0.33. With a 50mm lens, the table shows a magnification range of 0.20 to 0.38 with 4 diopters.

Stacking Close-Up Lenses—The forward end of a close-up lens frame repeats the thread pattern so you can screw one close-up lens into another—called *stacking*.

If you stack two close-up lenses with different diopter ratings, put the higher-rated lens nearest the camera. If you are stacking a 3 and a 1, put the 3 lens closest to the camera.

EFFECT OF CAMERA-LENS FOCAL LENGTH

To get more magnification with the same close-up lens, use a camera lens with longer focal length. With a 100mm camera lens, for example, minimum magnification is twice what you get with a 50mm camera lens. Change to a 200mm camera lens and you get four times as much magnification with the camera lens set at infinity.

Maximum magnification will not increase as much. That is, it will not be double or quadruple as in the preceding examples. Nevertheless, you will always get more magnification with a camera lens of longer focal length.

IMAGE QUALITY

Image quality is never as good with a close-up lens screwed on the front of the camera lens as it would be using camera lens alone. The close-up lens has aberrations that are not corrected in the design of the camera lens so the combination has reduced optical quality.

Image quality becomes progressively worse at higher magnifications. However, the image quality you need in a particular photo depends on what you are shooting and what your standards are. In general, you have to decide for yourself if a particular photographic technique gives satisfactory image quality. As a rule of thumb, some people suggest that a magnification of about 0.5 is as much as you should use with close-up lenses.

In general, stacking close-up lenses will reduce picture quality because of multiple reflections among the glass surfaces and the resultant light scattering. If you have to stack close-up lenses to get the magnification you need, naturally you will do it. I prefer to

increase magnification by using a longer-focal-length camera lens rather than stacking close-ups.

The close-up lenses described so far are typical of those available on the accessory market for any brand of camera. You can find them at most camera stores in a variety of thread sizes to fit most brands of lenses.

OLYMPUS CLOSE-UP LENSES

Olympus offers two close-up lenses that have the same focal length but differ in thread diameter. One is labeled 49mm CLOSE-UP $f=40$cm, which means it fits lenses with a filter-thread diameter of 49mm and the focal length of the close-up lens is 40cm. The other is the 55mm CLOSE-UP $f=40$cm, which fits lenses with 55mm filter threads. Both of these close-up lenses have the same focal length—40cm—which is the same as 400mm.

Notice that Olympus does not use diopter numbers to identify these close-ups. They tell you the focal length directly, which is handy, but it is in centimeters. Remember to change it to millimeters when figuring magnification with a camera lens whose focal length is given in millimeters.

You can stack two of these lenses for more magnification, but with some reduction in image quality. When two are stacked, the combination has a focal length of 200mm.

The accompanying chart shows the range of magnifications available with either one Olympus close-up lens or two stacked when used with any of the standard Zuiko lenses of 50mm focal length. Magnification depends on where you set the lens focus control. When set at infinity, you get the least magnification.

A special close-up lens called Close-Up Lens 80mm Macro is intended for use only with the 80mm macro lens. This combination is discussed later in this chapter.

EXPOSURE WITH CLOSE-UP LENSES

Close-up lenses don't change exposure enough to worry about. At higher magnifications, they make a small change that you can ignore. Usually, you will be using the camera's built-in exposure meter anyway, so it measures the effect of the close-up lens and exposure is adjusted accordingly. This applies whether you operate the camera on manual or automatic.

USING CLOSE-UP LENSES

For high-magnification photography, the camera should be on a tripod or solid mount. If you are a solid mount, you can try hand-holding. Use a lens hood to exclude stray light.

These lenses do not interfere with camera

OLYMPUS CLOSE-UP LENSES								
		MINIMUM MAGNIFICATION			MAXIMUM MAGNIFICATION			
			Subject Distance			Subject Distance		
Camera Lens	Close-Up Lens	M	mm	inches	M	mm	inches	
50mm	40cm	0.13	402	15.8	0.29	193	7.6	
	2 40cm stacked	0.26	202	8	0.44	130	5.1	
55mm	40cm	0.14	400	16	0.3	189	7.4	
	2 40cm stacked	0.28	200	8	0.43	128	5.1	

This table shows the range of magnifications available with one or two Olympus close-up lenses and a standard camera lens. Doubling camera-lens focal length will double *minimum* magnification but will not exactly double maximum magnification although it will increase.

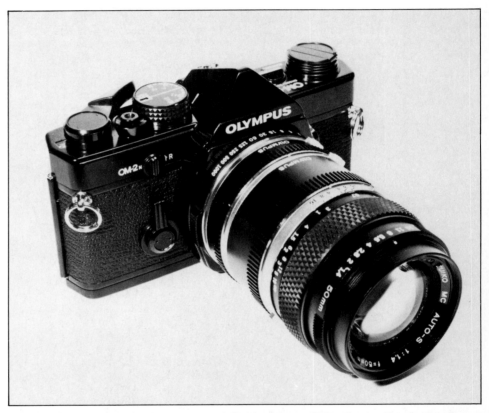

Increasing the distance between lens and film has three effects: image distance increases; subject distance must be decreased; magnification increases. Here, image distance is increased by placing extension tubes between lens and camera body.

automation, so you can meter and set exposure as you normally do. In general, you'll get satisfactory image quality if you use close-up lenses for magnifications of 0.5 or less. If you must stack them, don't stack more than two. When close-up lenses are stacked, the diopter rating of the combination is the sum of the individual ratings.

With the same close-up lens, camera lenses of longer focal length give more magnification. If you focus the camera lens closer than infinity, magnification increases; subject distance decreases.

Depth of field is usually a major problem in close-up and macro photography because it is seldom enough. About the only thing you can do is close down the lens. In the high-magnification domain, closing aperture is not as effective as in normal photography, but it will help some. Olympus recommends using f-8 or f-11 with close-up lenses.

Changing focus with any lens changes magnification, but when subject distance is small, focusing the lens causes large magnification changes. Set the focus control for magnification, then move the entire camera

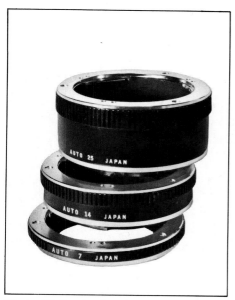

Three Olympus Auto Extension Tubes are available to fit between a Zuiko lens and a camera. Their lengths are: 7mm, 14mm and 25mm. They increase magnification of the image and preserve all automatic features of lens and camera.

back and forth to find focus.

A good way to get acquainted with a new set of close-up lenses is to try different combinations while focusing on a yardstick.

MAGNIFICATION BY EXTENSION

Rotating the focusing ring on a lens, to focus on closer subjects, moves the glass elements of the lens farther from the film. The lens elements travel along an internal thread in the lens barrel, called a *helicoid*.

As the lens is extended along the helicoid, magnification increases. The limit is the end of the helicoid because you can't extend the lens any farther. This is the near limit of focus and the maximum magnification of any lens without using accessory items to increase magnification still more.

Olympus offers several ways to move the lens away from the film for more magnification. They are attachments that fit between lens and camera body to increase lens-to-film distance or *extension*. They increase magnification, but with reduced image quality.

One handy way to increase lens extension is the use of spacers called *extension tubes* that fit between lens and camera body. It can also be done by a bellows between lens and body.

Magnification obtained by increasing the distance between lens and camera body is

calculated by the formula:

$$M = \frac{X}{F}$$

where M is magnification, X is the added distance or extension of the lens, and F is the focal length of the lens being used.

When X and F are equal, magnification is 1.0, as would be the case with a 50mm lens and 50mm of added extension with the lens set at infinity.

You can rearrange the formula to figure the amount of lens extension required for a desired amount of magnification:

$$X = M \times F$$

where the symbols mean the same as before. Suppose you are using a 50mm lens and need a magnification of 0.8:

$$0.8 \times 50mm = 40mm$$

Using bellows or extension tubes, move the lens 40mm farther from its normal position and magnification will be 0.8 with the lens set at infinity.

How Far is the Lens Actually Exended?—
Magnification of any lens is determined simply by the ratio of image distance to subject distance. The lens doesn't care how it is positioned in front of the film to get a certain image distance, but the ways can be confusing to a photographer. So, let's spend a minute on it.

When a lens is moved farther from the film, to focus on subjects that are closer than infinity and to get more magnification, the image distance may be composed of three parts:

First is the focal length of the lens. That distance is always between lens and film. Additionally, there is the forward movement along the lens helicoid if the lens focusing ring is not set at infinity. Finally, there is the thickness of any extension added between lens and camera body due to insertion of extension tubes or bellows.

The focusing helicoid in the lens can move the glass lens elements farther from the film by an amount equal to the length of the helicoid. This varies among lenses, but let's assume it's 7.5mm.

With a 50mm lens on a camera, the total distance from lens to film can range from 50mm to 57.5mm, depending on where you set the focus control. When focused on the closest subject possible, the image distance is 57.5mm.

If a separate lens extender is inserted be-

tween lens and camera, its thickness adds to the distance already there. Using 20mm for the extension device, image distance ranges from:

$$50mm + 20mm = 70mm$$

up to

$$50mm + 7.5mm + 20mm = 77.5mm$$

In both cases, total distance between lens and film includes the lens focal length of 50mm plus the added extension of 20mm that you inserted between lens and camera. The remaining 7.5mm depends on where you set the lens focus control.

When you add extension between lens and film by any kind of an extension device, the distance scale on the lens focus control no longer means anything. When you have it set for infinity, the lens is actually focused much closer than infinity. At every setting of the lens focus control, the actual focused distance is much less than the scale shows.

With added extension, think of the focus control as a way of changing the total distance between lens and film rather than a way of adjusting where the lens is focused.

Effect of Lens Nodes—As mentioned earlier, the lens-to-film distance is really the distance from the rear lens node to the film. Because it's an optical location, rather than a physical point on the lens, we can't find it to measure from. But with the lens focused at infinity, you can be sure the image distance is equal to its focal length.

Subject distance is less certain because lenses have two optical nodes—one front and one rear. Subject distance is from the front node to the subject. In complicated lens designs, such as telephoto and reversed telephoto, the lens designer puts the nodes where he needs them. The rear node may be in the air in front of the lens, and also in front of the front node. Lens designers take this calmly, but ordinary people prefer not to think about it even. Which is exactly what I recommend you do.

Because node location varies among lens types and nodes typically are separated from each other by an amount that you and I can't discover, calculation of magnification may be inexact. The formulas given here will usually be close enough but if you find a case where they aren't, just blame it on the nodes and find the magnification you need by making small changes in image and subject distances.

EXTENSION DEVICES WITH OM77AF CAMERAS

Olympus AF lenses cannot be used with the extension devices discussed in this chap-

OLYMPUS EXTENSION TUBES WITH STANDARD LENSES

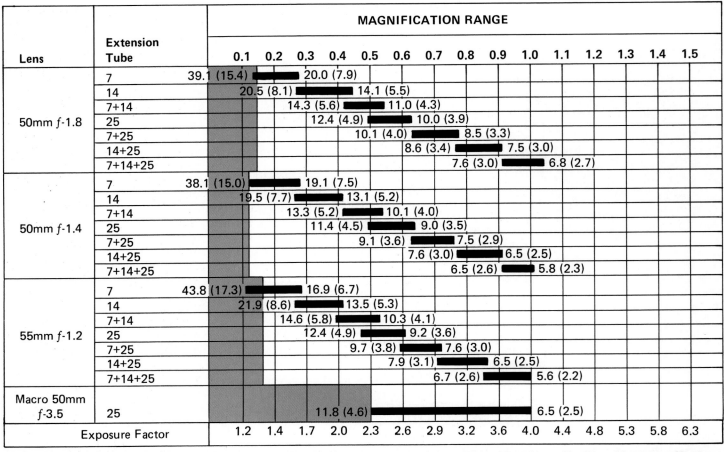

Bars show magnification range of lenses with extension tubes. Figures at ends of bars show distance from front of lens to subject plane. Numbers in parentheses are inches, numbers not in parentheses are *centimeters*. Shaded area at left is magnification range of lens mounted directly on camera. Numbers along bottom are Exposure Factors, discussed later in this chapter.

ter. These extension devices do not couple the focus motor in the camera to the AF lens, so the lens cannot be focused. When this book was prepared, no extension devices for AF lenses had been announced.

The lens extension devices discussed here were designed for use with non-autofocus cameras and Zuiko lenses. They will fit the OM77AF and function as described here, but only with Zuiko lenses and with manual focus.

With this setup, the camera provides aperture-priority automatic exposure, which is the preferred mode for macro photography. However, the OM77AF does not display aperture or shutter-speed settings in this mode.

How To Increase Magnification—When this book was prepared, there were three ways to get higher-than-normal magnification with autofocus lenses. You can use close-up lenses on the front of AF lenses; you can use the close-focus ability of the AF zoom lenses for magnifications up to about 0.2; and you can use the AF Macro 50mm f-2.8 for magnifications up to 0.5.

AUTO EXTENSION TUBES

Extension tubes are simple spacers that fit between lens and camera body. They don't have any glass lens elements in them and their only purpose is to increase lens-to-film distance.

Extension Tubes with Fixed Length—Auto Extension Tube 7, Auto Extension Tube 14 and Auto Extension Tube 25 have fixed length. The length is stated in the nomenclature—for example, Auto Extension Tube 7 is 7mm long.

They can be used singly or stacked. The tubes preserve automatic aperture operation and full-aperture metering. You meter and use the camera in the normal way.

The three extension tubes can be combined to give seven extension lengths:

Extension Tube	Length (mm)
7	7
14	14
7 + 14	21
25	25
7 + 25	32
14 + 25	39
7 + 14 + 25	46

Notice that the largest gap between any of these combinations is 7mm. If you use a 50mm Zuiko lens with these extension tubes, every extension between 7mm and about 52mm is available because these lenses have a little more than 7mm extension due to focusing.

For example, if you need an extension of 28mm, use the 25mm extension tube and then crank the lens out an additional 3mm using the focusing ring.

Lenses with focal lengths shorter than 50mm typically have focusing movements shorter than 7mm, so there are extensions that you cannot make exactly. Therefore, there are a few exact magnifications that are not possible with this set of extension tubes. Usually this doesn't matter because you can always get close to the magnification you need.

Lenses with focal lengths longer than 50mm have focusing movements longer than 7mm, so there are no gaps in the amount of extension you can get using this set of extension tubes.

Auto Extension Tube 65-116— For higher

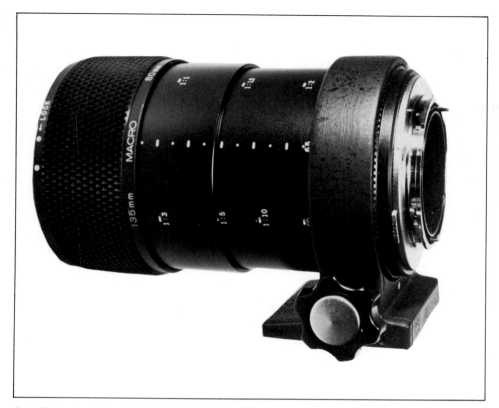

Auto Extension Tube 65-116 telescopes from 65mm to 116mm so you can set extension for the desired amount of magnification. Center scale shows amount of extension. Scales on left and right show magnification with 135mm or 80mm macro lenses.

magnifications and some special applications, Olympus offers this special telescoping tube. Turning the outer barrel counterclockwise releases the lock so you can extend the tube or make it shorter. Turning the barrel clockwise locks it at the length you have set. The extension range of 65mm to 116mm can be read on a scale on the tube.

This tube preserves all automatic features of a Zuiko lens and camera so you meter and use the camera in the normal way. It has a removable tripod mount that can be loosened to allow rotating the camera for a vertical-format shot.

Any Zuiko bayonet-mount lens can be used on the auto extension tube, but it is designed specifically for two special macro lenses: the 80mm and 135mm macros. These and some other special macro lenses that I will describe later are not intended to mount directly on a camera body. They must be used on extension tubes or a bellows.

The 80mm macro has a focusing helicoid with about 7.5mm of travel for fine focusing adjustments with the lens mounted on extension tubes or a bellows. The 135mm macro does not have a focusing helicoid and can be focused only when mounted on Auto Extension Tube 65-116 or a bellows.

To obtain a desired amount of magnification with any lens, calculate the amount of extension required and set the auto tube for that length. In addition to the extension distance scale on the tube, there are two magnification scales, one each for the special 80mm or 135mm macro lenses. With either of these lenses, just extend the tube so the scale shows the desired amount of magnification.

MAGNIFICATION RANGE WITH AUTO EXTENSION TUBE 65-116

Lens	Magnification
80mm macro	0.5 to 1.2
135mm macro	0 to 0.43

The 135mm macro has less maximum magnification but provides greater working distance between the front of the lens and the subject. This is useful for some kinds of work, such as medical photography.

The minimum magnification is zero, which is a mathematical fiction. It means the lens will focus at infinity. If there were a subject at infinity, it would be imaged with zero magnification and appear as a point.

With the Auto Extension Tube 65-116 as the focus control for the 135mm macro lens, you can use the combination just like any other 135mm lens. It will focus all the way to infinity and it will focus close enough to the subject to provide a magnification of 0.43—much more than an ordinary 135mm lens mounted directly on the camera.

The magnification range of the 80mm macro, mounted on this extension tube is 0.5 to 1.2, which means it is restricted to high magnification work and will not focus all the way to infinity. As you will see later in this chapter, this lens is specially designed for a magnification of 1.0 and it's main purpose is high magnification.

Close-up Lens 80mm Macro— Designed for the 80mm macro lens on Auto Extension Tube 65-116, this close-up lens changes the magnification range. Instead of 0.5 to 1.2, it becomes 1.0 to 2.0. This is a very simple way to get higher magnification—at a slight reduction in image quality.

Using Extension Tubes—Because extension tubes are lightweight, handy and simple to use, they are convenient to carry in your camera bag for occasions when you need more magnification than you can get with lens alone.

You can use any lens with extension to get more magnification, but image quality will vary and in some cases may not be acceptable. Later in this chapter there is a discussion of recommended lenses for best image quality.

Because M = X/F you get different magnification with different lenses at the same amount of extension. Long focal lengths give less magnification; short focal lengths give more.

For example, a 100mm lens used with a 25mm extension tube gives a magnification of 25/100 = 0.25 with the lens set at infinity. You get a little more magnification by cranking the lens out to the end of its focusing movement. But, if you use a 24mm lens with the 25mm extension tube, magnification starts at about 1 and increases with focus travel.

Extension Tube 25 with the 50mm Macro Lens—The 50mm Macro lens mounts directly on the camera and focuses all the way to infinity. It can be used as a standard lens. It provides relatively high magnification without accessories because it has a focusing helicoid that is 25mm long. When all of the helicoid extension is used, to focus on the closest possible subject, magnification 0.5.

If you install the 50mm Macro lens on the 25mm extension tube, the total extension range becomes 25mm to 50mm, depending on where you set the lens focus control. This gives a magnification range of 0.5 to 1. This is a good lightweight combination for magnifications from about 0.15 up to 1.

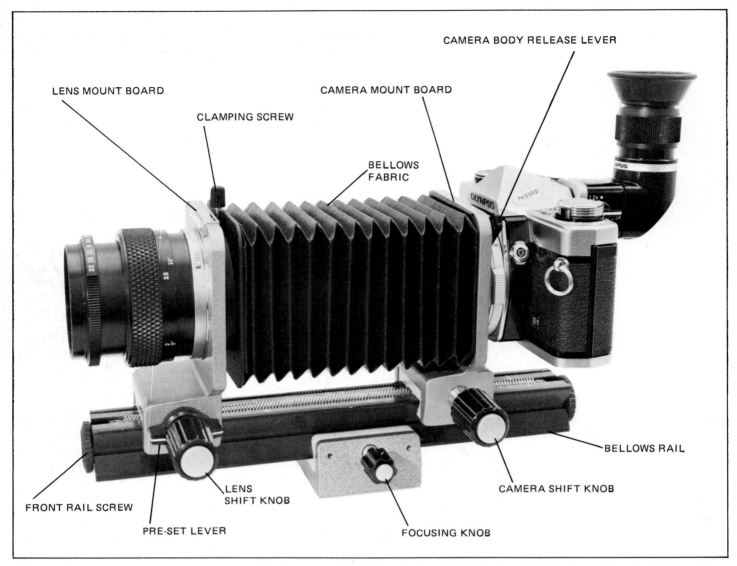

LENS MOUNT BOARD

CLAMPING SCREW

CAMERA MOUNT BOARD

CAMERA BODY RELEASE LEVER

BELLOWS FABRIC

BELLOWS RAIL

FRONT RAIL SCREW

LENS SHIFT KNOB

PRE-SET LEVER

FOCUSING KNOB

CAMERA SHIFT KNOB

The Auto Bellows extends from 36mm to 198mm. On the opposite side of the Camera Shift Knob, Lens Shift Knob and Focusing Knob are three clamping knobs that lock the adjustments. A Varimagni Finder is useful with a bellows, as shown here. Lens is the 50mm macro; other lenses can be used.

BELLOWS

The amount of extension available with a bellows is considerably more than with a set of extension tubes, so maximum magnification is greater. The Olympus Auto Bellows mounts a camera body on the back and a lens on the front. The bellows allows varying the amount of extension from 36mm to 198mm. The movable front part of the bellows is called the Lens Mount Board and the back part is the Camera Body Mount Board.

The Camera Body Mount Board has a circular opening that accepts a metal part called the Camera Body Mount. This separate piece fits on the camera the same way a lens does.

Attach the Camera Body Mount to the camera, then install camera and mount in the

Camera Body Mount Board on the bellows. It is held in place by a Camera Mount Clamping Screw. By releasing the clamping screw, you can rotate the camera body for a vertical format, horizontal format, or any angle in between.

The front and back mounting boards of the bellows travel along the top surface of the *bellows rail*. Each mounting board is controlled independently, each with its own adjusting screw and lock knob.

A tripod mount travels along the bottom side of the bellows rail and has its own adjusting knob and lock knob. This allows you to set magnification by adjusting the length of the bellows and then find focus by moving the entire bellows assembly toward or away from the subject using the movable

tripod mount on the bottom of the rail. Therefore, the adjusting knob on the tripod mount is called the Focusing Knob.

Reversing the Lens—Lenses for general use are designed with the expectation that subject distance will be considerably longer than image distance—the subject a few feet from the camera and the lens only a few inches from the film. If the lens is not used as the designer expected, lens corrections don't work as well and image quality is degraded.

If magnification is increased by lens extension until the image on film is larger than the subject in real life, the image distance must be longer than subject distance. For magnifications larger than 1.0, general-purpose lenses make a better image if they are reversed so the longer optical path is on

First, attach the Camera Body Mount. It bayonets onto the camera just as a lens does.

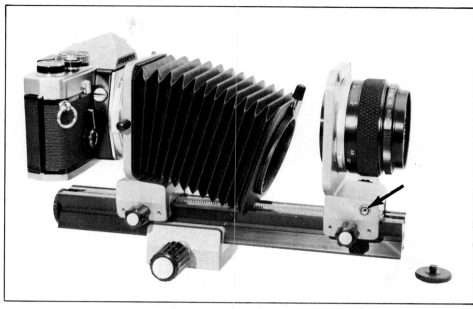

Any lens that can be mounted on the camera will fit on the front Lens Mount Board of the bellows in the same way. To reverse these lenses, loosen the set screw and remove the front of the bellows fabric from the Lens Mount Board. Take the Lens Mount Board off the bellows rail, reverse it, and reinstall on the rail. Then clamp the bellows fabric to the front of the lens—which points to the rear because the lens is reversed. The socket (arrow) on the base of the Lens Mount Board is for use with the special Double Cable Release.

Then slide the Camera Body Mount into the opening in the Camera Body Mount Board on the bellows and tighten the set screw. By loosening the set screw, you can rotate the camera for a vertical-format shot, when needed.

the side of the lens that the designer intended—even though it becomes image distance rather than subject distance. This applies to all Olympus lenses designed to mount directly on the camera body.

When used at magnifications less than 1, a general-purpose lens such as the 50mm f-1.8 or the 50mm macro lens is mounted on the bellows so it extends forward from the bellows. If you use a general-purpose lens at magnifications higher than 1, reverse the lens by reversing the lens board on the bellows.

Here's how: The bellows fabric is clamped to a ring on the back side of the lens board when the board is installed normally. Loosen the Clamping Screw and separate the bellows fabric from the lens board. Unscrew

and remove the Front Rail Screw. This screw normally serves as a stop to prevent extending the bellows so much that the lens board comes off the end of the rail. For this operation, you want the lens board to come off the end.

Using the Lens Shift Knob to move the lens board, move the lens board off the end of the rail. Reverse the board and wind it back onto the rail using Lens Shift Knob. Reinstall the Front Rail Screw.

You can do this with or without the lens attached to the bellows front board. If the lens was attached, it is now pointing backwards, toward the camera. If the lens was not attached, now is the time to do it. Then clamp the bellows fabric to the front of the lens and turn the Clamping Screw to secure it. If you are using a lens with 55mm filter-thread diameter, screw Adapter Ring 55∞49mm into the front of the lens. This reduces the diameter so the bellows fabric will fit over the adapter ring.

Automatic Diaphragm Operation—As you know, the Automatic Diaphragm Lever on the back of the lenses so equipped is operated by a lever in the camera. When a lens of this type is mounted on the front of the bellows, there is no direct mechanical connection between lens and camera. Automatic diaphragm operation is done another way, using a Double Cable Release.

One branch of the Double Cable Release is screwed into a socket on the front board of

the bellows. The other branch is screwed into the camera shutter button in the normal way. When you depress the plunger in the handle of the Double Cable Release, two things happen in sequence. First, the lens is stopped down to the aperture size selected by the aperture ring on the lens. Then the camera shutter is operated so the exposure is made with the lens stopped down to correct aperture. A Time Screw on the cable release can be used to hold the plunger depressed for time exposures.

Exposure Measurement—When the Auto Bellows is installed on an Olympus camera, the camera is automatically set up for stopped-down metering—which means metering at shooting aperture.

Metering and viewing depth of field stopped down is done using the Pre-Set Lever, which is adjacent to the Lens Shift Knob on the front board of the bellows. When this lever is turned so it points upward, lens aperture takes the size you have selected on the lens. With this setting, you can meter and set the camera exposure controls.

At high magnification, the amount of light reaching the viewfinder screen is greatly reduced and the image is dim. Composition and focusing are easier with the Pre-Set Lever turned so it is horizontal. At this setting, lens aperture remains wide open no matter where the lens aperture ring is set. If you shoot with the Pre-Set Lever at this setting, the Double Cable Release will automatically

SETUP DATA FOR THE OLYMPUS AUTO BELLOWS

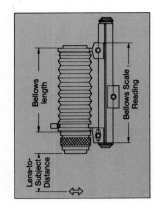

Bellows length · Lens-to-Subject Distance · Bellows Scale Reading

MAGNIFICATION

Lens and Position		Setup Data	0.2	0.3	0.4	0.5	0.6	0.7	0.8	0.9	1.0	1.2	1.4	1.6	1.8	2.0	2.2	2.4	2.6	2.8	3.0	3.5	4.0	4.5	5.0	5.5	6.0	6.5	7.0	7.5	8.0	9.0	10.0	11.0	12.0
BASIC METHODS																																			
ZUIKO 1:1 MACRO 80mm f/4	Normal	Scale Reading (mm)	71	79	87	95	103	111	119	127		143	159	175	191	207	223																		
		Distance from lens to subject (cm)	31.0	24.3	20.3	17.6	15.7	14.3	13.2	12.3		11.0	10.0	9.3	8.8	8.3	8.0																		
ZUIKO MACRO 38mm f/3.5	Normal	Scale Reading (mm)						68	75	83	90	98	106	113	132	151	170	189	208	227															
		Distance from lens to subject (cm)						4.6	4.4	4.3	4.1	4.0	3.9	3.8	3.6	3.5	3.4	3.3	3.2	3.2															
ZUIKO MACRO 20mm f/3.5	Normal	Scale Reading (mm)																		73	83	93	103	113	123	133	143	163	183	203	223				
		Distance from lens to subject (cm)																		2.1	2.1	2.0	2.0	2.0	2.0	2.0	1.9	1.9	1.9	1.9	1.8				
AUXILIARY METHODS																																			
ZUIKO MACRO 50mm f/3.5	Normal *(Lens Focusing Ring at ∞)*	Scale Reading (mm)						69	74	79	84																								
		Distance from lens to subject (cm)						8.6	7.7	7.0	6.4																								
	Reversed *(Lens Focusing Ring at closest distance)*	Scale Reading (mm)									102	112	123	134	144	155	166	177	187	198	209	230													
		Distance from lens to subject (cm)									6.2	5.3	4.7	4.2	3.8	3.5	3.3	3.1	2.9	2.8	2.6	2.4													
ZUIKO 50mm f/1.8	Normal	Scale Reading (mm)						69	74	79	85																								
		Distance from lens to subject (cm)						9.2	8.3	7.6	7.0																								
	Reversed *(Lens Focusing Ring at ∞)*	Scale Reading (mm)									78	89	99	109	120	130	140	151	161	171	197	223													
		Distance from lens to subject (cm)									7.8	7.2	6.7	6.3	6.1	5.8	5.6	5.5	5.3	5.2	4.9	4.8													
ZUIKO 50mm f/1.4	Normal	Scale Reading (mm)						69	74	79	85																								
		Distance from lens to subject (cm)						8.2	7.3	6.6	6.0																								
	Reversed	Scale Reading (mm)									74	84	95	105	115	126	136	146	157	167	193	219													
		Distance from lens to subject (cm)									7.8	7.2	6.7	6.3	6.0	5.8	5.6	5.4	5.3	5.2	4.9	4.8													
ZUIKO 55mm f/1.2	Normal	Scale Reading (mm)					72	78	83	89																									
		Distance from lens to subject (cm)					8.0	7.0	6.2	5.6																									
	Reversed *(Use Adapter Ring 55–49mm)*	Scale Reading (mm)									93	104	115	126	137	149	160	171	182	211	231														
		Distance from lens to subject (cm)									7.5	7.0	6.6	6.3	6.0	5.8	5.6	5.5	5.3	5.1	4.9														

EXPOSURE FACTOR

1.4	1.7	2.0	2.3	2.6	2.9	3.2	3.6	4.0	4.8	5.8	6.8	7.8	9.0	10	12	13	14	16	20	25	30	36	42	49	56	64	72	81	100	121	144	169

Figure 12-3/Read magnification from the scale at top. Numbers above bars are *bellows scale readings*, not actual lens extension. Actual extension is 33mm less than scale reading. Numbers below bars show the setup distance from the front of the lens to the subject plane, in *centimeters*. Example: If the 38mm Macro lens is used at a magnification of 3.0, bellows scale reading will be 113mm and lens-to-subject distance will be 3.8 centimeters.

None of the basic methods shown in the top three rows allow reversing the lens. Auxiliary methods shown in the lower part of the chart *require* reversing the lens when magnification is greater than 1. Numbers along bottom of chart are Exposure Factors, discussed later in this chapter.

For the 1:1 80mm macro lens, the thick bar indicates magnification range recommended for best image quality. Narrower lines at each end show acceptable image quality. The recommended range of the ZUIKO 1:1 80mm Macro lens is from 0.5 to 2.0.

114

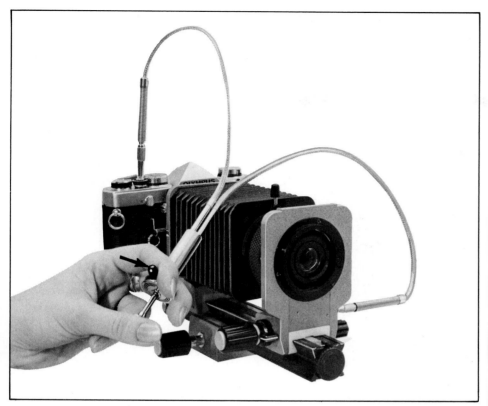

This Lens Mount Board has been reversed so the lens is between the board and the bellows fabric. The Double Cable Release has two branches: One screws into the camera shutter button, the other into the socket on the base of the Lens Mount Board. The Double Cable Release stops down the lens to shooting aperture before operating the shutter in the camera. The Time Screw (arrow) is a set screw to hold the plunger depressed for time exposures.

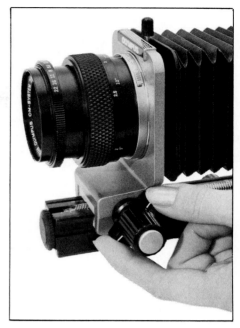

The Pre-Set Lever on the base of the Lens Mount Board is normally horizontal. To meter stopped-down, rotate the lever as shown. It will lock in place, holding the lens at shooting aperture until released.

stop down the lens to shooting aperture as already described.

Setting Up for a Desired Magnification— The formulas given earlier for magnification by extension apply no matter how the extension is obtained: $X = MF$ and $M = X/F$ where X is added extension between lens and camera, F is lens focal length, and M is magnification. If you use these formulas, you should be aware of the difference between the bellows scale reading and the actual bellows extension.

A millimeter scale on the bellows rail is read between the rear edge of the support for the rear mount board and the front edge of the support for the front board. This reading is for reference only and will be called the *bellows scale reading*. It is never the actual extension between lens and camera.

When the front lens mount board is not reversed, actual bellows extension is 33mm less than the bellows scale reading. If you are setting up for 100mm of extension, use a bellows scale reading of 133mm.

When the lens mount board is reversed, actual bellows extension is uncertain because the lens is included in the distance between the two bellows mount boards.

In many cases, it is not necessary to use the formulas to make a bellows setup. Figure 12-3 gives magnification for several lenses with the bellows scale reading and the distance from the front of the lens to the subject plane. Knowing lens-to-subject distance is very useful in making the setup.

This chart gives setup distances for some lenses both reversed and not reversed. In every case, the bellows scale reading is given as you actually read it on the bellows. These are practical numbers to guide you in making the setup, not actual lens extension.

SPECIAL LENSES
FOR HIGH MAGNIFICATION

Lenses for general use are usually optimized for a distant subject and usually don't have optical corrections to produce good flatness of field. This may be apparent if you copy a postage stamp, for example, at a magnification of 1.0 with an ordinary camera lens such as the 50mm *f*-1.4. If you look closely, you may see that the edges of the stamp are not focused as sharply as the center.

Some short-focal-length Zuiko lenses have the automatic correction mechanism, which uses floating elements in the lens to change the optimum subject distance as you

focus on closer subjects. With these lenses, when you focus on a distant subject, the lens is corrected to give the best image of a distant subject. When you focus on a nearby subject, the lens is changed internally so it gives the best image on a nearby subject. The automatic correction mechanism is not effective in the macro range.

In general, if you use an ordinary camera lens for high magnification photography, you will get the best image with the 50mm *f*-1.8. This is because flatness of field and large maximum aperture are incompatible in lens design. If you don't need flatness of field because the object you are photographing is not flat, then any of the 50mm lenses should serve about as well.

Zuiko MC Macro 50mm *f*-3.5— For better image quality and more magnification than you can get with an ordinary camera lens, use the 50mm Macro lens on the camera. It has good correction for flatness of field. Without accessories, it gives magnifications up to 0.5 and the recommended use of this lens is up to 0.5.

Zuiko MC Auto Macro 135mm *f*-4.5— This lens has automatic aperture and is meter-coupled, but it is not intended to mount directly on a camera. The rear ele-

ment of this lens extends backward from the lens mount, so it would reach into the camera body if mounted directly on the camera. This would prevent the mirror from moving up. This lens is intended to mount on an extension tube or bellows. This lens does not require reversing when used within the recommended range. There is a fine-focus control on the lens.

The 135mm macro on a bellows is recommended for magnifications from about 0.05 up to about 1.0. However, the preferred range is from 0.05 to 0.5. Above 0.5, the 80mm 1:1 macro is preferred.

Zuiko MC 1:1 Auto Macro 80mm *f*-4— This lens is designed for best image quality at a magnification of 1, with image size equal to subject size. This is implied by the 1:1 symbol in the lens nomenclature. It has automatic aperture and is meter-coupled, but it is not intended to mount directly on a camera.

The rear element of this lens extends backward from the lens mount, so it would prevent the mirror from moving up if mounted directly on the camera. This lens is intended to mount on an extension tube or bellows. It has a focusing helicoid with about 7.5mm of travel as an aid to focusing and getting set up for high magnification. This lens does not require reversing when used within the recommended range.

In Figure 12-3, notice that the 80mm macro on a bellows is capable of magnifications from about 0.1 up to about 2.4. However, the preferred range as shown by the thicker part of the bar is from 0.5 to 2. Below that range, the 135mm macro lens works better. Above that range, the 38mm bellows macro is preferred.

Zuiko Macro 38mm f-2.8—This lens has a built-in standard bayonet mount. It is used on Olympus bellows or extension tubes. It has a limited-range focus adjustment for fine focusing. It replaced the earlier special 38mm macro that required a mounting plate to fit on a bayonet mount.

The preferred magnification range of the 38mm macro is from about 1.7 up to about 6.7, which is from minimum extension of the Auto Bellows to maximum extension. This lens is never reversed.

The lens uses 32mm slide-on filters. There is a threaded accessory ring near the front of the lens which accepts all lens-mounted macro flash units such as the T10 Ring Flash.

Zuiko Macro 20mm f-2—This lens has a built-in standard bayonet mount. It is used on Olympus bellows or extension tubes. It has a limited-range focus adjustment for fine focusing. It replaced the earlier special 20mm macro that required a mounting plate to fit on a bayonet mount.

The preferred magnification range of the 20mm macro is from about 4.2 up to about

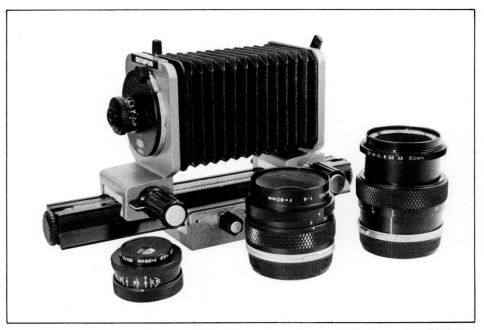

At right is the 50mm macro lens. It can be used on a camera, on a bellows or extension tubes. The 80mm 1:1 macro lens in the center cannot be mounted directly on the camera body. It can be used on a bellows or extension tubes, including Auto Extension Tube 65-116. At left is a special 38mm macro lens that requires an adapter plate to fit the OM bayonet mount. On the bellows is a special 20mm macro lens, attached to the bellows with the adapter plate. The special 38mm and 20mm macro lenses have been replaced with lenses equipped with a standard bayonet mount, so no adapter plate is required.

16, which is from minimum extension of the Auto Bellows to maximum extension. This lens is never reversed.

The lens uses 21mm slide-on filters. There is a threaded accessory ring near the front of the lens which accepts all lens-mounted macro flash units such as the T10 Ring Flash.

ANGLE OF VIEW OF BELLOWS LENSES

For the 20mm, 38mm, and 80mm macro lenses, the lens table shows the same angle of view for each lens, 9°, even though some of the lenses have short focal lengths and would seem to be wide-angle. The 9° specification doesn't have much significance, but here's what it means:

As a bellows is extended, the image gets larger and larger. Only the central part of the image can fall within the film frame and expose the film. When the bellows is fully extended, the part of the image that is in the film frame is the same as it would be if the lens had an angle of view of 9°.

CHOOSING A LENS

Even though there are preferred lenses for each magnification, you are not required to use them unless it is essential to get best image quality. If your interest in high magnification is casual, or if your interpretation of the subject does not require the sharpest image, you can use any lens.

For example, the Zuiko 21mm *f*-3.5 Super Wide-Angle lens reversed on the Auto Bellows will give approximately the same range of magnification as the special 20mm bellows macro lens. Image quality won't be as good, but you are the best judge of image quality for your purpose.

Besides image quality, there are some advantages to using the lenses shown in Figure 12-3. The figure does the arithmetic for you. It tells you the amount of bellows extension you need for the desired magnification and how far to place the lens from the subject. This is really convenient. If you are a non-mathematical type, it leads you into high-magnification setups with no arithmetic at all.

Working Distance—Sometimes the distance between lens and subject is important. As you will see in a few more paragraphs, high magnification greatly reduces the

amount of light that reaches the film. Often it is necessary to put more light on the subject just so you can see it in the viewfinder. It is difficult to illuminate the subject when the lens is practically touching it, but much easier when there is some working distance between lens and subject.

Working distance is directly influenced by your choice of lens focal length. For the same magnification, lenses with longer focal length give more working distance. They also require more extension, which is sometimes a problem.

Here's a simple example: When magnification is 1, subject distance and image distance are equal. Each is twice the focal length of the lens. Suppose you are using the 50mm macro. Image distance is 100mm; subject distance is 100mm.

I should remind you that these distances are measured from front and rear lens nodes, which are usually inside the lens somewhere but their locations are not marked and usually are not precisely known to the user. According to Figure 12-3, the actual working distance between *the front* of the 50mm macro lens and the subject plane is about 64mm at a magnification of 1. Therefore, the front node is actually 36mm behind the front of this lens.

Suppose you switch to the 80mm macro lens at the same magnification. Subject and image distances both become 160mm. Actual working distance is about 125mm as you can see in Figure 12-3.

By changing from a 50mm lens to an 80mm lens, working distance increased from 64mm to 125mm. The bellows scale reading increased from 84mm to 142mm which can be set on the bellows. It is possible to seek high magnification with a long-focal-length lens and discover that the bellows won't stretch that far. In such cases you can use extension tubes between the front of the bellows and the lens.

HOW TO DETERMINE THE AMOUNT OF MAGNIFICATION

Sometimes you need to know how much magnification you are using. There are several ways to find out. If you are using any of the setups shown in Figure 12-3, you can read magnification from the graph. If you are using the 80mm or 135mm macro on Auto Extension Tube 65-116, you can read magnification on the barrel of the extension tube. With the 50mm macro lens mounted directly on the camera, you can read magnifications up to 0.5 from a scale engraved on the lens barrel.

If you are using any lens on a bellows or extension tubes and the lens is not reversed, you can calculate magnification easily using the formula already given. If the lens is re-

Macro photos by Holly Thomson show improvement in depth of field at *f*-16 with flash illumination compared to *f*-4 with ambient light. Dark background with flash is due to flash fall-off at increased distance.

versed, you will get approximate magnification from the calculation but it will not be exact because of uncertainty in the location of the lens front node—which becomes the rear node when the lens is reversed.

You can always find magnification by testing with film. Photograph a millimeter scale parallel to the long dimension of the film. On the negative, count how many millimeters on the scale are visible in the frame. To find actual magnification, divide the long dimension of the frame by the number of millimeters you counted on the film. For extreme accuracy, measure the long dimension of the frame. For a close approximation, assume it is 36mm. If magnification is 0.5, you will count 72mm on the photograph of the scale. 36/72 = 0.5

You can estimate magnification closely by focusing on a millimeter scale and counting how many millimeters you see in the viewfinder. If the viewfinder shows the entire frame, you should see the same length of the scale as you would on film if you took the picture. Olympus cameras don't show the entire frame. They show 93% or 97%. After making the calculation, multiply the result by 0.93 or 0.97 and the answer will be close

to actual magnification on film.

TOTAL MAGNIFICATION

Occasionally you may need to know the total amount of magnification used to make a print or reproduce a photo in a publication. Total magnification is the magnification in the camera multipled by any subsequent magnification. For example, if you shoot at a magnification of 1.2 and the image is later magnified by 3, total magnification is 3 x 1.2 = 3.6

DEPTH-OF-FIELD PROBLEM

When you increase magnification by any method, depth of field is automatically reduced, At magnifications of 1 or more, depth of field is so limited that you will think there isn't any at all.

This is not a major problem with a flat subject such as a postage stamp, provided the lens is well corrected for flatness of field so the zone of good focus is flat and can be placed in the same plane as the flat subject.

Depth of field is a major problem with three-dimensional subjects such as a small insect because you can't get all of the subject in sharp focus. The best treatment depends both on the subject and your purpose in photographing it. I usually prefer to put the zone of good focus near the front part of the subject so the viewer gets a sharp first impression of the subject. From there, everything recedes into fuzz if depth of field is really poor.

Shooting at small aperture helps some, but not nearly as much as when using the lens at normal magnifications. Nevertheless, you take all you can get and therefore you should shoot at *f*-8 or smaller if you can get enough light on the subject.

LIGHT LOSS DUE TO LENS EXTENSION

From the film's point of view, light emerges from the lens as an expanding cone making a circle at the film plane.

Light sources that produce diverging rays are subject to the *inverse-square law*. The law says the amount of light changes inversely with the distance from the source.

When the inverse-square law applies, light decreases according to distance squared. If distance is doubled, light does not decrease to 1/2 its former value, it decreases to 1/4. Making the distance 3 times as large decreases the amount of light by 3 times 3, which is 9, and so forth.

The inverse-square law is always applicable inside the camera, between the lens and the film. When you change the distance between lens and film, both magnification and the amount of light on the film change.

The amount of movement in the normal

The bellows rail has a millimeter scale along the far side which you use to read bellows settings. The calibration marks along the near edge are for use with a slide copier, discussed later.

focusing range of the lens is so small that the amount of light on the film doesn't change very much. If you set exposure controls after focusing, it doesn't matter because you set exposure for whatever light there is.

When you use extension tubes or a bellows to put distance between lens and film, the distance may change enough to have a major effect on the amount of light at the film plane.

A simple example is this: A 50mm lens with 50mm of added extension makes a life-size image. However, inserting 50mm of extension *doubled* the image distance—from 50mm without the extension to 100mm with extension. By the inverse-square law, doubling distance reduces illumination to 1/4, which is two exposure steps. The image is less bright on film and also in the viewfinder. As magnification is increased above 1, the light falls off very rapidly and the focusing screen becomes very dark.

As long as you are using the built-in camera meter and it is reading within its range of accuracy, the meter measures the actual amount of light that exposes the film, so the camera-recommended exposure settings should be satisfactory. The possibility of reciprocity failure of the film should always be considered for longer-than-normal exposure times as discussed in the following chapter.

It is possible to get such a small amount of light through the lens and into the camera that the camera meter can't measure it accurately. Here's what to do if you can't measure the light using the meter in the camera: Determine exposure for the subject in some other way, assuming you are not using any lens extension. Then correct that exposure for light loss at the lens extension you are using. Then correct again for reciprocity failure of the film, if necessary.

When you can't get a reading through the camera, you can often get it with a separate accessory light meter. This reading, of course, does not consider lens extension. If you don't own a separate light meter, remove the lens extension device from the camera; then make an exposure reading of the subject. This reading will not include the effect of lens extension.

However you do it, you have a camera exposure setting that would work fine with no extension but will not give enough exposure when using lens extension. To correct for this, multiply the amount of exposure for no lens extension by an Exposure Factor that is determined by the amount of magnification you are using.

For normal lenses you can figure the Exposure Factor (EF) as follows:

$$EF = (M + 1)^2$$

Using another simple example, if magnification is 1,

$$EF = (1 + 1)^2$$
$$= (2)^2$$
$$= 4$$

This number is a *factor,* which means it is used as a *multiplier.* To remind you that the Exposure Factor is a multiplier, Olympus writes it with the symbol X which means *times.*

In this example, exposure must be 4 times as much with extension as it would be without extension. Each exposure step increases exposure by a factor of 2, so two additional exposure steps are needed. From the exposure setting that would be satisfactory without lens extension, increase by two steps.

This simple formula and correction method applies only when you are using normal lenses. Normal means neither telephoto nor retrofocus (wide-angle). All of the macro lenses are normal.

For these lenses, you can find the exposure factor at the bottom of the tables shown earlier in this chapter. For each indicated magnification, the exposure factor is given for a normal lens.

If you use telephoto or wide-angle lenses with extension, the formula just given will not work. A discussion of these special cases is in my book *SLR Photographers Handbook* along with formulas to figure the exposure factor.

EFFECTIVE APERTURE

As you know, aperture size as stated by an *f*-number is used as an indication of the light-gathering ability of a lens.

Because added extension reduces light on the film, it has an effect similar to using smaller aperture. The lens may be set at *f*-4 with extension, but the amount of light on the

The simplest and easiest way to do high-magnification photography with flash is with an OM-2N on automatic and a T-series flash set for TTL Automatic. This is a T32 flash connected to the camera with a TTL Auto Cord. TTL Auto Connector Type 4 is mounted on the camera, replacing the hot shoe.

film corresponds to f-8 if the lens were being used with no extension. *Effective aperture* is f-8 because that's how much light there is.

$$EA = (\text{aperture on lens}) \times (M + 1)$$

EA is effective aperture and M is magnification. The idea is to convert the effect of added extension into a fictitious but practical f-number for the lens, rather than use the exposure factor. This will sometimes be handy when using a camera with flash—when both camera and flash are non-automatic and exposure is found by a guide-number calculation as discussed in Chapter 11.

The guide-number calculation tells you what f-stop to use, based on the amount of light and film speed. This is the *effective aperture* required for proper exposure. What you need to know is how to set the lens to get that aperture.

$$f\text{-stop on lens} = \frac{EA}{(M + 1)}$$

Suppose a flash guide-number calculation calls for an aperture of f-8 but you are using a magnification of 0.4.

$$
\begin{aligned}
f\text{-stop on lens} &= f\text{-8}/(0.4 + 1) \\
&= f\text{-8}/1.4 \\
&= f\text{-5.7}
\end{aligned}
$$

Round off to f-5.6 and exposure should be the same as if you had used f-8 without the lens extension.

Even if you set the camera so it provides the effective aperture needed by the flash, you may not get correct exposure if the flash is very close to the subject. In general, guide number calculations work OK if the distance between flash and subject is greater than 10 times the maximum diameter of the flash window. If flash-to-subject distance is less than that, a guide-number calculation may not give correct exposure. Making exposure tests is one way to solve this problem.

You can use the idea of effective aperture when using normal automatic flash with a camera on non-automatic. If you are using magnification greater than about 0.15—with the 50mm macro lens on the camera, for example—remember that the flash is requesting effective aperture, not the actual lens setting.

A better solution is to use a T-series flash on TTL automatic.

HIGH-MAGNIFICATION PHOTOGRAPHY WITH OLYMPUS TTL AUTO FLASH

An OM camera with TTL OTF flash metering and any of the Olympus TTL auto flash units is a excellent solution to most lighting problems of high-magnification photography. There are two reasons: No matter which lens you use, or how much lens extension, the flash is always controlled by measurement of the subject you are actually photographing. Measurement of light at the film plane automatically compensates for light lost.

You can't use the flash in the camera hot shoe when the lens is extended by bellows or extension tubes. The end of the lens will be close to the subject and usually it will block light from the flash. The T-series macro flash units, such as the T10 Ring Flash mount the flash head on the front of the lens—which solves that problem.

If you are using a T32 or T20, remove the flash from the hot shoe using a TTL Auto Cord. Position the flash so it puts light onto the subject without the lens getting in the way. You should also arrange the setup so the flash does not point into the lens. You can place the flash directly behind the subject for special effect or to trans-illuminate the subject. That means the light comes through a translucent subject.

PRECISION IN EXPOSURE SETTINGS

People often think photography is an exact science. Usually it isn't. One exposure step is a change of 100%. A half-step is sometimes hard to detect in looking at a print. One-third of a step is the smallest amount most people recommend worrying about. Nearly everybody agrees you can forget differences of 20% in light, time or exposure.

When making calculations, you may get an answer that isn't an exact control setting on the camera. Usually it makes no difference if you round off to the nearest half-step or third-step. In the calculation I made in the preceding section, the answer came out f-5.7 and I suggested rounding it off to f-5.6.

VIEWFINDER ACCESSORIES FOR MACRO PHOTOGRAPHY

At high magnifications, depth of field is very small and the viewfinder is darker than normal. It is good practice to focus at maximum aperture for two reasons: It makes the image brighter so you can see it better. It gives minimum depth of field, which gives you added incentive to put the zone of good focus exactly where you want it.

It is very important to choose viewfinder accessories to give you the clearest and best view of the focusing screen. With cameras

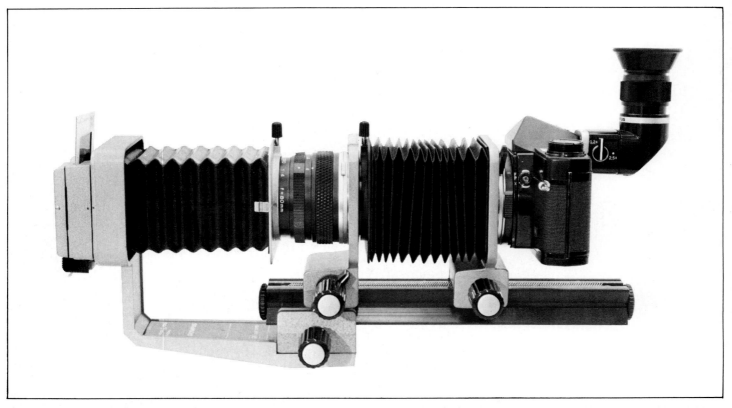

For slide copying, a special Slide Copier attaches to the tripod mount on the bellows. The slide copier has its own bellows which attaches to the front of the 80mm 1:1 macro or 50mm macro lens.

that allow changing focusing screens, choose one from this list:

MAGNIFICATION	SUITABLE FOCUSING SCREENS
up to 0.5	1-1, 1-4, 1-10
0.5 to 2	1-4, 1-10, 1-11
2 to 4	1-11, 1-12
4 to 12	1-12

These screens are described in Chapter 9. Note that the only one on the above list with a biprism or microprism is type 1-1, and it is recommended only for low magnifications. That's because prism-type focusing aids black out at high magnifications and are not useful.

Instead, you can use the cross-hairs of 1-11 or 1-12. However, it is essential that the viewing optics are adjusted for your eyesight. The procedure is to adjust the viewing system diopters so you see the cross-hairs sharply, then bring the image into sharp focus at the same plane. Viewing optics can be tailored to your eyesight by installing a Dioptric Correction Lens in Eyecup 1 and then installing the eyecup on the frame of the viewfinder eyepiece.

The Varimagni Finder solves several problems: It is adjustable for your eyesight; it

rotates on the camera so you can view from any angle, depending on how you have the camera supported and the setup you are using; and it can be switched to a magnification of 1.2 or 2.5 for critical focusing.

Notice that all screens recommended for high magnification have a matte surface except screen 1-12, which is for magnifications from 4 to 12. Screens with a matte surface allow you to see depth-of-field effects. You see not only what is in good focus but also the parts of the image that are in poor focus. This is desirable to help you cope with the limited depth of field.

However, at magnifications above 4, screen 1-12 is recommended. This screen is clear so you see an aerial image without depth of field. The advantage is that an aerial image is brighter than one formed on a matte surface. At magnifications greater than about 4, the viewfinder image is so dim that anything you can do to make it brighter is worth doing.

SLIDE COPYING

A slide copier fits on the end of a bellows and lets you do a lot of interesting things. You can copy slides, seeking to make exact duplicates. You can copy slides while making deliberate changes such as cropping the

original image or using filters to change the color of the original. You can make slide "sandwiches" of two slides so the copy combines the two images. You can add a textured background, put the moon or sun where they never were in reality, and other tricks.

Among all of those possibilities, and whatever else you may think of, the one I don't recommend is making exact duplicates. If that's what you want, you'll be better off making several identical exposures at the time you shoot the picture, or else having duplicate slides made for you by a commercial lab.

I enthusiastically recommend slide copying to alter or improve the end result. You need an Auto Bellows and the Slide Copier. Mount camera body and lens on the bellows in the usual way. Then mount the bellows on the Slide Copier. This is done by attaching the movable tripod mount of the bellows onto the copier base as shown in the accompanying photo.

Copying 35mm slides onto 35mm film requires magnifications of 1 or more. The best lens to use is the 80mm 1:1 macro because it is designed for that magnification range and because it has good flatness of field. Next best is the 50mm macro because it is also corrected for flatness of field. Next

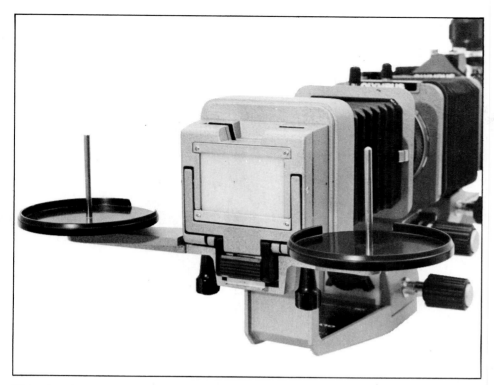

Slides drop into the slot on top of the copier. An accessory Roll Film Stage is available, shown here. It has two trays with spindles to hold 35mm roll film. The film passes through slots in the sides of the copier. A frosted glass pane in the front of the copier diffuses the light used to illuminate the frame being copied.

best is any of the standard 50mm lenses, such as the 50mm *f*-1.8.

Even when using the 80mm or 50mm macro lens, you should close the lens one or two steps smaller than maximum aperture to be sure the depth of field includes the entire surface of the slide. Although we think of slides as flat, they are actually curved. With any other lens, stop down more depending on how much light there is.

The lens is mounted on the front of the bellows, not reversed. Calibration marks on the bellows rail show where to put the front and rear mounting boards with an 80mm macro lens to get either 1 or 1.5 magnification. There are two sets of marks. One is for the earlier 80mm macro that was not automatic. The other is for the current automatic lens and is marked 80mm AUTO.

The slide copier has its own bellows to exclude light from the optical path between lens and the slide being copied. Release the slide-copier bellows by loosening a screw at the top of the copier. Extend the copier bellows until it fits over the front of the lens and tighten the screw. If you are using the 55mm *f*-1.2 lens, screw Adapter Ring 55∞49mm into the lens. This reduces the diameter at the front of the lens so the copier bellows will fit.

To find focus, the entire Auto Bellows

assembly—camera, bellows and lens—is moved forward or back until the lens-to-slide distance is correct. The copier bellows between lens and copier expands or contracts as necessary. This adjustment is made by turning the adjuster knob on the Auto Bellows tripod mount—called the Focusing Knob. Because the tripod mount is actually screwed onto the slide copier base, this has the effect of moving the entire Auto Bellows in relation to the slide copier and thereby changing lens-to-slide distance.

To make a preliminary setup, move the Auto Bellows so the front edge of the bellows rail aligns with calibration marks on the slide copier base. These marks also show magnifications of 1 and 1.5.

Using the calibration marks gives you a starting setup that will be close to the correct magnification and lens-to-slide distance. This is very helpful. There are so many variables in setting up to copy slides that I have seen people give up in despair because they couldn't get things adjusted to produce a focused image in the viewfinder. With the calibration marks on the Olympus bellows and copier, you can make a working setup almost automatically.

Drop a mounted slide into the copier, from the top, or insert a strip of 35mm film into the

slots on the side. To make a copy with the same left-to-right orientation as the original, place the emulsion side of the film you are copying away from the camera. Then find best focus by turning the Focusing Knob on the tripod mount of the bellows. You shouldn't have to turn it very far.

Change magnification by moving the rear mounting board of the bellows a very small distance. Then find focus again by moving the entire bellows toward or away from the slide using the Focusing Knob on the bellows tripod mount. You can do it other ways but this is simplest and least confusing.

Roll Film Stage—If you are duplicating roll film rather than individual slides or short strips, attach the Roll Film Stage to the Slide Copier. This has two trays to hold the film as you pass it through the copier.

Illuminating the Slide—At a magnification of 1, the exposure factor is $(1 + 1)^2$, which is 4. That's an exposure increase of only two steps. It is relatively easy to get enough light on the slide so the viewfinder has a bright image and you don't have to use long exposures. With a continuous light source, use the camera's built-in exposure meter just as if you were photographing the scene on the slide.

Match the type of illumination to the kind of light the film was designed for. That is, use daylight or flash with daylight film; tungsten light with tungsten film. Matching the light to the film can be done with filters as you'll see in the following chapter.

For casual slide copying, use ordinary daylight film in the camera and daylight or electronic flash illumination. A handy way to get natural daylight illumination is to point the front of the copier toward a white surface, such as paper, that is illuminated both by direct sunlight and light from the sky.

If you copy a slide on ordinary color slide film, the copy will show increased contrast compared to the original and probably a noticeable color change. This isn't always bad news. Sometimes it is tolerable; sometimes it improves the image.

If you are serious about slide copying and getting the closest possible match in contrast and color, use a special film such as Ektachrome Slide Duplicating Film. Carefully read the instruction leaflet and be prepared to do some testing with color filters and exposure settings. One way to use color filters is screw them into the front of the lens, then attach the slide-copier bellows to the filter instead of the lens. Another way is to improvise a mount that puts the filter between the light source and copier.

Slide Copying with the T32 or T20 on TTL Automatic—By now you will not be surprised to learn that a T32 or T20 flash on TTL automatic is an excellent way to copy slides.

A Copy Stand is very useful. Many of the equipment photos in this book were made with this stand.

Gooseneck copy-stand lamps screw onto a heavy base to use separately. With the base removed, the goosenecks screw onto the top of the copy stand—one on each side.

A handy accessory combination is the Focusing Rail and Focusing Stage. It can be used several ways: on a Copy Stand, on a tripod, or on the Macrophoto Stand as shown here.

Use a TTL Auto Cord between camera and flash. Position the flash so it illuminates the opaque diffusing glass on the front of the copier. Follow the same general procedures given earlier for macro photography. You may have to make some tests to find the right color filters for realistic copies.

Other Kinds of Flash—Of course you can use any other flash with any camera for slide copying but there is no easy way to get correct exposure.

Make a guide-number calculation for flash-to-slide distance and test at that setting. Then bracket, including several steps toward more exposure. Instead of changing camera settings, you can move the flash closer or farther away.

Dividing the distance by 1.4 increases illumination by one step; multiplying distance by 1.4 decreases it by one step. When the flash is very close to the window of the slide copier, this rule may not apply.

CROPPING IN THE SLIDE COPIER

One of the best reasons for using a slide copier is to crop the image. By using magnification greater than 1, you automatically crop all four sides of the picture because the image of the slide you are copying becomes larger than the frame of film you are copying onto.

To crop unsymmetrically, shift the slide in the holder. If it is a mounted slide, dropped in from the top, you can crop as much as you wish in the vertical direction by moving the slide upward in the slot and using enough magnification. If that is the wrong direction for the crop, put the slide in upside down. With a mounted slide, unsymmetrical cropping from side-to-side is limited because you can't move the slide very far in the holder.

To crop a mounted slide along its long dimension, turn the slide 90° and drop it in the slide holder. Then rotate the camera on the bellows so the long dimension of the film frame is also vertical. With that arrangement, you can move the slide vertically in the holder but you are actually cropping one side of the picture.

To crop roll film or film strips unsymmetrically, move the film left or right in the copier. Vertical motion is limited.

HOW TO SUPPORT CAMERA AND BELLOWS

Higher-than-normal magnifications require rigid support for camera and subject, so neither moves in respect to the other. There are several ways to do this.

Using a Tripod—In the earlier discussion of the Auto Bellows, I referred to the mov-

able mounting block on the bottom of the bellows rail as the Tripod Mount. You can use a tripod to support the bellows, although it is often an unsuitable arrangement. A problem usually results when you want to point the camera straight down to photograph a subject on a table or counter so the subject plane and film plane are parallel. Some tripods will adjust to do this but many won't. You may end up with a makeshift arrangement such as leaning the tripod on the edge of the table or counter.

Copy Stand—A better arrangement for some purposes is the Olympus Copy Stand, which has a flat base, a vertical column mounted on the base, and a movable arm that travels up and down on the column. You can attach a bellows to the movable arm or even mount a camera body directly on the arm using the tripod socket in the baseplate of the camera.

If desired, the vertical column of the copy stand can be removed from the base and attached to the edge of a table or counter using a special Table Clamp.

As the name implies, copy stands are often used to photograph printed pages, photographs and similar objects of relatively large size.

Focusing Rail and Focusing Stage—When

The Handy Copy Stand is small enough to fit in a gadget bag.

This is a slide-copying setup using the Macrophoto stand on Trans-Illuminator Base X-DE. Light from the built-in source in the base is being reflected upward by an inclined mirror in the base. Position of the mirror is controlled by the knob on the left side of the base.

photographing a printed page or a relatively large object using a copy stand, you don't need high magnification and a bellows is not necessary. The 50mm macro lens will give enough magnification—or a 50mm lens with extension tubes or a close-up lens.

With any of these combinations, mounting the camera directly on the movable arm of a copy stand is possible but inconvenient because it is difficult to make small height adjustments of the movable arm.

A better way is to mount a Focusing Rail on the copy stand arm. If you own an Auto Bellows, you can remove the Focusing Rail from the bellows. If not, you can purchase one separately. Mount a Focusing Stage on the Focusing Rail and attach the camera body to the Focusing Stage.

Now there are three adjustments: Set the copy stand arm at approximately the correct location and clamp it. Use the Focusing Knob on the Focusing Rail to move the entire rail in respect to the copy stand arm. The Camera Shift Knob on the Focusing Stage moves the stage along the rail and positions the camera. The knobs on both rail and stage are easy to use for small precise adjustments of camera position. Both have locks.

The Focusing Rail and Focusing Stage combination can also be used on a tripod.

Macrophoto Stand—For magnifications in the range of 0.5 up to about 12, Macrophoto Stand VST-1 is a convenient and versatile method of camera support. There are many accessories. In addition to the stand, you must also obtain Macrophoto Stand Extension Bar VST-E and Macrophoto Stand B Adapter. The extension bar screws into the vertical column on the stand and makes it longer. Macrophoto Stand B Adapter fits on the top of the extension bar and provides a mounting plate with an attachment screw so you can mount the Auto Bellows on the vertical column. You can attach a Focusing Rail and Focusing Stage combination if you are not using a bellows.

The Macrophoto Stand is not tall enough to photograph large objects because you can't get enough distance between lens and subject. It is ideal for high magnification of small objects.

As you can see in the accompanying photo, the base of the stand has a large round hole that accepts round *stage plates* that, in turn, support the object you are photographing. The stand comes with a round, opaque, frosted-glass plate that is black on the reverse side. Other plates to fit in the base can be used with a variety of light sources as described in the following section.

Handy Copy Stand—Also called a Portable Copy Stand, this is a small four-legged "tripod" that attaches directly to the front of the lens. The stand then supports the camera, pointing downward, to photograph an object placed between the legs on a table.

The legs telescope to make a small and lightweight camera support suitable for copying printed pages, photographs and other relatively large objects. The handy stand mounts directly on any lens that uses 49mm filters. For lenses using 55mm filters, screw Adapter 55→49 into the front of the lens. This reduces the diameter so the handy stand will fit.

You can use this stand with the 50mm macro lens or any other suitable lens. Use extension tubes or close-up lenses as needed to get the desired magnification.

LIGHT SOURCES

Olympus manufactures a diversified line of microscopes and microscope accessories. Some of the techniques described here are drawn from this field rather than ordinary photography.

Copy Stand Lighting Set—This is a set of two flexible gooseneck lamps on heavy circular bases. Each accepts screw-in floodlamps with wattage ratings up to 500W. The gooseneck portion of each lamp can be unscrewed from the base and screwed into a socket at the top of the copy stand column. The gooseneck extensions can be bent to place the lamps as desired.

To copy documents and photograph objects on the copy stand base, it is customary to direct the two light beams from above, each at a 45° angle—one lamp on the left and one on the right. This symmetrical arrangement tends to produce shadowless lighting. If shadows are needed for modeling of details on the object, turn one lamp off or rearrange them so they are not symmetrical.

Lighting an object directly, so you can take a photo using reflected light from the object, is sometimes called *incident* lighting.

Trans-Illuminator Base X-DE— The hole in the base of the Macrophoto Stand is to allow illuminating objects from below as is

Figure 12-4/Trans-Illuminator LSD used with an Incident Illuminator Mirror Housing attached to the lens gives uniform lighting of the subject by reflected light.

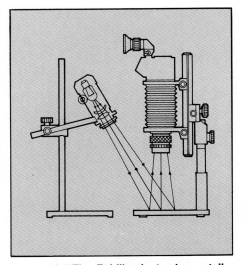

Figure 12-5/The Epi-Illuminator has a taller stand so it can be used to illuminate the subject directly from above.

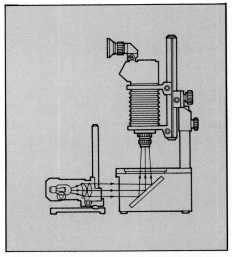

Figure 12-6/The subject is lit from below using light from Trans-Illuminator LSD reflected off the angled mirror in the Trans-Illuminator Base.

commonly done when using microscopes. This requires elevating the Macrophoto Stand so you can get light underneath it, which is the purpose of the Trans-Illuminator Base.

Built into the Trans-Illuminator Base, at the rear, is a light source of 20 or 30 watts, depending on which model you are using. A round adjustable mirror is inside the Trans-Illuminator Base, directly below a hole in the top surface. The mirror is flat on one side and concave on the other. When using the built-in light source, adjust the mirror so it reflects light from the built-in source. The light beam passes up through the hole in the top of the Trans-Illuminator Base, through the hole in the Macrophoto Stand, and illuminates the object from below.

If the object is transparent or translucent, some light will pass through it and we say the object is *trans-illuminated*. The photograph is made with light transmitted *through* the object.

For this application, you can't use the opaque stage plate that comes with the Macrophoto Stand. Choose one of several possibilities discussed later.

Trans-Illuminator LSD—The front of the Trans-Illuminator Base is cut away so you can direct a light beam from an external source through the opening and bounce it off the mirror. A special light unit, Trans-Illuminator LSD, is available for this purpose. It has more adjustments and flexibility of use than the built-in light source in the Trans-Illuminator Base.

One control changes the beam so it is

diverging, parallel or converging. Another control changes the diameter of the beam. A set of filters is available to change the color or amount of light.

Epi-Illuminator PM-LSD2—This is a pair of light sources on adjustable stands that can illuminate the object from above, similar to the copy stand light set. However, these lights are more controllable and flexible in their use. These lamps also have a control to change the beam so the rays are diverging, parallel or converging, and another control to change the diameter of the beam. These lights also use filters to change the color of the light.

If the Epi-Illuminator is mounted low on its stand, it can be used to direct a beam of light into the mirror of the Trans-Illuminator Base, similar to the Trans-Illuminator LSD.

LIGHTING METHODS USING THE MACROPHOTO STAND

Using these light sources in combination with other specialized accessories is best described with reference to drawings.

Figure 12-4 shows one form of incident lighting from above using the Epi-Illuminator and Macrophoto Stand. The stand is shown on the Trans-Illuminator Base but this is only to place the stand higher. The mirror and light source in the base need not be used.

A special box-like accessory, an Incident Illuminator Mirror Housing, is attached to the front of the lens. There are three models: PM-EL80 fits the 80mm macro lens and the 50mm macro; PM-EL38 fits the 38mm mac-

ro, and PM-EL20 fits the 20mm macro lens.

In each of these mirror boxes is a special semi-silvered mirror angled at 45° to the horizontal and facing the opening in the box. Using a parallel light beam from the Epi-Illuminator, light travels to the mirror surface in the mirror housing and is reflected downward to the object being photographed. Reflected light from the surface of the object then travels upward and through the angled mirror into the lens. Light is lost in each direction but that can be compensated for by choice of film speed and exposure settings.

This has the advantage of sending a beam of light onto the object from directly above. This produces shadowless, even illumination that is useful in photographing flat reflecting surfaces such as polished metallurgical and mineral specimens.

Another method of incident lighting is shown in Figure 12-5. Here, the Epi-Illuminator source is elevated so it illuminates the object from above, at an angle. This will create some shadows that show texture and detail of three-dimensional objects.

Transmitted lighting from below is shown in Figure 12-6 using a beam from Trans-Illuminator LSD bounced upward off the mirror in the Trans-Illuminator Base. For this application, an opaque stage plate in the Macrophoto Stand cannot be used.

There are several other choices. You can use a clear Stage Glass, which is just a round transparent disc. Place the object on the glass. You can use Stage Plate 45 or Stage Plate 28. These are black metal discs with a 45mm hole or 28mm hole in the center. The

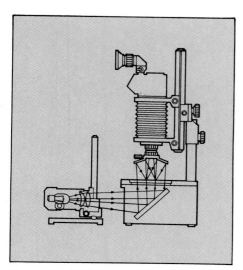

Figure 12-7/Light coming up through the Trans-Illuminator Base is reflected down to subject by a Lieberkuhn Reflector mounted on the lens. Subject should be opaque or on an opaque center insert in a transparent stage plate.

object is placed over the opening in the stage plate, either mounted in a glass slide, on a glass support or as appropriate.

Mechanical Stage FM is a special device that fits on top of Stage Plate 28. It has micrometer screw adjustments for precise positioning of a glass-mounted specimen.

Still another special lighting accessory is

shown in Figure 12-7. You will recognize the Trans-Illuminator used to bounce a light beam off the mirror in the Trans-Illuminator Base. The novel accessory used here is a ring-shaped angled mirror, called a Lieberkuhn Reflector, clamped to the front of the lens. Light that strikes this mirror is reflected downward to illuminate the object with shadowless lighting. There are two Lieberkuhn Reflectors: PM-LM38 fits the 38mm macro lens; PM-LM20 fits the 20mm macro.

Another special plate is used with these reflectors. It's called a Shade Stage Plate. This is a transparent glass disc with a round hole in the center. Two inserts are supplied to fit in the center hole. One insert is black, the other is opaque white. The object being photographed is placed over the insert.

Illumination is by light that passes upward around the edge of the opaque insert and is then reflected back downward by the Lieberkuhn Reflector. This gives shadowless illumination of the object against a black or white background, depending on which insert you are using.

In making this setup, it is essential to get light source and mirror correctly aligned. Accessory Centering Mirror PM-ELCS is used for this purpose, following a procedure given in literature packed with Incident Illuminator Mirror Housings.

Combining Light Sources and Methods— You can combine these lighting techniques and equipment items as needed for whatever

lighting effect you want.

POWER SOURCES

External power is required for the built-in light source in the Macrophoto Stand, the Epi-Illuminator and the Trans-Illuminator. Transformer Model TF or Transformer Model TE-11 can supply power to any of the three illuminators. Both have a control to adjust the output voltage of the power supply. This controls both brightness and color quality of the light source. The TE-11 has a meter that allows more precise adjustment of the output voltage.

PHOTOMICROGRAPHY

This is photographing through a microscope at magnifications from about 3.3 up to 750. The camera lens is removed and the camera body is attached to the microscope. An extensive set of adapters and accessories is available to do this.

Photographing through a microscope is beyond the scope of this book. Information can be obtained from Olympus and from Olympus microscope dealers.

OTHER ADAPTERS

There are also the OM-Mount Astroscope Adapter, which allows you to attach your OM camera to a telescope, and the OM-Mount Endoscope Adapter for medical photography. Neither of these applications is covered in this book.

This shows the setup of Figure 12-7 using the 38mm macro lens. Trans-Illuminator LSD is receiving electrical power through Transformer Model TF.

13
LIGHT, FILTERS & FILMS

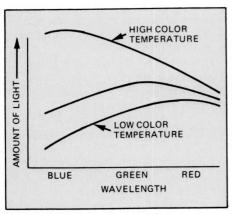

Figure 13-1/The relative proportions of red, green and blue wavelengths in incandescent light are determined by the temperature of the source, called *color temperature* because it's a way of implying color by stating temperature. Low color temperatures produce mainly long wavelengths of red light. High color temperatures produce blue light.

Several characteristics of light affect equipment and technique when taking pictures.

COLOR OF LIGHT

We say that direct light from the sun is *white*. It's composed of all colors in the visible spectrum. Light appears to travel in waves, similar to waves in water. Different wavelengths appear as different colors in human vision.

Human vision does not actually respond to all colors of light. We see only three colors: Red at the long-wavelength end of the spectrum, green in the middle, and blue at the short-wavelength end. The sensation of other colors is produced in the mind by noting the relative proportions of these three *primary* colors.

Beyond the visible blues in the spectrum

Color filters transmit some wavelengths and block others.

are shorter wavelengths called *ultraviolet* (UV). We can't see them, but film can and most types of film will be exposed by UV. When you expose ordinary film in your camera, some exposure results from light you can see and some from UV wavelengths you can't see. At times this is a technical problem and there are technical solutions.

Most films do not respond to wavelengths longer than visible red, called *infrared* or IR, but some special films do. You have probably seen photos taken with IR-sensitive film and noticed that natural objects such as water and foliage do not photograph the same in IR as in visible light.

Even though eyes cannot see IR, you have a sensor for it—your skin. IR waves are "heat waves" and cause the sensation of warmth. When you take a picture using IR film you are photographing reflected or radiated heat from the scene rather than visible light. People use IR films for fun and science.

LIGHT SOURCES

Not all light sources produce the entire spectrum. There are two main categories: Those that produce light due to being heated are called *incandescent*. Incandescent sources include the sun, a candle and the

common household lamp—sometimes called an incandescent lamp but in photography it's called a *tungsten* lamp. The glowing-hot filament inside an incandescent lamp is made of tungsten.

The other category of light sources does not depend on temperature to make light. These are sources such as fluorescent lamps and the yellowish sodium-vapor lamps used to illuminate highways and streets. The quality of light from non-incandescent sources is often a problem in color photography.

COLOR TEMPERATURE

The light produced by an *incandescent source*—including the sun—depends on its temperature. By stating the temperature of the source, the color balance of the light is implied. When so used, the temperature of the source is called *color temperature*.

Figure 13-1 shows the spectrum of several color temperatures. The main thing to observe is that low temperatures produce mainly long wavelengths of light that we see as red, orange and yellow. Candles and matches operate at low color temperatures and you don't see any blue or green in candlelight.

As color temperature increases, the amount of short-wavelength light increases. At a high color temperature, the light appears to be more blue than red. Light from the sky is a very high color temperature and it is blue.

In practical photography you worry about color temperature in one of two ways. For ordinary photography, you think of it in general terms: Is the light warm-looking and made up of red and yellow colors, or is it cold-looking and bluish? Are you shooting outdoors under the blue sky, or indoors with warm tungsten illumination? In everyday photography you respond to these questions by selecting film and choosing filters to control the color of the image.

If you do technical photography where

exact color rendition is important, you worry in more detail and use color temperatures to make equipment choices. Color temperatures are disguised in the technical term *mired*. A discussion of this is in my book *Understanding Photography*.

Color temperatures are just labels to indicate the color quality of light, expressed in absolute temperature—degrees Kelvin (K).

You can talk about the warm color of candlelight or you can say it has a color temperature of about 1800K. The two types of photoflood lamps used in photography produce light with color temperatures of 3200K or 3400K. They have a higher color temperature than ordinary room lamps.

Sunlight alone is about 5000K, but the cold-looking blue light from the sky may be around 12000K. Therefore, combinations of sunlight, light from the blue sky and a few puffy white clouds is between those two color temperatures. It is about 5500K to 6000K, which we call *average daylight*. Light from an electronic flash simulates daylight.

A subject in the shade of a tree is illuminated only by the blue light from the sky without the "warming" effect of direct sunlight. We think the light is cold-looking and it looks too blue.

Much of color photography is concerned with these color effects and sometimes changing them.

THE COLORS OF THINGS

A white piece of paper reflects whatever color of light falls on it. If illuminated by white light, it looks white. If illuminated by red light, it looks red.

Things that don't look white may owe their color to the light that is illuminating them, or to a property known as *selective reflection*. That means they do not reflect all wavelengths of light uniformly. A blue cloth in white light looks blue because it reflects mainly blue wavelengths. The other wavelengths of white light are absorbed.

The color of transparent things, such as glass, is determined by *selective transmission*. Blue glass looks blue because it transmits mainly blue wavelengths. If illuminated by white light, blue wavelengths pass through the glass to your eye.

The other wavelengths are either absorbed by the glass or reflected from its surface—back toward the source. As far as the viewer is concerned, the glass looks blue because only blue light comes through.

The color of an object is determined both by the color of the light that illuminates it and the selective transmission or reflection of the object.

THE VISUAL COLOR OF FILTERS

If you hold a color filter between your eye and white light, you see the colors that are transmitted by the filter. The effect of a filter on film is often more easily predicted by thinking about the colors the filter stops rather than those that get through.

Because human vision responds only to red, green and blue, it is only these three primary colors and their combinations that you have to worry about.

If a filter blocks all three primary colors completely, it looks black. If it reduces light transmission but some light at each color still comes through, the filter appears gray. Color filters usually operate by reducing the amount of light transmitted at one or two of the three primary colors.

If a filter blocks red, then it transmits both blue and green. To the eye, light coming through the filter appears bluish-green—a color photographers call *cyan*. We say cyan is the *complementary color* to red because you get cyan if you block red but transmit blue and green. Each of the three primary colors has a complement, according to this table.

In printing color films, laboratories use complementary-colored filters. The words, *cyan, magenta* and *yellow* are part of the language of photography and you should know what they mean.

ADAPTATIONS OF THE EYE

There are three kinds of human visual adaptation that are important in photography. One relates to the brightness of light. On entering a building, we have the sensation that it is darker for only a few seconds and then we adapt to the lower level of illumination and don't notice it any more. On returning outdoors, we adapt to increased brightness in a short time.

Because of this adaptation to different brightnesses, people are very poor judges of the amount of light and should rely on exposure meters.

We adapt to color of light in the same way. If you are reading at night, using a tungsten reading lamp, you adapt to the yellowish color and don't even notice it. The paper in this book looks white to your mind. Go outside and look at your window. It will be

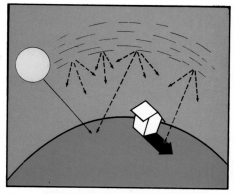

As sunlight travels toward the earth, atmospheric scattering takes blue lightwaves out of the sunlight and scatters them all over the sky. That's why the sky looks blue and why light *from* the sky is blue.

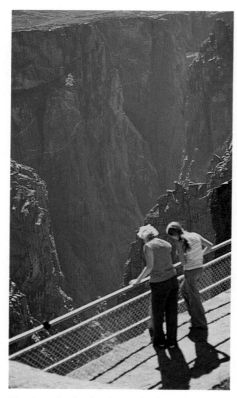

Blue haze is due to atmospheric scattering of light.

obvious that you are reading in light that has a definite yellow cast.

Another adaptation results from your feeling of participation in a real-life situation. This turns up in several ways that often make a photo look ridiculous.

You can pose somebody in front of a tree and think it's a fine shot. When you look at the print, a tree limb seems to be growing out of your model's ear, which seems absurd in the picture, even though it didn't bother you when it was real life.

127

EFFECTS OF ATMOSPHERE

The sun flings energy toward the earth over an extremely wide spectrum, part of which is visible. The atmosphere acts as a filter to block transmission of some wavelengths and allows transmission of others, including all visible wavelengths.

The atmosphere also has an effect on light rays that is called *scattering*. Instead of traveling in a straight path through the air, some light rays are diverted and bounce around in the atmosphere. This becomes light from the sky.

The atmosphere scatters short wavelengths much more than long wavelengths. Therefore, blue light is extracted from the direct rays of the sun and scattered all over the sky. That's why the sky is blue.

More blue light is removed from sunlight by scattering when there is more air between you and the sun. At noon, sunlight comes directly to the earth where you are and takes the shortest path through the air. Therefore, there is minimum scattering of blue light and more of it is in the direct rays of the sun.

During the morning or evening, the sun's rays come to you at an angle and therefore travel through more air. More blue light is extracted from the sun's rays, so sunlight appears to be more red-colored.

On a nice clear day, the sky is blue except near the horizon where it often looks white. This is another form of scattering caused by dust and smoke particles that are large enough to reflect most wavelengths of the visible spectrum. They scatter all of the light from the sun and the lower atmosphere looks white.

If you look from here to that distant mountain, you are looking through a lot of lower atmosphere with both white-light scattering and blue-light scattering. The light rays coming to your eye from trees and rocks on the mountain are diverted from straight paths, details are obscured and the image looks hazy. We call that *atmospheric haze*. From point to point in the lower atmosphere, blue light is scattered more than any other wavelength.

If you take a picture without using the blue light rays to expose the film, there will be less atmospheric haze in your picture. Details of a distant scene will be more distinct. You can do that by using a color filter that excludes blue light. It must therefore pass both green and red light. If you hold such a filter against white light it will look yellow because the combination of red and green makes the sensation of yellow light.

It is common to use a yellow-colored filter over the lens to cut atmospheric haze. This works fine on b&w film, but on color film it

A distant view is obscured by atmospheric haze, which *always* looks worse on film than in the real world.

A yellow filter cuts some haze by blocking short wavelengths.

A red filter cuts still more haze by blocking both short and medium wavelengths. The same filters that cut haze also darken blue sky, making clouds stand out.

will make a yellow-colored picture.

If your picture on b&w film is still too hazy with a yellow filter, remember that short wavelengths of light are scattered more than long wavelengths. If excluding short wavelength blue won't do the job, try also leaving out medium-wavelength greens. The filter now transmits red only, but image detail is greatly improved.

What if you exclude, blue, green and also red? That will use still less scattered light to make the picture. A filter that excludes all three primary colors will look black because no visible wavelengths get through. Invisible IR wavelengths can come through a very dark-looking red or IR filter and expose IR film. That's the best haze cutter of them all.

Any filter that blocks scattered rays will improve contrast and sharpness of the image on the film.

Another effect of light scattering between your camera and the scene is reduced contrast of the image on the film. Light rays coming from bright parts of the scene are diverted by scattering so they land on the film at the wrong places. Some will land where it should be dark and that will make the dark places lighter.

You can see this when outdoors on a sunny day. Notice the contrast in brightness between sunlight and shadow nearby. Then look as far away as you can and compare the brightness of sunlight and shadowed areas over there. The shadows will appear lighter than those nearby.

COLOR-SENSITIVITY OF B&W FILM

Even b&w film is color sensitive. The early b&w emulsions were sensitive mainly to blue and UV light. Photos of women with red lipstick caused the lipstick to appear black because the film did not respond to red.

An improved film, called *orthochromatic*, was still deficient in red-response.

Current b&w films, called *panchromatic*, are said to be responsive to all visible wavelengths and as a practical matter, they are. There is still a slight deficiency in red response and too much sensitivity to blue, but it is usually not noticeable.

COLOR FILTERS WITH B&W FILM

For most photographic purposes, the major problem of b&w film is that it records in shades of gray. The print does not show colors that help to distinguish a red apple from green leaves or a yellow skirt from a blue sweater. If the skirt and sweater happen to cause the same shade of gray on the film, they will look the same in b&w.

Usually, a b&w picture is improved if objects of different color record as different tones or shades of gray because the viewer of

With no filter and b&w film, a rose is about the same shade of gray as the surrounding green leaves.

A red filter lightens the rose and darkens the leaves so there is more contrast.

A green filter lightens leaves and darkens the rose. Any red and green filters will have these effects, but deeper colors have a more noticeable effect.

the print *expects to see* some difference between a necktie and jacket, or a rose and foliage.

You can use color filters on your camera to make a visible brightness difference between adjacent objects of different colors, as you can see in the accompanying photos.

The rule when using color filters with b&w film is: A filter lightens its own color. This applies to the final print, not the negative, but it is the print you are concerned about. A corollary to the rule is: A color filter used with b&w film darkens every color except its own.

It is common with b&w film to use filters to make clouds stand out against a blue sky. With no filter, clouds in the sky are sometimes nearly invisible and the entire sky is light-colored in the print. It is much more dramatic to have a dark sky with white clouds.

White clouds reflect all colors of light, but the sky is blue. Suppress blue with a filter and the sky darkens. The clouds darken too, but not as much. Because you are using b&w film, you can use any filter color and only different shades of gray will result. The hierarchy of sky-darkening filters for b&w film runs from yellow to light red to dark red with more effect as you use darker reds.

Naturally, the effect of a red filter appears on everything in the scene. If you include a model with red lipstick, the filter is an open door for red color and your model's lips will be lighter in tone.

A compromise filter often used for outdoor b&w portraits is a shade of green. This suppresses blue to darken the sky some but also holds back red so makeup and skin tones are not affected as much as with a red filter.

HOW COLOR FILMS WORK

Color film and the color-printing process used in books and magazines are possible because human color vision is based on the three primary colors. A color picture need have only these three colors mixed in proper proportions to do a good job of presenting all colors we can see.

Color film does this with three different layers of emulsion coated on a base. The main difference between a color slide and a color print is that the base of the print is opaque white paper.

The trick of color film is to use one layer to record the amount of each primary color at every point in the scene. When viewing a color slide by transmitted light or a print by reflected light, each layer controls the amount of light at its primary color. The light we see from the combination of all three layers causes our vision to see the colors of the original scene.

Naturally, the colors we see when viewing a slide or print are affected by the color of the projector light or room illumination where we are viewing the picture.

NEGATIVE-POSITIVE COLOR

Color prints are made from color negatives. A comparision to b&w will be useful. In b&w negatives, the shades of gray are reversed from the original scene. A white shirt appears black in the negative.

In color-negative film, after development, each layer transmits a reversed density of that particular color. If the subject is strongly red, the color-negative layer will be strongly not-red, meaning cyan-colored. A color print made from the negative reverses the color densities again with the result that a strong red in the scene becomes a strong red on the print.

You have probably noticed an overall orange cast of color negatives. Even the clear parts are orange. The dyes used in color films are as good as each film manufacturer can make them, but not as good as the manufacturer would like them to be. These slight deficiencies in the color dyes are corrected by a complicated procedure called *color masking*. Evidence of masking is the orange color. This color is removed by filtering when making a print. Because of color masking, the colors in a negative-positive process can be more true-to-life.

Color filters can be used to change the color of the printing light and thereby make small corrections in the color balance of the print.

If you miss exposure a step or two when using color-negative film, it is often possible to make a correction during printing, so the print is properly exposed and not too dark or too light.

Color-negative film allows the camera operator to make small mistakes, or be less precise about his work, and still end up with an acceptable print.

COLOR-SLIDE FILM

A color slide or transparency is the same piece of film you originally exposed in the camera. It is developed and chemically processed to make a positive image directly. This procedure is called *reversal processing* because it makes a positive out of a negative. There is no color masking because there is no opportunity to remove the orange color when making a print. The color balance of slide film is theoretically inferior to that of a good color negative-positive procedure but in practice it's hard to see.

Because there is no separate printing step to make a color slide, there is no opportunity to correct a bad exposure and no way to change the color balance of the positive. This makes exposure more critical, both in the

amount of light on the film and its color.

Color-slide film will often make a perfectly good image when under- or overexposed a small amount, but it won't look right when projected on a screen. It will be too light or too dark overall, particularly when viewed in sequence with other slides that were properly exposed. For this reason, we say that color slides should be correctly exposed—within half a step either way.

When any color film—negative or reversal—is seriously over- or underexposed, two effects may result. One is comparable to over- or underexposing b&w film. Light areas become too light, or dark areas become too dark, and contrast is lost between portions of the scene in the too-light or too-dark areas.

The second effect is peculiar to color film and is caused by reciprocity failure. Because the three layers are different emulsions, they usually don't go into reciprocity failure simultaneously—and when they do, they don't react in exactly the same way.

A typical result of serious exposure error with color film is that one layer goes into reciprocity failure and needs more exposure but doesn't get it. Therefore, that layer is effectively underexposed and does not properly control its color when developed. The end result is an overall color cast such as pink or blue that affects the entire picture.

This can be corrected in a negative-positive process if the color change is not too severe. But with color-slide film, you get what you shoot. Instructions for correcting reciprocity failure with color film usually call for both additional exposure and a color filter over the camera lens.

Making Tests—Whenever you are making tests of equipment or your skill, it's important to see what you actually put on the film. Most film laboratories will automatically make corrections when printing b&w or color negatives to compensate for apparent errors in exposure or color balance. If you are testing exposures and deliberately shoot some frames over- or underexposed, you don't want the lab to correct your shots.

Color-slide film is the best way to make tests. What you get is what you shot, without any corrections by the film lab.

FILTERS FOR COLOR FILM

There are three types of color film. Two are made to produce a good color image with tungsten illumination. These are called *tungsten* films.

If you use tungsten film in tungsten light, you don't have to use a filter to change the color balance of the light that gets on the film.

If there is not enough room light to shoot with, you can add light by using special

LIGHT SOURCES
Daylight
Tungsten, 3400K
Tungsten, 3200K
Household Tungsten below 3200K
Fluorescent
TYPES OF COLOR FILM
Daylight, 5500K
Tungsten Type A, 3400K
Tungsten Type B, 3200K

Skylight coming from Irene's right, and warm tungsten light from her left, create two different skin tones.

photo lamps, commonly called *photofloods*. There are two types. Some operate at 3400K to produce more light output but with shorter life. Some operate at 3200K, which is closer to normal room lighting.

Type B tungsten film is intended for use with 3200K lights. If you use 3400K lamps with Type B film, you should use a filter over the camera lens.

Type A color film is designed for use with 3400K lighting. If you use it with 3200K lamps or ordinary room lighting, compensate with a filter over the camera lens.

You can often "get away" with mixing photofloods with room light from table and floor lamps, but technically this is mixed lighting with a visible color difference between the two types of light.

Daylight color film is balanced for daylight, but you may decide to use one of the following filters anyway.

Ultraviolet light is reduced by the atmosphere but is present in some amount everywhere. The higher the altitude, the more UV there is to expose film. In cleaner air, there is more UV because less of it is blocked. You can't see UV and your exposure meter probably ignores it, but film will be exposed by UV.

UV filters reduce transmission of UV. They are clear because they don't stop any visible wavelengths.

In the mountains, and usually at the seashore, a UV filter should be used. This applies equally to color or b&w film because both are sensitive to UV. Using a clear filter has a secondary benefit of protecting the lens itself.

If atmospheric haze is a problem, exclude short wavelengths. With color film, you can't use a strongly colored filter unless you want the picture to have that color. *Haze filters* for color film cut UV and also cut some of the barely visible blue wavelengths— the shortest. A haze filter for use with color film is practically clear. If you use one, you don't need a UV filter because it will do both jobs.

A subject in shade outdoors is illuminated by skylight, which has more blue in it than average daylight or direct sunlight. With color film, the effect is usually noticeable as an overall blue cast of the picture and bluish skin tones on people.

Skylight filters for use with color film block some of the blue light to give a more warm-looking picture. Some photographers like the effect even in daylight or direct sunlight, so they put a skylight filter on the lens and use it all the time with color film outdoors. It also blocks UV.

There are filters that allow you to use indoor film in daylight, and daylight film indoors. To use tungsten film in daylight, the filter has to alter daylight so it looks like tungsten to the film. The filter will reduce the amount of blue and green so what comes through has a color balance similar to tungsten light. Such filters have a yellow-orange appearance when viewed in white light.

To use daylight film indoors, filtering depends on the illumination being used inside the building. If it is tungsten light, the filter must change it so it appears to be daylight as far as the film is concerned. The filter will

USING NEUTRAL-DENSITY FILTERS TO INCREASE EXPOSURE TIME OR APERTURE		
FILTER NOMENCLATURE	MULTIPLY EXPOSURE TIME BY:	OPEN LENS APERTURE BY (*f*-STOPS):
ND .1	1.25	1/3
ND .2	1.6	2/3
ND .3 or 2X	2	1
ND .4	2.5	1-1/3
ND .5	3.1	1-2/3
ND .6 or 4X	4	2
ND .8	6.25	2-2/3
ND .9 or 8X	8	3
ND 1.0	10	3-1/3
ND 2.0	100	6-2/3
ND 3.0	1000	10
ND 4.0	10,000	13-1/3

Glass screw-in ND filters with *filter factors* greater than 8X are hard to find. Camera dealers can supply Eastman Kodak gelatin ND filters in *densities* up to 4.

block a lot of red and will look blue in white light.

If the indoor illumination is fluorescent lamps, it is difficult to filter. Some look bluish and some are designed to look like daylight to humans. Fluorescent light sources *do not look like daylight* to film. Filter manufacturers offer filters for use with fluorescent lighting. The best guide to their use is the maker's instructions.

Except for polarizing and neutral density filters, which will be discussed shortly, those are the filter types that can be used with color film without an unusual or noticeable effect on the overall color of the picture. If you shoot through a red filter, you get a red picture— including skin and snow, which most people expect to be skin-colored and snow-colored.

FILTER FACTORS

Most filters reduce light at visible wavelengths. They reduce it more at some wavelengths than others, but the net result is still less light on the film. This does not apply to visually clear filters such as UV and some haze filters for color film.

Filter manufacturers normally state the amount of light loss as it affects the film exposure by a number known as the *filter factor*. This number is used to multiply the camera exposure that would be used without the filter, to get the correct exposure with the filter. The symbol X is included in a filter factor to remind us that it is used as a multiplier.

A 2X filter must be compensated for by two times as much exposure, which is one more exposure step. Use the next smaller *f*-number or the next slower shutter speed. A 4X filter requires two exposure steps. An 8X filter needs three exposure steps.

Olympus OM cameras meter behind the lens so the camera exposure meter automatically compensates for the effect of a filter on the lens. You can ignore filter factors as long as you use the camera's built-in meter. This is a great convenience.

You are not getting filtering free. Even though it is simple and uncomplicated to set exposure with a filter on the lens, the correction must have the effect of increasing aperture or exposure time.

Although TTL metering spares you the inconvenience of using filter factors, you should know about them because they can affect the technical solution you are using to make the picture. Filter factors are also a guide in purchasing a filter because they tell you how strong the color will be. Higher filter factors mean deeper colors and more light loss.

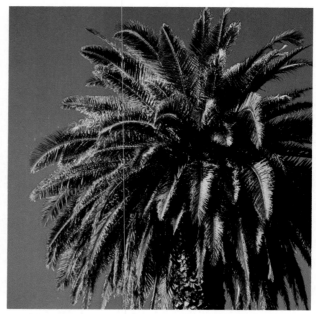

A polarizer over the camera lens can darken blue sky if pointed at the right part of the sky. It also blocks light that has been reflected from some surfaces, which changes the appearance of these palm fronds. Photos by Ted DiSante.

NEUTRAL-DENSITY FILTERS

There are circumstances when you want less light so you can use larger aperture for less depth of field. There are also some cases where you want less light so you can use longer exposure times.

Gray-colored filters called *neutral density* (ND) reduce the amount of transmitted light uniformly across the visible spectrum, which is why they are called neutral. They can be used with either color or b&w film because they have uniform color response.

Some ND filters are rated the same way as color filters—by a filter factor. Commonly available ratings are 2X, 4X and 8X.

You may have to stack filters, meaning put one in front of another, to get the required density. When stacking filters using filter factor ratings, the combined rating is obtained by multiplying the individual ratings. A 2X filter and an 8X filter used together have a rating of 16X.

Some ND filters are labeled with their optical density instead of a filter factor. Each increase of 0.3 in optical density is equal to a filter factor of 2X.

When filters rated by optical density are stacked, the densities add directly. An ND 0.3 filter plus an ND 0.3 filter makes an ND 0.6 filter—with a filter factor of 4X.

You can use ND filters in ordinary photography when the film in the camera is too fast for the job at hand. If you have high-speed film already in the camera and you want to make a shot or two in bright sunlight, clip on an ND filter and effectively slow down the film.

The camera will behave as though the film speed is divided by the filter factor. For example, if you have ASA 400 film in the camera and put on an ND filter with a factor of 4X, you will end up with an aperture and shutter speed as if the film had a rating of ASA 100.

Does this mean you should change the film-speed dial of the camera from 400 to 100? No, even though some instructions seem to say that.

POLARIZING FILTERS

Still another property of light waves is *polarization,* the direction of movement or vibration of the light waves. Water waves serve as a good analogy. Water particles in a water wave move up and down, so the wave is vertically polarized. Light can be vertically polarized, horizontally polarized, or polarized in all directions at once— called *random polarization.* Direct sunlight is randomly polarized.

Some materials have the ability to transmit waves with only a single direction of polarization. These materials are made into polarizing filters, sometimes called polariz-

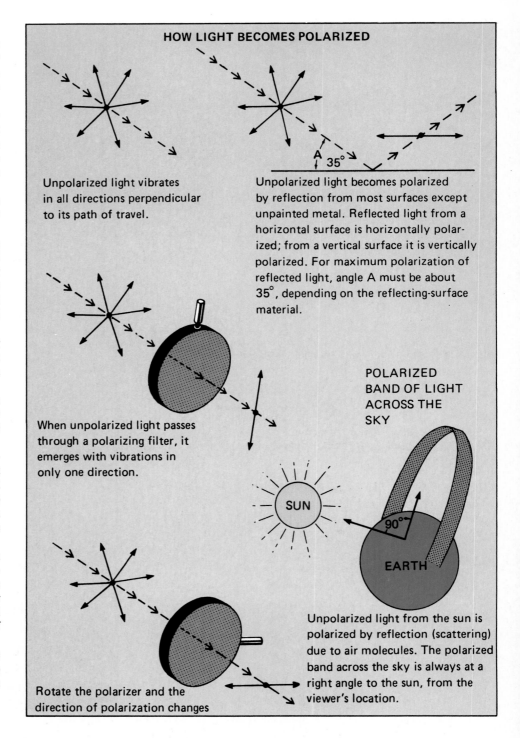

HOW LIGHT BECOMES POLARIZED

Unpolarized light vibrates in all directions perpendicular to its path of travel.

Unpolarized light becomes polarized by reflection from most surfaces except unpainted metal. Reflected light from a horizontal surface is horizontally polarized; from a vertical surface it is vertically polarized. For maximum polarization of reflected light, angle A must be about 35°, depending on the reflecting-surface material.

When unpolarized light passes through a polarizing filter, it emerges with vibrations in only one direction.

POLARIZED BAND OF LIGHT ACROSS THE SKY

Unpolarized light from the sun is polarized by reflection (scattering) due to air molecules. The polarized band across the sky is always at a right angle to the sun, from the viewer's location.

Rotate the polarizer and the direction of polarization changes

ing screens. A polarizing filter that transmits vertically polarized light will not transmit horizontally polarized light, and the reverse.

If randomly polarized light arrives at a polarizing filter oriented to pass vertical polarization, the horizontally polarized component will be blocked by the filter. If the filter were perfect, this would block exactly half of the total light in a randomly polarized beam and the filter would have a filter factor of 2X or a density of 0.3. Practical filters vary from around 2.5X to 4X. They don't

block all light of the wrong polarization, but the filter material is gray-colored so it absorbs some light of all polarizations just because of the gray color.

Unpolarized light becomes polarized by reflection from smooth surfaces—except unpainted metal. Where such reflections occur, we see the reflection as a glare, such as in a store window or glass display case, and on the surface of varnished wood furniture. When a polarizing filter is used to block such reflections, the improvement is some-

The accessory Ring Cross Filter Pol mounted on the T10 Ring Flash has a polarizer with a circular shape that covers the front of the lens. It also has a ring-shaped polarizer that covers the ring flash. The two work together to reduce reflections of the flash.

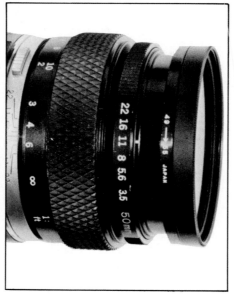

A 55mm filter can be mounted on a lens with 49mm filter threads by using a 49→55 *step-up* ring.

times dramatic.

When unpolarized light is reflected from a non-metallic surface, vibrations in the light that are parallel to the surface are reflected and those that are perpendicular are suppressed. For example, light reflecting from a horizontal surface will become polarized horizontally.

Polarizers are normally supplied in mounts that allow the filter to be rotated so you can change the angle of polarization while viewing the result. Meter and set the exposure controls after you have rotated the polarizer for the desired effect.

With color film, a polarizer is the only way to darken blue skies to make the clouds stand out. Scattered blue light from the sky is polarized and the effect is maximum when viewed at a right-angle to the sun. When you rotate the polarizer so it suppresses the polarized blue light, the sky becomes darker and white clouds become highly visible.

In studio setups, maximum control of reflections can be done by polarizing the light source and using a polarizing filter over the camera lens.

Ring Cross Filter Pol—This special accessory for the T10 Ring Flash is used to suppress reflections of the ring-shaped light source. It is two filters in one. The center part is a circular polarizing filter that fits over the camera lens. The outer part is a ring-shaped polarizer that fits over the ring flash. The filter screws into the lens and does not require rotating for best effect. The two parts are permanently mounted in relation to each other for maximum reduction of reflections.

FILTER MOUNTING

Most Zuiko lenses use the filter type that screws into the threaded ring on the front of the lens. Each filter repeats the thread on the front of the filter, so a second filter can be screwed into the first.

Stacked filters may vignette the image because the filter frames extend too far forward. Olympus filters are made with narrow frames to minimize the possibility of vignetting. With some wide-angle Zuiko lenses, a single filter of conventional design may vignette but an Olympus filter will not.

A problem results from lenses with different screw-thread diameters. If you have a filter that fits a small-diameter lens, it will be too small for larger-diameter lenses and you may end up buying the same filter type in two diameters.

With screw-in filters, the lens-size problem can be solved by purchasing filters to fit your largest-diameter lens. Adapter rings are available at most camera shops. These are usually called *step-up rings* and *step-down rings*. The step-down type puts a smaller filter on a larger lens—which may cause vignetting of the image by blocking some of the light around the edges of the frame. Using a filter larger than the lens, installed using a step-up ring, rarely causes any problem unless several are stacked.

CONVERSION FILTERS			
Color Film Type	Light Source	Filter Needed	Filter Factor (Approx.)
Daylight	Tungsten 3400K	80B	3X
Daylight	Tungsten 3200K	80A	4X
Tungsten Type A 3400K	Daylight	85	2X
Tungsten Type B 3200K	Daylight	85B	2X

To use daylight color film in tungsten light or the reverse, use a conversion filter over the lens. This table gives standard filter designations used by most filter manufacturers.

IMAGE DEGRADATION DUE TO FILTERS

Besides vignetting due to stacking filters, image quality may deteriorate when several filters are used together.

The light reflects back and forth between glass surfaces, just as in a lens. All good quality modern filters are coated to reduce reflections.

Filters have least effect on image quality when they are mounted close to the front of the lens. Stacking and use of step-up rings puts some of the glass far enough from the lens to make aberrations and defects more apparent.

Dirt, scratches or fingerprints on a filter surface will scatter the light and reduce contrast of the image, the same as dirt does on the lens itself. Filters should receive the same care as lenses.

Filters may fade with age, particularly if exposed to bright light a lot of the time. This change is hard to detect because it is gradual, but it may not be important until you can detect it.

FILTER CATEGORIES

There is very little standardization in the names given to types of filters to indicate their purpose. Common designations are used here.

Filters are often grouped into categories that are logical but possibly misleading. A filter is a filter and it has some effect on light. Even though one may be labeled for use in making color prints in the darkroom, it can be just as useful in front of your camera if you can find a way to hold it there.

Conversion Filters—This type of filter alters light to make it suitable for the film you are using. It converts daylight to look like tungsten illumination and vice versa.

Light-Balancing Filters—These make smaller changes in the quality of light, such as changing from 3200K light to 3400K light and the reverse for Type A and Type B color film. Another example is a skylight filter to take out some of the blue when the subject is in shade.

Exposure Control Filters—These are neutral-density filters that alter the amount of light, not the relative amounts of each wavelength.

Contrast Control Filters—These are color filters used with b&w film to control or alter visual contrast on the print between objects of different color in the scene—the red apple among green leaves, for example.

Haze Filters—Useful with either color film or b&w, depending on the filter. They cut haze by cutting the shorter wavelengths of light. Obviously a dark red filter used to cut haze with b&w film can also serve as a special-effect filter with color film.

Special-effect lens attachments produce a variety of eye-catching effects including multiple images, star effects, rainbow effects and sometimes surprising colors. They are fun to use and often produce a photo with impact. Usually the device needs some help from the subject matter. This shot was made at night using a multiple-image attachment.

OLYMPUS FILTERS

	Type	Color	SIZES (mm)				FILTER FACTOR		Description
			49	55	72	100	Day-light	Tungsten light	
For B&W and Color films	Skylight (1A)	Colorless	●	●	●	●	1	1	Absorbs ultraviolet rays. With color films, reduces haze and bluish tones in daylight photography. Makes marked improvements by absorbing bluish cast, particularly at the seashore, on high mountains, or in tree shadows under clear sky.
	L39 (UV)	Colorless	●	●	●	●	1	1	Eliminates undesirable ultraviolet rays which cause dull, flat pictures, especially in distant shots. May be used at all times to protect the lens.
	ND2 ND4	Gray Gray	● ●	● ●			2 4	2 4	Reduces the amount of light entering the lens without any change of color, tone or contrast. Use to maintain a wide lens aperture or slow shutter speed.
	POL	Gray	●	●			3 to 4	3 to 4	Reduces glare due to reflection from most surfaces. Will emphasize clouds against a blue sky by darkening sky.
For B&W film	Y48 (Y2)	Yellow	●	●	●	●	2	1.5	Absorbs a wide range of wavelengths from UV, to part of blue. Accentuates contrast of clouds, darkening blue skies. Useful in copying documents where letters or figures are blue or black against light background.
	O56 (O2)	Orange	●	●	●	●	4	3	Absorbs a wider range of wavelengths from UV to blue-green than the Y2. Makes contrast higher than Y2. Can be used with infrared films.
	R60 (R1)	Red	●	●	●	●	8	4	Makes contrast higher than O2. Penetrates haze to make landscape photographs clearer and sharper than viewed by the naked eye. Use with infrared films.
For Color film	A4 (81C)	Amber	●	●			1.3		Use when taking color pictures in cloudy or rainy weather. Reduces bluish tone and gives warmer colors.
	B4 (82C)	Blue	●	●			1.6		Use when taking color pictures in early morning or late evening hours when red rays are predominant. Reduces red tone. Can also be used to give bluish tone for special effects.

Color Compensating Filters— These are for making prints from color film but can also be used over the camera lens. They have relatively low densities in six colors that are important in color films: red, green blue, cyan, magenta and yellow.

These filters have an orderly system of nomenclature that uses the letters CC as prefix in all cases. Following the prefix is a number such as 05, which is the optical density of the filter. Following the density indicator is a letter that is the initial of the visual color of the filter itself. If the filter looks red when viewed against white light, it is called a red, or R filter.

A filter identifed as CC30G looks green to the eye, therefore, it suppresses red and blue. The density of 0.30 is to magenta light. A CC50M filter is magenta colored.

CC filters have good optical quality and can be used in front of a camera lens and below the negative in an enlarger without noticeable degradation of the image.

Color Printing Filters—These have the same colors and density ranges as CC filters but are not of good optical quality. They are intended to change the color of the printing light by insertion of the CP filter above the negative in an enlarger. At that point in the optical path, the image is not yet formed, so optical quality of the filter is not important as long as the color is correct.

Special Filter Types—These include such things as star-effect filters, and soft-focus or diffusion filters.

14
MOTOR DRIVES, FILM WINDERS, SPECIAL CAMERA BACKS

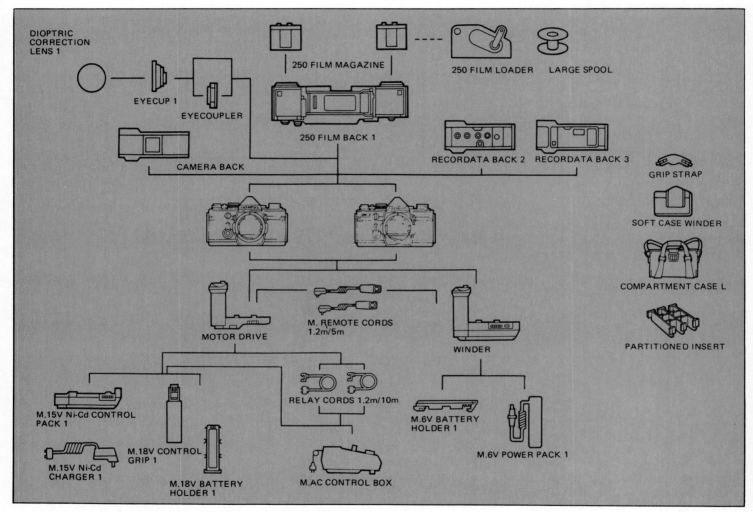

This "road map" shows Olympus motor drives, winders, special backs and accessories.

The OM77AF has a built-in motor drive to provide film advance and rewind. Therefore, it doesn't use the accessory Motor Drive 2 or Winder 2 described in this chapter. This camera has no provision for remote control, so it doesn't use any of the remote control equipment described here. The only accessory mentioned in this chapter that can be used by the OM77AF is Recordata Back 100.

Motor Drive 2 and Winder 2 can be used by all cameras in this book, except OM77AF.

Motor Drive 2 exposes frames of film continuously, as long as you hold your finger on the motor-drive control button. It can also be set to expose single frames—one for each time you depress the button. Winder 2 also exposes frames in sequence or one at a time.

Motor Drive 2 advances a frame in 0.16 second, which is about twice as fast as Winder 2. Therefore, the maximum operating speed of the motor drive is about twice as fast: five frames per second with the motor

drive; 2.5 frames per second with the winder.

Either unit attaches to the bottom of the camera using a screw that fits into the tripod socket.

With a motor drive or winder installed and turned on, you trigger motor-driven operation by pressing the shutter-release button on the motor-drive grip or winder grip instead of the shutter button on the camera body.

Either unit can be turned off and left on the

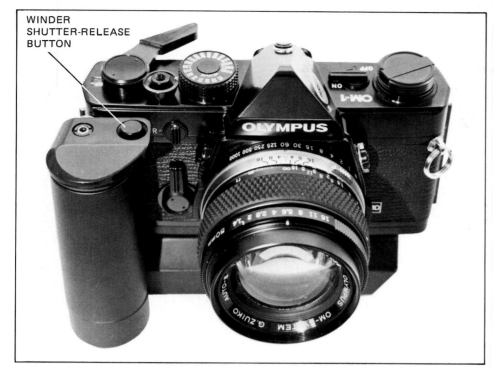

WINDER
SHUTTER-RELEASE
BUTTON

A winder adds very little bulk or weight to an OM camera. The winder bottom is shaped so it doesn't interfere with using your left hand to support the lens while shooting.

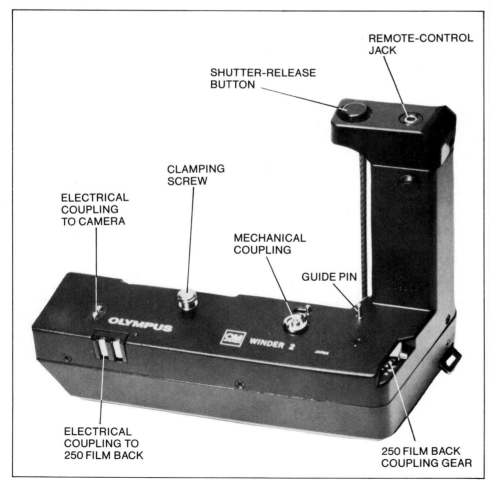

REMOTE-CONTROL
JACK

SHUTTER-RELEASE
BUTTON

CLAMPING
SCREW

ELECTRICAL
COUPLING
TO CAMERA

MECHANICAL
COUPLING

GUIDE PIN

ELECTRICAL
COUPLING TO
250 FILM BACK

250 FILM BACK
COUPLING GEAR

Winder 2 attaches to base of most OM cameras by screwing the Clamping Screw of the winder into the camera tripod socket.

camera while the camera is operated in the normal way: advancing film manually and making each exposure using the camera shutter-release button.

Motor Drive 2 can be set to expose a predetermined number of frames, such as 5, and then stop. Winder 2 does not have that capability.

WINDER 2

This unit uses four 1.5V AA-size batteries in a holder in the bottom of the winder. NiCads are OK. It can also receive power from an external power source, plugged into the External Power Jack on the bottom of the grip.

The control switch surrounds the power jack, on the bottom of the grip, and has three settings: OFF, SINGLE and SEQUENCE.

When set to SINGLE, the winder keeps the camera always ready to shoot. You never forget to wind the film after a shot because the winder does it for you. The time required for film advance is only about 0.3 second, which is faster than you can do it with your thumb.

In the single-frame mode, the winder advances the next frame as soon as an exposure is completed without waiting for you to lift your finger from the control button. But, before you can expose the next frame, you must lift your finger and depress the button again. You can lift your finger while the winder is advancing film so your reaction time doesn't slow down the procedure.

In this mode, you can shoot frames rapidly by operating the shutter button once for each frame. Thus, you can expose a sequence of frames quickly but at varying time intervals depending on when you press the button. You can get lots of frames of an event as it happens, but you can time each one to capture a particular bit of the action according to your purpose in shooting the event.

When set to SEQUENCE, the winder will expose frames continuously, as long as you hold down the Shutter-Release Button on the winder. At exposure times of about 1/15 second and shorter, the winder can expose frames at rates up to 2.5 frames per second, depending on shutter speed.

With Winder 2 installed, there are two shutter buttons—one on the winder and one on the camera. Both remain active and either can be used. If you depress the winder Shutter-Release Button, the camera makes an exposure and the winder immediately advances the frame. If you depress the camera Shutter-Release Button, the camera makes an exposure and then you must advance the next frame manually using your thumb on the camera's film-advance lever.

The mechanical connection between winder and the film-advance mechanism in the camera is by a coupler in the Motor-Drive Socket on the camera base. On some models, this socket is covered by a Motor-Drive Socket Cap. On other models, the coupler is exposed so you don't have to remove a cap.

Installation of the winder is simple. If the camera has a motor-drive socket cap, remove it. Store it in the holder on the end of the winder case, exposed by withdrawing the battery holder.

Then position the winder carefully on the bottom of the camera so all connectors and pins mate properly. Turn the Clamping Screw in the winder body so it threads into the tripod socket on the camera. The winder has a tripod socket on its bottom surface so you can tripod mount the combination.

Electrical connections are made automatically, both to the camera and to the special 250-frame film back if installed, as discussed later in this chapter.

At the end of a film roll, the winder automatically stops operating until you load new film.

Power Source—Winder 2 uses four AA-size batteries in the M.6V Battery Holder 1. For normal use, the battery holder slides into the bottom of winder case.

In cold weather, batteries suffer reduced output and the winder will not work as well. To prevent this, use the M.6V Power Pack 1. This is a plastic case for the M.6V Battery Holder 1 with batteries and an extension cord that plugs into the External Power Jack at the bottom of the winder grip. Remove the battery holder from the winder case, install it in the power pack unit and put the power pack in your pocket. This keeps the batteries warm so their power output does not deteriorate.

The External Power Jack can also be used to receive power from an external source other than the power pack, provided the source voltage is in the range of 4V to 5.5V.

Remote Control—On top of the winder grip is a Remote Control Jack used to control the winder and camera from a distance using the Olympus Remote Cord or Intervalometer.

Application of these devices is the same as discussed in the following section. In addition to Olympus remote control devices, you can use accessory items such as radio control if they provide a switch closure to trigger each exposure and if you can provide the connecting cord to fit the External Power Jack.

MOTOR DRIVE 2

This equipment is in two parts. The motor drive unit attaches to the bottom of the camera. A shutter-release button is on the top

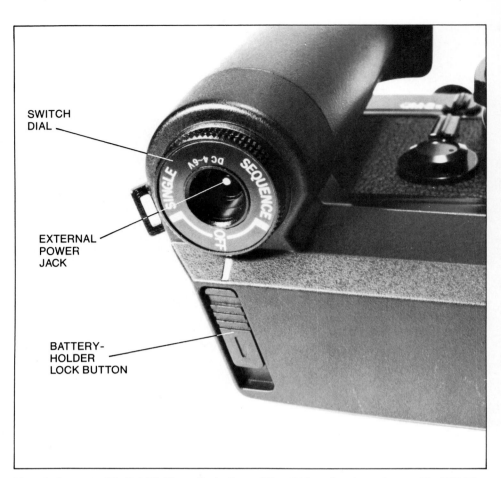

The winder control Switch Dial is on the bottom of the winder grip, shown here set to OFF. The winder has its own tripod socket so you can tripod-mount the combination of camera and winder. Batteries are loaded into a holder that slides into the bottom of the case at the opposite end from the Battery-Holder Lock Button.

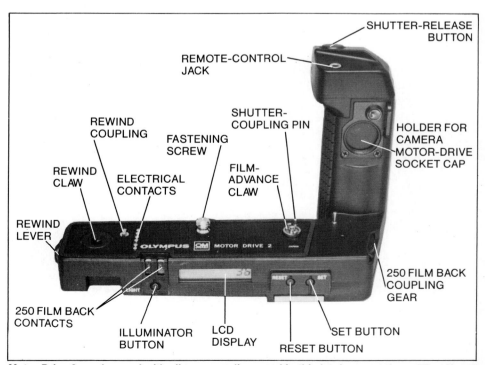

Motor Drive 2 can be used with all cameras discussed in this book except the OM77AF. Not all camera models use all of the features of Motor Drive 2. Differences are shown in the accompanying table.

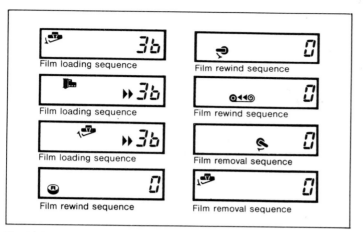

The LCD display of Motor Drive 2 uses symbols to guide you through each operation. With 1.5V display batteries installed, this display is always visible so you know the status of the camera.

		Advance to	Film Out
Camera	**Rewind**	**Frame 1**	**Display**
OM-1N	Manual, then reset	Manual, then reset	None
OM-2S	Manual	Automatic	None
OM-3	Automatic	Automatic	Yes
OM-4	Automatic	Automatic	Yes
OM-F	Manual	Automatic	None
OM-G	Manual	Automatic	None
OM-PC	Automatic	Automatic	Yes

CAPABILITIES OF MOTOR DRIVE 2

of the motor-drive grip. A separate power source for the motor attaches to the bottom of the motor drive, either directly or through a connecting cable. The power source also has a shutter-release button

Motor Drive 2 has an LCD frame counter and display, which is powered by two 1.55 volt SR44 or LR44 batteries installed in the motor drive.

The motor drive has three modes of operation, selected by a Mode Selector switch on the power source being used. They are OFF, SINGLE, and SEQUENCE. With the motor drive turned off, you can operate the camera normally as though it were not attached. At the SINGLE setting, the motor drive will expose a single frame each time you press the shutter-release button on the motor drive or power source.

At the SEQUENCE setting, the motor drive will expose and advance frames continuously, as long as you hold down the shutter-release button on the motor drive or power source—until the motor-drive frame counter reaches zero.

The motor drive always waits for exposure to be completed on one frame before advancing the next, so frame rate may depend on shutter speed. The maximum rate is 5 frames per second.

To install, remove the camera Motor-Drive Socket Cap, if it has one. A threaded storage receptacle for the cap is on the motor-drive grip. If fits the cap from recent camera models, but not the OM-1N or OM-2N. Place the motor drive on the bottom of the camera and turn the Attaching Screw until it is tight.

LCD Display—The display includes a frame counter, which counts downward to zero, and some symbols to guide you in operating the camera. The symbols and their meanings are shown in the accompanying illustration.

Film Loading—When film is first loaded, the display shows two arrow symbols and the number 36. The arrow symbols indicate that two frames of film are to be advanced to reach frame 1 on the film. The motor drive advances the two frames automatically and the arrow symbols disappear.

The frame counter on the camera indicates 1. Frame 1 is ready to be exposed. The frame counter on the motor drive indicates 36. The motor drive will expose 36 frames, either on single-shot or a continuous sequence, and then stop. As the motor drive operates, its frame counter counts down to zero.

Set and Reset—Pressing the SET button causes the frame counter to cycle through all possible values, from 40 to zero. If the film cartridge just loaded does not hold 36 frames, set it to the number of frames that were loaded.

If you want to expose a set number of frames in a single burst in the sequence mode, set the counter to the desired number of frames. For example, you may set it to 5. When 5 frames have been exposed, the counter shows zero and the motor drive stops automatically.

Pressing the RESET button resets the motor-drive frame counter to the last set value. If it was set to 5, it is reset to 5. Using the SET button, you can set it to any desired value.

Normally, the motor drive exposes one frame and then immediately advances the next. When the motor-drive frame counter reaches zero, there is no advance following the last exposure. If you had set the counter to expose less than the full number of frames on the roll, and then reset to shoot another burst, the first action when you press the shutter-release button will be to advance the film.

Disabling the Frame Counter and Auto Stop—If you use the SET button to cycle past zero, a symbol with three triangles appears on the LCD display and no frame number is visible. At this setting, the motor-drive frame counter does not operate and the motor drive will operate until the end of the roll is reached.

Automatic Rewind—With camera models shown in the accompanying table, the motor drive will automatically rewind film. When the motor-drive frame counter shows zero, symbols on the display guide you through the following rewind and reload sequence of operations.

Press the Rewind Button on the camera. Turn the Rewind Lever on the motor drive fully counterclockwise until it latches. The motor drive rewinds the film. During rewind, a rewind symbol appears on the display and the camera Rewind Knob turns clockwise. When the motor stops, move the Rewind Lever on the motor drive fully counterclockwise to its normal position. Open the camera back cover. Remove the exposed film. It may be necessary to pull the film end free of the takeup spool.

Reload—If you close the camera back without loading a fresh roll of film, a "film out"

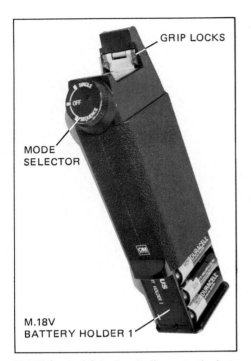

GRIP LOCKS

MODE
SELECTOR

M.18V
BATTERY HOLDER 1

M.18V Control Grip 1 or 2 clips onto the bottom of the motor drive and supplies power from a set of 12 AA-size batteries. The Mode Selector controls the motor drive. It can be set to SINGLE, OFF **or** SEQUENCE.

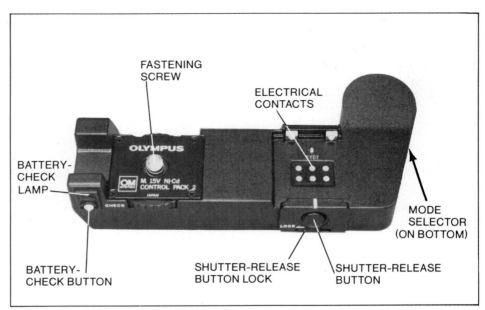

FASTENING
SCREW

ELECTRICAL
CONTACTS

BATTERY-
CHECK
LAMP

MODE
SELECTOR
(ON BOTTOM)

BATTERY-
CHECK BUTTON

SHUTTER-RELEASE
BUTTON LOCK

SHUTTER-RELEASE
BUTTON

A more compact power source for the motor drive is the rechargeable M.15V Ni-Cd Control Pack 2. It clips in place on the bottom of the motor drive. You can use the shutter-release button on the motor-drive grip or the shutter-release button on the back of the power source—which is convenient for vertical-format shots. The Lock Button locks the shutter-release on the Ni-Cd Control Pack.

symbol on the display suggests opening the camera again. If you do load film, the double-triangle symbol appears and the camera advances two blank frames automatically. The frame counter returns to the last set value, if it is not 36.

Illuminator—To illuminate the LCD display, press the LIGHT button.

MOTOR DRIVE POWER SOURCES

There are several ways to supply power to Motor Drive 2.

M.18V Control Grip 2—This is a pistol grip that fits on the bottom of the motor drive. It has a trigger you work with your index finger or you can use the control button

on top of the motor-drive grip.

Any power source can be separated from the motor drive using Relay Cord 1.2m or Relay Cord 10m to keep the batteries warm or for remote control of motor drive and camera.

This source uses 12 AA-size batteries. You can use ordinary dry cells, alkaline cells for longer life, or NiCad cells. Rechargeable NiCad cells and a companion charger are available.

The individual AA-size batteries fit into a clip called M.18V Battery Holder 1, and the clip slides into the control grip from the bottom.

M.15V Ni-Cd Control Pack 2— This is a

rechargeable NiCad battery in a flat case that attaches directly to the bottom of the motor drive. The bottom of the battery case has a tripod socket.

On the back side of the control pack is a second motor-drive shutter button that provides an alternate way to operate the motor drive and camera. You'll find the button on the control pack handy to use when you rotate the camera for vertical format shots. This button has a sliding mechanical lock that prevents accidental operation.

The control pack can be separated from the motor drive by using a Relay Cord. Two cords are available: one is 1.2 meters long, the other 10 meters. The short cord is useful

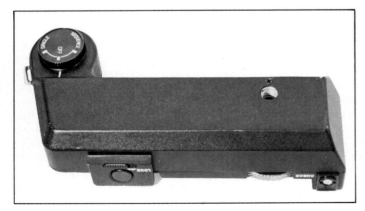

M.15V Ni-Cd Control Pack controls the motor drive unit through the Mode Switch on the bottom of the power source. You can select SINGLE, OFF **or** SEQUENCE.

Any of the standard power sources for Motor Drive 1 can be located remotely and connected to the motor drive unit with a Relay Cord. Two lengths are available: 1.2 meters and 10 meters.

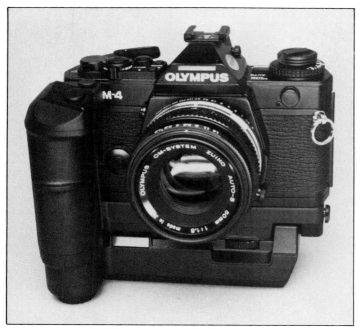

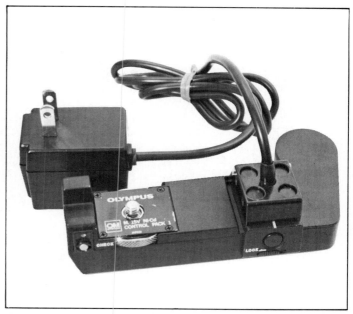

An OM camera with Motor Drive 2 and Ni-Cd Control Pack 2 is compact and easy to carry.

This simple lightweight recharger connects to the Ni-Cd Control Pack and plugs into a wall receptacle.

in cold weather because you can put the battery pack in your pocket to keep it warm. Either cord can be used to control the camera remotely using the Mode Selector and Shutter-Release Button on the control pack.

A battery-check button on the back of the control pack, marked CHECK, is used to check battery condition. When you depress the button, an adjacent indicator lamp glows steadily if there is enough charge left in the NiCad battery for 10 or more 36-exposure cartridges. If the lamp blinks, enough charge remains to shoot about 10 more rolls but recharging is recommended. If the lamp does not light, the battery is discharged and should be given a full recharge.

Part of the convenience and long term economy of the control pack is the fact that the built-in NiCad battery can be recharged many times using the M.15V Ni-Cd Charger 1. This has an adjustment to set the charger for various line voltages—100V, 115V, 220V and 240V—depending on where you are in the world. Tourist-type adapter plugs may be necessary to fit between the charger unit and the wall outlet. When properly set, plug in the charger and connect the charger cord to the electrical terminal on the control pack.

Full recharge, enough to expose about forty 36-exposure cartridges of film, takes four to five hours. Recharging for about thirty minutes supplies enough power to shoot six to ten rolls of film. In an emergency, recharge for five minutes and you can shoot one or two rolls. After recharging, unplug

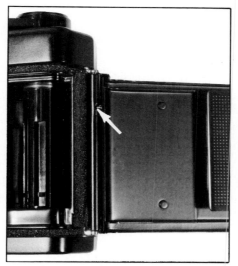

To remove the back cover, push downward on the pin projecting from the cover hinge (arrow), and lift the back off of the camera. To replace, reverse the procedure. Not all models have removable backs.

the charger unit to protect it from damage.

M.AC Control Box—For use indoors where household current is available, this control box converts power from a wall outlet and supplies the motor drive through Relay Cord 1.2m or Relay Cord 10m. The control box offers single-frame or continuous sequences using either a pushbutton on the control box or a toggle switch to turn on the

motor drive for long periods.

Also in the control box is an interval timer (intervalometer) controlled by a rotary switch that you can set for single-frame exposures with various time intervals between the frames. The switch has 12 positions, offering frame rates from four every second to one frame every two minutes. The toggle switch that turns the equipment on for long periods is intended mainly for use with the interval timer mode.

M Quartz Remote Control Intervalometer—Interval timing over a much greater range is offered by this control box, which uses household current and connects to the motor drive through Relay Cord 1.2m or Relay Cord 10m. This unit can also work with Winder 2 using either of the Relay Cords.

It can be set for frame intervals from 0.5 second to 24 hours.

TM-2 Program Timer—For longer intervals, the TM-2 Program Timer times exposure intervals from 24 hours to one week.

Other Remote-Control Methods—Adjacent to the motor-drive Shutter-Release Button on the top of the motor-drive grip is a Remote Control Jack that can be used for other kinds of remote control. A similar Remote Control Jack is on Winder 2 and both are used in the same way.

Available from Olympus dealers are Remote Cords, 1.2 or 5 meters long, that plug into the jack. A pushbutton switch on the far end of the cord closes the circuit when depressed and this triggers the motor drive or

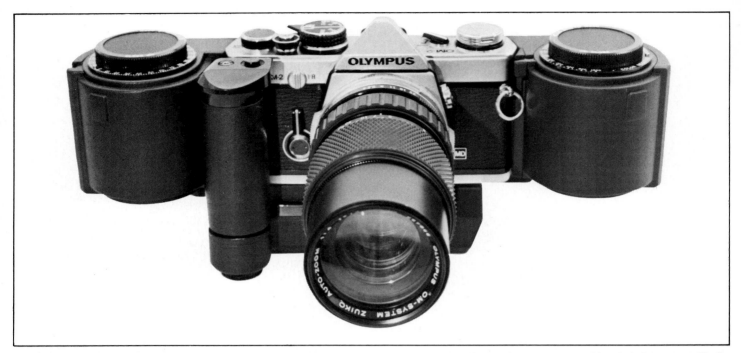

The 250 Film Back must be used with a motor drive or winder because a gear on the motor drive or winder is used to drive the take-up spool in the film back.

film winder and shutter.

Any remote-control device that closes the circuit to start the shot or sequence of shots can be plugged into the Remote Control Jack on either Motor Drive 2 or Winder 2. You can use accessory radio-control units, timers or specially fabricated switches for special purposes.

OPTIONAL CAMERA BACKS

The back cover of all models in the book except OM-F and OM-G is removable so you can install special backs. To remove the standard cover, open the camera and locate the projection on the back-cover hinge pin. With your fingernail, slide the projection downward and withdraw the upper tip of the hinge pin from the camera body. Lift out the lower tip of the hinge pin and remove the back. To reinstall, reverse the procedure.

250 Film Back—Some applications using Winder 2 or Motor Drive 2 benefit from a larger supply of film than a standard 36-exposure cartridge. For document copying for example, Winder 2 is convenient to use. If a lot of copying is to be done the 250 Film back is recommended because 250 frames of film can be loaded and shot at one time.

With a motor drive operating at five frames per second, a 36-exposure cartridge is used up in a hurry. Many shooting situations with the motor drive can be handled better using the 250-frame back.

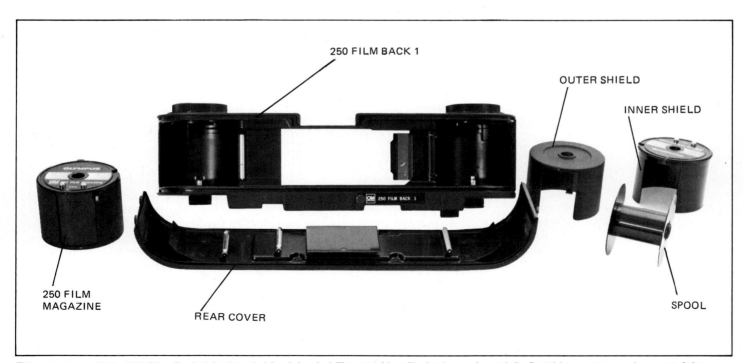

250 FILM BACK 1

OUTER SHIELD

INNER SHIELD

250 FILM MAGAZINE

REAR COVER

SPOOL

The rear cover of the 250 Film Back 1 is detachable. A loaded film cartridge fits in the cavity at left. Cartridge parts are shown at right.

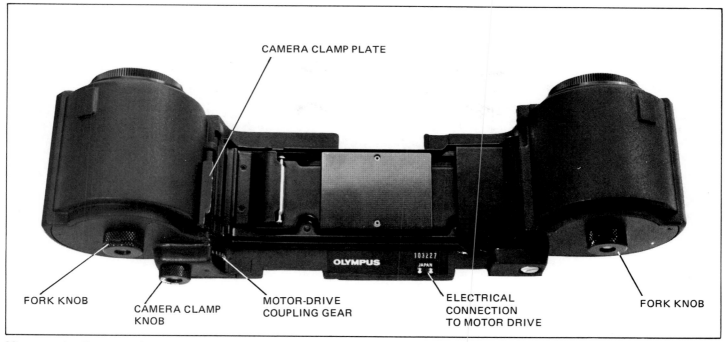

CAMERA CLAMP PLATE

FORK KNOB
CAMERA CLAMP KNOB
MOTOR-DRIVE COUPLING GEAR
ELECTRICAL CONNECTION TO MOTOR DRIVE
FORK KNOB

After removing the camera back cover, place the camera in the 250 Film Back. Rotate the Camera Clamp Knob on the film back. This causes the Camera Clamp Plate to press on the camera body to hold camera in place. Fork Knobs connect to inner spools of film magazines and are used to tension film. To remove magazines, pull downward on the Fork Knobs.

Use this Film Loader to load magazines for the 250 Film Back, spooling from a bulk roll.

After removing the standard camera back, place the 250 Film Back face up on a table. Holding the camera with the lens toward you, place the right side of the camera body in position in the film back, then drop the left side of the camera into place and rotate the Camera Clamp Knob on the bottom of the 250 Film Back. This causes a plate to move out and downward from the film back to securely clamp the camera body in place. It helps to think of it as installing the camera into the 250-frame back, rather than installing the back onto the camera.

On each side of the special back are Magazine Chambers that hold special 250-frame film magazines, one to feed film through the back and the other to take up the film. Film feeds from the left and is taken up at the right, as viewed from behind the camera.

The 250-frame magazines are made up of three parts as you see in the accompanying photo. They are loaded and unloaded in a darkroom. Loading is done with the special 250 Film Loader, which has a frame counter so you can spool on any desired number of frames up to a maximum of 250.

When the spool is loaded with film, it is inserted in the inner shield, which is then installed in the outer shield. Each of these shields has a U-shaped gap in the side. When loaded, the film end is pulled out through the U-shaped gaps and then the outer shield is turned so the two gaps are offset and the magazine is light tight.

Closed, light-tight magazines can be transported and loaded into the film back in daylight although they should be shielded from direct sunlight. When storing and transporting, it's a good idea to keep the magazines in a light-proof container.

The large knobs on top of the magazine chambers serve several purposes. The OPEN and CLOSE settings of these knobs refer to the condition of the rear cover of the film back. When the left n/Close knob set to OPEN, it prepares the film magazine inside the chamber so the back cover can safely be opened. It does that by rotating the outer shield to close the gap and block light. When a film magazine has been placed in the film back and the rear cover has been closed, turn the left knob to CLOSE. This actually opens the gap inside the film magazine so film can feed freely out of the magazine and across to the take-up side.

The right Open/Close knob opens and closes the film magazine on that side according to the condition of the back cover. In addition, it controls the latch for the back cover so you cannot remove the back without first turning the knob to OPEN, which closes the take-up film magazine so the film will not be light-struck when you open the back.

To load the 250-frame back, place a loaded magazine in the left chamber and an empty magazine in the take-up side. Magazines are dropped in place by pulling down on the Fork Knobs at the bottom of each chamber.

Pull film across and start it in the take-up magazine. Then close the back cover and rotate both Open/Close knobs to CLOSE. This opens both magazines so film can pass freely from feed to take-up without friction or scratching.

If you expose the full amount of film you have loaded, you can safely open the back and remove the take-up magazine. If you

shoot only part of the film in the feed magazine, then the length of film in the camera back between the magazines will be light struck if you open the back in the light. You can save exposed frames in that area by advancing six frames before opening the back. Or else, open the back in a darkroom. A sharpened film-cutter edge on the gap in the outer shield of the film magazines can be used to cut the film so you can remove the exposed part for processing.

Motor Drive or Winder can be installed before or after the camera is installed on the film back. Both have electrical contacts that automatically mate with contacts on the 250-frame back. These stop film advance when the frame counter on the 250-frame back reaches zero.

A frame counter surrounds the Open/ Close knob on the right side of the 250 Film Back. It can be set to any number up to 250. When that number of frames has been exposed, the winder or motor drive will stop operating. You can use this frame counter to control short bursts if you wish. For example, you can set it to 8 and shoot that number of frames. If you load 250 frames and want to shoot all of them without an automatic stop along the way, set the counter to 250.

The take-up spool in the 250-frame back is mechanically driven by a gear on the top right of the winder or motor drive. This gear is normally protected by a sliding cover. Before installing the winder or motor drive with the 250-frame back, be sure to slide the gear cover back so the gear teeth are exposed. They will mate automatically with the gear in the 250-frame back.

RECORDATA BACKS

Recordata Back 2 is shown in the accompanying photo. The sync cord from the back is plugged into the sync socket on the camera body. This back imprints a letter and number code of your choice in the lower right corner of the frame. These alphanumeric codes can be used to show the date, roll number, sequence number or whatever is appropriate.

Recordata Back 4 makes all connections to the camera automatically, without a connecting cord. It displays and records one of the following items on the film: the date as Year/Month/ Day, Month/Day/Year, or Day/Month/Year, the time of day in hours/ minutes, the frame number, or any six-digit code number that you select.

Recordata Back 100 replaces the standard back cover of the OM77AF to imprint date or time on the film. All connections are made automatically. With DX-coded film, the brightness of the imprint is automatically adjusted for film speed.

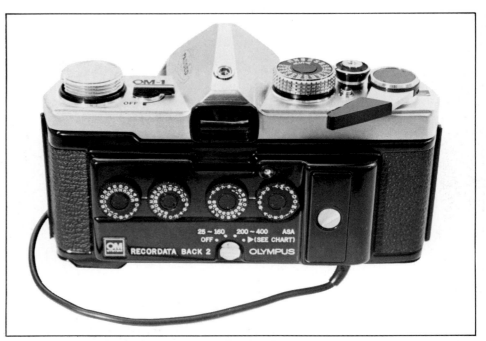

Recordata Back 2 fits earlier OM cameras and is triggered by an external sync cord that plugs into the PC socket on the camera.

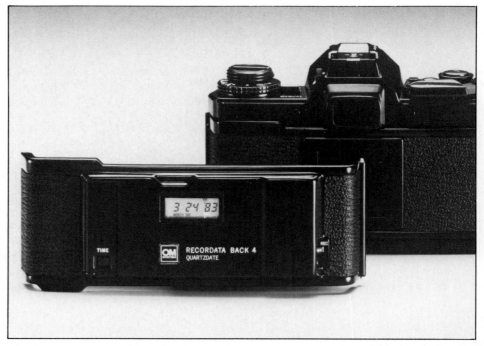

Recordata Back 4 replaces the standard back cover of the OM-1N, OM-2SPROGRAM, OM-3, OM-4 and OM-4T. Electrical connections to the camera body are made automatically, so no external sync cord is needed.

HOW TO CARE FOR YOUR CAMERA

With proper care, Olympus equipment will give you many years of good service and great photographs. The best care you can give any piece of equipment is to use it properly so you don't cause problems to develop.

CHECK OUT YOUR CAMERA

You will not harm your camera by operating it without film. Get acquainted with its operation and practice using the controls by firing "blank shots" as much as you wish.

If batteries are more than 6-months old, it's good insurance to replace them before leaving on a trip. If more than a year old, they are living on borrowed time.

If the camera is new, or you haven't used it in a long time, test by exposing a roll of film. If you are going on a trip or planning to make some very important photos, check out the camera first by testing with film. For tests that you will send out for processing, color-slide film is best. Make test shots under a variety of lighting situations. Check a wide range of operating conditions.

Send the film in for developing through your local dealer. Carefully inspect the finished slides. If you see something that doesn't look right, it could be your shooting technique, improper use of the camera controls, a fault in the camera, or a problem resulting from improper processing. If you can't figure out which, your dealer will be glad to help you.

THINGS THAT CAN HARM YOUR CAMERA

Cameras can be damaged by improper storage and use. Here are some "natural enemies" and what you should do about them.

Dirt—Cameras and lenses are not dust-proof. Under normal conditions, dust is not a problem. Where dirt is in the air, protect your camera by keeping it enclosed. Use a camera case, a plastic bag, or even an article of clothing wrapped around the camera. You can shoot with the camera inside a plastic bag

Good camera care begins with a suitable case for your camera and accessories. Simple cases like this hold a camera body with lens installed.

if you cut an opening for the lens. Use lens caps—both front and rear—on lenses not mounted on a camera. Use body caps for your spare camera bodies.

Water—Cameras and lenses are not water-proof. Protect them from rain or splashing water. If the camera exterior gets wet, dry it immediately with a clean soft cloth.

If a camera is thoroughly wet due to being submerged or left for a long time in rainfall, it may be damaged beyond repair. Get it to an authorized Olympus service facility as soon as possible.

Condensation—When exposed to a sudden temperature drop, condensation may form on and inside lenses and camera. If you store them in such a way that they can't dry out properly, problems may result. Leave camera and lens uncovered at room temperature for two or three days.

Amateur Repairs—Amateur camera servicing and repairs can cause more damage than they cure. Never take a camera body or

lens apart. Never attempt to lubricate camera parts yourself. If the camera seems to have mechanical damage, visible or invisible, take it to your authorized Olympus dealer for repair.

Lengthy Storage—Like people, cameras need regular exercise. If you are not using a camera, it will survive the inactivity better if you exercise it every 2 or 3 months. Fire some blank shots at various shutter speeds. Operate the film-advance lever and other camera controls to free them up and redistribute lubricants. If you won't be using a camera for several weeks, it's a good idea to remove the old battery and put it back in when you use the camera again.

Never store a camera with the shutter cocked. Make a point of depressing the shutter button just before you put it away, so the internal springs are unwound and relaxed.

Storage Conditions—Store camera and lenses in a cool dry place. A shelf or drawer in a room occupied by people is much better than a basement or attic where there may be humidity or temperature extremes.

Store the equipment in cases, wrappings or bags. It's a good idea to package it with small bags of desicant to reduce humidity. New camera equipment usually has these desicant bags in the packaging—don't throw them away.

Shooting Conditions—A short neckstrap around your neck instead of over your shoulder is very good insurance against inadvertent bangs and knocks that can damage your camera. When you are using the camera, have the strap around your neck, except when the camera is on a tripod or copy stand.

When carrying a camera in a vehicle, keep it in the passenger compartment and pad it so it does not receive steady vibrations. Vibration can loosen screws and possibly damage the precision mechanism. Catalytic converters are mounted under the floor of a car and get extremely hot. Keep your camera away from this heat source.

To carry more equipment, use a compartment case, sometimes called a *gadget bag.* Compartment Case S (Small) holds one camera with lens attached, two additional lenses and small items such as filters in the pockets in the cover. The partitions are removable and adjustable for a variety of equipment setups.

Compartment Case M (Medium) holds two or three camera bodies and four or five lenses with room to spare. Tripod straps on the outside are used as shown. The front pocket holds film, filters and small accessories.

Compartment Case L (Large) has removable adjustable partitions and camera supports to hold two OM bodies, six to eight lenses and miscellaneous accessories. An optional partitioned insert divides the case into two layers to carry a camera with 250 Film Back installed in the bottom along with extra magazines for the film back. In the top you can carry two cameras with motor drives or winders and spare lenses.

When you're using the camera, always have the proper lens hood on the lens. It can improve image quality and also protect the front of the lens.

If you're going outdoors in very cold weather, keep the camera under your coat when you're not actually shooting. This will help keep the battery functioning and when you return to a warmer area you'll have less worry about condensation forming on or inside the camera.

If you've been out long enough so the camera has gotten cold, seal it inside a plastic bag before going into a warm room. Don't take it out of the bag until it is the same temperature as the surrounding air. Otherwise, condensation will form. This is especially important if you are going to go back outside, into the cold again. Condensation inside a camera may freeze when you go outside, jamming the camera.

In hot weather, protect the camera from the direct heat of the sun. High temperature may affect the camera and the film. Color film is especially sensitive to high temperatures. Don't leave your camera in the open sun. Don't leave it in the trunk of a car, the glove compartment, on the car's dash or back window ledge.

If you must leave it in a closed car, place it in the shade on a cool portion of the floor or seat. Drop a jacket or blanket over it. This protects it from the sun and camouflages it from thieves.

ASSEMBLE A CLEANING KIT

Put together a small cleaning kit and keep it with your camera. Include spare batteries, camera lens-cleaning tissue, lens-cleaning fluid, a brush for lens barrel and camera body, a soft lens-cleaning brush for glass surfaces, and cotton swabs.

A can of "pressurized air" is useful but can be left at home. Practical portable substitutes are: A puff of air from your mouth, a rubber squeeze bulb such as an ear syringe or a combined squeeze bulb and brush of the type sold at camera shops.

Don't use any other kind of tissue, such as facial or bathroom. Don't use the tissues sold for cleaning eyeglasses because they are often impregnated with silicone—fine for your glasses but not for your camera lens.

How To Clean a Lens—With lens cap in place, or both caps if the lens is removed from the camera, use a blast of air and a brush to clean dust from the lens barrel and the crevices around the controls. Use this brush on metal surfaces only. Use the lens-cleaning brush on glass surfaces only.

Then remove the front lens cap and blow loose dust off the front element. With the lens brush, gently lift off any remaining dirt particles.

If dirt or fingerprints remain on the lens, apply a drop or two of lens-cleaning fluid to a piece of lens-cleaning tissue and lightly wipe the lens. Start at the center and spiral outward. Don't rub hard and don't use more than a drop or two of lens-cleaning fluid. Never apply fluid directly to the lens.

The rear lens element can be cleaned in the same way. It should not require frequent cleaning because it is protected by a rear lens cap or the camera body.

Clean a lens only when it actually needs it—when it's covered with dust or has finger smudges.

How To Clean The Camera Body—Use a brush to clean loose dust off the body and out of crevices. Work around all controls to remove dirt. Then open the back and use the brush to clean out any dust or film particles. You can also use a puff of air. Be very careful not to spray the air directly on the shutter curtains and don't touch them with anything.

Using a small piece of lens-cleaning tissue dampened with lens-cleaning fluid, clean the pressure plate and guide rails in the camera body.

Never attempt to clean the camera mirror. Its reflective surface is on the front and is

To clean a lens: First use a blower of some kind to blow away dust particles without touching the lens surface. If that removes the dirt, stop cleaning.

If the blower doesn't do it, use a brush with soft bristles to gently lift off the dirt. Have one soft brush to use *exclusively* for lens cleaning.

If there are marks or smears that the brush won't remove, apply a small amount of *lens-cleaning* fluid to a piece of *lens-cleaning* tissue and gently remove them.

easy to scratch. Never apply a piece of lens-cleaning tissue or even try to brush it. Use your can of air or squeeze bulb to clear away loose dirt, or have it cleaned by a camera repair shop.

How To Clean The Viewfinder Eye-piece—This will get dirtier and greasier than lenses. Blow out the dust first, then use a slightly dampened cotton swab to lift off any remaining dirt or smears.

IF YOU HAVE A PROBLEM

Through use, even the best camera may develop problems, but many are not serious.

What if the film stops advancing? There's a good chance you've simply reached the end of a roll of film. It may have only 20 exposures but you thought it had 36. Or, maybe you advanced the film a little farther than normal before closing the camera back. Nev-

er use unusual force to advance the film—or on any other camera control. Rewind the film, operate the camera without film and it may check out OK. If so, try another roll of film.

If the meter quits, put in a new battery. This will frequently solve exposure or meter problems instantly. You should replace the battery once a year, even if it tests OK.

While using your camera, be aware of how the controls feel. The film-advance and lens controls should be smooth with no grinding, crunching or scraping. Usually, if something does go wrong, you'll know it immediately because the smooth feel will be gone.

How To Test Exposure Accuracy—If you are getting some bad exposures, check the simple things first. Try a new battery. Is your metering technique causing the problem—

such as shooting a subject against a bright background without making any compensation? If you get bad exposure on prints, it may be the lab—not likely but possible.

Exposure errors due to a fault in the camera metering system will usually occur at all shutter-speed settings and all apertures. One check is to compare the settings read from the camera meter to those of another SLR camera. They should agree within about one-half step. Check at different scene brightnesses. If you get fairly good agreement, the meter in your camera is probably OK—if the comparison camera is making good exposures.

If you are checking a camera on TTL automatic exposure, remember that the camera will behave differently without film. If film is not loaded, the exposure meter "sees" the black pressure plate on the camera back

To clean the camera interior, use a soft brush. Avoid touching the focal-plane shutter.

To clean the pressure plate, use lens-cleaning fluid and lens-cleaning tissue.

When a lens is not is use, keep front and rear covered with lens caps.

when the shutter is open and will give too much exposure. Some Olympus cameras are packaged with an insert to simulate film inside the back cover. Or, you can use a piece of paper with a medium tone.

To test with film, find a brick wall or other uniform textured surface. Put the camera on a tripod and focus carefully on the wall. Then make a series of exposures starting at the largest aperture and going down to the smallest. Use the meter in the camera to measure the light and set the exposure controls for each frame you shoot. Record the settings for each frame.

Send the film out for processing. It will be easier to check results if you enclose a note asking that the slides not be mounted. You'll get back a continuous roll of film. Hold the film strip against a light source such as a window pane and examine each frame. Use a magnifying glass to spot any problems.

All should be reasonable exposures of the scene. All exposures should look the same. If some are lighter or darker, look for a pattern or some clue as to what is wrong.

How To Test Focus—It may be your vision or technique instead of the camera. When your vision is getting fuzzy images from everything, it's hard to tell good focus from bad.

With a non-autofocus camera on a tripod and at large aperture so depth of field is minimum, ask somebody with good vision to focus your camera sharply. Then you do it. If you had to refocus, somebody did it wrong because there is only one camera setting that gives best focus.

To test manual or automatic focus with film, use a tripod and focus on a wall as before. Move the camera to at least four different distances from the wall, focusing carefully each time. Make notes. Check the returned film with a magnifying glass. Every frame should be in good focus. If some or all are not, it's either your eyesight or the camera. Have one or both checked. A simple Dioptric Correction Lens will often solve this problem if it's your eyesight.

HOW TO GET IT FIXED

If you can tell by feel of the controls or the pictures you get that the camera needs repair, have it fixed by an authorized Olympus service agency. Save your receipts when you purchase camera gear, so you will have a record of the purchase date. Read the warranty card that comes with new equipment—it is different in different parts of the world. Save the warranty card with your receipt so you will later be able to double check warranty provisions and also check to see if your equipment is still in warranty.

OLYMPUS OM CAMERAS

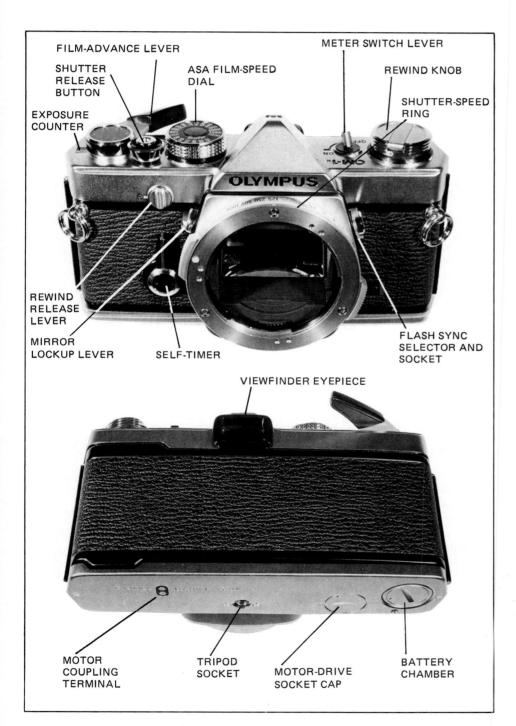

FILM-ADVANCE LEVER

SHUTTER RELEASE BUTTON

ASA FILM-SPEED DIAL

METER SWITCH LEVER

REWIND KNOB

SHUTTER-SPEED RING

EXPOSURE COUNTER

OLYMPUS

REWIND RELEASE LEVER

MIRROR LOCKUP LEVER

SELF-TIMER

FLASH SYNC SELECTOR AND SOCKET

VIEWFINDER EYEPIECE

MOTOR COUPLING TERMINAL

TRIPOD SOCKET

MOTOR-DRIVE SOCKET CAP

BATTERY CHAMBER

This chapter includes a description of current Olympus OM cameras. The descriptions are intended to be factual and complete but without explanations and basic theory that were covered earlier in this book.

Related items such as lenses, flash and motor-drive equipment were described in earlier chapters and are mentioned here only incidentally, as part of the general camera discussions.

Specifications are given for each current OM camera for reference and comparison among models. Specs for other major hardware items are included in the chapters covering those items.

OM-1N

With the OM-1, Olympus started the industry trend toward compact SLR cameras. The OM-1N is an evolutionary improvement of the original OM-1 and is the model discussed here. It's a simple, non-automatic camera with some advantages that derive from being non-automatic. For example, if the battery fails and you have no replacement, the only thing that stops working is the meter. You can still use the camera on all shutter speeds. With the recent trend toward automatic features, it's easy to overlook virtues of the simple basic cameras.

Current production cameras are designed to use motor drive or a film winder and have the necessary coupler on the bottom plate.

LENS MOUNT

The OM-1N uses the full array of bayonet-mount Olympus Zuiko lenses. Place the lens on the camera with the red dot on the lens aligned with the red dot on the camera body. Turn the lens clockwise until it clicks into place. Remove by depressing the Lens-Release Button on the lens and rotating it counter-clockwise until the lens can be lifted away from the body.

With most Zuiko lenses, the camera provides full-aperture metering and automatic aperture operation.

ON-OFF CONTROL

The Meter Switch Lever on top of the camera turns the exposure-measuring system on. To conserve battery power, be sure to

turn the switch off when you are not using the camera. Nothing else in the camera is controlled by this switch.

LOADING FILM

The procedure is straightforward and conventional. Open the camera back by lifting up the Rewind Knob. Load film as shown in Chapter 5.

FILM-ADVANCE LEVER

The Film-Advance Lever has a stand-off position, at which it is partially rotated so it is convenient to place your thumb in position to rotate it further. From this position, film is advanced by rotating the lever through an arc of 150°. This can be done all in one stroke or in a series of short strokes, each beginning at the stand-off position of the lever.

METERING

The camera has a center-weighted metering pattern using CdS sensors in the viewfinder housing. Metering range is EV 2 to EV 17 with ASA 100 and an f-1.4 lens. EV 2 is a shutter speed of 1/2 second with f-1.4 and therefore this is the lower limit of metering accuracy with ASA 100 film. Olympus applies this limit also to lenses with maximum apertures of f-1.8 and f-1.2.

There is no indication in the viewfinder that the metering accuracy limits are being exceeded, however you shouldn't have to worry about the bright-light limit.

You may have occasion to shoot at light levels below the dim-light metering-accuracy limit and the only way to know if you are is to observe the specification and refer to the EV discussion and table in Chapter 8.

VIEWFINDER DISPLAY

On the left side of the focusing screen, within the picture area, is a moving-needle exposure indicator. When the needle is centered, exposure should be correct for an average scene. Exposure compensation for non-average scenes and deliberate over- or underexposure can be done simply by not centering the needle. Calibration points to show how much over- or underexposure you are using are shown in drawings in Chapter 8.

At the left side of the viewfinder is an LED indicator that works with Accessory Shoe 4 and Olympus T-series flash. This indicator glows steadily to indicate that the flash is charged and ready to fire. After firing, the indicator will flicker if there was sufficient light for correct exposure.

Focusing screens are interchangeable as discussed in Chapter 9. The standard screen supplied with the camera is Type 1-13: a split-image biprism surrounded by a microprism, all in a matte field.

OM-1ɴ VIEWFINDER

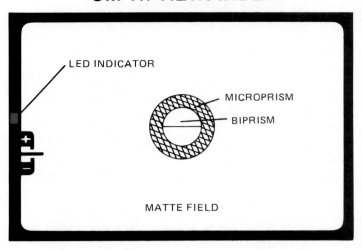

Because the camera metering system views the focusing screen from above, the exposure reading is affected by the amount of light transmitted by the screen. Screens with a matte surface produce correct exposure readings except with the 8mm f-2.8 circular fisheye lens.

Screens with a clear field do not give correct exposure readings. Olympus does not give correction factors for these screens, however the factor can be determined by testing for a particular application.

With a 50mm lens set at infinity, viewfinder magnification is 0.92, which means objects in the viewfinder appear to be 92% as tall as they are when viewed directly. The picture area shown in the viewfinder is 97% of the actual area recorded on film. Illumination of the exposure display is by light coming through the lens.

STOPPED-DOWN METERING

The camera is switched to the stopped-down metering mode automatically, when necessary, with no control settings or special procedures required of the operator. The viewfinder exposure display appears the same and is interpreted in the same way whether metering at full aperture or stopped down. Stopped-down metering is required with the 35mm shift lens mounted directly on the camera and with all lenses if used with non-meter-coupled accessories between lens and camera.

A special procedure is used with the 35mm shift lens as described in Chapter 10.

EXPOSURE CONTROLS

Aperture is set by rotating the Aperture Ring on the lens. The range of aperture sizes varies among lenses as shown in the lens table of Chapter 10. Intermediate settings

between marked aperture values are OK.

Shutter speed is set by rotating the Shutter-Speed Ring that is part of the lens mount. It has two knurled projections to make gripping the ring easier. Shutter-speed range is from 1 second to 1/1000 in standard steps, plus a B setting. Intermediate settings should not be made.

VIEWING DEPTH OF FIELD

The Depth-of-Field Preview Button on the lens stops-down lens aperture to the value set on the lens Aperture Ring so you can see depth of field in the viewfinder.

If you depress the Depth-of-Field Preview Button with a quick, sharp movement while simultaneously holding the camera Shutter-Release Button partway down, the shutter may be released. Operate the preview button gently and avoid depressing both buttons simultaneously.

You can estimate depth of field, after focusing, by using the Depth-of-Field Scale on the lens.

If the lens is mounted on the forward end of a non-metercoupled accessory, the lens aperture is always the size you set on the Aperture Ring, so you always see depth of field. In this case, the Depth-of-Field Preview Button on the lens has no function.

MIRROR LOCKUP

To lock up the mirror, rotate the Mirror Lockup Lever counterclockwise until the groove in the lever is vertical. This feature is normally used with the camera on a tripod, copy stand or other firm support and it is done after focusing, composing and setting the exposure controls. After the mirror is locked up, you can no longer view the scene and the exposure meter is inoperative. Mirror lockup is useful to reduce camera vibra-

OM-1N SPECIFICATIONS

Type: 35mm Single-Lens Reflex with focal-plane shutter.
Format: 24mm x 36mm.
Standard Lenses: Zuiko 50mm *f*1.8, Zuiko 50mm *f*1.4, Zuiko 55mm *f*1.2.
Lens Mount: Olympus OM bayonet.
Shutter Speeds: 1/1000 to 1 second in standard steps and B.
Self-Timer: Variable 4- to 12-second delay; can be canceled.
Exposure Measurement: Full-aperture, through-the-lens with most Zuiko lenses. Uses two CdS sensors in viewfinder housing. Moving-needle exposure indicator with over- and underexposure markings in half-step increments.
Exposure-Measuring Range: EV 2 to EV 17 with *f*1.4 and ASA 100.
Battery: One 1.3V mercury, Eveready EPX625 or equivalent.
ASA Film-Speed Range: 25 to 1600.
Viewfinder: Pentaprism type shows 97% of frame. Magnification is 0.92 with 50mm lens set at infinity. Apparent viewing angle is 23°30' by 35°. LED indicator works with T-series flash to show charge and sufficient exposure.
Focusing Screen: Interchangeable. Type 1-13 is standard. Any of 14 types can be used.
Mirror: Oversize, instant-return, with lockup control.
Flash Sync: X or FP selectable by switch on camera body. Installation of Accessory Shoe 4 automatically sets X-sync at both hot shoe and camera-body socket.
Accessory Shoe: Shoe 4 is standard.
Film Advance Lever: Ratchet type with 130° total stroke.
Exposure Counter: S to 36 to E. Automatic reset when back cover opened.
Rear Cover: Removable to allow use of accessory camera backs.
Dimensions: Body only—5.35 x 3.27 x 1.97" (13.6 x 8.3 x 5.0 cm). With 50mm *f*1.8 lens—5.35 x 3.27 x 3.19" (13.6 x 8.3 x 8.1 cm).
Weight: Body only 18 oz. (510 gm); with 50mm *f*1.8 lens—24 oz. (680 gm).

tion during exposure due to mirror movement before the exposure. It is normally recommended only with long-focal-length lenses or when photographing at high magnification.

Never allow direct sunlight to enter the lens with the mirror locked up. This may produce a focused image of the sun on the first shutter curtain, which will quickly burn a hole in the curtain. Carrying or storing the camera with mirror locked up is not recommended.

SELF-TIMER

For maximum time delay, rotate the Self-Timer Lever fully counterclockwise until it stops. This exposes the Self-Timer Start Lever. Move the start lever clockwise to the vertical position to start the timer. When started, the Self-Timer Lever will rotate back to its normal position and an exposure will be made about 12 seconds after the lever starts to move. For less time delay, rotate the Self-Timer Lever a smaller amount. The minimum time delay you can get is about 2 seconds by rotating the lever approximately 90 degrees. Do not use the self-timer with shutter speed set at B.

The self-timer cycle can be stopped at any time while it is counting down by moving the start lever counterclockwise. While stopped, you can reset the Self-Timer Lever to the original amount of delay if you wish. If you don't, when you reactivate the timer it will count down only the time remaining from the preceding cycle.

After stopping the timer, reactivate it by moving the start lever clockwise again. If you decide not to use the self-timer, you can make exposures using the camera shutter button while you have the timer stopped. The timer can never be canceled, once set, however you can let it run down and operate the shutter with no film in the camera.

If you forget to advance film after the preceding exposure, then set and start the self-timer anyway, the timer lever will stop rotating about halfway through the cycle and the shutter, of course, will not operate. If you then rotate the film-advance lever, the shutter will operate immediately—which may be a surprise—and the timer will finish its cycle. To prevent the surprise, turn the timer off before advancing film and start all over again.

The self-timer is useful to allow time for

you to dash around in front of the camera to get into the picture. It is also useful as a way of operating the camera to minimize vibrations caused by touching the camera. When using long-focal-length lenses or shooting at high-magnification with the camera on a tripod or other firm support, release the shutter with the self-timer or a cable release.

If you need to make an exposure while the self-timer is counting down, you can do it by depressing the shutter-release button on the camera. The timer will complete its countdown, without effect.

FRAME COUNTER

You see frame numbers through a window on top of the camera, at the extreme right. The frame counter is automatically reset to the symbol S when you open the camera back cover. From S, three strokes of the film-advance lever bring the counter to frame 1. Even numbers are shown by numerals. Starting with frame 3, each odd number is represented by a dot.

The start symbol, S, and the numbers 12, 20, 24 and 36 are bright yellow because these are the last frames in some film cartridges. After the counter passes frame 36, the next frame is represented by a dot. One more stroke of the film-advance lever brings the bright yellow symbol E into view. At this point, the frame counter stops. If there are still unexposed frames in the camera, you can shoot until you reach the actual end of the roll.

MULTIPLE EXPOSURES

After shooting the first exposure, turn the Rewind Knob clockwise until you feel slight resistance. Use one finger to hold it that way. Turn the Rewind-Release Lever counterclockwise until the red dot is opposite the letter R on the camera body. Use another finger to hold it that way. Use a third finger to move the Film-Advance Lever through a full stroke. Release everything. The shutter is cocked for the next exposure but the film has not been advanced. Make the next exposure. Repeat the procedure to make as many additional exposures as desired.

With this method, film registration is not exact and the film may move slightly between exposures. Shooting a blank frame with the lens cap on is a good idea both before and after a multiple exposure.

The frame counter counts strokes of the Film-Advance Lever rather than actual frames of film as they go by. Therefore the frame counter ends up reading one frame too high after a double exposure; two frames too high after a triple exposure; and so forth.

Exposure adjustment for multiple exposures is discussed in Chapter 8.

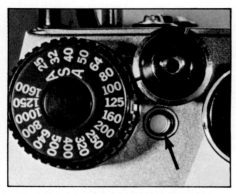

To set film speed on an OM-1N, push down the Film-Speed-Dial Release Button (arrow) while turning the ASA Film-Speed Dial to the desired setting. This camera is set for ASA 100.

HOW TO SET FILM SPEED

Move the Film-Advance Lever to the standoff position. Depress the Film-Speed-Dial Release Button with the tip of your finger. While holding the button depressed, turn the ASA Film-Speed Dial so the desired film-speed number aligns with the index mark engraved on the ring surrounding the shutter button. All standard ASA film speeds from 25 to 1600 appear on the dial—none are represented by dots. Always set the dial exactly on a marked film speed. Check by attempting to turn the dial after removing your finger from the Film-Speed-Dial Release Button. If the dial is not set exactly on a marked film speed, it can be turned slightly until it clicks into place.

INTERCHANGING FOCUSING SCREENS

Remove the lens. Focusing screens are held in a frame that is locked in place by a catch in the top of the mirror chamber, just in front of the focusing screen. Pull this catch forward and the focusing screen frame drops down. Replacement screens are packaged with a small tool used to exchange screens as shown in Chapter 9.

HOT SHOE

Accessory Shoe 4 mounts on top of the pentaprism housing when needed. Although intended primarily for use with Olympus T-series flash units, it will accept and fire other flashes that have the standard mounting foot. On the camera body is a sync socket surrounded by a switch that can be set for X-sync or FP sync. This switch controls the sync both at the camera body socket and the hot shoe.

When Shoe 4 is installed, X-sync is automatically selected with any flash installed in the hot shoe, regardless of the setting of the Flash Sync Selector on the camera body.

If you are using a flash cord-connected to the camera sync socket and do not intend to install a second flash unit in the hot shoe, remove the hot shoe if installed. Otherwise the exposed electrical contact on the hot shoe could give you a mild shock if you happen to touch it at the instant the flash fires. With an electronic flash in the hot shoe, it is possible to get a mild shock from the camera-body sync socket if you press your finger firmly against the socket.

FLASH SYNC

Electronic flash and flashbulbs in holders can be used with X or FP sync according to the accompanying flash-sync table. To use FP sync, do not install Shoe 4. Derive sync from the camera-body flash-sync socket.

BATTERY CHECK

If the battery fails, or is missing, the exposure meter stops working. The meter needle remains at the bottom of its travel even when you point the camera at a bright light. Everything else operates normally. You can use all shutter speeds, determining exposure settings with an accessory exposure meter, another camera or by estimate.

TO REPLACE BATTERY

With a coin, remove the battery chamber cap. Tip the camera so the old battery drops out. Discard the battery but not in a fire or incinerator because it may explode at high temperature. Replace with a 1.35V mercury battery such as Mallory PX625 or equivalent.

Do not use any other type of battery. Clean both sides of the new battery by rubbing on cloth or paper and drop the battery into the chamber with the + side facing toward the cap. Replace the cap. Turn on the meter switch and verify that the exposure meter is working.

MAJOR ACCESSORIES

The OM-1N can use all major accessories in the OM System. These include Zuiko interchangeable lenses; all lens accessories such as filters and hoods; macro equipment such as extension tubes, bellows and stands; viewfinder eyepiece accessories; interchangeable focusing screens; flash units; motor drives and film winders; and interchangeable camera backs such as the 250 Film Back or a Recordata Back. An assortment of camera cases and gadget bags is available.

OM-1N FLASH SYNC

Flash Type	Connection To Camera	Camera Flash Sync Selector	SHUTTER SPEED										
			1000	500	250	125	60	30	15	8	4	2	1
T 20 Manual or Normal Auto	Shoe 4	Either Setting Note 1	■	■	■								
Other Electronic Flash	Shoe 4 or Sync Socket	X	■	■	■								
Flashbulb M, MF, FP	Shoe 4 or Sync Socket	X	■	■	■	■	■	■					
Flashbulb FP	Sync Socket Note 2	FP							■	■	■	■	■

□ OK ■ Do not use.

Note 1: Shoe 4 sets camera for X sync.
Note 2: Remove Shoe 4.

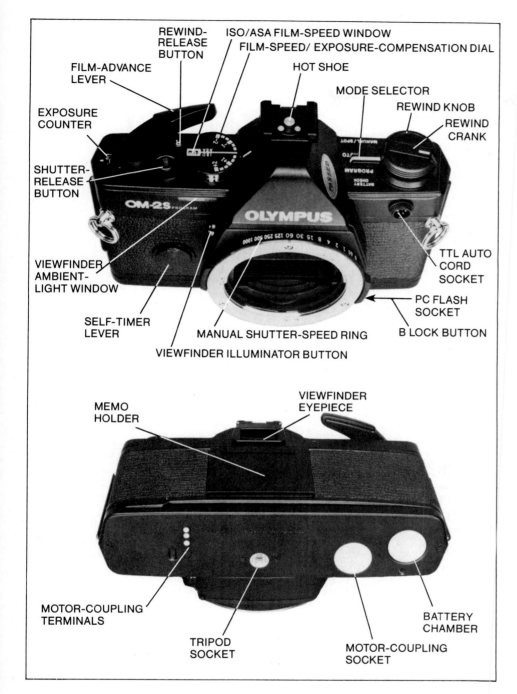

FILM-ADVANCE LEVER

REWIND-RELEASE BUTTON

ISO/ASA FILM-SPEED WINDOW

FILM-SPEED/ EXPOSURE-COMPENSATION DIAL

HOT SHOE

MODE SELECTOR

REWIND KNOB

REWIND CRANK

EXPOSURE COUNTER

SHUTTER-RELEASE BUTTON

VIEWFINDER AMBIENT-LIGHT WINDOW

SELF-TIMER LEVER

VIEWFINDER ILLUMINATOR BUTTON

MANUAL SHUTTER-SPEED RING

TTL AUTO CORD SOCKET

PC FLASH SOCKET

B LOCK BUTTON

MEMO HOLDER

VIEWFINDER EYEPIECE

MOTOR-COUPLING TERMINALS

TRIPOD SOCKET

MOTOR-COUPLING SOCKET

BATTERY CHAMBER

OM-2SPROGRAM

The OM-2SPROGRAM has programmed automatic, aperture-priority auto and manual modes. Metering is center-weighted in auto modes and exposure is controlled by the OTF method. On manual, spot metering is used.

ON-OFF CONTROL

The camera is turned on by partially depressing the shutter button. It remains on for about 90 seconds. Making an exposure resets the 90-second timer.

METERING

All metering is done by a silicon sensor in the bottom of the camera, facing backward toward the film. As discussed in Chapter 8, the main mirror reflects the image upward into the viewfinder but allows part of the light to pass through to an auxiliary sub-mirror for metering. The submirror reflects light to the silicon sensor.

Metering before exposure is done with the mirrors down. In the auto modes, this provides a preliminary indication of shutter speed. Actual shutter speed is determined by the OTF system. The light sensor measures light at the film plane and closes the shutter when exposure is correct for an average scene. Metering is center-weighted in the auto modes.

In the manual mode, spot metering is used. Exposure controls are set manually before you press the shutter button.

MODE SELECTION

Use the Mode Selector Lever to choose PROGRAM, AUTO, and MANUAL/SPOT.

VIEWFINDER DISPLAY

As shown in the accompanying illustrations, the viewfinder exposure display uses a vertical column of LCD dots that changes in height along the left edge of the frame. Each dot represents one-third of an exposure step. Olympus refers to this as a "bar graph" indicator.

In the auto modes, a scale of shutter speeds appears to the left of the bar graph. The top of the bar indicates the shutter speed selected by the camera.

In the manual mode, an index mark with plus and minus symbols appears at the left of the bar graph. Correct exposure for an average scene is indicated when the top of the bar aligns with the index mark.

In addition, mode indicators and warning symbols appear when needed.

PROGRAM MODE

The camera sets both shutter speed and aperture automatically, according to a program built into the camera electronics. Move the Mode Selector Lever to PROGRAM. Press the shutter button partway to turn on camera and display. A PRGM symbol appears above the shutter-speed scale.

Set the lens to its minimum aperture. This allows the camera to use all available apertures on the lens. Focus and compose. The bar graph shows the shutter speed selected by the camera. The camera-selected aperture value is not displayed. Press the shutter button fully to make the exposure.

The actual shutter speed may be slightly different than the viewfinder indication because the OTF system will provide correct exposure for an average scene.

If the Lens is Not at Minimum Aperture— In the program mode, the camera *cannot* select an aperture smaller than the aperture set on the lens. If you don't set the lens at minimum aperture, the camera will adjust shutter speed automatically if possible, so it can use an available aperture—the set value or larger.

Overexposure Warnings—If overexposure will occur even at the fastest shutter speed, *and the lens is not set at minimum*

OM-2S PROGRAM DISPLAYS

OTF PROGRAM Mode
The LCD viewfinder display shows a bar graph indicating the shutter speed selected by the camera. The symbol PRGM appears above the shutter-speed scale to show that the Program Mode has been selected.

OTF PROGRAM Flash
The flash symbol appears indicates flash charge. The camera sets a suitable aperture. Olympus T-series flash units automatically set X-sync shutter speed at 1/60 and mark that shutter speed on the scale. UNDR and OVER symbols show incorrect exposure.

OTF AUTO Mode
In this mode, you set aperture, the camera sets shutter speed automatically. The bar graph shows the shutter speed set by the camera. Overexposure is indicated by the symbol OVER at the top of the display.

OTF AUTO Flash
The flash symbol indicates flash charge. You set aperture for a shutter-speed indication of 1/60 or slower. UNDR and OVER symbols show incorrect exposure.

MANUAL/SPOT Mode
In this mode, the camera uses spot metering. You set both aperture and shutter speed by reference to the display. When exposure is correct for an average scene, the bar graph is centered between the two arrows as shown. With increasing exposure, the bar graph moves upward.

ALL SYMBOLS
All available symbols are shown here although not all are used simultaneously. The + - symbol at the bottom appears when exposure compensation is used.

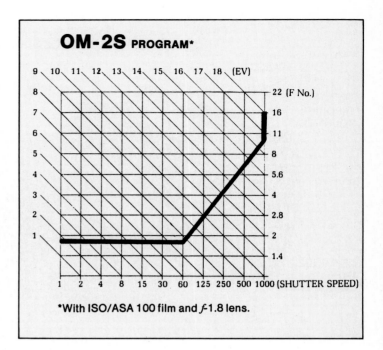

OM-2S PROGRAM*

*With ISO/ASA 100 film and f-1.8 lens.

aperture, an OVER symbol appears along with a symbol representing a lens aperture diaphragm. Both symbols blink and an intermittent audible beep also occurs.

The diaphragm symbol suggests setting the lens to minimum aperture, which may allow correct exposure. If so, you can make the shot.

If the lens is at minimum aperture, and overexposure will occur even at the fastest shutter speed, the blinking OVER symbol appears and the camera beeps. The diaphragm symbol does not appear. You can make the shot if you wish.

Unusable Lenses—These lenses are not designed for use in the programmed auto mode: 250mm *f*-2, 350mm *f*-2.8, 600mm *f*-6.5, 100mm *f*-11 and reflex lenses.

AUTO MODE

This mode is aperture-priority automatic. Set the Mode Selector Lever to AUTO. Press the shutter button partway to turn on camera and display. Set an aperture on the lens. The viewfinder bar graph display shows the shutter speed to be used with that aperture. No special symbol appears above the shutter-speed scale.

The aperture set on the lens is not displayed. Press the shutter button fully to make the exposure.

The actual shutter speed may be slightly different from the viewfinder indication because the OTF system will close the shutter when exposure is correct for an average scene.

Overexposure Warning—If overexposure will occur at the set aperture, even at the fastest shutter speed, the blinking OVER symbol appears and the camera beeps. Use a smaller aperture if possible.

UNDEREXPOSURE IN AUTO MODES

There is no specific indication of underexposure in the auto modes. If the bar graph indicator is at minimum height, just below 1 second on the shutter-speed scale, correct exposure requires more than 1 second. The camera will hold the shutter open for a minute or longer, attempting to get correct exposure. Reciprocity failure of the film being used will be a factor.

MANUAL MODE

Set the Mode Selector Lever to MANUAL/SPOT. Press the shutter button partway to turn on camera and display. Focus and compose. Remember that spot metering is used. The metering area is defined by the outer border of the microprism ring in the viewfinder. It is approximately 2% of the total image area.

The display shows a correct-exposure index mark with arrow symbols and plus-minus symbols as shown in the accompanying illustration. The moving bar graph represents *exposure.*

Set aperture. Set shutter speed using the Manual Shutter-Speed Ring. Use any combination of shutter speed and aperture that causes the bar graph to indicate correct exposure. Neither the set aperture or shutter speed are displayed. Press the shutter button fully to make the shot.

Over- and Underexposure—The display shows one and two exposure steps in each direction. The ends of the arrow symbols are one step away from the index mark. The plus and minus symbols are two steps away.

EXPOSURE COMPENSATION

The Exposure-Compensation Dial is combined with the Film-Speed Dial. To use exposure compensation, turn the dial without lifting the outer rim. Range is +2 to –2 exposure steps in increments of 1/3 step, except at the extreme ends of the film-speed dial setting.

On PROGRAM, exposure compensation follows the program graph, changing both shutter speed and aperture. On AUTO, exposure compensation changes shutter speed. On manual, exposure compensation changes the length of the bar.

Exposure-Compensation Warning—A blinking +– symbol appears at the bottom of the display when exposure compensation is being used.

FILM SPEED

Lift the outer rim of the Film-Speed Dial and turn it to place the desired film-speed number in the ISO/ASA Film-Speed Window. Release and press down the outer rim. This changes the exposure-compensation setting. Reset exposure compensation to zero. The film-speed change procedure, as just described, is limited to plus or minus four steps of film speed. If a greater change is required, repeat the operation.

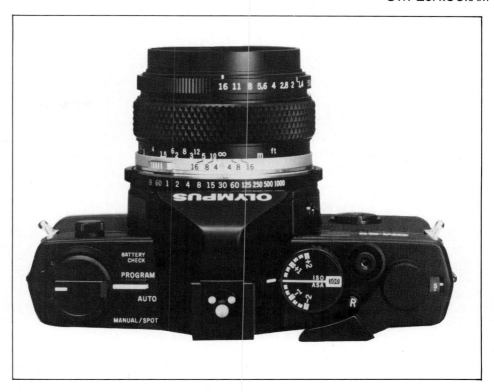

VIEWING DEPTH OF FIELD

Pressing the Depth-of-Field Preview button on the lens closes aperture to the value set on the aperture ring. In the aperture-preferred auto and manual modes, this is the aperture at which the shot will be made.

In the programmed auto mode, shooting aperture is probably not the value set on the lens. Viewing depth of field is probably not valid.

MECHANICAL SHUTTER SPEEDS

Two mechanical shutter speeds are available that do not require battery power: B and the X-sync speed of 1/60 second. They are marked on the Manual Shutter-Speed Dial in red. To select either, depress the B LOCK button at the bottom of the lens mount. To turn the dial back to the electronically controlled shutter speeds, pressing B LOCK is not required.

SELF-TIMER

To set the timer, rotate the Self-Timer Lever fully counterclockwise. When the shutter button is pressed, the mirror moves up and the lens closes to shooting aperture. A delay of 12 seconds occurs before the shutter opens. The red lamp in the center of the self-timer control blinks during countdown. The beeper beeps during countdown, using a higher pitch during the last two seconds.

The self-timer cannot be used with mechanical shutter speeds.

BEEPER OFF

To disable the beeper for all functions except self-timer, pull the Self-Timer Lever outward and rotate it fully clockwise. It cannot be disabled when the self-timer is being used.

STOPPED-DOWN METERING

On automatic or manual, the camera uses stopped-down metering when necessary with no special control settings or procedures required.

MULTIPLE EXPOSURES

Use the "three-finger" method described in Chapter 8.

FRAME COUNTER

The frame counter actually counts strokes of the Film-Advance Lever. After multiple exposures are made, the counter shows a higher number than the actual frame. The counter advances past 37 and stops at an E symbol. If there are still unused frames, they can be exposed.

VIEWFINDER
DISPLAY ILLUMINATOR

Normal illumination for the LCD display in the viewfinder is through a window on the front of the camera. If the ambient light is too dim, press the Viewfinder Illuminator Button on the lens mount. The illuminator turns itself off in 10 seconds or when the shutter button is pressed.

FLASH

Flash units may be used in the hot shoe, connected to the five-pin socket on the camera body or the standard PC socket on the lens mount, depending on the flash type. Only X-sync is available.

With Olympus T-series flash units, a "lightning" symbol at the top of the display glows when the flash is charged. With the flash on TTL auto and the camera on PROGRAM, shutter speed is set automatically to 1/60 and aperture is set according to a built-in program.

With the flash on TTL auto and the camera on AUTO, set aperture manually to produce a shutter-speed indication in the viewfinder of 1/60 or slower. At indicated shutter speeds faster than 1/60, the flash will not fire but exposure will be made correctly with ambient light.

In either auto mode, the flash symbol blinks to show correct exposure after the flash is fired. If the OTF system measured under- or overexposure, an UNDR or OVER symbol blinks in the display.

With the flash on manual and the camera on MANUAL/SPOT, set shutter speed to 1/60 or slower and aperture according to the guide number. The blinking flash symbol does not assure correct exposure.

Normal auto flash using a light sensor on the flash unit can be used with the camera on manual. See Chapter 11.

BATTERY CHECK

Turn the Mode Selector Lever to BATTERY CHECK. If the batteries are OK, the red lamp on the front of the camera glows continuously and the beeper sounds continuously. If the batteries are usable but weak, the light blinks and the beeper sounds intermittently. With dead batteries, the camera electronics and metering systems do not operate. The mechanical shutter speeds can be used.

MAJOR ACCESSORIES

The OM-2S can use Zuiko lenses and lens accessories, macro equipment such as extension tubes and bellows, viewfinder eyepiece accessories, flash units, motor drives and auto winders, interchangeable camera backs, interchangeable viewfinder screens, and Camera Grip 1.

OM-2S SPECIFICATIONS

Type: 35mm SLR with TTL programmed auto exposure, TTL aperture-priority auto, or manual. Center-weighted or single-spot metering. TTL auto flash with T-series flash units.
Shutter: Horizontal cloth focal-plane.
Shutter Speeds: Auto—1/1000 to approx. 1 minute, stepless. Manual—1/1000 to 1 second in standard steps. B and mechanical X-sync speed of 1/60.
Flash Sync: 1/60 X-sync at hot shoe, 5-pin connector and PC socket.
Exposure Compensation: Plus or minus 2 steps in increments of 1/3 step, except at extremes of film-speed range.
Film-Speed Range: ASA 12 to 3200.
Viewfinder: Interchangeable focusing screen. Standard screen is biprism surrounded by microprism. Shows 97% of picture area. Magnification is 0.86 at infinity with 50mm lens.
Viewfinder Displays: LCD moving bar with illuminator. Shows shutter speed on auto. Fixed metering index on manual. Mode indicators, overexposure warning, exposure-compensation warning, incorrect aperture warning on programmed auto, flash charge and exposure indication.
Self-Timer: Electronic. 12-second display. LED and audible signal.
Grip: Camera Grip 1.
Battery Check: LED and audible signal.
Automatic Turnoff: Turns itself off in 90 seconds if not used.
Batteries: Two 1.5 V silver-oxide SR44 or alkaline LR44.
Dimensions: Body only—5.35x3.3x1.97" (136x84x50mm).
Weight: Body only—19 oz. (540g).

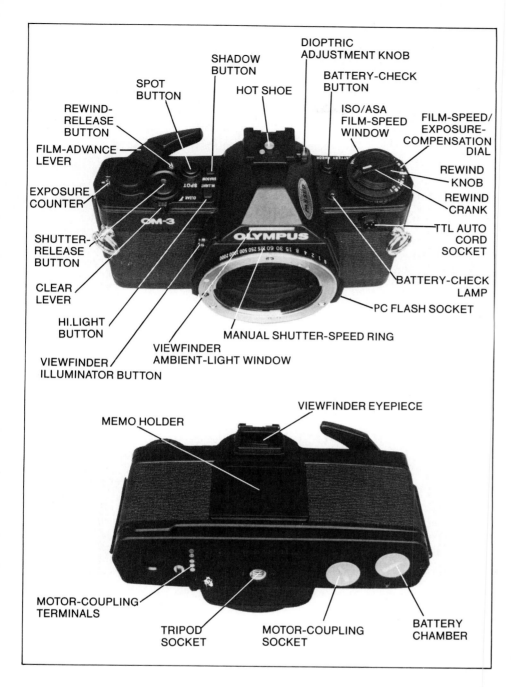

SPOT BUTTON

SHADOW BUTTON

DIOPTRIC ADJUSTMENT KNOB

HOT SHOE

BATTERY-CHECK BUTTON

REWIND-RELEASE BUTTON

FILM-ADVANCE LEVER

ISO/ASA FILM-SPEED WINDOW

FILM-SPEED/ EXPOSURE-COMPENSATION DIAL

EXPOSURE COUNTER

REWIND KNOB

REWIND CRANK

SHUTTER-RELEASE BUTTON

CLEAR LEVER

TTL AUTO CORD SOCKET

BATTERY-CHECK LAMP

HI.LIGHT BUTTON

PC FLASH SOCKET

MANUAL SHUTTER-SPEED RING

VIEWFINDER ILLUMINATOR BUTTON

VIEWFINDER AMBIENT-LIGHT WINDOW

VIEWFINDER EYEPIECE

MEMO HOLDER

MOTOR-COUPLING TERMINALS

TRIPOD SOCKET

MOTOR-COUPLING SOCKET

BATTERY CHAMBER

OM-3

The OM-3 is a manual-only camera with mechanical shutter operation using center-weighted, single spot or multi-spot metering. The shutter-speed range is 1 to 1/2000 second, plus B. All shutter speeds can be used with dead batteries. The camera does not have a self-timer.

ON-OFF CONTROL

The camera metering system is turned on by partially depressing the shutter button. It remains on for about 120 seconds. Making an exposure resets the 120-second timer.

METERING

Metering is done by a silicon sensor in the bottom of the camera, facing backward toward the film. As discussed in Chapter 8, the main mirror reflects the image upward into the viewfinder but allows part of the light to pass through to an auxiliary sub-mirror for metering. The submirror reflects light to the silicon sensor.

Metering is done before exposure, with the mirrors down. Exposure controls are set manually before pressing the shutter button.

VIEWFINDER DISPLAY

As shown in the accompanying illustration, the viewfinder exposure display has a horizontal row of dots that changes length along the bottom of the frame. Olympus refers to this as a "bar graph" indicator.

A metering index mark with plus and minus symbols appears above the bar graph. Correct exposure for an average scene is indicated when the left end of the bar aligns with the index mark.

The set shutter speed appears below the bar. In addition, metering-mode indicators and warning symbols appear when needed.

CENTER-WEIGHTED METERING

When the camera meter is turned on by partially depressing the shutter button, it is automatically set for center-weighted metering. Focus, compose and set aperture and shutter speed as desired, referring to the exposure display. Press the shutter button fully to make the shot.

SINGLE-SPOT METERING

The spot metering area is the outer boundary of the microprism ring at the center of the screen. Turn on the camera by pressing the shutter button partway. Place the metering spot at the desired location in the scene. Press the SPOT button to make a spot reading. This switches the camera instantly from center-weighted to spot metering. The length of the exposure bar changes because it now represents the exposure produced by the brightness of the spot that was measured.

The word SPOT appears at the right, in the display. The camera beeps to indicate that a spot measurement was made. A small diamond-shaped symbol appears above the end of the bar. If you point the camera at a different brightness, the length of the bar does not change and the diamond symbol above it remains fixed in position. The exposure reading for that spot has been memorized by the camera.

To set exposure for the spot that was measured, change shutter speed or aperture to bring the end of the bar into alignment with the metering index. The diamond above the end of the bar moves with it.

After you make the spot measurement, a second diamond-shaped symbol appears above the bar and moves when you point the camera at a different brightness. The second symbol is used for multi-spot metering, discussed later.

HIGHLIGHT SPOT METERING

If a spot measurement is made of a white surface in the scene and no exposure compensation is made, the white surface will record as 18% gray. If you want the white surface to appear white in the resulting slide

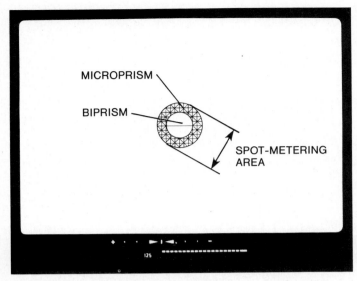

With center-weighted metering, adjust shutter speed and aperture so the bar graph aligns with the metering index mark for correct exposure of an average scene. The set shutter speed is displayed, such as 1/125 second.

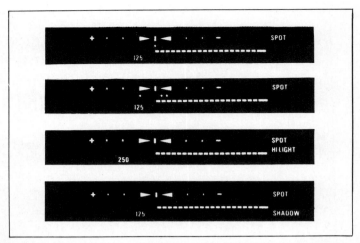

The OM-3 offers four types of spot metering with a slightly different display for each mode. From top to bottom, the displays show single-spot, multi-spot, high-light compensation and shadow compensation.

or print, about two steps more exposure than the metered value is required. That can be done in several ways, for example with the Exposure-Compensation Dial as discussed in Chapter 8.

The OM-3 provides a special control for this purpose, labeled HI.LIGHT. Make a spot measurement of the white surface by pressing the SPOT button. Then press the adjacent HI.LIGHT button. The bar becomes shorter by 2 exposure steps. The word HI.LIGHT appears in the display, just below the word SPOT.

If the end of the bar is then brought into alignment with the metering index, by changing aperture or shutter speed, this gives two steps more exposure than the original spot measurement. The white surface records on film as a white surface.

SHADOW SPOT METERING

The SHADOW control is similar to the highlight control except that it decreases exposure by 2-2/3 exposure steps to cause a black surface to appear black in the resulting photo.

First take a spot reading of the black surface, then press the SHADOW button.

MULTI-SPOT METERING

If a scene has only light and dark surfaces, with no middle gray area to meter on, you can set exposure by metering on each of the surfaces and then averaging the two results.

Multi-spot metering allows that and more sophisticated metering techniques.

Multi-spot metering is done by pressing the SPOT button repeatedly while spot metering different areas of the scene. Each time the SPOT button is pressed, the camera averages that reading with all readings taken earlier, up to a maximum of the eight most recent readings. If you take nine readings, the first is lost when the ninth is made.

Each time a spot reading is taken, a fixed diamond symbol appears to show the brightness of that spot. The exposure bar in the viewfinder changes length to show the new average. If you point the camera at a different brightness, a moving diamond shows the brightness of that point. If you press the SPOT button, the moving diamond becomes fixed and a new moving diamond appears. After eight spot readings, eight diamonds are in the display. If the same brightness was measured more than once, two or more of the diamonds may be at the same location.

If you press the HI.LIGHT button during multi-spot metering, only the brightest spot reading is affected. If you press the SHADOW button, only the darkest spot is affected.

CLEARING MEMORY

In any spot-metering mode, the exposure measurement is held in memory. The memory is cleared by making an exposure. If an exposure is not made within 120 seconds, memory is cleared automatically. If you

want to clear memory, so you can start over, move the Clear Lever fully clockwise.

Removing and replacing the lens clears memory.

Clearing memory by any of these methods returns the camera to the center-weighted metering mode.

OVER- AND UNDEREXPOSURE

The display shows three exposure steps in each direction from the metering index mark. The ends of the arrow symbols are one step away. The first dot is two steps and the second dot is three steps away.

EXPOSURE COMPENSATION

The Exposure-Compensation Dial is combined with the Film-Speed Dial. It affects the meter reading in all metering modes. To use exposure compensation, turn the dial without lifting the outer rim. Range is +2 to –2 exposure steps in increments of 1/3 step, except at the extreme ends of the film-speed dial setting.

Exposure-Compensation Warning—A blinking +– symbol appears at the bottom of the display when exposure compensation is being used.

FILM SPEED

Lift the outer rim of the Film-Speed Dial and turn it to place the desired film-speed number in the ISO/ASA Film-Speed Window. Release and press down the outer rim.

This changes the exposure-compensation setting. Reset exposure compensation to zero. The film-speed change procedure, as just described, is limited to plus or minus four steps of film speed. If a greater change is required, repeat the operation.

VIEWING DEPTH OF FIELD

Pressing the Depth-of-Field Preview button on the lens closes aperture to the value set on the aperture ring. You see depth of field at that aperture.

BEEPER OFF

To disable the beeper, turn the Beeper Muffling Lever counterclockwise.

STOPPED-DOWN METERING

On automatic or manual, the camera uses stopped-down metering when necessary with no special control settings or procedures required.

MULTIPLE EXPOSURES

Use the "three-finger" method described in Chapter 8.

FRAME COUNTER

The frame counter actually counts strokes of the Film-Advance Lever. After multiple exposures are made, the counter shows a higher number than the actual frame. The counter advances past *37* and stops at an *E* symbol. If there are still unused frames, they can be exposed.

VIEWFINDER DISPLAY ILLUMINATOR

Normal illumination for the LCD display in the viewfinder is through a window on the front viewfinder housing. If the ambient light is too dim, press the Viewfinder Illuminator Button on the lens mount. The illuminator turns itself off in about 10 seconds.

VIEWFINDER EYEPIECE CORRECTION

The viewfinder eyepiece has a built-in dioptric correction to match the viewfinder optics to your vision. Range is from +1 to –3 diopters. With an unfocused image of a blank surface, pull out the Dioptric Adjustment Knob on the left side of the viewfinder. Turn it to place the circles surrounding the focusing aids in sharpest focus. Press the knob back in.

FLASH

Flash units may be installed in the hot shoe, connected to the five-pin socket on the camera body or to the standard PC socket on the lens mount, depending on the type of flash. Only X-sync is available.

With Olympus T-series flash units, normal auto or manual modes may be used. A flash symbol at the lower right in the display glows when the flash is charged. On auto, the flash symbol blinks to show correct exposure after the flash is fired. At shutter speeds faster than 1/60, the flash will not fire, but an exposure will be made correctly with ambient light. See Chapter 11.

OM-3 SPECIFICATIONS

Type: 35mm SLR with mechanical shutter, manual exposure control, center-weighted, single-spot or multi-spot metering.
Shutter: Horizontal cloth focal-plane.
Shutter Speeds: 1/2000 to 1 second in standard steps, plus B.
Flash Sync: 1/60 X-sync at hot shoe, 5-pin connector and PC socket.
Exposure Compensation: Plus or minus 2 steps in increments of 1/3 step, except at extremes of film-speed range.
Film-Speed Range: ASA 6 to 3200.
Viewfinder: Interchangeable focusing screen. Standard screen is biprism surrounded by microprism. Shows 97% of picture area. Magnification is 0.84 at infinity with 50mm lens. Built-in dioptric correction of +1 to –3 diopters.
Viewfinder Displays: LCD moving bar with illuminator. Fixed metering index. Metering-mode indicators, exposure-compensation warning, flash charge and exposure indication.
Grip: Camera Grip 1.
Battery Check: LED and audible signal.
Automatic Turnoff: Turns itself off in 120 seconds if not used.
Batteries: Two 1.5 V silver-oxide SR44 or alkaline LR44.
Dimensions: Body only—5.35x3.3x1.97" (136x84x50mm).
Weight: Body only—19 oz. (540g).

The Dioptric Adjustment Knob, just left of the hot shoe, is a very convenient way to adjust the viewfinder optics to your eyesight.

BATTERY CHECK

Press the BATTERY CHECK button. If the batteries are OK, the adjacent red lamp glows continuously and the beeper sounds continuously. If the batteries are usable but weak, the light blinks and the beeper sounds intermittently. With dead batteries, the camera metering systems does not operate. All shutter speeds can be used.

MAJOR ACCESSORIES

The OM-3 can use Zuiko lenses and lens accessories, macro equipment such as extension tubes and bellows, viewfinder eyepiece accessories, flash units, motor drives and auto winders, interchangeable camera backs, interchangeable viewfinder screens, and Camera Grip 1.

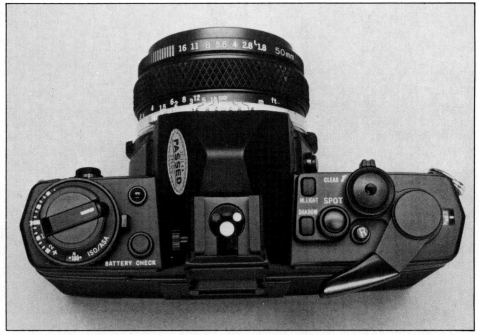

Your right index finger quickly learns the locations of the SPOT, SHADOW, HI.LIGHT and CLEAR controls.

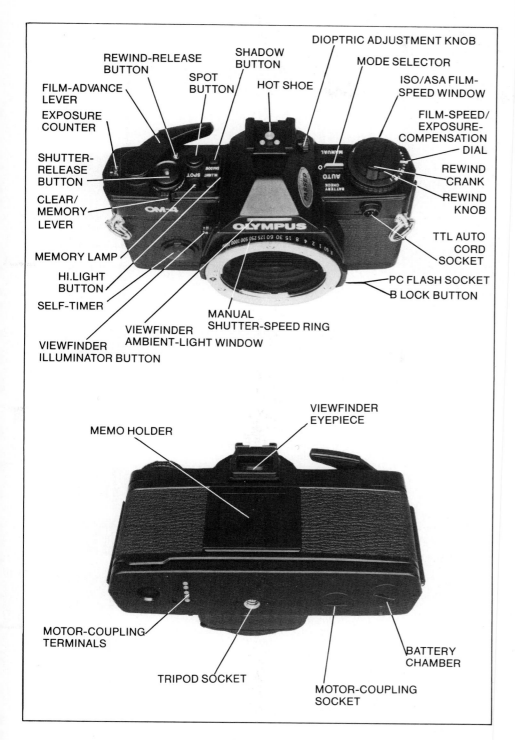

FILM-ADVANCE LEVER

EXPOSURE COUNTER

SHUTTER-RELEASE BUTTON

CLEAR/MEMORY LEVER

MEMORY LAMP

HI.LIGHT BUTTON

SELF-TIMER

VIEWFINDER ILLUMINATOR BUTTON

REWIND-RELEASE BUTTON

SPOT BUTTON

SHADOW BUTTON

HOT SHOE

DIOPTRIC ADJUSTMENT KNOB

MODE SELECTOR

ISO/ASA FILM-SPEED WINDOW

FILM-SPEED/EXPOSURE-COMPENSATION DIAL

REWIND CRANK

REWIND KNOB

TTL AUTO CORD SOCKET

PC FLASH SOCKET

B LOCK BUTTON

MANUAL SHUTTER-SPEED RING

VIEWFINDER AMBIENT-LIGHT WINDOW

MEMO HOLDER

VIEWFINDER EYEPIECE

MOTOR-COUPLING TERMINALS

TRIPOD SOCKET

MOTOR-COUPLING SOCKET

BATTERY CHAMBER

OM-4 AND OM-4T

The OM-4T is an improvement of the OM-4. The major changes are: the OM-4T has a titanium body which is stronger and slightly lighter. The OM-4T can use the F280 flash in the Super FP mode; the OM-4 cannot. The OM-4T has five contacts in the hot shoe; the OM-4 has three. A minor improvement is that the OM-4T battery-check system turns itself off after 30 seconds; the

OM-4 will remain on.

In this discussion of both models, I will call attention to the differences. The photos on this page are of the OM-4.

The OM-4 and OM-4T have aperture-priority automatic and manual exposure control. In either mode, metering is center-weighted, single spot or multi-spot. When using spot metering, the metering area is the outer boundary of the microprism ring in the

center of the screen. The manually-selected shutter speed range is 1 to 1/2000 second, plus B and a mechanical shutter speed of 1/60.

ON-OFF CONTROL

The camera is turned on by partially depressing the shutter button. It remains on for about 120 seconds. Making an exposure resets the 120-second timer.

METERING

All metering is done by a silicon sensor in the bottom of the camera, facing backward toward the film. As discussed in Chapter 8, the main mirror reflects the image upward into the viewfinder but allows part of the light to pass through to an auxiliary sub-mirror for metering. The submirror reflects light to the silicon sensor.

Metering before exposure is done with the mirrors down, using either center-weighted or spot metering. Metering during exposure, by reading light at the film plane, is always center-weighted.

MODE SELECTION

Use the Mode Selector Lever to choose AUTO or MANUAL. In either mode, several metering options are available.

VIEWFINDER DISPLAY IN AUTO MODE

As shown in the accompanying illustration, shutter speed is displayed in the auto mode by a row of dots along the bottom of the screen, above a scale of shutter speeds. Olympus refers to this as a "bar graph." The bar changes in length, depending on scene brightness. Shutter speed is indicated by the left end of the bar. Additional mode and warning symbols appear when needed.

AUTO MODE WITH CENTER-WEIGHTED METERING

This mode is aperture-priority automatic. If you do not press the SPOT button, metering is center-weighted and exposure is controlled by the camera OTF system.

Set the Mode Selector Lever to AUTO. Press the shutter button partway to turn on camera and display. Set an aperture on the lens. The viewfinder bar graph display shows the shutter speed to be used with that aperture, based on center-weighted metering before exposure.

Press the shutter button fully to make the shot. When the shutter opens, exposure control is switched to the camera-body sensor, reading light off the film. The actual shutter speed may be slightly different than the viewfinder indication because the OTF system will close the shutter when exposure is correct for an average scene.

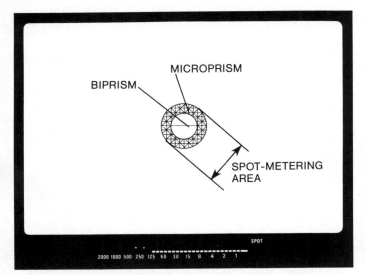

The OM-4 display on automatic in the multi-spot metering mode. Three spots have been measured, marked by three dots above the bar graph. The bar shows the averaged reading and the shutter speed that will be used.

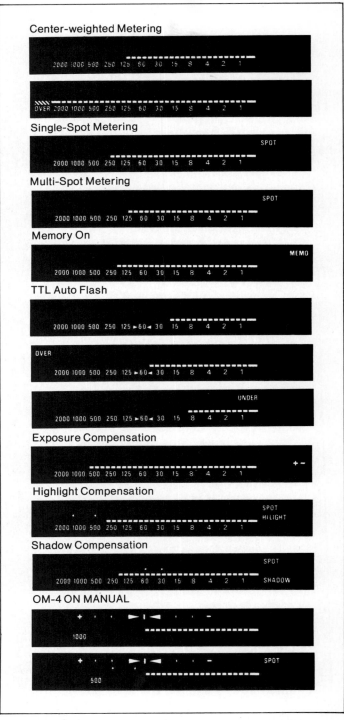

The OM-4 display changes according to the operating mode.

AUTO MODE WITH SINGLE-SPOT METERING

Set the Mode Selector Lever to AUTO. Press the shutter button partway to turn on camera and display. Set an aperture on the lens. Place the circular microprism area in the center of the screen over the spot on the scene to be measured.

Press the SPOT button. This instantly switches the camera to spot metering. The camera automatically calculates shutter speed for the aperture set on the lens, based on the spot reading of scene brightness.

The viewfinder bar graph display shows the shutter speed to be used with that aperture. The word SPOT appears at right in the viewfinder display. A diamond-shaped dot appears above the left end of the bar. If you point the camera at a different brightness, the shutter speed does not change. The exposure value has been memorized.

Because the exposure value has been memorized, you can change aperture and shutter speed will change automatically to maintain the same exposure.

If you point the camera at a different brightness, a second diamond will appear and move left or right according to scene brightness. The second diamond is used in multi-spot metering, discussed later.

Press the shutter button to make the shot. Exposure will be made using the shutter speed determined by the spot measurement before the exposure. The camera OTF system does not control exposure after the shutter opens.

HIGHLIGHT SPOT METERING

If a spot measurement is made of a white surface in the scene and no exposure compensation is made, the white surface will record as 18% gray. If you want the white surface to appear white in the resulting slide or print, about two steps more exposure than the metered value is required.

That can be done in several ways, for example with the Exposure-Compensation Dial as discussed in Chapter 8. The OM-4 provides a special control for this purpose, labeled HI.LIGHT. Make a spot measurement of the white surface by pressing the SPOT button. Then press the adjacent HI.LIGHT button. The bar becomes shorter, indicating a shutter speed that is two steps slower. The

word HI.LIGHT appears in the display, just below the word SPOT.

This gives two steps more exposure than the original spot measurement. The white surface records on film as a white surface.

SHADOW SPOT METERING

The SHADOW control is similar to the highlight control except that it decreases exposure by 2-2/3 exposure steps to cause a black surface to appear black in the resulting photo.

First take a spot reading of the black surface, then press the SHADOW button.

AUTO MODE WITH MULTI-SPOT METERING

If a scene has only light and dark surfaces, with no middle gray area to meter on, you can set exposure by metering on each of the surfaces and then averaging the two results. Multi-spot metering allows that and more sophisticated metering techniques.

Make the first spot measurement as described earlier. The viewfinder bar graph display shows the shutter speed to be used with that aperture. The word SPOT appears at right in the viewfinder display. A diamond-shaped dot appears above the left end of the bar. The exposure value has been memorized.

Center the metering spot over another area of the scene. A second diamond will appear above the bar, indicating the brightness being measured. Press the SPOT button again. The second diamond becomes fixed in place, indicating that a second spot measurement has been made. The camera averages the two spot measurements. The bar changes length to show the shutter speed based on the average of the preceding spot measurements.

This procedure may be repeated indefinitely. The camera always averages a maximum of eight spot measurements. If you make a ninth measurement, the first measurement is lost and the most recent eight measurements are averaged.

Press the shutter button to make the shot. Exposure will be made using the shutter speed determined by the averaged spot measurements before the exposure. The camera OTF system does not control exposure after the shutter opens.

Because the exposure value has been memorized, you can change aperture and shutter speed will change automatically to maintain the same exposure.

Highlight and Shadow Adjustments—If you press the HI.LIGHT button, only the brightest spot measurement is affected. If you press the SHADOW button, only the darkest spot measurement is affected.

OM-4 SPECIFICATIONS

Type: 35mm SLR with TTL aperture-priority auto, or manual. Center-weighted, single-spot or multi-spot metering. TTL auto flash with T-series flash units.
Shutter: Horizontal cloth focal-plane.
Shutter Speeds: Auto—1/2000 to approx. 1 minute with center-weighted metering, 1/2000 to approx. 4 minutes with spot metering. Manual—1/2000 to 1 second in standard steps. B and mechanical X-sync speed of 1/60.
Flash Sync: 1/60 X-sync at hot shoe, 5-pin connector and PC socket. Exposure Compensation: Plus or minus 2 steps in increments of 1/3 step, except at extremes of film-speed range.
Film-Speed Range: ASA 6 to 3200.
Viewfinder: Interchangeable focusing screen. Standard screen is biprism surrounded by microprism. Shows 97% of picture area. Magnification is 0.84 at infinity with 50mm lens. Built-in dioptric correction of +1 to −3 diopters.
Viewfinder Displays: LCD moving bar with illuminator shows shutter speed on auto. Fixed metering index on manual plus set shutter speed. Mode indicators, overexposure warning, exposure-compensation warning, flash charge and exposure indication.
Self-Timer: Electronic. 12-second display. LED and audible signal.
Grip: Camera Grip 1.
Battery Check: LED and audible signal.
Automatic Turnoff: Turns itself off in 120 seconds if not used.
Batteries: Two 1.5 V silver-oxide SR44 or alkaline LR44.
Dimensions: Body only—5.35x3.3x1.97" (136x84x50mm).
Weight: Body only—19 oz. (540g).

OM-4T DIFFERENCES

Type: 35mm SLR with TTL aperture-priority auto, or manual. Center-weighted single-spot or multi-spot metering. TTL autoflash with T-series flash units plus Super FP long-duration flash with F280 flash.
Flash Sync: 1/60 X-sync at hot shoe, additional Super-FP contacts in hot shoe. 5-pin connector on body for T-series flash and PC socket.
Weight: Body only—18 oz. (510g).

OVEREXPOSURE WARNING ON AUTO

If overexposure will occur at the set aperture, even at the fastest shutter speed, a blinking OVER symbol along with a crosshatched rectangle appears at the left end of the shutter-speed scale and the camera beeps. Use a smaller aperture if possible.

UNDEREXPOSURE ON AUTO

There is no specific indication of underexposure. If the bar is at minimum length, to the left of 1 second on the shutter-speed scale, correct exposure requires more than 1 second. The camera will attempt to make correct exposure by holding the shutter open for a minute or longer with center-weighted metering or about four minutes with spot metering. Reciprocity failure of the film being used will be a factor.

MEMORY LOCK

After making a shot on auto, using either spot or center-weighted metering, you may wish to recompose and shoot again with the same exposure setting. To hold the exposure value, move the Clear/Memory Lever counterclockwise anytime before making the first shot. The word MEMO appears at right in the display. The red lamp on top of the camera blinks.

Exposure is locked after the first shot is made, at the exposure value used for that shot. Subsequent shots will be made at the same exposure value. You can change aperture and shutter speed will change automatically to hold the same exposure.

The exposure value will be retained for 60 minutes. It may be canceled by the Clear/Memory Lever, described later. Even if the display turns itself off because you allow 120

seconds to elapse without pressing the shutter button, the exposure value is stored. The display will return as before if you press the shutter button partway. The Memory Lamp on top of the camera blinks intermittently when an exposure value has been locked.

VIEWFINDER DISPLAY ON MANUAL

As shown in the accompanying illustration, the viewfinder exposure display for the manual mode has a horizontal bar that changes length along the bottom of the frame. A metering index mark with plus and minus symbols appears above the bar. Correct exposure for an average scene is indicated when the left end of the bar aligns with the index mark. The bar represents *exposure*.

The set shutter speed appears below the bar. In addition, metering-mode indicators and warning symbols appear when needed.

MANUAL MODE

Metering is done and exposure controls set manually before you press the shutter button. The camera OTF system does not operate during the exposure. Either center-weighted or spot metering can be used.

Set the Mode Selector Lever to MANUAL. Press the shutter button partway to turn on camera and display.

Manual with Center-Weighted Metering—If you do not press the SPOT button, metering is center-weighted.

Set aperture. Set shutter speed using the Manual Shutter-Speed Ring. Use any combination of shutter speed and aperture that causes the bar graph to indicate correct exposure. Press the shutter button fully to make the shot.

Manual with Single-Spot Metering— Place the metering spot at the desired location in the scene. Press the SPOT button. This switches the camera instantly to spot metering. The length of the exposure bar changes because it now represents the exposure produced by the brightness of the spot that was measured.

The word SPOT appears at the right in the display. The camera beeps to indicate that a spot measurement was made. A small diamond-shaped symbol appears above the end of the bar. The exposure reading for that spot has been memorized by the camera.

To set exposure for the spot that was measured, change shutter speed or aperture to bring the end of the bar into alignment with the metering index. Press the shutter button to make the shot.

Manual with Highlight Spot Metering— The purpose of the HI.LIGHT button is the same as described earlier. After making a spot measurement, pressing the HI.LIGHT button causes the exposure bar to become shorter by two exposure steps. If you then adjust aperture or shutter speed to place the end of the bar into alignment with the metering index, the scene receives an additional two steps of exposure.

Manual with Shadow Spot Metering— The purpose of the SHADOW button is the same as described earlier. After making a spot measurement, pressing the SHADOW button causes the exposure bar to become longer by 2-2/3 exposure steps. If you then adjust aperture or shutter speed to place the end of the bar into alignment with the metering index, the scene receives 2-2/3 steps less exposure.

Manual with Multi-Spot Metering—This is generally the same as described earlier. By pressing the SPOT button repeatedly, up to eight spot measurements may be taken and averaged. To set exposure for the resulting average, change shutter speed or aperture to bring the end of the bar into alignment with the metering index. Press the shutter button to make the shot.

If you press the HI.LIGHT button, only the brightest spot measurement is affected. If you press the SHADOW button, only the darkest spot measurement is affected.

OVER- AND UNDEREXPOSURE ON MANUAL

The display shows three exposure steps in each direction. The ends of the arrow symbols are one step away from the index mark. The first dot is two steps and the second dot is three steps.

CLEARING MEMORY

In any spot-metering mode, the exposure measurement is held in memory. The memory is cleared by making an exposure. If an exposure is not made within 120 seconds, memory is cleared automatically. To clear memory, so you can start over, move the Clear/Memory Lever fully clockwise.

If the memory lock function has been used to store an exposure value on automatic, moving the Clear/Memory lever clockwise will erase the stored value.

Removing and replacing the lens clears memory.

Clearing memory by any of these methods returns the camera to the center-weighted metering mode.

EXPOSURE COMPENSATION

Exposure compensation affects exposure in all modes, except when the memory lock function is operating in the auto mode. The Exposure-Compensation Dial is combined with the Film-Speed Dial. To use exposure compensation, turn the dial without lifting the outer rim. Range is +2 to –2 exposure steps in increments of 1/3 step, except at the extreme ends of the film-speed dial setting.

Exposure-Compensation Warning—A blinking +– symbol appears at the right in the display when exposure compensation is being used.

FILM SPEED

Lift the outer rim of the Film-Speed Dial and turn it to place the desired film-speed number in the ISO/ASA Film-Speed Window. Release and press down the outer rim. This changes the exposure-compensation setting. Reset exposure compensation to zero. The film-speed change procedure, as just described, is limited to plus or minus four steps of film speed. If a greater change is required, repeat the operation.

VIEWING DEPTH OF FIELD

Pressing the Depth-of-Field Preview button on the lens closes aperture to the value set on the aperture ring.

MECHANICAL SHUTTER SPEEDS

Two mechanical shutter speeds are available that do not require battery power: B and the X-sync speed of 1/60 second. They are marked on the Manual Shutter-Speed Dial in red. To select either, depress the B LOCK button at the bottom of the lens mount. To turn the dial back to the electronically controlled shutter speeds, pressing B LOCK is not required.

SELF-TIMER

To set the timer, rotate the Self-Timer Lever fully counterclockwise. When the shutter button is pressed, the mirror moves up and the lens closes to the shooting aperture. Then a delay of 12 seconds occurs before the shutter opens. The red lamp in the center of the self-timer control blinks during the countdown. The beeper beeps during countdown, using a higher pitch during the last two seconds.

The self-timer cannot be used with mechanical shutter speeds.

BEEPER OFF

To disable the beeper for all functions except self-timer, rotate the Self-Timer Lever fully clockwise. It cannot be disabled when the self-timer is being used.

STOPPED-DOWN METERING

On automatic or manual, the camera uses stopped-down metering when necessary with no special control settings or procedures required.

MULTIPLE EXPOSURES

Use the "three-finger" method described in Chapter 8.

FRAME COUNTER

The frame counter actually counts strokes of the Film-Advance Lever. After multiple exposures are made, the counter shows a higher number than the actual frame. The counter advances past 37 and stops at an E symbol. If there are still unused frames, they can be exposed.

VIEWFINDER
DISPLAY ILLUMINATOR

Normal illumination for the LCD display in the viewfinder is through a window on the front of the camera. If the ambient light is too dim, press the Viewfinder Illuminator Button on the lens mount. The illuminator turns itself off in 10 seconds or when the shutter button is pressed.

FLASH

Flash units may be installed in the hot shoe, connected to the five-pin socket on the camera body or to the standard PC socket on the lens mount, depending on the type of flash. Only X-sync is available.

With Olympus T-series flash units, a "lightning" symbol at lower right in the display glows when the flash is charged.

With the flash on TTL auto and the camera on AUTO, set aperture manually to produce a shutter-speed indication in the viewfinder of 1/60 or slower. At indicated shutter speeds faster than 1/60, the flash will not fire but exposure will be made correctly with ambient light.

The flash symbol blinks to show correct exposure after the flash is fired. If the OTF system measured under- or overexposure, an UNDER or OVER symbol blinks in the display.

With the flash on manual and the camera on MANUAL, set shutter speed to 1/60 or slower and aperture according to the guide number. The blinking flash symbol does not assure correct exposure.

Normal auto flash using a light sensor on the flash unit can be used with the camera on manual. See Chapter 11.

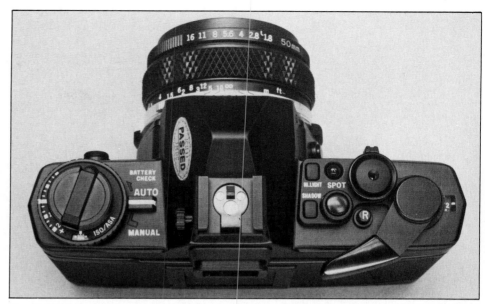

The CLEAR/MEMORY Lever extends forward, in front of the shutter button. To clear the internal memory of the camera, move the lever clockwise. To lock an exposure value in memory for up to an hour, move the lever counterclockwise. When an exposure value is locked in memory, the red Memory Lamp adjacent to the shutter button blinks.

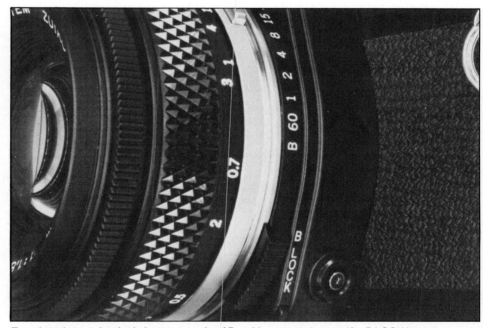

To select the mechanical shutter speeds of B or 60, you must press the B LOCK button near the bottom of the lens mount.

BATTERY CHECK

Turn the Mode Selector Lever to BATTERY CHECK. If the batteries are OK, the red lamp on the front of the camera glows continuously and the beeper sounds continuously. If the batteries are usable but weak, the light blinks and the beeper sounds intermittently. With dead batteries, the camera electronics and metering systems do not operate. The mechanical shutter speeds can be used.

The OM-4T has an automatic 30-second timer that turns off the battery-check system after 30 seconds. If you then use the camera without moving the Mode Selector lever away from the BATTERY CHECK setting, the camera operates on aperture-priority automatic, as though the lever were set to AUTO.

MAJOR ACCESSORIES

The OM-4 and OM-4T can use Zuiko lenses and lens accessories, macro equipment such as extension tubes and bellows, viewfinder eyepiece accessories, flash units, motor drives and auto winders, interchangeable camera backs, interchangeable viewfinder screens, and Camera Grip 1.

oMPC

The oMPC has a novel ESP metering system that adjusts exposure automatically when photographing non-average scenes such as a subject against an unusually bright or dark background, or a scene including a bright reflection or light source such as the sun. It also has center-weighted averaging metering.

There are three exposure modes: programmed auto, aperture-priority auto and manual. With DX-coded film, the camera can set film speed automatically, or you can do it manually. Olympus Zuiko lenses are used.

LOADING AND REWINDING FILM

Film is loaded and rewound manually, as shown in Chapter 5. A film window in the back cover allows you to see if a film cartridge is in the camera and read imprinted data on the cartridge.

ON-OFF CONTROL

The camera is turned on by touching the shutter button, without depressing it fully. It remains on for about 60 seconds if you don't make an exposure. Making an exposure resets the 60-second timer.

METERING

All metering is done by a silicon sensor in the bottom of the camera, facing the film. The sensor has two zones: the center of the frame and the edges of the frame. As discussed in Chapter 8, some light from the scene passes through the main mirror and is reflected downward to the light sensor by an auxiliary submirror.

Metering before exposure is done with both mirrors down and the resulting shutter speed displayed in the viewfinder. Metering during exposure is OTF (Off The Film), using the same sensor.

EXPOSURE MODE SELECTOR

There are three exposure modes, plus battery check. The exposure-mode settings are MANUAL for manual control, AUTO for aperture-priority auto, and P for programmed automatic exposure.

PROGRAMMED AUTO

In addition to setting the Exposure Mode Selector on P, the lens aperture ring should normally be set to the smallest aperture—such as f-16.

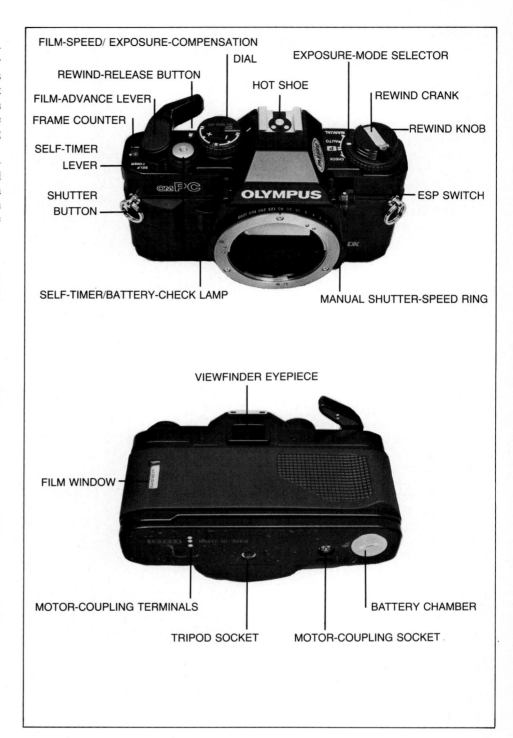

OMPC EXPOSURE-PROGRAM GRAPH

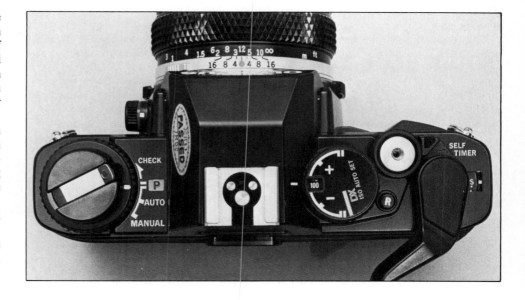

With the lens set at minimum aperture, the exposure program can use all possible aperture values. This graph is for the 50mm *f*-1.8 lens, which has aperture settings from *f*-1.8 to *f*-16. If the lens is not set at minimum aperture, the range of aperture settings is reduced. For example, if the lens is set at *f*-4, only apertures in the range of *f*-1.8 to *f*-4 can be used by the program. This allows you to prevent use of small apertures and correspondingly slow shutter speeds.

The camera will provide correct exposure using an aperture size between maximum and the value set on the aperture ring, if possible. If you set *f*-4, for example, instead of the minimum aperture, then the program cannot use apertures smaller than *f*-4. You can do this deliberately to avoid the smaller apertures and therefore reduce depth of field.

If you have set an aperture larger than minimum and overexposure will result, even at the fastest shutter speed, an aperture symbol appears in the viewfinder—suggesting that you set the lens to a smaller aperture size.

The viewfinder displays a P symbol and the shutter speed selected by the program. The accompanying program graph is for an *f*-1.8 lens with a minimum aperture of *f*-16, with ISO/ASA 100 film.

APERTURE-PRIORITY AUTO

You set aperture on the lens. The camera sets shutter speed and displays the selected speed in the viewfinder.

MANUAL

You set aperture on the lens and shutter speed using the camera's Manual Shutter-Speed Ring. The camera displays a *recommended* shutter speed for the set aperture, no matter what shutter speed you have actually set. You can use the camera-recommended shutter speed, or any manual setting.

OVEREXPOSURE

Overexposure is indicated when the fastest shutter speed, 1000, blinks in the viewfinder.

On Program—If 1000 and the aperture symbol both blink, the lens is not set at its smallest aperture. Try smaller apertures. If 1000 continues to blink at the smallest aperture setting, it means that overexposure will result even at smallest aperture and fastest shutter speed.

On Aperture-Priority Auto—If 1000 blinks, it means overexposure will result with a shutter speed of 1/1000 second and the aperture value set on the lens. Try a smaller aperture.

On Manual—If 1000 blinks, the camera "thinks" that no available shutter speed is fast enough to prevent overexposure with the aperture value set on the lens. You can use any aperture and shutter speed, as you wish.

UNDEREXPOSURE

There is no specific warning of un-derexposure. In the auto modes, the slowest available shutter speed is 2 seconds. On manual, the slowest camera-controlled speed is 1 second. In the viewfinder, the slowest displayed speed is 1 second with a downward-pointing arrow beside the 1 symbol.

On Program—In the viewfinder, the 1-second symbol glows to show that the shutter speed will be 1 second or slower. As you can see on the program graph, the maximum lens aperture is used at that shutter speed. Underexposure is possible.

On Aperture-Priority Auto—If the 1-second symbol glows, shutter speed will be 1 second or slower with the set aperture. Underexposure is possible. You may wish to use a larger aperture, if available.

On Manual—If the 1-second symbol glows, the *metered shutter* speed is 1 second or slower with the set aperture. You may use any shutter speed or aperture that you wish.

SETTING FILM SPEED

The Film-Speed/Exposure-Compensation Dial has several functions.

Manual Method—To set film speed manually, lift the outer rim of the control and turn to place the desired film-speed value in the window on the top of the control. This will change the Exposure-Compensation setting. Reset Exposure Compensation to zero.

The manual film-speed setting procedure is limited to a maximum change of four steps at a time. If a greater change is required, repeat the operation.

DX Coding—The camera can be set to read DX-coded film and set film speed automatically. Turn the exposure-compensation control clockwise past the end of the exposure-compensation scale at -2 steps. That places a DX symbol on the control opposite the index mark on the viewfinder housing.

With DX-coded film in the camera, film speed is set automatically, but there is no indication of what speed has been set. If the control is set for DX-coding and you load a film cartridge without DX coding, the camera sets exposure as though the film speed were ISO/ASA 25.

EXPOSURE COMPENSATION

To use exposure compensation, turn the Film-Speed/Exposure-Compensation Dial to select the desired amount of compensation. The range is plus or minus two steps, with detents at intervals of 1/3 step. A plus/minus warning symbol glows in the viewfinder when the Exposure-Compensation dial is not set at zero. Exposure compensation changes the displayed shutter speed in all three exposure modes. It changes exposure in either of the automatic modes.

Exposure compensation and automatic film-speed setting with DX-coded film cannot be used simultaneously because they require different settings of the same control. With DX-coded film, you can set film speed manually and retain use of the Exposure-Compensation Dial.

METERING PATTERNS

The compound silicon light sensor in the bottom of the camera is used two ways.

Center-Weighted—Scene brightness measured in the central zone is combined with the surrounding brightness to provide a center-weighted metering pattern.

ESP metering—A computer in the camera compares the brightness of the central zone to the brightness at the edges of the frame. If

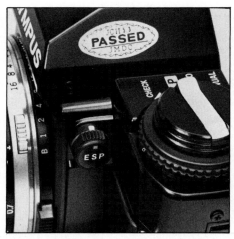

When the Light-Metering Mode Selector switch is set for ESP, as shown here, the camera will use ESP metering when needed. If the scene does not require ESP, the camera automatically switches to center-weighted averaging metering.

exposure compensation is needed, the shutter-speed display in the viewfinder changes to show how much. A special symbol appears in the viewfinder display to show when the ESP system is working.

Exposure is adjusted automatically in either of the automatic-exposure modes. On manual, the viewfinder display is a sugges-

tion by the ESP system in the camera. You can make whatever exposure settings you wish.

If ESP metering has been selected, but the scene is average and requires no exposure adjustment, the ESP symbol in the display is turned off. The scene is metered with a center-weighted pattern.

ESP CONTROL

ESP metering is selected by rotating this switch to place the green dot opposite the adjacent white index mark. To select center-weighted metering, rotate the control counterclockwise about 1/4 turn.

VIEWFINDER

The matte non-interchangeable focusing screen has biprism and microprism focusing aids. The accompanying viewfinder drawing shows most of the symbols.

SELF-TIMER

To set the self-timer, move the Self-Timer Lever to the right. This reveals a red dot. When the shutter button is pressed, there is a 12-second delay before the exposure is made. During the delay, a beeper sounds and a red light on the front of the camera flashes.

The timer cannot be canceled. If you return the lever to its normal setting, the shutter operates and a frame is lost.

OMPC SPECIFICATIONS

Type: 35mm SLR with programmed auto exposure, aperture-priority auto and manual. Uses OTF center-weighted metering or special ESP mode.
Shutter: Horizontal focal-plane, cloth.
Shutter Speeds: On automatic exposure, 1/1000 to 2 seconds, plus B. On manual, 1/1000 to 1 second, plus B.
Flash Sync: 1/60 X-sync at hot shoe.
Metering: Off the film, using compound light sensor in camera body. Pattern is center-weighted or ESP (Electro-Selective Pattern) for non-average scenes.
Flash: With T-series flash units, choice of OTF automatic or OTF programmed auto. Shutter speed set automatically to X sync speed.
Exposure Compensation: Plus or minus 2 steps in increments of 1/3 step.
Film Speed: Automatic with DX-coded film cartridge, or manual. Range is ISO/ASA 25 to 3200.
Viewfinder: Shows 93% of frame on non-interchangeable Lumi-Micron Matte focusing screen with combination biprism and microprism focusing aid. Magnification is 0.92 at infinity with 50mm lens.
Viewfinder Displays: LEDs show exposure mode, shutter speed, ESP operation, exposure compensation warning, flash info.
Self-Timer: 12-second delay, with flashing lamp and beeper signals.
Battery Check: LED and audible signal.
Automatic Turnoff: Turns itself off in 1 minute if not used.
Batteries: Two 1.5V silver oxide SR44 or alkaline LR44.
Dimensions: Body only—5.33 x 3.39 x 2.09 inches (135.5 x 86 x 53mm).
Weight: Body only—16.2 oz. (460g).

When using the self-timer, the mirror moves up as soon as the shutter button is pressed. When shooting with long lenses or with high magnification, with the camera on a tripod or other rigid support, using the self timer allows 12 seconds for vibrations due to mirror movement to decay before the shutter opens.

MULTIPLE EXPOSURES

Use the procedure described in Chapter 8.

DEPTH OF FIELD

Pressing the Depth-of-Field Preview Button on the lens will show depth of field at the aperture value set on the lens. On programmed automatic, this is usually minimum aperture and may not be the aperture that will be used to make the exposure.

BATTERY CHECK

Move the Exposure Mode Selector to the CHECK setting. If the batteries are OK, a beeper will sound steadily and the red light on the front of the camera will glow steadily. If the signals are intermittent, replace the batteries.

T-SERIES FLASH

Flash units are installed in the hot shoe. There is no other connector on the camera body. Only X-sync is available. T-series flash units are automatically set to match the camera mode. A lightning symbol at top left in the viewfinder glows steadily to indicate that the flash is charged and ready to fire. After each flash exposure, the symbol blinks to indicate sufficient exposure.

Programmed Auto—Set the camera Exposure Mode Selector to P and the lens at minimum aperture. Turn on the flash. When the ready-light glows, press the shutter button. If the ambient light requires a shutter speed of 1/8 second or slower, the flash will be fired. The shutter will operate at X-sync speed, 1/60 second. If the ambient light requires a shutter speed faster than 1/8 second, the flash will not fire.

Aperture-Priority Auto—Set the camera Exposure Mode Selector to AUTO. Turn on the flash. Adjust aperture for an indicated shutter speed of 1/60 second or slower. To be sure the flash operates, use 1/30 second or slower. When the ready-light glows, press the shutter button. The flash will not fire at shutter speeds faster than 1/60 second.

On Manual—Set the camera Exposure Mode Selector to MANUAL. Set the camera Manual Shutter-Speed Dial to 1/60 second or slower. Set the aperture according to the guide number of the flash.

MAJOR ACCESSORIES

The omPC can use Olympus Zuiko lenses and accessories, macro equipment such as extension tubes and bellows, viewfinder eyepiece accessories, flash units, motor drives and auto winders and the associated remote-control equipment.

OM77AF

This is an autofocus camera using Olympus AF lenses. It has built-in motors for autofocus, automatic film loading, film advance and rewind, and a built-in AF Illuminator to assist autofocus in dim light. Film speed is set automatically, using DX-coded film.

There is one exposure mode—programmed automatic. The camera automatically selects among three programs, depending on lens focal length. The program in use can be altered manually by a control on the camera.

LENSES

The camera is designed to use Olympus AF lenses, which are focused automatically by the camera. Olympus Zuiko lenses may also be used but without autofocus. With Zuiko lenses, exposure control is aperture-priority automatic and there is no viewfinder exposure display.

POWER

Four AAA-size alkaline batteries are held in a detachable grip. Power Flash Grip 300 is packaged with the camera and has a built-in pop-up flash. Accessory Power Grip 100 is similar, but without the flash.

MAIN SWITCH

Power is controlled by an ON-OFF switch on the camera body.

DISPLAYS

At left in the viewfinder, you see the autofocus indicator, shutter speed, aperture, and other information related to the frame you are preparing to expose. Shutter speed and aperture values are shown in half-steps. See the accompanying drawing. The viewfinder numerals are LCDs, backlit by LEDs, which makes them very bright and easy to read.

On top of the camera, an LCD Panel shows status and general information such as frame number, drive mode, focus mode, film speed, battery check, film loading and rewinding symbols. The accompanying illustration shows typical LCD Panel displays.

The LCD Panel is turned on by the camera Main Switch. The viewfinder display is turned on by depressing the shutter button partway. If no exposure is made, it will turn itself off in about 30 seconds.

LOADING FILM

With the camera turned on, film-loading is automatic as shown in Chapter 5. A Film Window in the back cover allows you to see if a film cartridge is loaded and read the data imprinted on the cartridge.

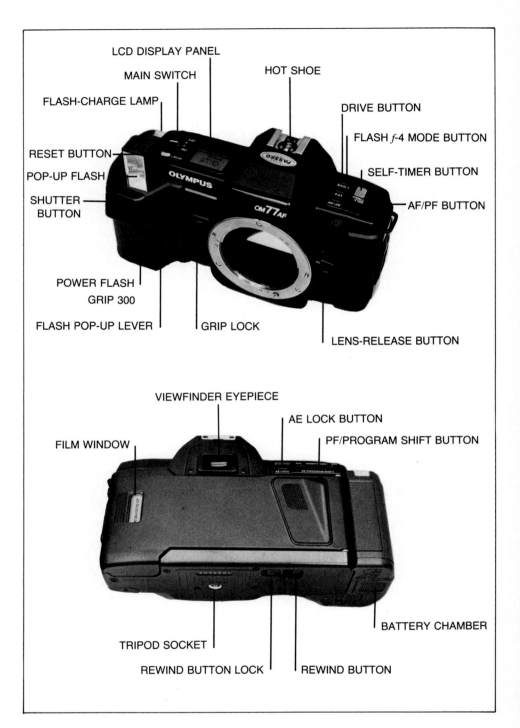

FILM SPEED

With DX-coded film, film speed is set automatically in the range of ISO/ASA 25 to 3200. If non-DX film is loaded, film speed is set to ISO/ASA 100. Each time the camera is turned on, the set film speed is displayed in the LCD Panel.

FILM ADVANCE

Film is advanced to the next frame automatically, after each exposure.

DRIVE MODE

A pushbutton labeled DRIVE selects single-frame or continuous film advance.

In the SINGLE mode, a single frame is exposed and advanced each time you press the shutter button. To expose the next frame, you must lift your finger and press the button again.

In the CONT. mode, frames are exposed and advanced continuously, as long as you press the shutter button.

Autofocus indicator at top of OM 77AF viewfinder display turns green to show good focus, red to show that autofocus cannot be performed. Numerals display shutter speed and aperture. Double arrow symbol represents Super FP long-duration flash. Single arrow represents conventional single-pulse short-duration flash. PF symbol glows when camera set for manual Power Focus.

OM77AF EXPOSURE PROGRAMS

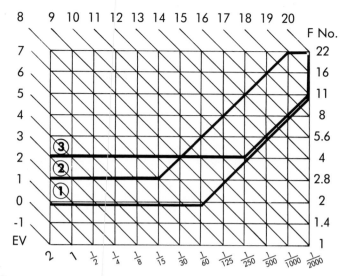

The OM77AF automatically selects one of three programs, depending on the focal length of the lens being used. The selected program may be shifted manually, if desired, to use different shutter-speed and aperture values.

Standard Program 1 is used with focal lengths from 35mm to 89mm. Wide-Angle Program 2 is used with focal lengths shorter than 35mm and favors depth of field. Telephoto Program 3 is used with focal lengths of 90mm or longer and favors faster shutter speeds, to minimize image blur due to camera motion.

AUTOFOCUS

The autofocus system uses a motor in the camera to focus the lens through a mechanical coupling at the lens mount. Focus is checked before each exposure, as discussed in Chapter 9.

Auto Focus Frame—The autofocus system focuses on whatever is in the center of the frame. The area used to focus is indicated by a rectangle that is visible in the viewfinder.

Autofocus Indicator—When the autofocus system has brought the image to focus, it turns on a green light in the viewfinder. If autofocus is impossible, for reasons discussed in Chapter 9, the system turns on a red light in the viewfinder.

Focus Mode—The autofocus system is controlled by a pushbutton labeled AF/PF, meaning Auto Focus or Power Focus.

At the AF setting, the autofocus system operates. It is turned on by depressing the shutter button partway.

At the PF setting, the autofocus system is turned off. The lens is focused manually by a control on the camera.

Single or Continuous—When operating, the autofocus system adopts the same mode as the film-advance system, controlled by the DRIVE button.

In the single-frame mode, depressing the shutter button partway causes the autofocus system to focus. If focus is found, a green light appears in the viewfinder and focus is locked at that distance. Press the shutter button fully to make an exposure. To make the next exposure, you must lift your finger and then press the shutter button again. If focus is not found, the exposure will not be made.

In the continuous mode, depressing the shutter button partway causes the camera to autofocus continuously. Depressing the shutter button fully causes the camera to autofocus and make exposures repeatedly, as

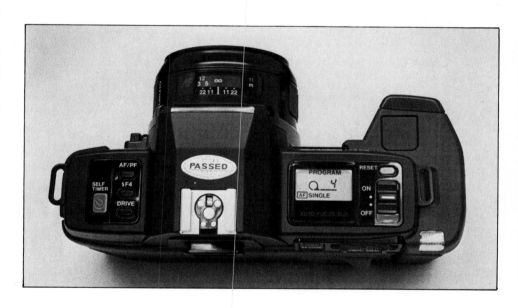

long as the shutter button is depressed. Each frame is focused individually. If focus is not found, the frame is not exposed.

Power Focus—If autofocus is impossible, you can focus manually by pressing the AF/PF button to select the PF mode. The PF/PROGRAM SHIFT control has two functions. When Power Focus has been selected, moving the control to the right or left causes the motor in the camera body to focus the lens closer or farther away.

FOCUS LOCK

In the single-frame autofocus mode, you

can recompose after focusing. Place the subject in the center of the frame, with the Auto Focus Frame over a vertical line or edge or texture of some kind to aid focusing. Press the shutter button partway. When focus is found, the green light glows and the focused distance is locked until you release the shutter button. Recompose to place the subject off center, if you wish, and press the shutter button fully to make the exposure.

FOCUSING SCREEN

The non-interchangeable Super Lumi-Micron Matte focusing screen gives a bright,

171

OM77AF LCD DISPLAY PANEL SYMBOLS

SYMBOL	MEANING	SYMBOL	MEANING
ISO 100 🔋	Film speed is ISO/ASA 100. Battery OK. If battery symbol appears "half full," batteries should be replaced.	PROGRAM PF 🔾__5 SINGLE	Camera is ready to expose frame 5 using power focus in single-frame mode.
PROGRAM 🔾__1 AF SINGLE	Film is loaded and advanced to frame 1. Camera is set for autofocus and in single-frame mode. If PROGRAM symbol blinks, program in use has been manually shifted.	PROGRAM ⏱ 🔾__6 AF SINGLE	Self-Timer is set.
PROGRAM 🔾__2 AF CONT.	Camera is ready to expose frame 2 with autofocus in continuous mode.	PROGRAM ISO 100 🔋 AF SINGLE	Pressing RESET button restores "power-on" condition, displays film speed and battery check.
⚡F4 🔾__4 AF SINGLE	Camera is in the *f*-4 flash mode. Shutter speed is 1/100 second, aperture is *f*-4.	⚡F4 PROGRAM 🔋 ⏱ ISO PF ⓡ 18800 AF SINGLE CONT.	This shows all available symbols in LCD Panel. Not all are used simultaneously.

clear view of the frame. It has a matte surface with a rectangular Auto Focus Frame at the center. There are no optical focusing aids.

Judging Focus—You can confirm autofocus by observing the image on the focusing screen—for example, to be sure focus is on the desired subject. When using manual Power Focus, judge focus by examining the focusing-screen image.

EXPOSURE METERING

Before exposure, with the main mirror down, scene brightness is measured at the focusing screen by a silicon light sensor in the viewfinder housing. Based on this measurement, preliminary shutter-speed and aperture values are displayed in the viewfinder. When the shutter opens, exposure is controlled by the OTF method, using a light sensor in the camera body—in the side of the mirror box.

EXPOSURE PROGRAMS

Three built-in programs are available, shown in the accompanying graph.

Auto Program Shift—The program being used is selected automatically, depending on focal length. When a zoom lens is used, the camera switches back and forth between programs as the lens is zoomed.

Manual Program Shift—The program being used depends on focal length. That program can be altered manually, so it uses different shutter speed and aperture settings without changing the amount of exposure. This allows control of image blur or depth of field.

To shift the program manually, the camera must be operating on autofocus, selected by the AF/PF button. In that mode, Power Focus is not used, so the PF/PROGRAM SHIFT control is not used for Power Focus. It can be used for program shift.

Moving the control to the left selects smaller aperture and correspondingly slower shutter speed. Moving the control to the right has the opposite effect.

The PROGRAM symbol blinks in the LCD Panel to show that the program has been shifted. If an exposure is not made within about 30 seconds, the program shift is automatically canceled and the camera reverts to the standard program.

OVER- AND UNDEREXPOSURE

Overexposure is indicated in the viewfinder by blinking the fastest shutter speed value, 2000. If underexposure is indicated, the symbol Lo appears instead of a shutter speed.

RESET BUTTON

When you turn on the camera, it sets itself to the autofocus mode with the lens focused at infinity, single-frame film advance and one of the standard exposure programs. These are the "power-on" settings. During operation, you may change any of those settings and select other features such as the self-timer.

To return quickly to the power-on settings, press the green RESET button on top of the camera. When pressed, it displays the set film speed and a battery-check indicator. When released, the power-on settings are restored.

AE LOCK

If the AE Lock button is pressed, the exposure setting is locked and will not change as long as the button is depressed.

Exposing Non-Average Scenes—The only way to adjust exposure for non-average scenes is to use substitute metering and the AE LOCK button as discussed in Chapter 8. There is no exposure-compensation control. Film speed cannot be changed from the DX-coded value.

SELF-TIMER

The self-timer provides a 12-second delay

OM77AF SPECIFICATIONS

Type: 35mm SLR with automatic focus using Olympus AF lenses, auto film loading, motor-driven film advance and rewind. Has multi-program auto exposure, with automatic program selection according to lens focal length. Selected program can be manually shifted.

Lenses: Camera designed for Olympus AF lenses. OM Zuiko lenses can be used with aperture-priority auto exposure, without autofocus and viewfinder exposure display.

Shutter: Vertical focal-plane.

Shutter Speeds: 1/2000 to 2 seconds.

Flash Sync: Hot shoe with X-sync at 1/100, Super FP sync and control contacts for T-series flash.

Autofocus: TTL phase-detection method. Range EV 4 to EV 18 with ISO/ASA 100. Single-frame or continuous. Focus lock in single-frame mode.

AF Illuminator: Built in. Automatic actuation when needed.

Manual Focus: Optional, using Power Focus control on camera.

Metering: Center-weighted. Range EV 1 to EV 20 with ISO/ASA 100 and f-1.8. Preliminary viewfinder indication by light sensor in viewfinder housing. Exposure control by OTF method using a light sensor in camera body.

Exposure Control: Multi-program with automatic program selection according to lens focal length. Selected program can be manually shifted.

AE Lock: By AE LOCK button.

Flash: Power Flash Grip 300 provides built-in pop-up flash controlled by camera metering system. With F280 or T-series flash, choice of OTF automatic or OTF programmed auto. With other flash, f-4 flash mode allows automatic exposure using light sensor on flash unit.

Film Speed: Set automatically with DX-coded film cartridge. No manual control. Range is ISO/ASA 25 to 3200.

Viewfinder: Shows 93% of frame on non-interchangeable Super Lumi-Micron Matte focusing screen. Screen has autofocus frame but no optical focusing aid. Magnification is 0.8 at infinity with 50mm lens.

Viewfinder Displays: Focus status, aperture, shutter speed, exposure warnings, flash info.

LCD Display Panel: Mode, frame counter, self-timer, battery check, film speed, film loading and rewind symbols.

Self-Timer: 12-second delay, with flashing lamp signal. Cancelable.

Battery Check: Automatic each time the shutter operates. Result displayed on LCD panel.

Automatic Turnoff: Turns itself off in 30 seconds if not used.

Batteries: Four AAA alkaline batteries in grip.

Data Hold: Camera retains essential data in memory, such as frame count, while batteries are being changed.

Dimensions: Body only without grip—5.55 x 3.50 x 2.05 inches (141 x 89 x 52mm).

Weight: Body only, without grip—19.6 oz. (555g).

To rewind, move the Rewind Lock Button in the direction of the arrow while pressing the Rewind Button, which is labeled R.

before making an exposure. To set the timer, press the button labeled SELF TIMER. A clock symbol appears in the LCD Panel. Press the shutter button.

If the autofocus system is working, it will seek focus. If the image is brought to focus, the timer starts. The viewfinder display becomes blank to indicate that the timer is working. The clock symbol in the LCD panel and a red light on the front of the camera blink during the countdown. After 12 seconds, the shutter opens. If focus is not found, the exposure is not made.

With Power Focus, the exposure will be made whether the image is in focus or not.

To Cancel—To cancel the self-timer before the exposure is made, press the RESET button or turn off the camera. After each exposure, the self-timer cancels itself. To use it again, it must be set again.

MULTIPLE EXPOSURES

There is no way to make multiple exposures.

DEPTH OF FIELD

There is no way to view depth of field. However, you can use the depth-of-field scale on fixed-focal-length lenses.

REWINDING FILM

When the last exposure is made, tension in the film path causes the camera to prepare to rewind. A blinking R symbol appears in the LCD Panel.

Move the Rewind Lock in the direction of the arrow while pressing the Rewind Button. The camera will rewind automatically, drawing the film end all the way into the cartridge.

BATTERY CHECK

Each time the camera is turned on, or the RESET button pressed, a battery symbol appears in the LCD Panel. When the battery appears to be "half full", replace the batteries.

AF ILLUMINATOR

An AF Illuminator lamp is in the front of the viewfinder housing, beside the OM77AF symbol. It blinks during self-timer countdown. Its primary purpose is to cast a dark red beam of light on the subject when the ambient light is too dim for autofocus. When needed, the camera turns on the AF Illuminator automatically. Its duration is about 1/4 second and its range is about 30 feet.

POWER FLASH GRIP 300

This detachable grip houses a small pop-up flash and batteries that power both flash and camera. Guide number of the flash is 12 meters or about 40 feet with ISO/ASA 100.

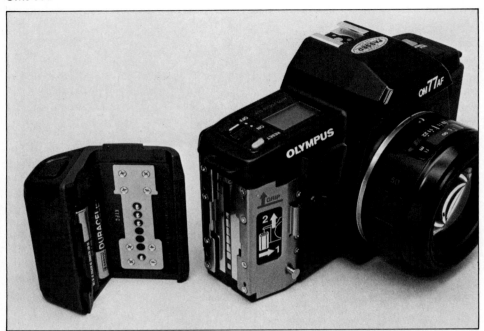

Power Grip 100, shown here, is similar to Power Flash Grip 300 except that Grip 100 does not have a built-in pop-up flash. Either grip holds batteries that power the camera.

It's a conventional single-burst short-duration electronic flash.

To use the flash, slide the Flash Pop-Up Lever toward the camera. To turn it off, press downward on the top of the flash to force it back into the grip.

The flash charges only if the camera Main Switch is on and the viewfinder exposure display is visible. When the flash is charged, a ready-light glows on the back of the grip and a flash symbol appears in the viewfinder. Press the shutter button. After the exposure, the viewfinder flash symbol blinks to indicate sufficient exposure.

The flash will fire only if the ambient light causes the exposure program to select a shutter speed of 1/100 second or slower. When the flash-ready light is on, shutter speed is switched to 1/100 (X-sync speed) and the shutter will operate at that speed.

The camera sets aperture by making a guide-number calculation. Flash-to-subject distance is the focused distance of the lens—whether set by the autofocus system or the Power Focus control. The calculated aperture is displayed in the viewfinder. You can see it change at different focused distances. For example, with a guide number of 40 feet and a focused distance of 20 feet, the camera will use f-2.

F280 FULL-SYNCHRO FLASH

As discussed in Chapter 11, this flash has two modes: conventional single-pulse short-duration flash to be used at X-sync speed or slower and Super FP long-duration flash that can be used at faster shutter speeds.

With the F280 installed in the hot shoe, turned on, and the flash Mode Selector Switch set to NORMAL, the flash is controlled by the OM77AF.

If the ambient light calls for a shutter speed of 1/100 second or slower, aperture is set at f-4 and a shutter speed of 1/100 second is used. The flash operates in the conventional single-pulse mode. Exposure is controlled by the OTF sensor in the camera. The viewfinder ready-light and sufficient-exposure indicator is a single lightning symbol. The flash-mode indicator lamp on the back of the F280 is a single lightning symbol.

If the ambient light calls for a shutter speed faster than 1/100 second, the F280 switches to the Super FP long-duration mode. The viewfinder ready-light and sufficient-exposure indicator is a double lightning symbol. The flash-mode indicator lamp on the back of the F280 is a double lightning symbol.

In this mode, light from the flash augments the ambient scene illumination. To set exposure as the scene becomes brighter, shutter speed increases. Aperture remains at f-4 until the fastest shutter speed of 1/2000 second is reached. Further increases in ambient light cause the aperture size to be reduced.

During exposure, the flash is controlled by the OTF light sensor in the camera body, which operates the sufficient-exposure indicators.

To use the F280 out of the hot shoe, install one end of TTL Auto Cord F 0.6m in the hot shoe and connect the other end to the 7-pin socket on the F280.

T-SERIES FLASH

The T20 and T32 flash units can be used when installed in the hot shoe. Reverse the calculator panel on the flash so the "blank" side is out. That sets the flash for TTL automatic control by the OTF light sensor in the camera. Turn on the flash.

When the flash is charged, the viewfinder ready-light will glow. The flash will fire if the indicated shutter speed is 1/100 second or slower. Press the shutter button. Check the sufficient-exposure indicators.

OTHER FLASH UNITS

For flash other than T-series, the F280 and Power Flash Grip 300, press the button labeled with a flash symbol and F4 on the OM77AF top panel. A similar symbol blinks in the LCD Panel.

That sets aperture to f-4 and shutter speed to 1/100 second. Both values blink in the viewfinder. Set the flash to work at f-4, according to the flash instructions. The viewfinder ready-light and sufficient-exposure indicator will not operate.

ITEMS THAT CANNOT BE USED

The OM77AF cannot be used with Zuiko Reflex 500mm f-8, Zuiko 600mm f-6.5, Zuiko 1000mm f-11 lenses. Do not use the Auto Bellows, 5-pin TTL Auto Cords for T-series flash, TTL Auto Multi Connector, TTL Auto Connector T20, Slide Copier, Roll Film Stage and Trans-Illuminator Base X-DE, Electronic Flash T45, Recordata Backs for other camera models, Polarizing Filter POL, red filter R60.

MAJOR ACCESSORIES

The OM77AF uses Olympus AF lenses (Zuiko lenses without autofocus and viewfinder display), Power Flash Grip 300, Power Grip 100, TTL Auto Cord F 0.6m, Recordata Back 100, and Dioptric Correction Lenses 2 which are supplied with a rubber eyecup.

INDEX